中国出土壁画全集

徐光冀／主编

科学出版社

北京

版 权 声 明

图书在版编目（CIP）数据

中国出土壁画全集／徐光冀主编.—北京：科学出版社，2011
ISBN 978-7-03-030720-0

Ⅰ．①中... Ⅱ．①徐... Ⅲ．①墓室壁画-美术考古-中国-图集
Ⅳ．①K879.412

中国版本图书馆CIP数据核字（2011）第058079号

审图号：GS（2011）76号

责任编辑：闫向东／封面设计：黄华斌　陈　敬
责任印制：赵德静

科 学 出 版 社 出版
北京东黄城根北街16号
邮政编码：100717
http://www.sciencep.com

北京天时彩色印刷有限公司印刷
科学出版社发行　各地新华书店经销

*

2012年1月第 一 版　开本：889×1194　1/16
2012年1月第一次印刷　印张：160
印数：1—2 000　字数：1280 000
定价：3980.00元
（如有印装质量问题，我社负责调换）

THE COMPLETE COLLECTION OF MURALS UNEARTHED IN CHINA

Xu Guangji

Science Press

Beijing

Science Press

16 Donghuangchenggen North Street, Beijing,

P.R.China, 100717

Copyright 2011, Science Press and Beijing Institute of Jade Culture

ISBN 978–7–03–030720–0

《中国出土壁画全集》编委会

凡　例

1. 《中国出土壁画全集》为"中国出土文物大系"之组成部分。

2. 全书共10册。出土壁画资料丰富的省区单独成册，或为上、下册；其余省、自治区、直辖市根据地域相近或所收数量多寡，编为3册。

3. 本书所选资料，均由各省、自治区、直辖市的文博、考古机构提供。选入的资料兼顾了壁画所属时代、壁画内容及分布区域。所收资料截至2009年。

4. 全书设前言、中国出土壁画分布示意图、中国出土壁画分布地点及时代一览表。每册有概述。

5. 关于图像的编辑排序、定名、时代、尺寸、图像说明：

编辑排序：图像排序时，以朝代先后为序；同一朝代中纪年明确的资料置于前面，无纪年的资料置于后面。

定　　名：每幅图像除有明确榜题外，均根据内容定名。如是局部图像，则在原图名后加"（局部）"；如是同一图像的不同部分，则在图名后加"（一）（二）（三）……"；临摹图像均注明"摹本"。

时　　代：先写朝代名称，再写公元纪年。

尺　　寸：单位为厘米。大部分表述壁画尺寸，少数表述具体物像尺寸，个别资料缺失的标明"尺寸不详"。

图像说明：包括墓向、位置、内容描述。个别未介绍墓向、位置者，因原始资料缺乏。

6. 本全集按照《中华人民共和国行政区划简册·2008》的排序编排卷册。卷册顺序优先排列单独成册的，多省市区合卷的图像资料亦按照地图排序编排。编委会的排序也按照图像排序编定。

《中国出土壁画全集》编委会

中国出土壁画全集

2

山西
SHANXI

主　编：马　昇
副主编：商彤流　李　非　刘俊喜　李百勤　王进先
Edited by Ma Sheng, Shang Tongliu, Li Fei, Liu Junxi, Li Baiqin, Wang Jinxian

科学出版社
Science Press

山西卷编委会名单

编　委

常一民　李　勇　马金花　杨林中　　王利民　马　昇　商彤流　李　非　刘俊喜

李百勤　王进先　张惠祥　曹臣明

参编人员（以姓氏笔画为序）

王　俊　王传勋　王进先　王银田　　厉晋春　朱晓芳　刘永生　李永杰　李舍元

李建生　张　炤　张庆捷　张惠祥　　陈庆轩　畅红霞　周雪松　高　峰　高礼双

商彤流　梁子明　焦　强　雷云贵

山西卷参编单位

山西省考古研究所　　　　　　　　　　运城市文物局

山西博物院　　　　　　　　　　　　　大同市博物馆

太原市文物考古研究所　　　　　　　　长治市博物馆

大同市考古研究所

山西地区出土壁画概述

商彤流　马昇

山西省位于中国黄土高原东缘，东、西两侧有太行、吕梁山脉，境内山岭起伏、河流纵横。远古以来即为中原农耕文化和北方游牧文化互动与融合的交汇地域，也是我国古代墓葬壁画的重要分布区域，迄今为止，已发现两汉以降各时期的壁画墓五十座以上。

1.汉代墓葬壁画

西汉晚期流行的砖室墓，沿承战国，乃至西汉前期木椁墓内漆棺画、帛画的艺术传统，出现了描绘天象、神祇等装饰性墓葬壁画。这些以祭献墓主、导引升仙为主要内容的艺术作品，形象地反映了当时人们的生死观、宇宙观。

西汉时期，山西省主要流行土坑墓、土洞墓，砖室墓较少且多分布于晋东南、晋南地区。晋东南平陆县枣园村壁画墓，墓葬主室平面长方形、附一小耳室；因随葬器物与中原地区西汉晚期同类遗存物相近，判断为两汉之际的新莽时期[1]。壁画系"先于壁上涂一层屑和麦糠的泥土，厚0.5～1厘米，外敷白粉，再于其上绘画"。以淡墨线起稿，用重墨线勾勒出具体形象，填涂红、黄、青等颜色。物象简略夸张，线描纤细流畅，赋色浓艳多变，沿承了战国、西汉时期绘画的某些特征。主室券顶上绘九只长颈短尾的白鹤，其间满布流云、星宿，"衬地繁缛，不留一点空白"；在墓顶起券处东侧绘太阳、西边绘月亮，按天文方位分布着青龙、白虎、玄武，是以天象诠释墓顶为天上仙界。在天象图以下，墓壁上层描绘出山峦、河流等景象（墓壁下部已脱落），分别在西壁上绘"牛耕"、在北壁上画"耧播"，以及院落、车马、农作等世俗庄园生活的情景；虽然分层构图的场景组合比较简率，个别画面还是鸟瞰式的粗略勾画，却是反映当时农业社会的形象资料。

晋南夏县王村壁画墓，坐东朝西，由甬道、一横前室附二耳室、并列二后室构成的砖室墓[2]；因墓室形制与洛阳烧沟汉墓五型类同，随葬的陶案、盘、杯

等形制相近，残碑字体与汉代曹全碑的字体相似，判断为东汉晚期墓。前、后室墓壁上，皆抹白灰泥层，再刷白灰浆；壁画以小棍划出物象的位置，大笔着色涂画出大体的形象，再以纤细劲挺的墨线勾勒出具象的轮廓与细部；在出行车舆的轮毂之间，有使用圆规的痕迹。甬道两侧壁上以红线界隔三栏，分别绘官吏或士卒的队列，皆面向墓外作迎奉状。前室券顶上点簇着密密匝匝的朵朵流云，墓顶起券处画出山峦叠嶂、仙人乘神兽的导引场面；在墓壁上以红线界隔四栏，涂画出左向出行的车马队伍；面对着墓门的前室东壁中部，有墓主（安定太守裴将军）夫妇并坐图，其左侧有拜谒的属吏。北后室内端墙上有两组在围廊院落中的厅堂式建筑图。若以"前室祭祀、后室安厝"的墓葬环境来考虑，前室正壁上的夫妇并坐图应为"墓主受祭图"；后室端墙上的建筑图应为墓主人的生活场所。

2.北朝墓葬壁画

魏晋时期，由于战乱频仍，最高统治阶层倡导薄葬，这使得本地区的壁画墓一度销声匿迹。北朝时期，随着拓跋鲜卑族文化与中原地区汉文化的融合，受到中原"墓内设奠"传统葬俗的影响，本地区的壁画墓又得以延续、复兴。

晋北大同市沙岭村北魏壁画墓，据出土漆器残皮上的墨书题记，推断为北魏太延元年（435年）[3]。墓室平面略呈方形，顶部虽已塌毁，但甬道、墓室壁画基本完整，为研究北魏时期车马出行、服饰装备、丧葬习俗等提供了珍贵的形象资料。墓壁上抹石灰泥层后，刷一层调和着颜料的石灰浆；壁画以红色线起稿，墨线勾勒出物象，笔迹肆意多变，再随类涂画红、黑、蓝等颜色。若与北魏司马金龙墓的木板漆画悠缓自然、富于节奏的墨线技法相比较；大同北魏墓壁画的线条粗细不一、遒劲奔放，似有意识地运用了线条与点簇的复合型技法，绘画风貌朴拙自然。

该墓壁画与本地同时期的棺板画、石椁壁画[4]一样，沿袭了汉墓壁画以界栏分层的构图法来表现祭祀、出行等内容。在残留的墓顶起券处，用红线划分多道隔栏，分别填画各类神兽。东壁上层一栏绘对列的男女侍从，向南、北两壁上层一栏延伸；东壁中部为墓主夫妇手执麈尾、团扇并坐于庑殿顶的堂屋内，两侧有大树、侍仆与备行的鞍马、牛车，似为"墓主受祭"图。北壁为纵向多排的车马出行队列，南壁以步障划分宴饮与庖厨的庞杂场面。

大同市怀仁县北魏壁画墓，为前、后室墓（前室两侧各附耳室），在垒砌墓壁的模印条砖中，发现有"丹阳王"的戳印文字；但《魏书》中不见有此人的记载。墓道、墓室不见有涂绘，仅在长甬道的两侧壁南端各绘一尊守护神（门神）形象。门神为一首、四臂，坦胸露腹，系条纹短裙，跣足；皆持一长杆（矛）、拖一金刚杵，或高举鼓锤，或捻作手指，披帛飘动，团花环绕。西壁门神的两脚踩在一女人向两侧伸展的手上，东壁门神则一脚着地、一脚蹬在一山羊向下塌陷的腰间；这种门神显然受到佛教护法金刚的影响，为山西省仅见的墓门守护神。

北齐时期的壁画墓，多发现于晋中及太原市附近。晋中寿阳县贾家庄北齐厍狄迥洛墓，为北齐河清元年（562年）的单室墓[5]。墓门的门楣正面绘朱雀、背面画忍冬纹；两门扇上绘青龙或白虎；甬道两侧壁各绘一舞者与三侍卫；墓室的两侧壁上有十字形图案。壁画以淡墨线起稿，粗墨线勾勒物象、细线条勾画局部，再因类赋色；人物、神兽造型生动，线条流畅，色彩绚丽，物象具有立体感。

太原市晋祠镇王郭村北齐娄睿墓，斜坡墓道经由过洞、天井，通过甬道、墓门与弧壁单室墓相连接；墓志纪年为武平元年（570年）[6]。壁画分栏绘制，技艺精湛，鞍马人物形神兼备。墓道两壁壁画分三栏，上栏为步骑、驼队，中栏为多组的骑卫，下栏为吹角的侍卫。"三栏行列远近有序，应是当时鲜卑贵盛外出与归来时从行部众的写照"[7]。

墓道下栏的吹角侍卫连接着过洞两壁的武士（过洞已坍塌，洞口之上的照壁处图画不详），再与天井下栏两侧的挂剑武士相连接。天井上栏两侧壁有持物仙人，甬道口之上的天井北壁为摩尼宝珠，天井上方的南壁有飞行的神兽。

甬道中段的墓门上涂画龙、虎，其内、外侧壁上绘有属史。墓室顶部画日月星辰，其北、东壁上遗存十二生肖以及羽人乘龙导引升仙的画面。在墓室北壁绘帷屋内墓主夫妇宴飨行乐图，两侧排列着伎乐、侍仆众，在东、西壁上分别绘鞍马、牛车备行的侍从队伍，南壁的甬道两侧绘侍卫众。

墓道、过洞、天井，甬道与墓室的壁面上皆抹一层白灰泥为地仗，壁画以小棍起稿，以墨线勾勒具体物象，运笔活泼爽利，刚柔并存。用朱砂色点着人物的额、颊、颔等部位，再浅淡退晕以表现肌体起伏，是为染高不染低的"三高"晕染画法。涂抹服饰、鞍马时，亦在轮廓线近处作渐次晕染，使物象具有立体感。

值得注意的是在墓道后端过洞内，清理出木柱、白灰、板瓦、条砖等遗物，推测原有"享堂"一类木构建筑，为北朝时期所罕见。在封门墙前的天井底部、封门墙后的甬道地面，摆放着陶罐、壶或陶马、镇墓兽，应为生人封墓时的祭奠遗物；且用以连接享堂与寝宫。而这些现象对认识该墓葬壁画布局及其内容，当有重要的启示。

太原市郝庄乡王家峰村北齐徐显秀墓，其墓葬形制与娄睿墓相似，墓葬年代为武平二年（571年）[8]。遗存壁画大部分完好如新。其墓道、过洞、天井壁下切平整，系土壁上粉刷白灰浆后制作壁画；甬道、墓室则在砖壁上抹白灰泥作为壁画的地仗层。墓道、过洞、天井两侧壁画均对称构图，皆为面向墓外站立的出行仪仗队列；过洞上方的照壁处绘仿木构建筑"门楼图"，甬道外口及两侧壁上有门吏或武士，两扇石门上部浮雕鹿头鸟身的蹄足兽，下部雕刻原为升腾状的龙、虎，却又被改绘成振翅状的朱雀。墓顶涂抹上下两层黄、灰色，依稀显露出稀疏的星辰；墓室北壁为墓主夫妇端坐帷帐内的宴飨行乐图；东、西壁分别绘备行的牛车、鞍马及张举羽葆、华盖的侍从队列；南壁门洞两侧为侍卫，门洞上方绘神兽。

北齐徐显秀墓壁画气势恢弘，形象生动，色彩艳

丽,内容丰富,技艺娴熟,是北朝到隋唐墓室壁画发展演变不可或缺的重要环节。

3. 唐代墓葬壁画

山西境内唐代壁画墓多发现于晋中及太原附近,晋南偶有发现。与北朝壁画墓相比较,墓室装饰成死者的住宅,屏风画大盛;甬道装饰成居室的外厅,与墓壁上廊柱间的男女侍从相配合,使得"居室化"成为太原唐代壁画墓的主要特征。

太原市南郊金胜村一带,陆续发现一批唐代单室壁画墓,平面方形,后部皆设棺床[9]。在墓壁的白灰泥层上,壁画多用黄色线起稿,以墨线勾勒出物象,再填染黄、红、绿等颜色。绘画线条流畅圆熟,有"曹衣出水"向"吴带当风"过渡的时代特征。据董茹庄唐墓出土的墓志纪年(万岁登封元年,即696年)[10],这一批墓葬均为唐武周时期,墓主人为低级官吏或富裕平民。墓顶中心绘莲花形图案,其旁绘日月、星辰、四神以表现天象。墓壁上沿均以红色粗线涂画出仿木构廊房的立柱、檐枋、斗拱;墓壁下层则以棺床为界,配置居室内外的壁画题材。以太原焦化厂唐墓为例[11],因墓室设置东、西棺床之故,在北壁中央的空当处,画一幅在立柱前的"驼马人物图",其两侧壁上仍为棺床旁边的屏风画。墓室南壁门洞两侧为门吏;东、西壁南侧有持物的侍女;不同于西安地区唐墓壁画"宅院化"的树下贵妇弄花扑蝶,表现的是墓主人的燕居生活场面。太原唐代壁画墓,皆在围绕着棺床的三面壁上安排屏风画,多为一树、一老翁为特征,习惯上称为"树下老人"。

晋南万荣县皇甫村唐代壁画墓(薛儆墓),墓葬年代为唐开元九年(721年)[12]。在附有六个过洞与天井的墓道东、西两壁,绘有朝向墓外的青龙、白虎;甬道顶部绘着仙鹤、流云;墓室西侧放置一庑殿顶石椁室,椁壁上刻画各种男女侍奉人物;而在环绕着石椁的墓室北壁与西壁上,残存的屏风画中多为树下老人的形象。这种墓葬壁画的布局及内容,明显受到了太原地区及西安地区同时期壁画墓的影响。

4. 宋、辽、金、元时期墓葬壁画

宋代墓葬主要分布于晋中以南的地区,出土数量

不多且较分散,其中土洞墓比较多,附有壁画的仿木构砖室墓较少。装饰题材沿袭前朝墓室的某些传统,皆以供奉墓主人为主旨,不仅有侍仆、妇人启门,还有乐舞、宴饮的情景,并且流行孝子故事画。

太原南郊第一热电厂北汉时期壁画墓,墓室平面圆形,墓顶已经塌毁,其下沿壁上有按天文方位绘出的四神,墓壁上部砌出仿木构建筑的斗拱、瓦垄。在墓壁上先涂泥巴层,又抹白灰泥层,再用土红色大笔涂画出倚柱、阑额、檐枋,将墓室壁面划分为八块柱间壁。甬道两侧壁各有门吏,在北壁及东、西壁正中砌作格子门,东北、西北壁正中砌作破子棂窗,其门、窗两旁绘单个的男、女侍仆;在东南、西南壁上为乐舞、侍宴的场面。壁画以淡墨线起稿,用深墨线勾勒人物轮廓,未染面相,只用土红色平涂衣物等,画面简洁、明丽[13]。

晋中平定县姜家沟村北宋晚期壁画墓,墓室平面六角形,砌筑倚柱、斗拱、檐枋、瓦垄,在遍涂白灰浆后施以壁画[14]。墓顶绘星宿,拱眼壁画四神或花卉,在东南柱间壁上遗存一幅女子乐舞图,皆容貌秀丽、体态优雅。画工技法娴熟,描线随衣纹起伏而转折自然,是难得的艺术佳作。

晋南侯马市宋代墓室,砌作仿木构建筑,柱间壁上绘山水屏风与墓主夫妇对坐图,左、右壁上画出各种持乐器的演唱场面[15]。晋东南晋城市南社村宋墓,前、后室分别砌作殿堂或居室,墓壁上嵌装侍者、孝子图砖;后室穹隆顶绘相扑、驯狮等画面[16]。长治市故县村宋墓,墓门上方两侧壁上绘有极富生活气息的舂米、推磨画,拱眼壁上还绘有颇具晚唐风貌的飞天形象[17]。

辽代壁画墓主要分布于晋北地区,在大同市郊区出土的辽墓就有十余座,墓室平面多为圆形;受佛教文化影响还出现了火葬的风俗,从纪年墓志上得知墓主多为汉人官吏或地主。墓室内以条砖砌筑斗拱铺作,用红色涂画建筑的立柱;壁画内容直接沿袭晚唐时期墓室"宅院化"的装饰题材。例如:大同新添堡村许从赟墓,墓顶绘星宿,柱间壁上设板门或破子棂窗,两侧画侍从与婢女[18]。大同十里村一辽墓,墓

顶绘星宿与仙人，北壁绘内宅和侍从，东、西壁绘庖厨、驼车，南壁绘门卫[19]。

辽代前期，继续流行花鸟树石的屏风画，但不见墓主人对坐的画面；在柱间壁上门、窗两侧多为单个的侍仆。辽代后期，其侍仆则为多人组合，有更为喧闹的乐舞、备宴场面；受到契丹族文化的影响，还出现了驼车、放牧的场景，以及内宅床榻上的朱色莲花毯。

山西各地区或多或少都有一些金代壁画墓，各自沿续本地前朝的丧葬礼俗，主要表现的还是家居生活题材，具有民间世俗化的绘画特色。大同金墓平面除圆形之外，还出现了方形与八角形；例如：大同南郊"正隆六年"（1161年）徐龟墓[20]，甬道两壁绘侍者，墓顶画星宿，南壁门洞两侧为武卫，其余三壁绘侍宴、散乐场景。未见晋中以南地区常见的孝子图。

晋南金墓平面多为长方形，多以砖雕砌作仿木构建筑；壁画逐渐成为新兴砖雕彩绘墓中的附庸。例如：稷山县金代段氏家族墓地，墓室砌作藻井、堂屋，砖雕戏台，盛行民间社火以及杂剧表演，还有二十四孝圆雕人物，阴宅之繁丽已达登峰造极的地步。

晋东南金墓的仿木构砖雕较为简单，但多有彩绘的壁画，仍以家居生活为装饰题材，并普遍流行孝子人物图。例如：屯留县宋村金天会十三年（1135年）砖室壁画墓，砌造二层楼阁，南壁绘武士，北壁绘墓主夫妇对坐图，东、西壁有生活劳作等场景；南壁中层有两幅杂剧人物，四壁上层绘孝子故事[21]。

陵川县玉泉村金大定九年（1169年）壁画墓，墓顶上绘孝子故事，围绕棺床的墓壁上绘屏风画、卷轴画，在棺床以外的壁面上画男仆侍酒、奉茶与劳作的场面。以墨线勾勒物象，彩色晕染，人物生动细致。

晋中地区金代砖室墓，多为砖雕砌筑且通施彩绘，亦有少量的墓葬壁画。例如：汾阳市金代早期家族墓中[22]，四号墓墓室后壁绘内宅、帷幔，两侧画格扇门、侍女。五号墓墓室集仿木构建筑砖雕与彩绘为一体，有墓主夫妇对坐、妇人半启门以及账房等，砖雕人物与墓壁分离为两层，极具立体感。六号墓墓

室后壁为墓主夫妇宴饮，两侧壁画格扇门和备宴的男仆。

平定县西关村金代壁画墓[23]，在八面柱间壁的上层砌作斗拱、阑额；墓壁上则分别绘出门吏、驼运、杂剧、尚宝、内宅、尚物、进奉、马厩等图。其"杂剧图"为一捷讯插科引戏，一副末于旁戏谑打浑，一副净被人取笑，一装孤则一脸正经的滑稽演出；人物形象生动，行笔流畅圆劲，生活气息浓郁，可谓金墓壁画中的佳作。

山西境内的元代壁画墓多为单室墓，壁画题材延续宋金时期的文化传统，表现出一些因地而异的蒙古族文化风情，画风拙朴有余。

晋北大同市元代冯道真墓[24]，墓壁上涂黏泥后再抹白灰泥层，绘大幅的水墨画。墓顶仙鹤云游，南壁墓门两侧仙鹤守望，东壁北侧老者观鱼、南侧道童奉茶，西壁北侧老人论道、南侧道童焚香；北壁为"疏林晚照"山水画。该墓壁画真实反映了道教官员的生活情趣，山水画景致优美，笔法流畅苍劲，颇有元代文人山水画的某些特色。

晋南运城市西里庄元代砖室墓[25]，其西壁与东壁壁画表现了杂剧演出和器乐伴奏之场景。晋东南长治市捉马村元代砖室墓[26]，墓顶绘覆莲与缠枝花卉，东、西壁分别绘侍宴图，孝子人物则明显减少。晋中平定县东回村元墓[27]，墓室砌出四铺作斗拱；壁画有夫妇对坐、男女侍仆，以及庖厨、马厩、钱库等。

明清时期，各地盛行家族墓地，墓室作纵列式拱券构造，墓壁多为素面而少有壁画。

注　释

［1］山西省文物管理委员会：《山西平陆枣园村壁画汉墓》，《考古》1959年第9期。

［2］山西省考古研究所等：《山西夏县王村东汉壁画墓》，《文物》1994年第8期。

［3］大同市考古研究所：《山西大同沙岭北魏壁画墓发掘简报》，《文物》2006年第10期。

［4］刘俊喜等：《大同智家堡北魏墓棺板画》，《文

物》2004年第12期。王银田等：《大同智家堡北魏墓石椁壁画》，《文物》2001年第7期。

［5］王克林：《北齐库狄迴洛墓》，《考古学报》1979年第3期。

［6］山西省考古研究所等：《太原市北齐娄睿墓发掘简报》，《文物》1983年第10期。山西省考古研究所、太原市文物考古研究所：《北齐东安王娄睿墓》，文物出版社，2006年。

［7］宿白：《太原北齐娄睿墓参观记》，《文物》1983年第10期。

［8］山西省考古研究所等：《太原北齐徐显秀发掘简报》，《文物》2003年第10期。

［9］山西省文物管理委员会：《太原南郊金胜村唐墓》，《考古》1959年第9期。山西省文物管理委员会：《太原南郊金胜村三号唐墓》，《考古》1960年第1期。山西省文物管理委员会：《太原市金胜村第六号唐代壁画墓》，《文物》1959年第8期。山西省考古研究所等：《太原金胜村337号唐代壁画墓》，《文物》1990年第12期。山西省考古研究所：《太原金胜村555号唐墓》，《文物季刊》1992年第1期。

［10］《太原董茹庄唐墓壁画》，《文物参考资料》1954年第11期，图版二二。《文物参考资料》1954年第12期，封三。

［11］山西省考古研究所：《太原市南郊唐代壁画墓清理简报》，《文物》1988年第12期。

［12］山西省考古研究所：《唐代薛儆墓发掘报告》，科学出版社，2000年。

［13］陶正刚：《北汉刘廷斌壁画墓》，《中华文物学会》1996年刊（台湾）。

［14］山西省考古研究所等：《山西平定宋、金壁画墓简报》，《文物》1996年第5期。商彤流：《山西平定县发现北宋佛塔地官》，《文物世界》2006年第2期。

［15］万新民：《侯马的一座带壁画宋墓》，《文物参考资料》1959年第6期。

［16］晋东南文物工作站：《山西晋城南社宋墓简介》，《考古学集刊》1981年第1期。

［17］朱晓芳等：《山西长治故县村宋代壁画墓》，《文物》2005年第4期。王进先：《长治市西白兔村宋代壁画墓发掘简报》，《山西省考古学会论文集》（三），山西古籍出版社，2000年。

［18］王银田等：《山西大同市辽代军节度使许从赟夫妇壁画墓》，《考古》2005年第8期。王银田等：《山西大同市辽墓的发掘》，《考古》2007年第8期。

［19］边成修：《大同西南郊发现三座辽代壁画墓》，《文物》1959年第7期。山西省考古研究所平朔考古队：《朔州辽代壁画墓发掘简报》，《文物季刊》1995年第2期。山西省文物管理委员会：《山西大同郊区五座辽壁画墓》，《考古》1960年第10期。

［20］大同市博物馆：《山西大同市金代徐龟墓》，《考古》2004年第9期。大同市博物馆：《大同市南郊金代壁画墓》，《考古学报》1992年第4期。

［21］王进先等：《山西屯留宋村金代壁画墓》，《文物》2003年第3期。山西省考古研究所晋东南工作站：《山西长子县石哲金代壁画墓》，《文物》1985年第6期。

［22］山西省考古研究所等：《山西汾阳金墓发掘简报》，《文物》1991年第12期。

［23］山西省考古研究所等：《山西平定宋、金壁画墓简报》，《文物》1996年第5期。

［24］大同市文物陈列馆等：《山西大同元代冯道真、王青墓清理简报》，《文物》1962年第10期。大同市博物馆：《大同元代壁画墓》，《文物季刊》1993年第2期。王银田等：《大同市西郊元墓发掘简报》，《文物季刊》1995年第2期。

［25］山西省考古研究所：《山西运城西里庄元代壁画墓》，《文物》1988年第4期。

［26］朱晓芳等：《山西长治市南郊元代壁画墓》，《考古》1996年第6期。长治市博物馆：《山西长治市捉马村元代壁画墓》，《文物》1985年第6期。长治市博物馆：《山西省长治县郝家庄元墓》，《文物》1987年第7期。

［27］山西省文管会：《平定东回村元墓》，《山西文物介绍》，山西人民出版社，1955年。

Murals Unearthed from Shanxi Province

Shang Tongliu, Ma Sheng

Located on the east edge of the Loess Plateau, Shanxi Province is embraced by Taihang and Lüliang Mountains on the east and west, and furnished by mountains and rivers all over the territory. Since remote ancient times, Shanxi has been the melting pot of agricultural cultures from the Central Plains and nomadic cultures from the northern steppe regions, and an important distribution area of ancient murals in China; to date, more than 50 mural tombs from the Han to Ming Dynasties have been found in Shanxi Province.

1. The Tomb Murals of the Han Dynasty

The murals in the brick-chamber tombs popularizing since the late Western Han Dynasty were still succeeding the motifs of the lacquer painting on the coffins or the silk paintings on the coffin palls which were prevailing in the Warring-States Period to the early Western Han Dynasty, which were celestial bodies, deities or decorative patterns for worshipping the tomb occupants and guiding them into immortal world. These motifs vividly reflected the people's views of life and death and cosmology. In the Western Han Dynasty, the main burial types in Shanxi were earthen pit shaft tombs and earthen cave tombs, brick-chamber tombs were rare and mainly distributed in the southern and southeastern regions.

In 1950s, a mural tomb was found at Zaoyuan Village, Pinglu County in southeastern Shanxi; it was a brick-chamber tomb in rectangular plan with a small side chamber, by the features of the unearthed grave goods, it was dated as in Wang Mang's Xin Dynasty between the Western and Eastern Han Dynasties[1]. The murals were painted in way of "a layer of clay mortar 0.5 to 1 cm thick tempered with wheat husks was applied to the walls first, then a layer of chalk plaster was coated as the base on which the murals were painted". The murals were sketched with light ink lines first, then the contours and details of the figures and objects were traced with dark and thick ink lines, and then red, yellow, blue and other colors were filled in to finish. The figures and objects were painted in simple and bold style, the lines were drawn fine and smooth and the colors were applied rich and varied, and some features of the paintings in the Warring-States and the Western Han Dynasty could be seen in these murals. On the vaulted ceiling of the main chamber, nine white cranes with long necks and short tails were painted among flowing clouds and celestial bodies, "the background was filled with decorative patterns without even an inch of blank left". At the springing line of the east wall, the sun was painted, and on that of the west wall, the moon; the Four Supernatural Beings -- the Green Dragon (east), White Tiger (west) and Sombre Warrior (north) were arranged by their directions, which implying that the ceiling was depicted as the heaven or immortal world. Below the celestial scene, the top parts of the walls were decorated with mountains, rivers and other landscapes, and the scenes of "Plowing with Oxen" on the west wall, "Sowing by Drill Seeder" on the north wall, and "courtyard", "carriage and horse", farming and other secular rural lives (the lower parts were missing). The layout of the murals in rows was still coarse and immature, and some of them were just simple bird's eye view painted as outlines, but they were valuable pictorial material for us to understand the agricultural society in the Han Dynasty.

In the early 1990s, a brick multi-chamber mural tomb of the Eastern Han Dynasty was excavated in Wangcun Village at Xiaxian County in southern Shanxi Province. Facing the west, it was composed of a corridor, a transverse front chamber with two side chambers attached and two parallel rear chambers[2]. Because the plan and structure resembled the Type V of the Eastern Han tombs of Shaogou Cemetery at Luoyang, the pottery tray, dishes and cups in the grave goods were also similar in shapes and style to that in the Shaogou tombs and the style of the scripts on the fragments of the stele was also similar to that of Cao Quan Tablet of the Eastern Han Dynasty, this tomb was dated as in the late Eastern Han Dynasty. The walls of the front chamber and the rear chambers were all coated with a layer of lime plaster and another layer of fine lime stucco as the base for the murals. The draft of the mural was scratched out with sharp sticks, and then color blocks were applied to the spaces among the scratched lines to get rough figures; at last, fine but sinewy dark ink lines were drawn

to figure out the contours and details of the figures and objects. On the hubs and flanges of the carriage wheels, traces of compasses could be seen. The two walls of the corridor were separated into three registers with red lines, in each of which formations of officials or warriors were painted, and all of the figures in these formations were facing outward as greeting. The vaulted ceiling of the front chamber was decorated with closely arranged flowing clouds, and at the springing line between the walls and the ceiling were the scene of "Immortals Guiding" in which were the undulating mountains and immortals riding flying mythic beasts. The walls of the front chamber were separated into four registers with red lines each of which was filled with procession formations facing to the entrance. In the middle of the east wall, which was facing the entrance, were the portraits of the couple of the tomb occupants (General Pei, who was the governor of Anding Prefecture, and his wife) seated together, on the left of whom were petty officials kneeling and paying respect. On the back wall of the northern rear chamber, two hall-shaped architectural complexes enclosed by courtyards were painted. If we consider the burial context of "the front chamber was used for worshipping and offering sacrifice, and the rear chambers were used to interment", then the portraits of the tomb occupants on the back wall (which was the central wall of the tomb) was the "tomb occupants receiving the sacrifice", and the architectural complexes on the back wall of the north rear chamber resembled the residence of the tomb occupants in the afterworld.

2. The Tomb Murals of the Northern Dynasties

In the Three-Kingdoms Period to the Western Jin Dynasty (220-316 CE), because of the incessant warfare and turmoil and the "Simple Burial" promoted by the rulers, mural tombs declined and disappeared for rather long time in Shanxi area. In the Northern Dynasties, along with the communication and melting of the nomadic culture of the Xianbei people in the Northern Frontier Zone and the agricultural culture of the Han people from the Central Plains, and the recovery of the old custom of "setting worshipping symbols and offering sacrifices in the grave", tomb murals revived and entered a new developing stage.

In Shaling Village at Datong City in northern Shanxi Province, a mural tomb was excavated; by the ink-written inscription on the fragment of lacquer ware, it was dated as in the first year of Taiyan Era (435 CE) of the Northern Wei Dynasty[3]. This tomb was roughly in a square plan; the ceiling had been caved in but the murals on the walls of the corridor and chamber were still preserved almost intact, which provided invaluable pictorial materials for the researches on the procession organizations, costumes and equipments, funeral ceremonies and burial customs of the Northern Wei Dynasty. The base of the murals was a layer of lime mortar applied to the brick walls over which a layer of lime plaster mixed with color was coated; the drafts were drawn with red lines and the outlines and details were traced with ink lines. The drawing strokes were free and varying, and colors of red, black and blue were applied to the places where they were suitable. Compared to the drawing skills of the wooden board paintings of Sima Jinlong's tomb, which were relaxed and rhythmic, the uneven, sturdy and vigorous skill of the Shaling Northern Wei mural tomb showed a plain and natural style, while the combined skills of stroking and wrinkling were applied intentionally in the mural paintings.

Like the wooden board paintings and sarcophagus murals of the same time in Shanxi[4], the murals in this tomb also followed the old layout of the murals in the tombs of the Han Dynasty, which was arranging scenes of sacrificing ceremonies and processions in registers bordered by lines. At the remaining springing line of the vaulted ceiling, the wall was separated into many columns with red lines, in which mythic animals in various shapes and postures were painted. On the top register of east wall, attendants and maids facing each other were painted, the formations of which were stretching to the top registers of the south and north walls; in the middle register of the east wall were the portraits of the couple of the tomb occupants holding fly whisk made of reindeer's tail and round fan in hands and seated in central hall with hipped roof, flanked by attendants, servants, saddled horses and readied ox carts. This might be the "tomb occupants receiving offerings". On the north wall were formations of chariots and cavalry for procession and on the south wall were scenes of feasting and cooking separated by fences.

A mural tomb of the Northern Wei Dynasty excavated at Huairen County had front and rear chambers (the front chamber

had two side chambers); on the tomb bricks, the impressed inscription "Danyang Wang (the Prince of Danyang)" was seen, but this "Danyang Wang" did not have corresponding records in historic literature. On the walls of the passageway and the chambers, no traces of murals were found, only on the ends of the corridor between the passageway and the front chamber were painted a door god on each side. The door gods had four arms, each of which was holding an object: spear, *Vajra* (a weapon used in Buddhism), drumstick, or streamer, or making a *mudra* (hand gestures with special meanings); their chests, abdomens and feet were bared, only the bodies below the waists were dressed with striped skirts; the door god on the west wall was standing by both feet on the two hands of a woman, and the one on the east wall was standing by one foot on the ground and the other on the downward bending waist of a goat. This type of door god was obviously influenced by the *Lokapala* (Dharma Protector) in Buddhist art, and these two door god figures in this tomb are the only case of this type of tomb patron saints seen in Shanxi Province to date.

The mural tombs of the Northern Qi Dynasty found so far in Shanxi Province were mainly distributed in Jinzhong Prefecture and nearby Taiyuan City. Shedi Huiluo's tomb, which was located at Jiajiazhuang Village, Shouyang County, was a single-chamber tomb built in the first year of Heqing Era (562 CE) of the Northern Qi Dynasty[5]. On the obverse of the lintel of the tomb entrance, a Scarlet Bird was painted; on the reverse, honeysuckle patterns were painted as decoration. On the two door leaves were Green Dragon and White Tiger. On each of the two side walls of the corridor, one dancer and three attendants were painted and on the side walls of the tomb chamber were cross-shaped pattern. The murals were sketched with light ink lines, the contours were drawn with thick dark ink lines and the details were traced out with thin dark ink lines, and then various colors were applied as needed. Human figures and mythic animal figures were both depicted vivid and smooth, and with three-dimensional effects.

Lou Rui's tomb, which was located at Wangguo Village, Jinci Township, Taiyuan City, was built in the first year of Wuping Era (570 CE) of the Northern Qi Dynasty. This tomb consisted of a long ramped passageway, a tunnel, a ventilating shaft, a corridor, a square tomb chamber with curved walls and a door linking the corridor and the chamber[6]. The murals in this tomb were painted into registers, the figures of people and animals in which were depicted true to life with sophisticated skills. The murals on the two side walls of the ramped passageway were divided into three registers each, the top one of which were cavalry and camel caravan formations, the middle one were groups of mounted cavalrymen, and the bottom one were saddled horses and buglers blowing long horns. "The processions in these three registers were arranged in tidy orders, which would be the depiction of the formations of guards and attendants of the Xianbei aristocrats when they were on the way outgoing and homecoming." [7]

In the same scene with the playing buglers in the bottom register (the tunnel to the south of the ventilating shaft had collapsed before the excavation, so it is not clear that if the facade over the entrance had murals or not) were figures of warriors painted on the walls of the tunnel, and again in the same scene with them were the guards bearing sword painted on the bottom registers of the two side walls of the ventilating shaft. In the top registers of the side walls of the ventilating shaft were immortals holding objects, on the north wall of the ventilating shaft over the corridor, a Mani Pearl was painted and on the south wall of the ventilating shaft were flying mythic beasts. On the tomb door in the middle of the corridor, dragon and tiger were painted; on the corridor side walls both inside and outside the door, figures of attendants were painted. On the top of the ceiling of the tomb chamber, the sun, the moon and other celestial bodies were painted, and traces of the twelve zodiac animals and winged immortals riding dragon could still be identified on the north and east sides of the ceiling. On the north wall was the feasting scene of the couple of the tomb occupants, who were seated abreast under a canopy and surrounded by musicians and guards of honor holding music instruments, fans and so on. On the east and west walls were the formations of readied horses, ox carts and lines of attendants, and on the south wall flanking the entrance were lines of guards.

All of the murals in Lou Rui's tomb were painted on the lime stucco base applied to the brick walls or cut-out earthen walls; the drafts were taken by thin sticks and the outlines and details were drawn with ink lines, the skill of which was animate and smooth, showing both strength and flexibility. The foreheads, cheeks and chins of the human figures were dotted with cinnabar, and the color was fading gradually to show the sense of fleshiness. The fading painting method of

reflecting three-dimensional effect applied in these murals is called "three-heights (the three most featured points of the face, which are forehead, cheek and chin)" in traditional Chinese paintings. The fading technique was also applied to the costumes and the animals such as the saddled horses to make them have three-dimensional effect.

Another noteworthy phenomenon in Lou Rui's tomb was that at the joint of tunnel and ramped passageway, architecture parts including wooden posts, lime plaster fragments, flat tiles and long bricks were excavated. This hints that there had been a wooden structure built here, which might be a shrine for offering sacrifices and was seldom seen in the burials of the Northern Dynasties. On the floor below the ventilating shaft and that behind the tomb door, pottery jars, pots, and pottery horse and tomb guardian animal figurines were set, which would have been the remains of sacrificial ceremony held at the time when the tomb door was sealed, as well as for connecting the shrine (as living room) and the tomb chamber (as bedroom). These remains were also helpful for us to understand the arrangement and contents of the murals in this tomb.

Xu Xianxiu's tomb, which was located at Wangjiafeng Village, Haozhuang Township, Taiyuan City, had similar type with Lou Rui's. This tomb was built in the second year of Wuping Era (571 CE) of the Northern Qi Dynasty[8]. Most of the murals in this tomb were preserved as just finished, the ones of which painted in the passageway, the tunnel and the ventilating shaft were painted on the lime plaster base applied directly to the smoothly cut out earthen wall and the ones in the corridor and the tomb chamber were painted on the lime stucco base applied to the brick walls. The murals on the walls of the passageway, tunnel and the ventilating shaft were all the guard of honor formations facing outward of the passage and holding feather banners, horns, weapons and so on; the facade between the top of the entrance and the present ground was painted as a wooden structure gate tower with simulated tiled roof, wooden rafters, bracket sets and columns.

Under the "gate tower" beside the entrance and on the side walls of the tunnel were figures of door guards or warriors; on the upper parts of the stone door leaves were bas-relief figures of mythic beasts with deer head, bird body and hoofs, and on the lower parts were originally bas-relief figures of Green Dragon and White Tiger, but both changed as painted Scarlet Birds spreading the wings. The ceiling of the tomb chamber was finished with two layers of color, a layer of yellow and a layer of gray; sparsely scattered celestial bodies could still be identified from them. On the north wall of the chamber was the scene of the tomb occupant couple having feast in a curtain and surrounded by musicians and attendants; on the east and west walls were formations of guards of honor holding feather streamers and canopies and readied ox carts and saddled horses. Flanking the entrance on the south wall were the formations of guards of honor linked to those on the east and west walls and above the entrance were flying mythic beasts and lotus flowers.

The murals in Xu Xianxiu's tomb were grandiose, vivid and colorful with rich contents and masterly painting skills, taking an indispensable link on the evolution chain of the tomb murals from the Northern Dynasties to the Sui and Tang Dynasties.

3. The Tomb Murals of the Tang Dynasty

Most of the mural tombs of the Tang Dynasty which have been found so far in Shanxi Province were distributed in Jinzhong Prefecture and Taiyuan City, and some cases were found in the southern area of the province. Different from that of the Northern Dynasties, the tomb chambers of the Tang Dynasty were usually decorated as living room of the tomb occupant, the very popular style of the tomb murals in which were that of screen painting; the corridors were usually decorated as the lobby or front hall of the residence; combined with the figures of attendants and maids standing between the columns on the walls, the "Living room Style" became the main feature of the Tang mural tombs in Taiyuan region.

A group of single-chamber mural tombs of the Tang Dynasty have been consecutively found nearby Jinsheng Village at southern suburb of Taiyuan City. All of these tombs were in square plan and with a coffin platform against the back wall[9]. The base of the murals was a layer of lime stucco applied to the walls of the tomb chambers, on which the drafts of the murals were done with yellow lines, then the contours and details of the scenes and figures were drawn with ink lines and colors such as yellow, red and green were filled out to finish. The lines were applied fluently and skillfully, and the styles were in the transitional stage from "Cao Yi Chushui (lit. Cao's costumes are [like just] getting out from water; a style of painting costumes as tight and heavy as sticking to the body of the figure)" to "Wu Dai Dangfeng (lit. Wu's draperies are

[like] floating in breeze; a style of painting costumes as loose and graceful as being blown by wind)".

According to the date on the epitaph unearthed from a Tang tomb at Dongru Village (the first year of Wansui Dengfeng Era, i.e. 696 CE)[10], these tombs were buried in Empress Wu Zetian's reign (690-704 CE) and the occupants of them were lower-ranked officials or rich citizens. The center of the tomb chamber ceiling was decorated with a lotus flower, surrounding which were the sun, the moon, stars and the Four Supernatural Beings. At the tops of the chamber walls were imitation wooden eaves, purlins, rafters and bracket sets painted with thick red lines, below which were motifs related to daily life inside and outside the living room bordered by the coffin platform. For example, the Tang tomb excavated at Taiyuan Coking Plant[11], which had two coffin platforms in east-west row, had a "Camel, Horse and Groom" scene in front of a column at the gap between the two coffin platforms, but on its both sides were still the screen paintings framed by simulated wooden structures. Flanking the entrance on the south wall were two attendants; on the south parts of the east and west walls were maids holding horsetail whisk and clothing fork. This arrangement was different from that of the Tang tombs in Xi'an region, which were showing noble women enjoying flowers or catching butterflies, but displayed the daily life of the tomb occupants. The most popular type of the murals in the Tang tombs of Taiyuan region was the screen paintings surrounding the three sides of the coffin platform, and most motifs of these screen paintings were an old man standing under a tree, which was usually called "Old Man under the Tree".

Xue Jing's tomb, which was located at Huangfu Village, Wanrong County, was built in the ninth year of Kaiyuan Era (721 CE) of the Tang Dynasty[12]. This tomb had a tunnel separated into six sections by six ventilating shafts; on the east and west walls of the passageway, Green Dragon and White Tiger facing outward were painted; on the ceiling of the corridor were cranes and floating clouds; in the west of the tomb chamber, a stone outer coffin with hipped roof was set, on the walls of which servants and maids in various postures were incised; on the north and west walls of the tomb chamber, the remained fragments of screen painting-shaped murals were mostly "Old Man under the Tree". The arrangement and motifs of the murals in this tomb showed clearly the influences from that of the Taiyuan and Xi'an region.

4. The Mural Tombs of the Song, Liao, Jin and Yuan Dynasties

Very few mural tombs of the Song Dynasty have been found so far in Shanxi Province; they were mainly distributed to the south of Jinzhong Prefecture, i.e. the Province's southern half, and scattered sparsely. Most of these mural tombs were cave tombs, and brick-chamber mural tombs were very rare. The motifs of the murals were still inherited from the previous periods, the theme of which was attending and serving the tomb occupants. The main contents were servants and maids, woman opening the door ajar, and the scenes of music and dancing performances and feastings, as well as the tale painting "Twenty-Four Paragons of Filial Piety".

A mural tomb of the Five Dynasties and Ten Kingdoms Period found at Power Plant No. 1 in the southern suburb of Taiyuan City was built in the fifth year of Tianhui Era of the Northern Han Kingdom (973 CE). The tomb chamber was in a circular plan; the ceiling had caved in before excavation, but the part at the springing line still had figures of the Four Supernatural Beings painted by their directions. Below the springing line were simulated wooden structures of *Dougong* bracket sets and tiled eaves made of bricks. The mural base of this tomb was two layers of plasters: the bottom layer was a clay mortar layer and the top layer was a lime stucco layer. The wall of the entire tomb chamber was partitioned into eight bays with pilasters, lintels and eave purlins painted with reddish-brown color. In the bay on the due south split by the entrance were petty officials, in the north, east and west bays were brick-inlaid grid doors, in the northeast and northwest bays were brick-inlaid vertical lattice windows; beside each of the doors and windows was an attendant or a maid. In the southeast and southwest bays were scenes of music and dancing performance and preparing for tea reception. All of the murals were drafted with light ink lines, and the contours and details were drawn with dark ink lines; the facial details were not colored and the costumes were simply painted with reddish-brown color without fading effects. The overall style of the murals of this tomb was plain and spirited[13].

A mural tomb of the late Northern Song Dynasty found at Jiangjiagou Village, Pingding County, Jinzhong Prefecture, was in a hexagonal plan. The tomb chamber was built as imitation wooden structure with brick pilasters, bracket sets, lintels and

tiled eaves. The walls were coated with lime mortar over which the murals were painted[14]. Celestial bodies were painted on the ceiling; the spaces in the gaps between the bracket sets were decorated with the Four Supernatural Beings or floral designs and a piece of dancing performance scene was preserved on the southeast bay, the dancers in which were all painted beautiful and graceful. This piece of mural painted with ease and mature skills was a rare artwork.

A mural tomb found at Houma City in southern Shanxi was built as imitation wooden structure in square plan; on the back (north) wall of the tomb chamber was the portraits of the couple of tomb occupants seated abreast in front of a landscape painting screen; on the east and west walls were musicians singing or playing various instruments[15]. A mural tomb of the Northern Song Dynasty found at Nanshe Village, Jincheng City in southeastern Shanxi was a double-chamber brick tomb, the front and rear chambers were built and finished as front hall and living room respectively; bricks with bas-relief figures of attendants and the "Twenty-Four Paragons of Filial Piety" were inlaid on the walls of both chambers, and on the dome-shaped ceiling of rear chamber were scenes of wrestling and lion taming[16]. Another mural tomb of the Northern Song Dynasty found at Guxian Village, Changzhi City in southeastern Shanxi had scenes of husking rice and milling flour painted on the side walls over the tomb entrance, which had rich daily life flavor; in the gaps between the brick-laid simulated bracket sets, figures of flying *apsaras* with features of late Tang Dynasty could be seen[17].

The mural tombs of the Liao Dynasty were mainly distributed in the northern Shanxi Province, over a dozen of which were found in the suburbs of Datong City. These mural tombs were usually in circular plan; cremation custom emerged under the influence of Buddhist culture. From the unearthed epitaphs, we know that most of the occupants of the mural tombs were Han people, who were officials or rich citizens. The tomb chambers were built as simulated wooden structure with brick-laid bracket sets and columns painted with red color; the motifs of the murals were directly inherited from those of the "Living room Style" of the late Tang Dynasty. For example, Xu Congyun's tomb found at Xintianpu Village had celestial bodies painted on the ceiling, doors with firm board leaves or windows with vertical slats set in the bays partitioned by pilasters and attendants and maids standing beside these doors or windows[18]. A mural tomb of the Liao Dynasty found at Shili Village had celestial bodies and immortals painted on the ceiling, inner room and attendants on the north wall, kitchen and camel cart on the east and west walls and door guards on the south wall[19].

In the early period of the Liao Dynasty, murals in screen painting style and with motifs of bird-and-flower and miniature landscapes were still popular, but portraits of tomb occupants were not seen; beside the doors or windows painted or inlaid in the bays separated by pilasters were usually single attendant or maid. In the late period of the Liao Dynasty, the attendants and maids appeared in groups, and more exciting scenes such as music and dancing performance and feasting emerged; influenced by nomadic culture of Khitan people, camel carts and herding scenes also appeared in tomb murals, as well as red wool blanket with lotus design put on the bed in the inner room.

Mural tombs of the Jin (Jurchen) Dynasty were widely distributed in Shanxi Province, the ones of which in different regions succeeded their own local funeral traditions; however, the main motifs of the murals were still that of daily life, showing strong folklore features. In addition to circular plan, the mural tombs of the Jin Dynasty in Datong area also had square and octagonal plans; for example, Xu Gui's tomb, which was built in the sixth year of Zhenglong Era (1161 CE) in the southern suburb of Datong City, was in square plan[20]; on the walls of the corridor, figures of attendants were painted, and celestial bodies were painted on the dome-shaped ceiling; armed guards were painted on the south wall flanking the entrance. The scenes of music band performing and maids serving feast were painted on the other three walls. No "Paragons of Filial Piety" which were popular in the southern regions appeared here.

The brick tombs of the Jin Dynasty in southern Shanxi Province were mostly built in rectangular plan and as imitation wooden structure; murals gradually became a kind of auxiliary decoration for the tombs mainly decorated with colored brick carvings. For example, the tombs of the Duan Family Cemetery at Jishan County were built as front hall with caisson ceiling and drama stage model, on which were the stills of *Shehuo* (folk art performance including dance, acrobatics, etc.) or *Zaju* (lit. "Variety Play"; traditional drama form flourishing in the Song to the Yuan Dynasties) as well as round sculpture human figures of the "Twenty-Four Paragons of Filial Piety". The luxury and magnificence of the afterworld residence reached their peak at this time in this region.

The brick carving decorations of the tombs of the Jin Dynasty in southeastern Shanxi were rather simple, but color painted murals were still popular, the motifs of which were also daily life and the "Twenty-Four Paragons of Filial Piety". For example, a brick-chamber mural tomb found at Songcun Village, Tunliu County, which was built in the thirteenth year of Tianhui Era (1135 CE), had a two-story pavilion set in the chamber; figures of door gods, saddled horse and groom were painted flanking the entrance on the south wall, portraits of the couple of tomb occupants seated abreast were painted on the north wall; working scenes such as winnowing grains and feeding horses and oxen were painted on the east and west walls; two scenes of *Zaju* performance were painted on the south wall, and on the top parts of the four walls were the tale paintings "Twenty-Four Paragons of Filial Piety"[21].

A mural tomb built in the ninth year of Dading Era (1169 CE) of the Jin Dynasty found at Yuquan Village, Lingchuan County had the tale paintings "Twenty-Four Paragons of Filial Piety" painted on the ceiling of the tomb chamber, on the parts of the walls over the coffin platform were murals in screen and vertical scroll painting forms, and on the other parts were scenes of servants cooking and preparing and serving tea and wine. The contours and details of the figures, backgrounds and objects were all drawn with ink lines and applied with colors, and the figures were painted minute and vivid.

The brick-chamber tombs of the Jin Dynasty found in Jinzhong Prefecture were mostly decorated with colored brick carvings, and murals were also occasionally seen in these tombs. For example, Tomb No. 4 in a family cemetery of the early Jin Dynasty at Fenyang City[22] had inner rooms and bed curtains painted on the back wall, and grid door and maids painted on the two side walls. The Tomb No. 5 of this cemetery combined imitation wooden structure, colored brick carving and murals together, which showed the tomb occupant couple seated abreast behind the dinner table, a woman opening door ajar, the counting room and so on; the brick carved figures were detached from the wall, showing strong three-dimensional effect. Tomb No. 6 of this cemetery had feasting scene of the tomb occupant couple on the back wall and grid doors and attendants serving wine and food on the two side walls. A mural tomb of the Jin Dynasty found at Xiguan Village, Pingding County[23] was built in octagonal plan; simulated wooden bracket sets and lintels were laid with brick on the top layers of the walls; the scenes of petty officials, loaded camel, *Zaju* performance, serving costumes and cosmetics, inner room, serving wine, preparing for travel and so on were painted. Among them, the "*Zaju* performance" scene was a farce still: on the most left was a "*Jieji* (eloquent ridiculer, primary comic role)" making impromptu joke to start the plot, a "*Fumo* (assistant comic role)" to his upper right with a bat in hand was echoing him; to their lower right was a *Fujing* (clown) being made fun of by the former two; and a *Zhuanggu* (role as a stern official) was standing still pretending to be serious in the middle of the whole scene. To the most right of the scene was an accompanying drummer. All of the characters in this scene were depicted vivid and perfectly coordinated, the strokes were smooth and forceful, and the whole composition was full of flavor of life. This *Zaju* performance scene could be regarded as a masterpiece in murals of the Jin Dynasty.

Most of mural tombs of the Yuan Dynasty found so far in Shanxi Province were single-chamber tombs, the murals in which were still succeeding the traditional motifs from that of the Song and Jin Dynasties, while some Mongol cultural factors also appeared in the tomb murals of some regions in plain and unadorned styles.

Feng Daozhen's tomb, which was found at Datong City in northern Shanxi, was a tomb of a Taoist official built in the second year of Zhiyuan Era (1336 CE) of the Yuan Dynasty[24]. The walls of this tomb were coated by a layer of clay mud and a layer of lime plaster, on which ink paintings were drawn: on the ceiling were flying cranes, on the south wall flanking the entrance were standing cranes watching; on the north half of east wall was a scene of an old man "watching fish on the brook bank" accompanied by a boy; and on the south half, a Taoist boy serving tea. On the north half of west wall was a scene of "lecturing" and on the south half, a Taoist boy burning incense. On the north wall was a large-sized landscape ink painting with inscription "*Shu Lin Wan Zhao* (Sparse Forest in the Evening Glow)". The murals of this tomb reflected the living interests of Taoist officials of the Yuan Dynasty, the landscapes in which were painted in dexterous skills and vigorous brushwork, showing some features of literati paintings of the Yuan Dynasty.

A brick-chamber tomb found at Xilizhuang Village, Yuncheng City in southern Shanxi, showed scenes of *Zaju* performance and music playing scenes on its west and east walls[25]. A brick-chamber tomb found at Zhuoma Village,

Changzhi City in southeastern Shanxi, had lotus flower and intertwined flowers and branches painted on the ceiling, feasting and serving scenes on the west and east walls, and the appearance of the "Paragons of Filial Piety" was very rare[26]. A mural tomb of the Yuan Dynasty found at Donghui Village, Pingding County in Jinzhong Prefecture, had imitation wooden structure of four-*puzuo* bracket sets; the motifs of its murals were portraits of tomb occupant couple seated abreast, servants and maids, kitchen, horse stable, treasury, and so on[27].

In the Ming and Qing Dynasties, family cemeteries were popular in the whole Shanxi Province, the tombs in which were mostly built in longitudinal barrel vault structure, and their walls were usually plain without murals.

References

[1] CPAM (Committee for the Preservation of Ancient Monuments), Shansi Province. 1959. A Han Dynasty Tomb with Painted Walls at Tsao Yuan Ts'un, P'in Lu County. Kaogu (Archaeology), 9: 462-463, 468.

[2] Shanxi Provincial Institute of Archaeology et al. 1994. Excavation of the Tomb with Murals of Eastern Han Dynasty at Wangcun in Xiaxian County, Shanxi. Wenwu (Cultural Relics), 8: 34-46.

[3] The Archaeology Institute of Datong City. 2006. A Brief Excavation Report on the Mural Tomb of the Northern Wei located in Shaling, Datong City, Shanxi Province. Wenwu, 10: 4-24.

[4] a. Liu Junxi et al. 2004. Excavation of a Northern Wei Tomb with a Painted Coffin. Wenwu, 12: 35-47.

b. Wang Yintian et al. 2001. Excavation of a Northern Wei Tomb with a Painted Stone Coffin Chamber. Wenwu, 7: 40-51.

[5] Wang Kelin. 1979. Excavation of the Tomb of Kudihuiluo [sic.] of the Northern Qi Dynasty. Kaogu Xuebao, (Acta Archaeological Sinica), 3: 377-402.

[6] Shanxi Provincial Institute of Archaeology et al. 2006. Lou Rui's Tomb. Beijing: Cultural Relics Press.

[7] Su Bai et al. 1983. A Collection of Essays on Lou Rui Tomb of the Northern Qi in Taiyuan. Wenwu, 10: 24-39.

[8] The Institute of Archaeology of Shanxi et al. 2003. Excavation of the Xu Xianxiu's Tomb of the Northern Qi in Taiyuan. Wenwu, 10: 4-40.

[9] CPAM, Shansi Province. 1959. Two T'ang Dynasty Tombs at Chin Sheng Ts'un, Tai Yuan. Kaogu, 9: 473-476. CPAM, Shansi Province. 1960. Tang Tomb No. 3 at Jinshengcun in Southern Suburb of Taiyuan. Wenwu, 1: 37-39. CPAM, Shansi Province. 1959. Tang Tomb No. 6 with Murals at Jinshengcun in Taiyuan. Wenwu, 8: 19-22. Shanxi Institute of Archaeology et al. 1990. Tang Tomb No. 337 with Murals at Jinshengcun in Taiyuan. Wenwu, 12: 11-15. Shanxi Institute of Archaeology. 1992. Tang Tomb No. 555 at Jinshengcun in Taiyuan. Wenwu Jikan (Journal of Chinese Antiquity), 1: 24-26, 99.

[10] Photographs of murals in Tang tombs at Dongruzhuang Village, Taiyuan, on Plate XXII of Wenwu Cankao Ziliao (Cultural Relics), No. 11, 1954. Photographs of murals in Tang tombs at Dongruzhuang Village, Taiyuan, on inside back cover of Wenwu Cankao Ziliao No. 12, 1954.

[11] Shanxi Institute of Archaeology. 1988. Excavation of the Tang Dynasty Tomb with Murals at the South Outskirts of the City of Taiyuan. Wenwu, 12: 50-59.

[12] Shanxi Provincial Institute of Archaeology. 2000. Excavation Report of Xue Jing's Tomb of the Tang Dynasty. Beijing:Science Press.

[13] CPAM, Taiyuan City. 1956. Preliminary Report of the Clearing-up of a Song Tomb at Nanpingtou, Taiyuan City. Wenwu Cankao Ziliao, 3: 41-44. Tao Zhenggang. 1996. Liu Tingbin's Mural Tomb of the Northern Han Kingdom. *in*:Chinese Culture & Fine Arts Association [ed.] . Taipei: Zhonghua Wenwu Xuehui.

[14] The Institute of Archaeology of Shanxi and Others. 1996. Excavation of Song and Jin Tombs Containing Mural Paintings at Pingding in Shanxi. Wenwu, 5: 4-16. Shang Tongliu. 2006. A Buddhist Pagoda Crypt Discovered in Pingding County, Shanxi. Wenwu Shijie (World of Antiquity), 2: 34-6.

[15] Wan Xinmin. 1959. A Song Tomb with Murals at Houma. Wenwu Cankao Ziliao, 6: 56-57.

[16] The Southern Shanxi Archaeological Team. 1981. Excavation of a Song Tomb at Nanshe, Jincheng, Shanxi. In: Kaoguxue Jikan (Papers on Chinese Archaeology). vol. 1. Beijing: Zhongguo Shehuikexue Chubanshe. pp. 224-230, 243.

[17] Zhu Xiaofang et al. 2005. Song Mural Tombs at Guxian Village, Changzhi, Shanxi. Wenwu, 4: 51-61. Wang Jinxian. 2000. A Preliminary Report on the Excavation of the Tombs Decorated with Frescoes of the Song Dynasty at Xibaitu Village in Changzhi. In: Treatises for the third Conference of Shanxi Archaeology Association, vol. 3. Taiyuan: Shanxi Guji Chubanshe. pp. 131-137.

[18] Wang Yintian et al. 2005. Mural Tomb of Xu Congyun, Regional Commander of the Liao Dynasty, and His Wife in Datong City, Shanxi. Kaogu, 8: 34-47. Wang Yintian et al. 2007. Excavation of Liao Period Tombs in Datong City, Shanxi. Kaogu, 8: 34-44.

[19] Bian Chengxiu. 1959. Three Mural Tombs of the Liao Dynasty Discovered in the Southwestern Suburb of Datong. Wenwu, 7: 73. Pingshuo Working Team, Shanxi Institute of Archaeology. 1995. A Preliminary Report of the Excavation of a Fresco-tomb of the Liao Dynasty at Shuozhou. Wenwu Jikan, 2: 19-26. CPAM, Shansi Province. 1960. The Five Liao Dynasty Tombs with Murals in the Suburbs of Ta T'ung, Shansi. Kaogu, 10: 37-42.

[20] Datong Municipal Museum. 2004. Xu Gui Tomb of the Jin Period in Datong City. Kaogu, 9: 51-7. Datong Municipal Museum. 1992. Painted Tombs of the Jin Period in the Southern Suburbs of Datong City. Kaogu Xuebao, 4: 511-27.

[21] Wang Jinxian et al. 2003. Excavation of a Mural Tomb of the Nurchen Jin Dynasty at Songcun, Tunliu in Shanxi. Wenwu, 3: 43-51. The Institute of Archaeology of Shanxi. 1985. Mural Tombs of the Jin Dynasty at Shizhe, Zhangzi County, Shanxi. Wenwu, 6: 45-54.

[22] Shanxi Provincial Archaeological Institute et al. 1991. Excavation of the Jin Dynasty Tombs in Fenyang, Shanxi. Wenwu, 12: 16-32.

[23] Institute of Archaeology of Shanxi and Others. 1996. Excavation of Song and Jin Tombs Containing Mural Paintings at Pingding in Shanxi. Wenwu, 5: 4-16.

[24] The Museum of the City of Ta T'ung et al. 1962. Tombs of Feng Tao-chen and Wang Ch'ing at Ta Tung, Shansi. Wenwu, 10: 34-46. Jiao Qiang et al. 1993. Frescoed-tomb of Yuan Dynasty at Datong. Wenwu Shijie (World of Antiquity), 2: 17-24, 82-100. Wang Yintian et al. 1995. A Preliminary Report of the Excavation of the Tombs of the Yuan Dynasty at the Western Outskirts of Datong. Wenwu Shijie, 2: 27-35.

[25] Institute of Archaeology of Shanxi. 1988. Excavation of the Yuan Tomb with Wall Paintings at Xilizhuang in Yuncheng, Shanxi. Wenwu, 4: 76-78, 90.

[26] Zhu Xiaofang et al. 1996. Yuan Mural Tombs in the Southern Suburbs of Changzhi City, Shanxi. Kaogu, 6: 91-2. Changzhi Municipal Museum. 1985. Yuan Mural Tomb at Zhuoma Village of Changzhi City, Shanxi. Wenwu, 6: 65-71. Changzhi Municipal Museum. 1987. A Yuan Tomb at Haojiazhuang Village of Changzhi County, Shanxi Province. Wenwu, 7: 88-92.

[27] CPAM, Shanxi Province. 1955. A Yuan Tomb at Donghui Village, Pingding. In: Introduction to Antiquities of Shanxi. Taiyuan: Shanxi People's Publishing House.

目 录 CONTENTS

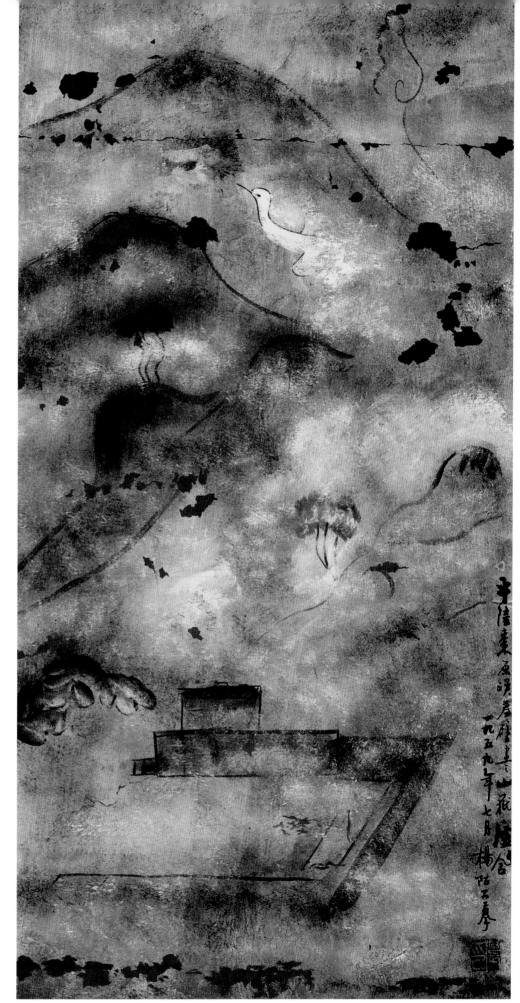

1.山峦院落图
（摹本）

新（9～23年）

高约86、宽约45厘米

1959年山西省平陆县枣园村汉墓出土。已残毁。墓向89°。位于墓室北壁东段上层。上部山峦叠嶂，山上有树木，山中有飞鸟、奔鹿，山下有一坞堡式的合围院落，后侧有一重楼。

（临摹：杨陌公

撰文：李勇

摄影：厉晋春）

Landscape and Courtyard (Replica)

Xin (9-23 CE)

Height ca. 86 cm; Width ca. 45 cm

Unearthed from Han tomb at Zaoyuancun in Pinglu, Shanxi, in 1959. Not preserved.

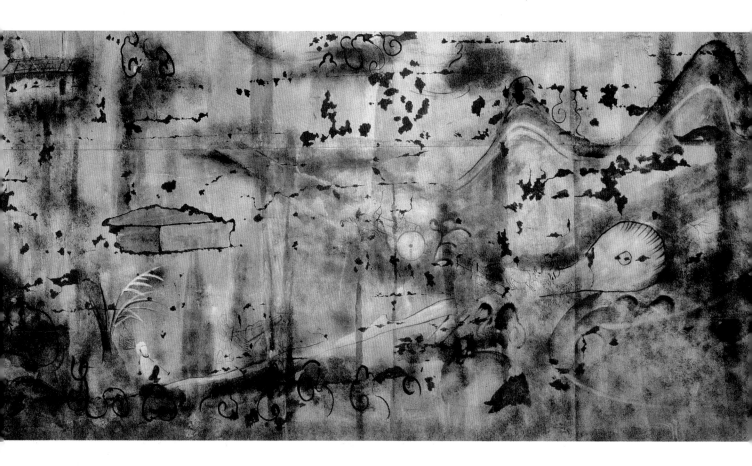

2.耧播图（摹本）

新（9～23年）

高约88、宽约177厘米

1959年山西省平陆县枣园村汉墓出土。已残毁。

墓向89°。位于墓室北壁西段上层。远山重叠，一条长河的两侧各有一路。左侧有或走或息的马车，右边一农夫驱牛耧播，一人在树下蹲坐。

（临摹：杨陌公　撰文：李勇　摄影：厉晋春）

Sowing by Drill Seeder (Replica)

Xin (9-23 CE)

Height ca. 88 cm; Width ca. 177 cm

Unearthed from Han tomb at Zaoyuancun in Pinglu, Shanxi, in 1959. Not preserved.

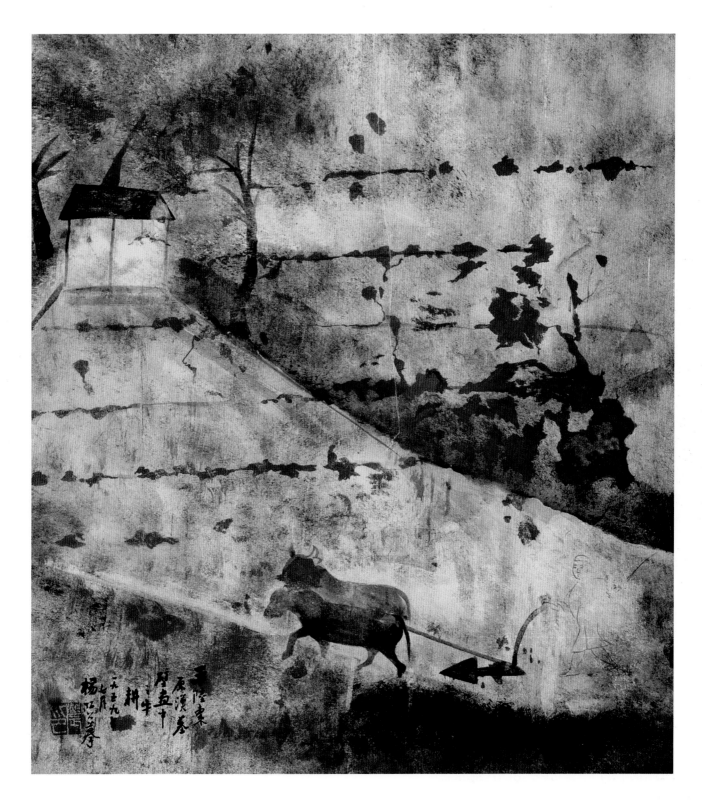

3. 牛耕图（摹本）

新（9～23年）

高约65、宽约60厘米

1959年山西省平陆县枣园村汉墓出土。已残毁。

墓向89°。位于墓室西壁上层。左上方有一房屋，两侧各有一树，屋前有宽广的路面。一短衣赤足的农夫，右手扶犁，左手扬鞭，驱二黑牛向左翻地，犁铧露于土外。

（临摹：杨陌公　撰文：李勇　摄影：厉晋春）

Plowing with Oxen (Replica)

Xin (9-23 CE)

Height ca. 65 cm; Width ca. 60 cm

Unearthed from Han tomb at Zaoyuancun in Pinglu, Shanxi, in 1959. Not preserved.

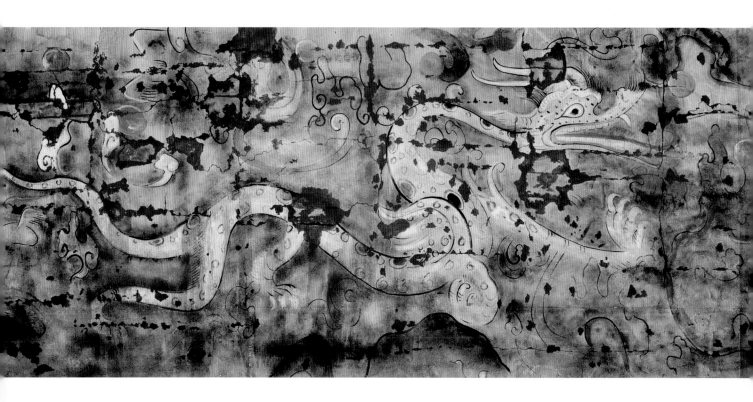

4. 青龙图（摹本）

新（9～23年）

高约81、宽约190厘米

1959年山西省平陆县枣园村汉墓出土。已残毁。

墓向89°。位于墓顶北壁中层。一条腾空的白色青龙，飞向墓门。

<div align="right">

（临摹：杨陌公　撰文：李勇　摄影：厉晋春）

</div>

Green Dragon (Replica)

Xin (9-23 CE)

Height ca. 81 cm; Width ca. 190 cm

Unearthed from Han tomb at Zaoyuancun in Pinglu, Shanxi, in 1959. Not preserved.

5. 玄武图（摹本）

新（9～23年）

高约49、宽约109厘米

1959年山西省平陆县枣园村汉墓出土。已残毁。

墓向89°。位于墓顶西壁中层。一只玄龟，龟背上有白色螺旋纹，不见有蛇。

<div align="right">（临摹：杨陌公　撰文：李勇　摄影：厉晋春）</div>

Sombre Warrior (Replica)

Xin (9-23 CE)

Height ca. 49 cm; Width ca. 109 cm

Unearthed from Han tomb at Zaoyuancun in Pinglu, Shanxi, in 1959. Not preserved.

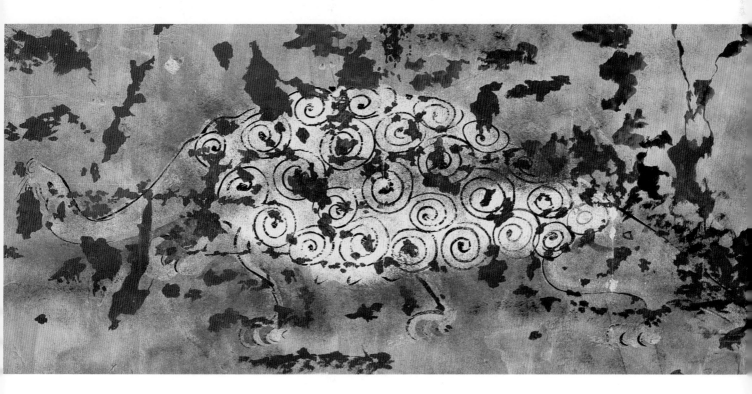

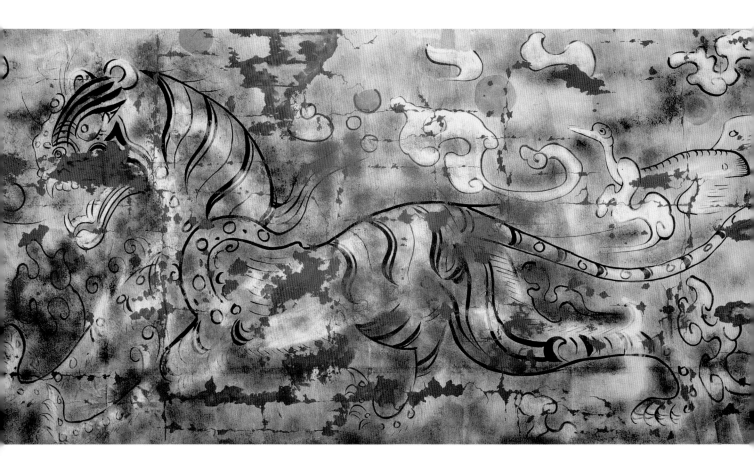

6.白虎图（摹本）

新（9～23年）

高约81、宽约156厘米

1959年山西省平陆县枣园村汉墓出土。已残毁。

墓向89°。位于墓顶南壁中层。一只凌空的斑斓白虎，飞向墓门。

（临摹：杨陌公　撰文：李勇　摄影：厉晋春）

White Tiger (Replica)

Xin (9-23 CE)

Height ca. 81 cm; Width ca. 156 cm

Unearthed from Han tomb at Zaoyuancun in Pinglu, Shanxi, in 1959. Not preserved.

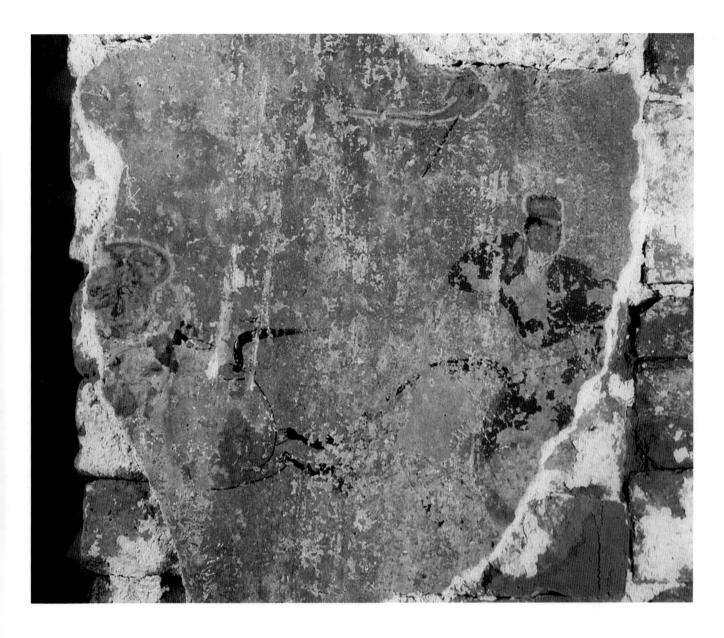

7.射猎图

东汉（25～220年）

高约35、宽约40厘米

1989年山西省夏县王村东汉墓出土。已残毁。

墓向256°。位于甬道东段拱券顶上。一匹灰马翘尾扬蹄，骑者返身张弓向上射，一长尾鸟已中箭；右侧一匹白马、伏颈疾进，骑者回首弯弓向下射。

<div align="right">（撰文：商彤流　摄影：梁子明）</div>

Hunting Scene

Eastern Han (25-220 CE)

Height ca. 35 cm; Width ca. 40 cm

Unearthed from Eastern Han tomb at Wangcun in Xiaxian, Shanxi, in 1989. Not preserved.

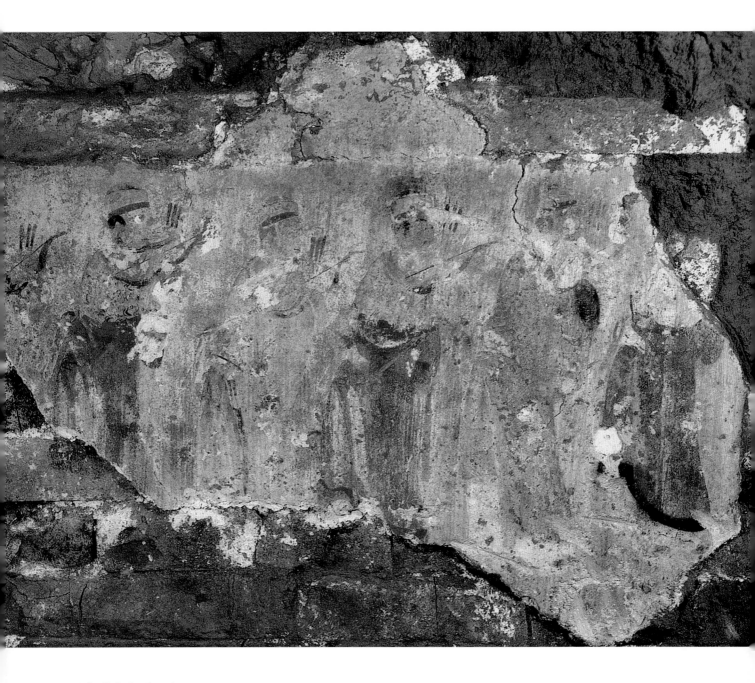

8. 迎奉图（一）

东汉（25～220年）

高约62、宽约95厘米

1989年山西省夏县王村东汉墓出土。现存于山西省考古研究所。

墓向256°。位于甬道南壁上栏。众属吏头戴平巾帻，身穿交领长袍，捧弓持箭，皆面向墓门，作迎奉状。

<div align="right">（撰文：商彤流　摄影：梁子明）</div>

Greeting and Attending (1)

Eastern Han (25-220 CE)

Height ca. 62 cm; Width ca. 95 cm

Unearthed from Eastern Han tomb at Wangcun in Xiaxian, Shanxi, in 1989. Preserved in the Institute of Archeology in Shanxi Province.

9.迎奉图（二）

东汉（25～220年）

高约51、宽约170厘米

1989年山西省夏县王村东汉墓出土。现存于山西省考古研究所。

墓向256°。位于甬道北壁下栏。众士卒头戴介帻，身著交衽长袍，持一长矛，拿一盾牌，均面向墓外，作迎奉状。

（撰文：商彤流　摄影：梁子明）

Greeting and Attending (2)

Eastern Han (25-220 CE)

Height ca. 51 cm; Width ca. 170 cm

Unearthed from Eastern Han tomb at Wangcun in Xiaxian, Shanxi, in 1989. Preserved in the Institute of Archeology in Shanxi Province.

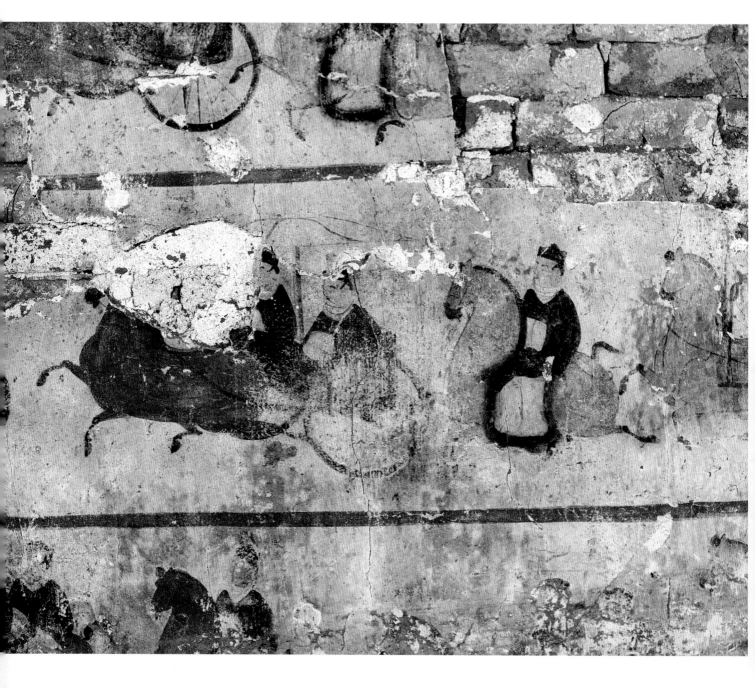

10. 车马出行图（局部一）

东汉（25～220年）

高约45、宽约45厘米

1989年山西省夏县王村东汉墓出土。现存于山西省考古研究所。

墓向256°。位于前室西壁甬道口南侧壁。共有四栏画像，现仅存下部三栏。画面为第三栏的"上计掾"车马出行图，绘有左行的辎车二乘，从骑一名。

<div align="right">（撰文：商彤流　摄影：梁子明）</div>

Procession Scene (Detail 1)

Eastern Han (25-220 CE)

Height ca. 45 cm; Width ca. 45 cm

Unearthed from Eastern Han tomb at Wangcun in Xiaxian, Shanxi, in 1989. Preserved in the Institute of Archeology in Shanxi Province.

11.车马出行图（局部二）

东汉（25～220年）

高约30、宽约40厘米

1989年山西省夏县王村东汉墓出土。现存于山西省考古研究所。

墓向256°。位于前室西壁甬道口南侧壁。壁画原为四栏，此图为第四栏的"进守长"车马出行图，左侧为导骑五名，题记："式进与功曹"，中部轺车一乘，题记："进守长"，车、骑皆左行。

（撰文：商彤流　摄影：梁子明）

Procession Scene (Detail 2)

Eastern Han (25-220 CE)

Height ca. 30 cm; Width ca. 40 cm

Unearthed from Eastern Han tomb at Wangcun in Xiaxian, Shanxi, in 1989. Preserved in the Institute of Archeology in Shanxi Province.

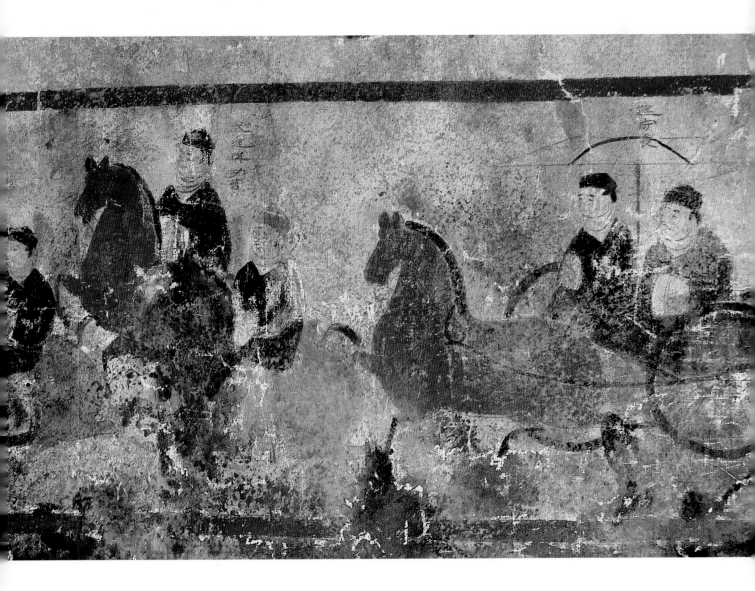

12. 车马出行图与夫妇并坐图

东汉（25～220年）

高约158、宽约207厘米

1989年山西省夏县王村东汉墓出土。现存于山西省考古研究所。

墓向256°。位于前室东壁中部。共四栏画像，上一栏已残毁不清，第二栏为车马出行图，绘一列左行的导骑、伍佰、轺车、从骑等。第三栏左段为上下两栏属吏向右跪拜；右段通幅为帷帐内端坐的男性墓主人，身旁绘曲足几案，帷帐右上角榜题："安定太守裴将军"，其右下侧残留另一朱红袍裾，为墓主夫人像的残迹。

（撰文：商彤流　摄影：梁子明）

Procession Scene and Tomb Occupant Couple Seated Abreast

Eastern Han (25-220 CE)

Height ca. 158 cm; Width ca. 207 cm

Unearthed from Eastern Han tomb at Wangcun in Xiaxian, Shanxi, in 1989. Preserved in the Institute of Archeology in Shanxi Province.

13. 仙人导引图

东汉（25～220年）

高约130、宽约55厘米

1989年山西省夏县王村东汉墓出土。现存于山西省考古研究所。

墓向256°。位于前室东券顶。上部为仙禽神兽穿行于山峦云气间，下部为两位导引仙人。

<div align="right">（撰文：商彤流　摄影：梁子明）</div>

Immortals Guiding

Eastern Han (25-220 CE)

Height ca. 130 cm; Width ca. 55 cm

Unearthed from Eastern Han tomb at Wangcun in Xiaxian, Shanxi, in 1989. Preserved in the Institute of Archeology in Shanxi Province.

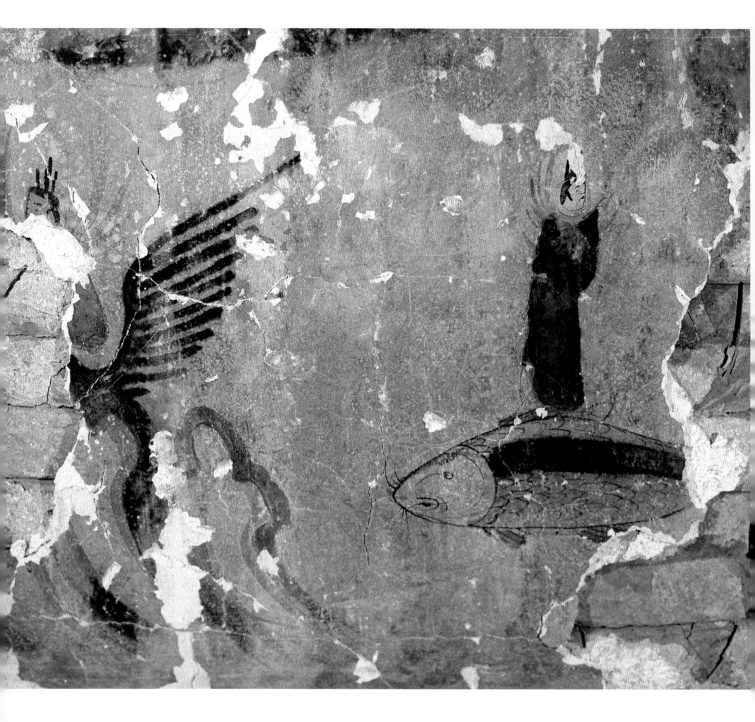

14. 仙人导引图（局部）

东汉（25～220年）

高约45、宽约55厘米

1989年山西省夏县王村东汉墓出土。现存于山西省考古研究所。

墓向256°。位于前室东券顶下部。一羽翼仙人骑一振翅大鸟，一羽翼仙人返身站在大鱼脊背上，皆左行。

<div align="right">（撰文：商彤流 摄影：梁子明）</div>

Immortals Guiding (Detail)

Eastern Han (25-220 CE)

Height ca. 45 cm; Width ca. 55 cm

Unearthed from Eastern Han tomb at Wangcun in Xiaxian, Shanxi, in 1989. Preserved in the Institute of Archeology in Shanxi Province.

15.院落图

东汉（25～220年）

高约160、宽约215厘米

1989年山西省夏县王村东汉墓出土。现存于山西省考古研究所。

墓向256°。位于北侧后室的东壁。两组廊庑合围的院落中，各有一座干栏式的四阿顶堂屋，院墙正面有门房，两侧站立持彗门吏（已脱落）。

<div align="right">（撰文：商彤流　摄影：梁子明）</div>

Courtyard

Eastern Han (25-220 CE)

Height ca. 160 cm; Width ca. 215 cm

Unearthed from Eastern Han tomb at Wangcun in Xiaxian, Shanxi, in 1989. Preserved in the Institute of Archeology in Shanxi Province.

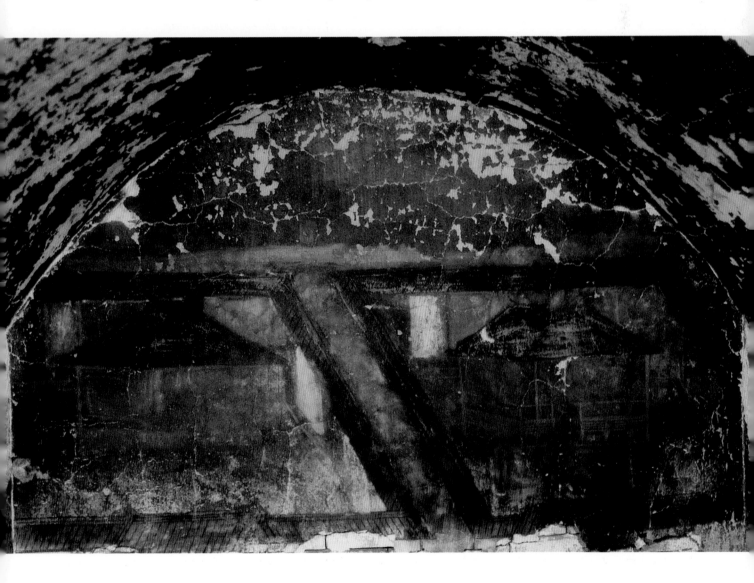

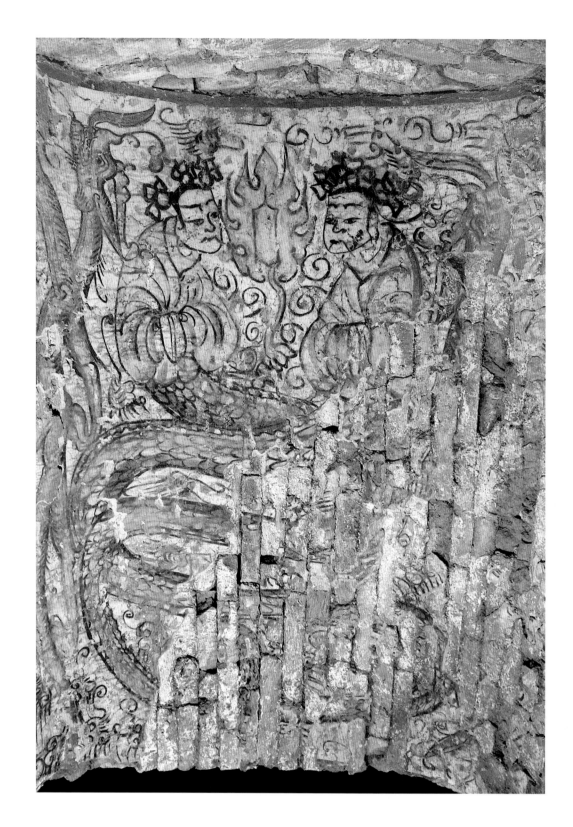

16. 伏羲、女娲图

北魏太延元年（435年）

长约160、宽约114厘米

2005年山西省大同市东郊沙岭村7号墓出土。原址保存。

墓向272°。位于甬道拱券顶部。伏羲、女娲相互面对，长尾交缠。头向墓外，戴花冠，穿交领上襦，拱袖于胸前，其间有一火焰纹围绕的摩尼宝珠。左侧有一条长龙。

（撰文：刘俊喜　摄影：高峰）

Fuxi and Nüwa

1st Year of Taiyan Era, Northern Wei (435 CE)

Height ca. 160 cm; Width ca. 114 cm

Unearthed from Tomb M7 at Shalingcun in eastern suburbs of Datong, Shanxi, in 2005. Preserved on the original site.

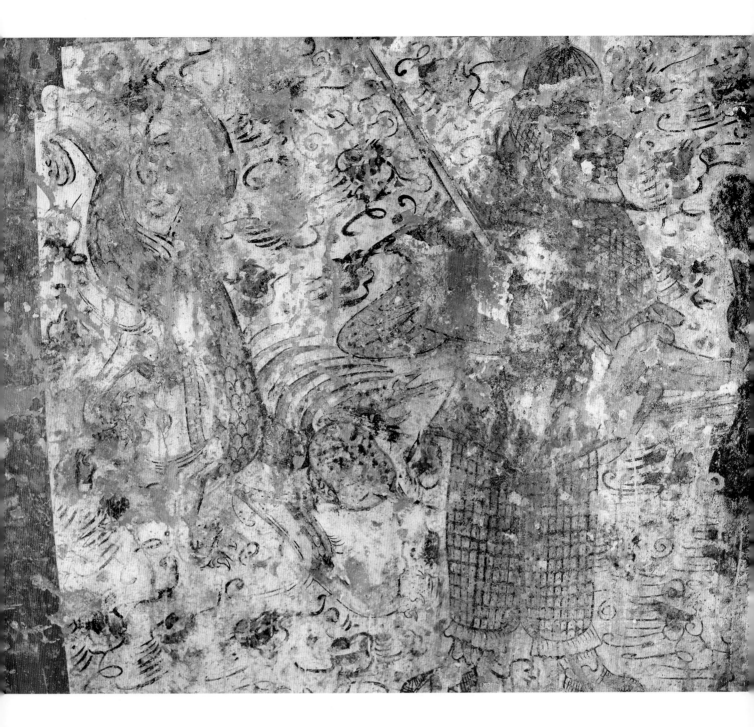

17.门吏图

北魏太延元年（435年）

高约160、宽约160厘米

2005年山西省大同市东郊沙岭村7号墓出土。原址保存。

墓向272°。位于甬道南壁。一武士面向右，戴盔、披甲、蹬便履；左手持盾牌，右手拿长刀斜立于肩上。画面左侧伴随一条人面龙身的神兽。

（撰文：刘俊喜　摄影：高峰）

Door Guard

1st Year of Taiyan Era, Northern Wei (435 CE)

Height ca. 160 cm; Width ca. 160 cm

Unearthed from Tomb M7 at Shalingcun in eastern suburbs of Datong, Shanxi, in 2005. Preserved on the original site.

18. 宰牲图

北魏太延元年（435年）

高约25、宽约35厘米

2005年山西省大同市东郊沙岭村7号墓出土。原址保存。

墓向272°。位于墓室南壁右侧下部。左侧一男仆右向白羊，用膝压住羊的左前腿，左手提起羊的右前腿；右侧一男仆以双腿夹住羊的右后腿，右手握一柄短刀，正在杀羊，血淌流到下方一黑盆中。

（撰文：刘俊喜　摄影：高峰）

Butchering

1st Year of Taiyan Era, Northern Wei (435 CE)

Height ca. 25 cm; Width ca. 35 cm

Unearthed from Tomb M7 at Shalingcun in eastern suburbs of Datong, Shanxi, in 2005. Preserved on the original site.

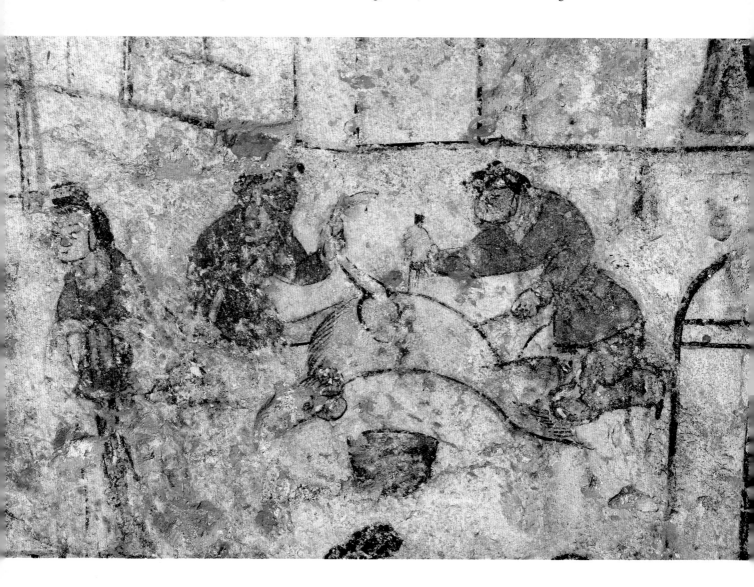

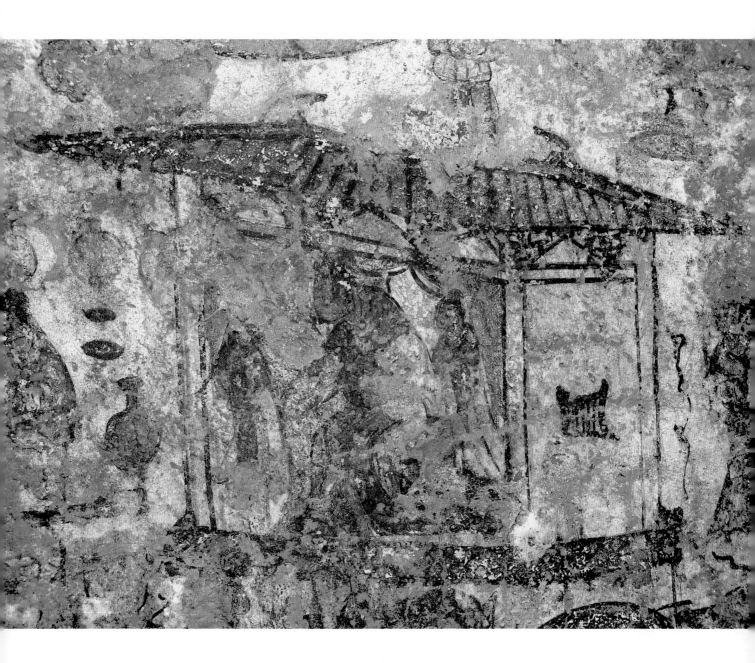

19. 主人、侍者图

北魏太延元年（435年）

高约30、宽约40厘米

2005年山西省大同市东郊沙岭村7号墓出土。原址保存。

墓向272°。位于墓室南壁左侧中部。庑殿顶堂屋，鸱尾上翘，阑额上有斗拱，侧面山墙有一直棂窗。在横楣、帷幔下，男主人躬身前倾，两侧有侍女，拱袖站立。

<div align="right">（撰文：刘俊喜　摄影：高峰）</div>

Tomb Occupant and Maids

1st Year of Taiyan Era, Northern Wei (435 CE)

Height ca. 30 cm; Width ca. 40 cm

Unearthed from Tomb M7 at Shalingcun in eastern suburbs of Datong, Shanxi, in 2005. Preserved on the original site.

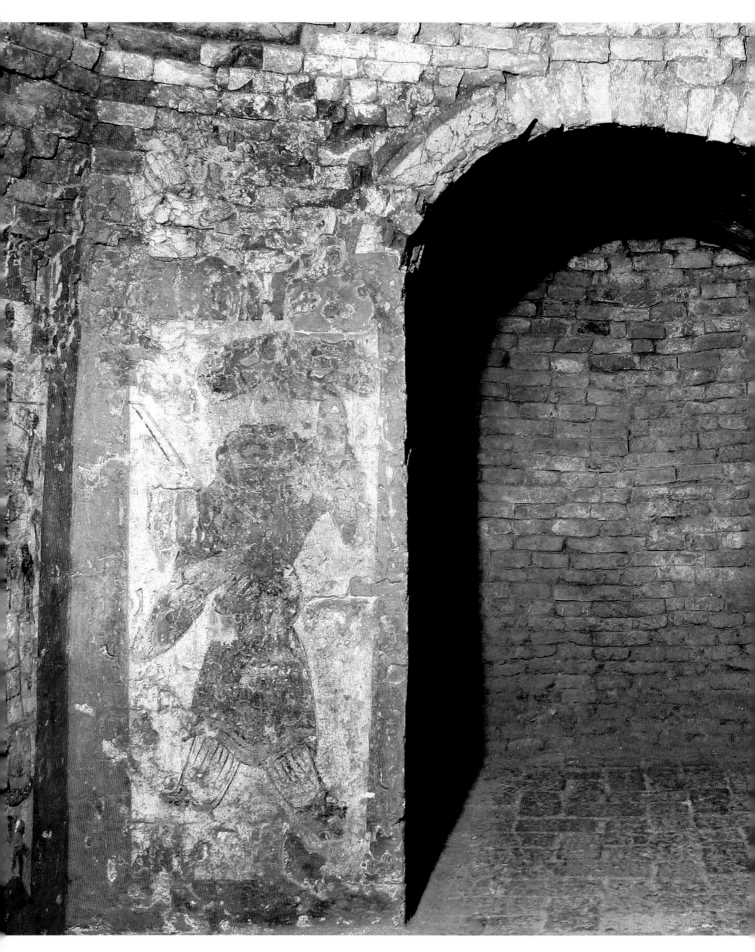

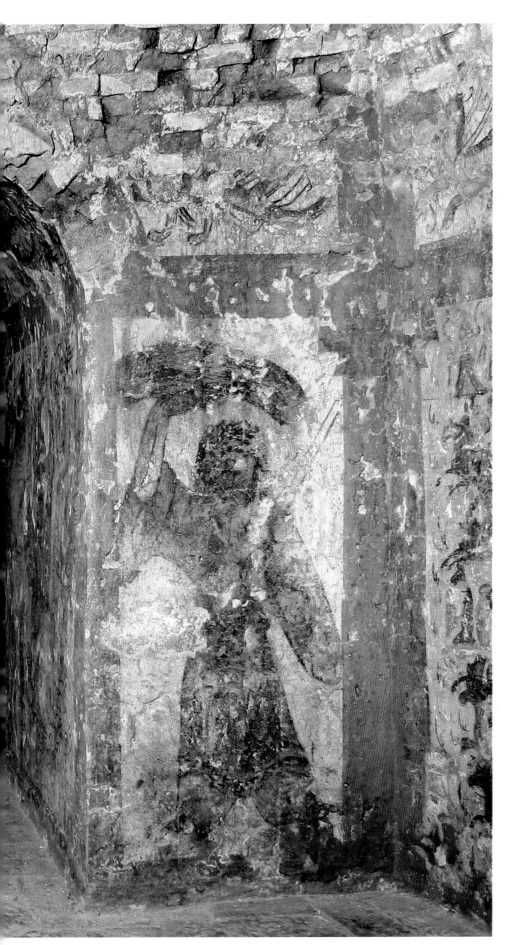

20. 武士图

北魏太延元年（435年）

高约180、宽约286厘米

2005年山西省大同市东郊沙岭村7号墓出土。原址保存。

墓向272°。位于墓室西壁入口两侧。墓壁上层红色平栏、框格一道，原有神兽，已毁。左侧壁站立武士，左手举盾牌，右手拿长刀；右侧壁武士右手举盾牌，左手执长刀。面容狰狞，头戴盔，身穿长袍。

（撰文：刘俊喜　摄影：高峰）

Warriors

1st Year of Taiyan Era, Northern Wei (435 CE)

Height ca. 180 cm; Width ca. 286 cm

Unearthed from Tomb M7 at Shalingcun in eastern suburbs of Datong, Shanxi, in 2005. Preserved on the original site.

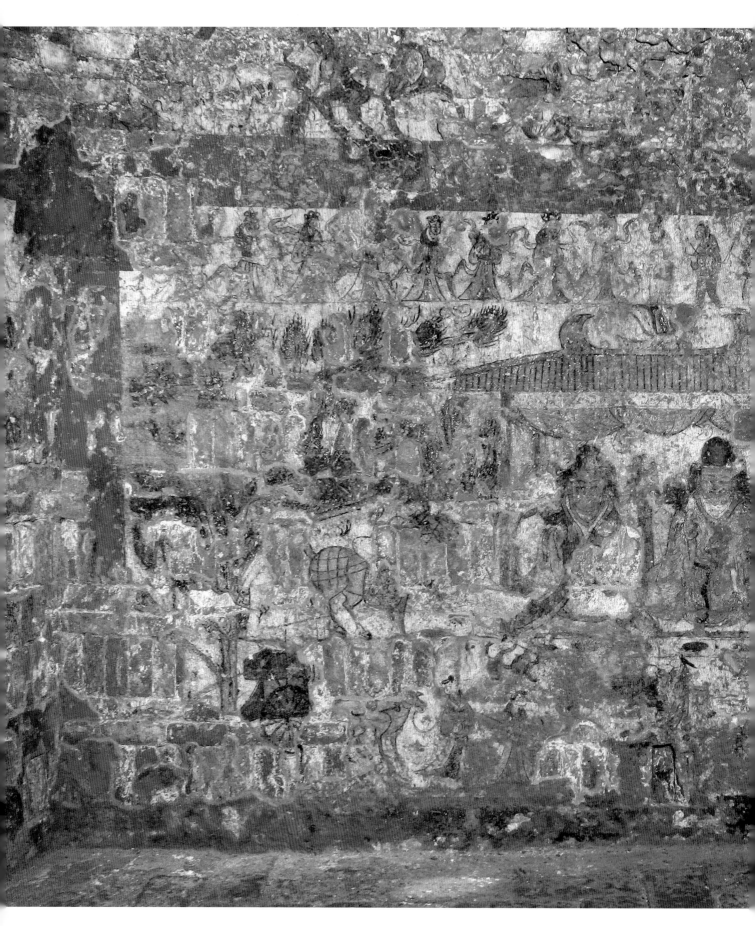

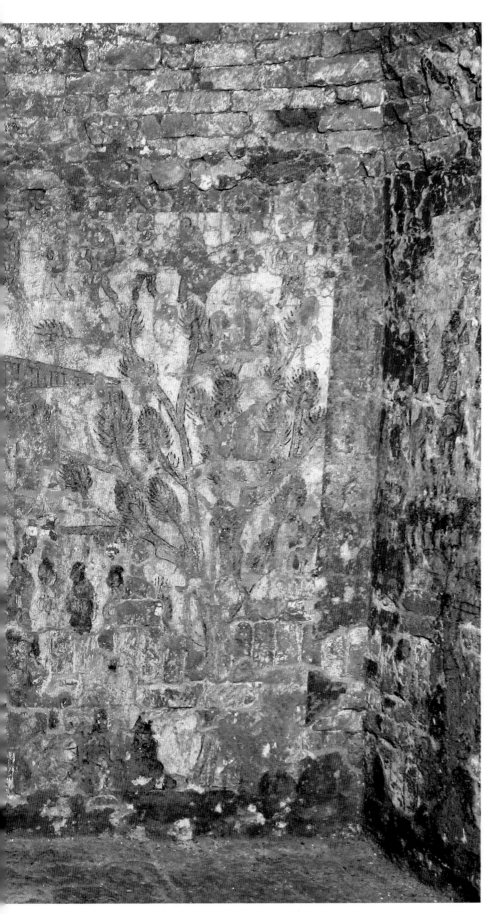

21.夫妇并坐图

北魏太延元年（435年）

高约180、宽约286厘米

2005年山西省大同市东郊沙岭村7号墓
出土。原址保存。

墓向272°。位于墓室东壁。壁画上端
一隔红线，从中分列男、女侍从与墓
室南、北壁上层红线隔内的男、女侍
从相贯通。画面正中一庑殿顶厅堂，
鸱尾间一金乌；建筑内帷幔下有墓主
夫妇端坐于曲足案之后，其身后有屏
风以及近侍。建筑两侧各有一棵大
树，画面右侧有侍仆，左侧有鞍马、
通幰牛车。

（撰文：刘俊喜 摄影：高峰）

Tomb Occupant Couple
Seated Abreast

1st Year of Taiyan Era, Northern Wei (435
CE)

Height ca. 180 cm; Width ca. 286 cm

Unearthed from Tomb M7 at Shalingcun
in eastern suburbs of Datong, Shanxi, in
2005. Preserved on the original site.

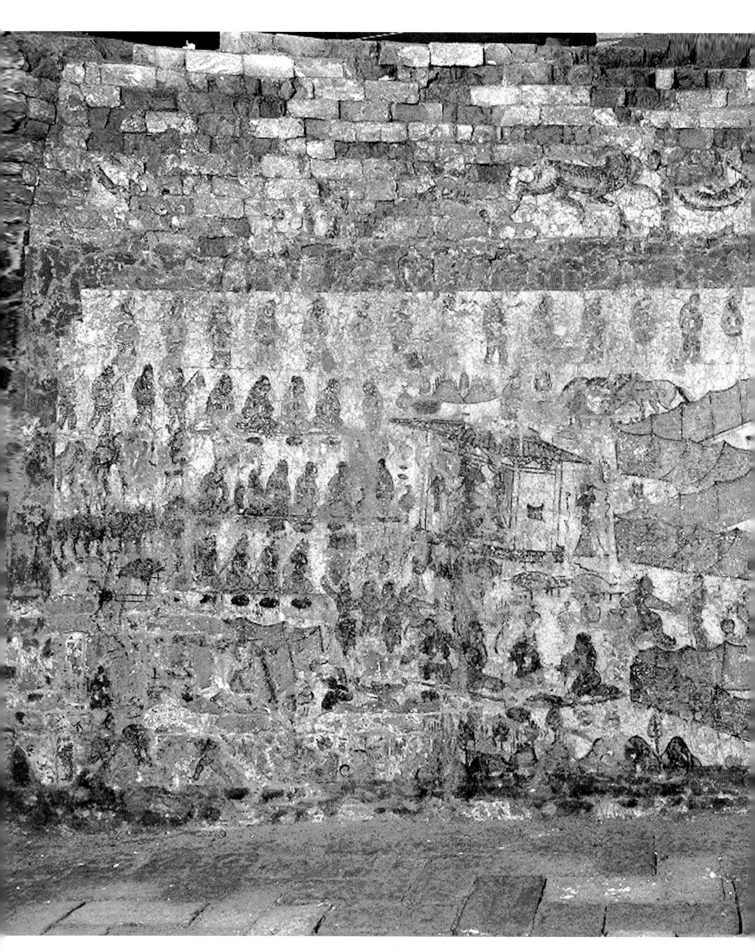

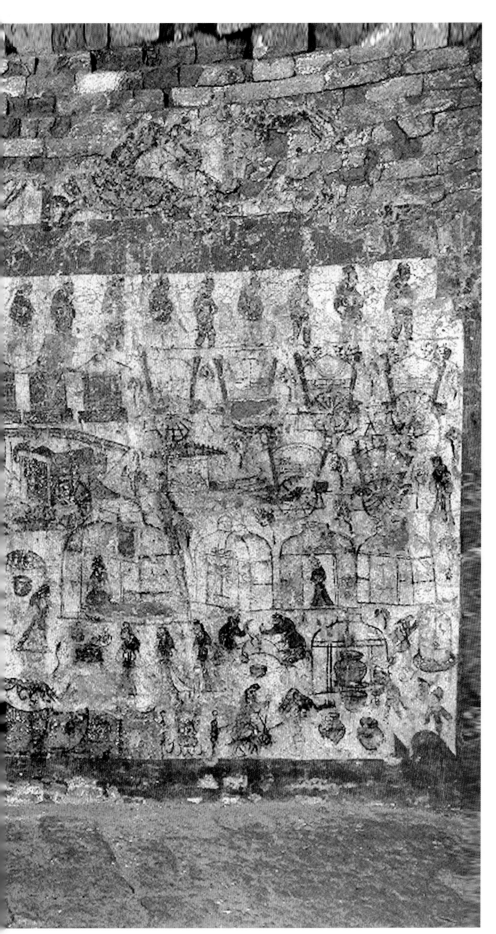

22.宴饮、庖厨图

北魏太延元年（435年）

高约180、宽约342厘米

2005年山西省大同市东郊沙岭村7号墓出土。原址保存。

墓向272°。位于墓室南壁。居中一道折曲的步障，划分出宴饮、庖厨的场景。左面以墓主人端坐的堂屋为中心，前上方有三行踞坐者，旁有男、女侍仆与车、牛，前下方有男、女乐伎；堂屋后有吃草的马匹，放置食物的架子，最下一层为山峦、树木。右面分别有粮仓、车辆、毡帐、宰杀与汲酒的场面，以树丛作点缀；车辆双辕下有支架，毡帐顶可以开启，周围有许多食物和壶、罐等。

（撰文：刘俊喜 摄影：高峰）

Feasting and Cooking

1st Year of Taiyan Era, Northern Wei (435 CE)

Height ca. 180 cm; Width ca. 342 cm

Unearthed from Tomb M7 at Shalingcun in eastern suburbs of Datong, Shanxi, in 2005. Preserved on the original site.

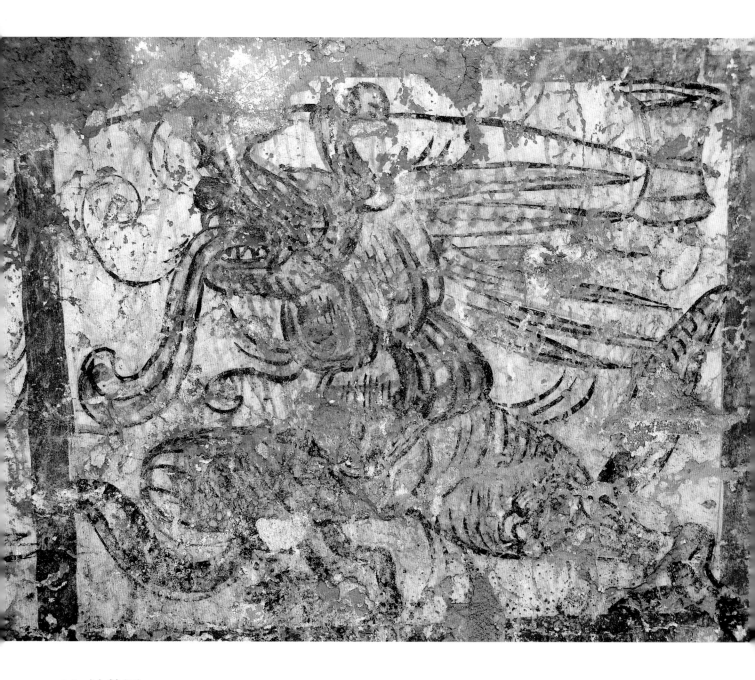

23. 神兽图

北魏太延元年（435年）

高约50、宽约55厘米

2005年山西省大同市东郊沙岭村7号墓出土。原址保存。

墓向272°。位于墓室北壁上层，即红色平栏上方左数的第二框格内。一神兽向左奔突，双臂奋力举一长柄兵器，只见其大张巨口、吐出长舌。跣足，附毛及长尾飞扬。

<div align="right">（撰文：刘俊喜　摄影：高峰）</div>

Mythical Animal

1st Year of Taiyan Era, Northern Wei (435 CE)

Height ca. 50 cm; Width ca. 55 cm

Unearthed from Tomb M7 at Shalingcun in eastern suburbs of Datong, Shanxi, in 2005. Preserved on the original site.

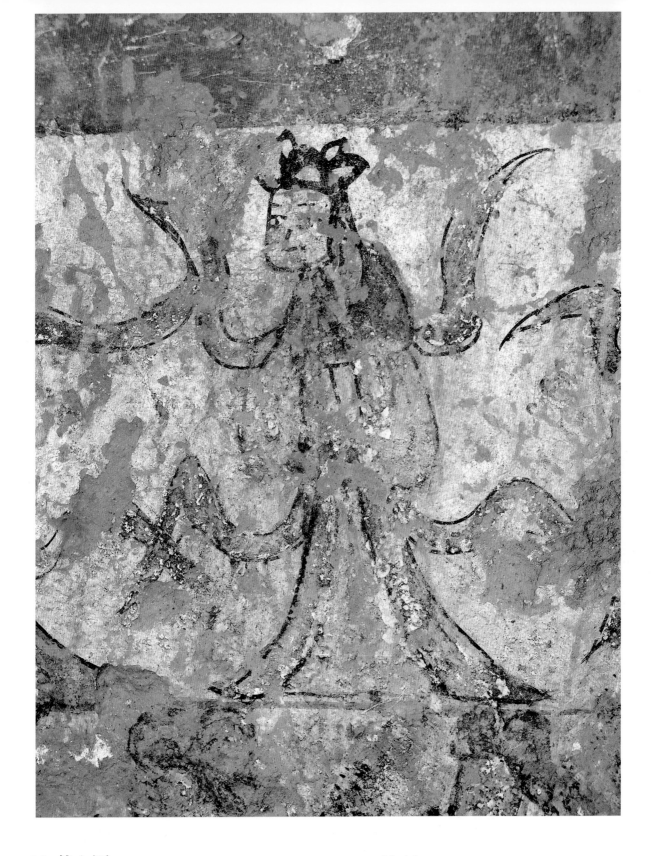

24.侍女图

北魏太延元年（435年）

高约25、宽约20厘米

2005年山西省大同市东郊沙岭村7号墓出土。原址保存。

墓向272°。位于墓室北壁上方，即红细线的界隔内左数第七人。

侍女头结花髻，上衣下裙，下摆曳地；体态婀娜，欲向左行。

（撰文：刘俊喜 摄影：高峰）

Maid

1st Year of Taiyan Era, Northern Wei (435 CE)

Height ca. 25 cm; Width ca. 20 cm

Unearthed from Tomb M7 at Shalingcun in eastern suburbs of Datong, Shanxi, in 2005. Preserved on the original site.

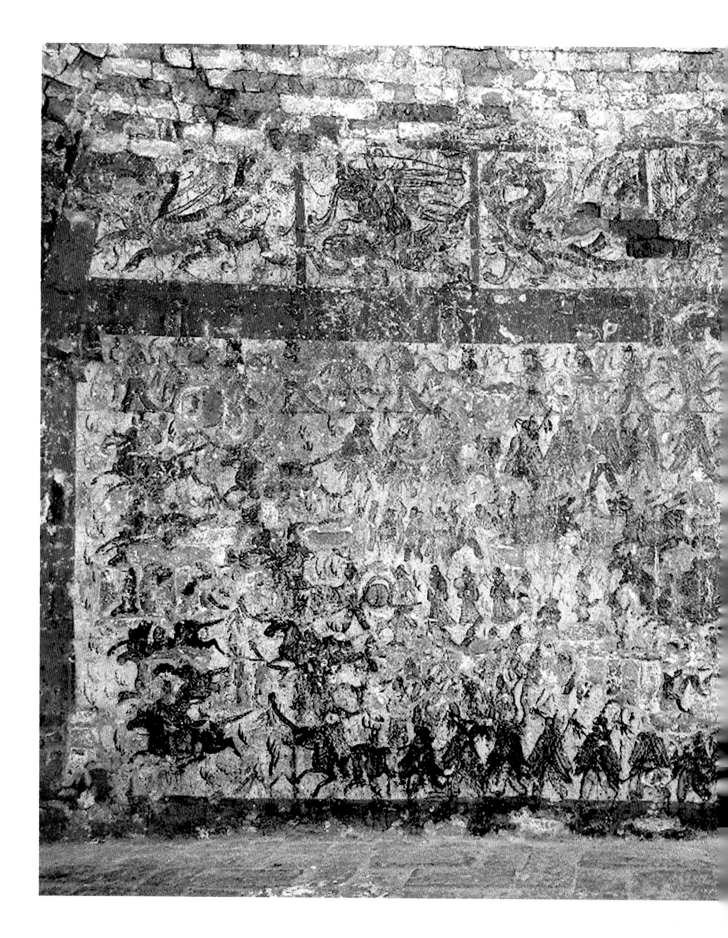

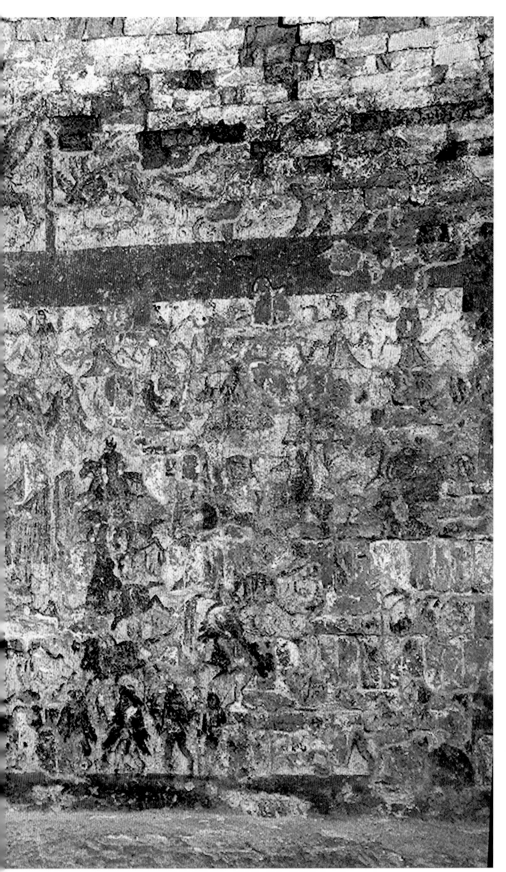

25.车马出行图

北魏太延元年（435年）

高约180、宽约342厘米

2005大同市东郊沙岭村7号墓出土。原址保存。

墓向272°。位于墓室北壁。上栏分格，内有神兽。壁画左侧一排持缰导骑，又一排吹角军士，其队伍上、下两列为手持长矛、弓箭的兵士，又有两列扛幡持节的侍卫，中间还有两列抬吹奏表演的男女艺伎。右侧一辆前覆帷帐后插旌旗的安车，端坐着男主人，随行有轻骑兵、重骑兵，男、女侍仆众。

（撰文：刘俊喜 摄影：高峰）

Procession Scene

1st Year of Taiyan Era, Northern Wei (435 CE)

Height ca. 180 cm; Width ca. 342 cm

Unearthed from Tomb M7 at Shalingcun in eastern suburbs of Datong, Shanxi, in 2005. Preserved on the original site.

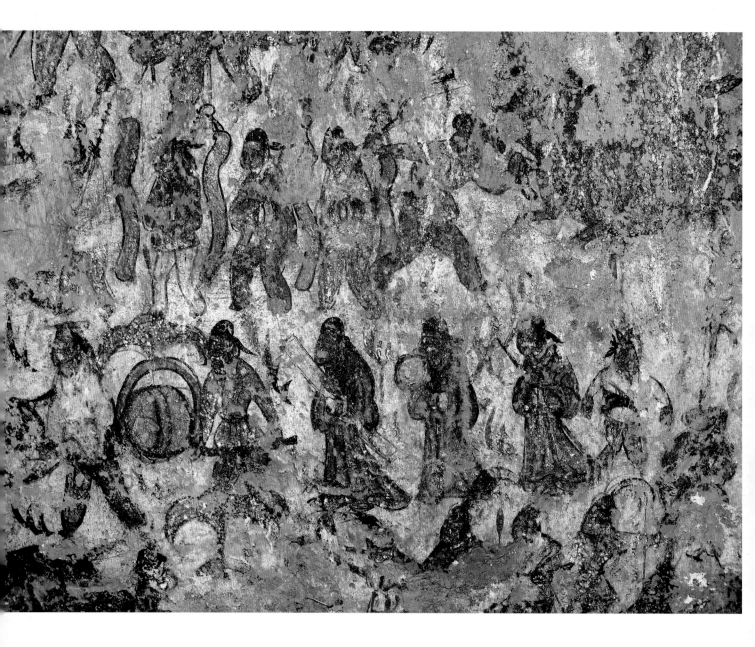

26.仪仗图（局部）

北魏太延元年（435年）

高约35、宽约35厘米

2005年山西省大同市东郊沙岭村7号墓出土。原址保存。

墓向272°。位于墓室北壁车马出行的中部。两人抬鼓，左行，随后的三人分别持一乐器。皆头戴垂带毡帽，抬鼓人穿上襦下裤，持乐器者着交领长袍。

（撰文：刘俊喜　摄影：高峰）

Guards of Honor (Detail)

1st Year of Taiyan Era, Northern Wei (435 CE)

Height ca. 35 cm; Width ca. 35 cm

Unearthed from Tomb M7 at Shalingcun in eastern suburbs of Datong, Shanxi, in 2005. Preserved on the original site.

27.宴饮图

北魏和平二年（461年）

高约120、宽约330厘米

2008年山西省大同垃圾电厂北魏墓群9号墓出土。现存于大同市博物馆。

墓向185°。位于墓室北壁。墓顶起券处中部残留一玄武。壁画有红色围框，画面较漫漶。中部为帷屋内端坐着男性墓主，身后屏风露出二侍女，两侧各有侍者，面对食案及侍从；左上部有拜谒的二列属吏众，左下部有空鞍马及牵马者；右侧为百戏杂耍，右上部二列乐伎人物，右下部有一牛车及侍从等。

（撰文、摄影：张庆捷）

Feast

2nd Year of Heping Era,Northern Wei (461CE)

Height ca. 120 cm; Width ca. 330 cm

Unearthed from Northern Wei Tomb M9 at Lajidianchang in Datong, Shanxi, in 2008. Preserved in Datong Museum.

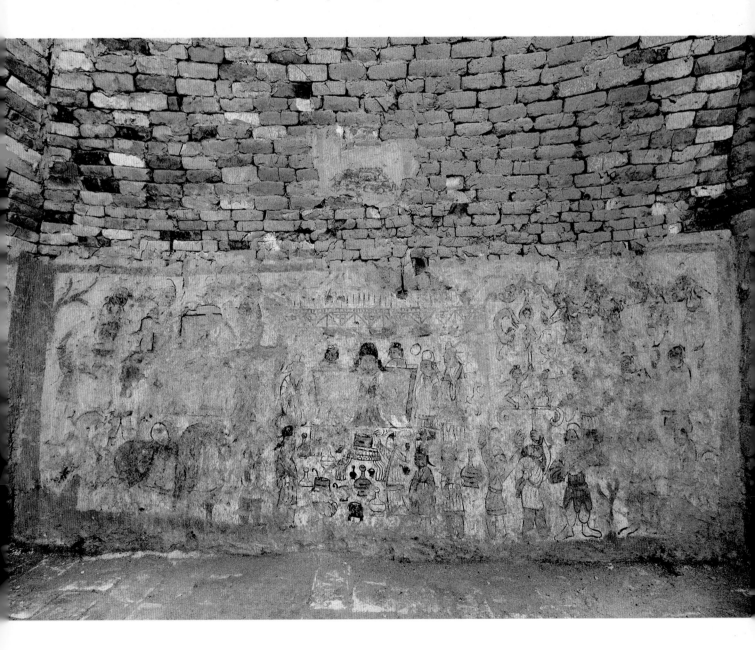

28.门神图（一）

北魏（386～534年）

高约150、宽约90厘米

1992年山西省怀仁县北郊北魏墓出土。已残毁。

墓向180°。位于长甬道东壁南端。一首四臂；头发飞散、未见项光，扭腰翘臀，围短裙，跣足。右臂一手举一长杆，一手按右胯拖一金刚杵；左臂一手持一物（不详），一手握拳于胸前。一脚着地、一脚踏在山羊的腰间。山羊，头顶尖角，颈有卷毛，曲肢斜躺在地上。

（撰文：商彤流　摄影：王传勋）

Door God (1)

Northern Wei (386-534 CE)

Height ca. 150 cm; Width ca. 90 cm

Unearthed from Northern Wei tomb in northern suburbs of Huairen, Shanxi, in 1992. Not preserved.

29.门神图（二）

北魏（386～534年）

高约150、宽约90厘米

1992年山西省怀仁县北郊北魏墓出土。已残毁。

墓向180°。位于长甬道西壁南端。一首四臂；头顶冠、有项光，坦胸露腹，系短裙，跣足。两膀有兽面护甲，左臂一手举一鼓锤，一手按左胯拖一金刚杵；右臂一手持一长杆，一手捻指于胸前。

（撰文：商彤流　摄影：王传勋）

Door God (2)

Northern Wei (386-534 CE)
Height ca. 150 cm; Width ca. 90 cm
Unearthed from Northern Wei tomb in northern suburbs of Huairen, Shanxi, in 1992. Not preserved.

30.门神图（二）（局部）

北魏（386～534年）

1992年山西省怀仁县北郊北魏墓出土。已残毁。

墓向180°。位于长甬道西壁南端。为门神图的下方局部。其两脚踝上有钏，分别踩踏在一女伸臂展开的手掌上。女子，黑发散乱，肩披红帛，撇腿、瘫坐在地上。

（撰文：商彤流　摄影：王传勋）

Door God (2) (Detail)

Northern Wei (386-534 CE)

Unearthed from Northern Wei tomb in northern suburbs of Huairen, Shanxi, in 1992. Not preserved.

31. 朱雀图（摹本）

北齐河清元年（562年）

高约68、宽约170厘米

1973年山西省寿阳县贾家庄北齐库狄迴洛墓出土。已残毁。

墓向197°。位于墓门上方的门额处（半圆形）。朱雀，头顶冠，翘长尾，左向跨大步，作回首返顾，振翅欲飞状。旁饰白色流云。

（临摹：龚森浩　撰文：商彤流　摄影：李建生）

Scarlet Bird (Replica)

1st Year of Heqing Era, Northern Qi (562 CE)

Height ca. 68 cm; Width ca. 170 cm

Unearthed from Northern Qi Shedi Huiluo's tomb at Jiajiazhuang in Shouyang, Shanxi, in 1973. Not preserved.

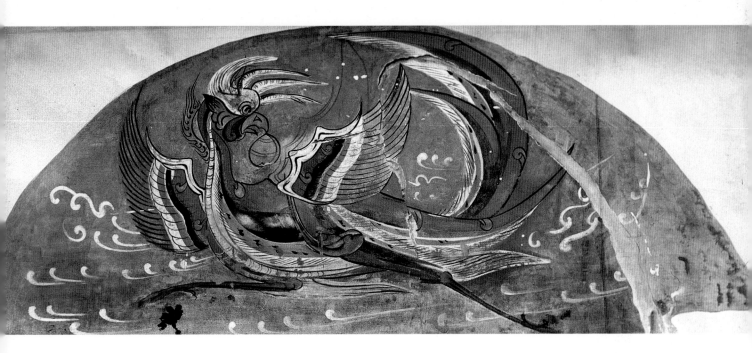

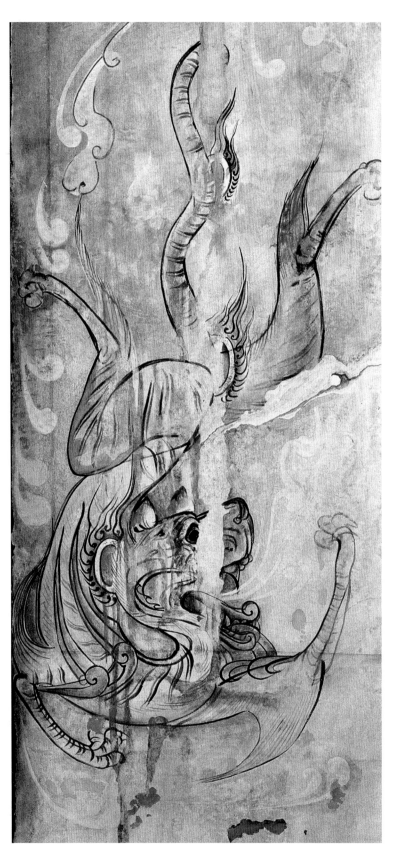

32.白虎图（摹本）

北齐河清元年（562年）

高约167、宽约68厘米

1973年山西省寿阳县贾家庄北齐库狄迴洛墓出土。已残毁。

墓向197°。位于墓门左扇门扉的正面。一只臀、尾向上的白虎，怒目张口，昂头右视，作扑食状；上、下饰白色流云。

（临摹：龚森浩　撰文：商彤流

摄影：李建生）

White Tiger (Replica)

1st Year of Heqing Era, Northern Qi (562 CE)

Height ca. 167 cm; Width ca. 68 cm

Unearthed from Northern Qi Shedi Huiluo's tomb at Jiajiazhuang in Shouyang, Shanxi, in 1973. Not preserved.

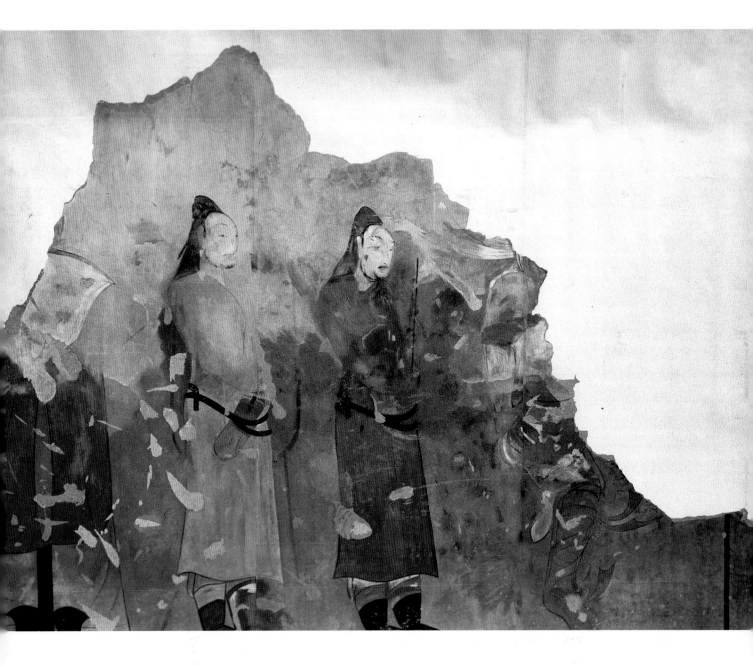

33.侍卫图（一）（摹本）

北齐河清元年（562年）

高约138、宽约203厘米

1973年山西省寿阳县贾家庄北齐厍狄迴洛墓出土。已残毁。

墓向197°。位于甬道东壁南侧。存四人，画面构图、人物服饰均与西壁南侧的壁画相近似，也有舞蹈者与侍卫仪仗，只是人物朝向相反，即右向墓门。

（临摹：龚森浩　撰文：商彤流　摄影：李建生）

Attendants (1) (Replica)

1st Year of Heqing Era, Northern Qi (562 CE)

Height ca. 138 cm; Width ca. 203 cm

Unearthed from Northern Qi Shedi Huiluo's tomb at Jiajiazhuang in Shouyang, Shanxi, in 1973. Not preserved.

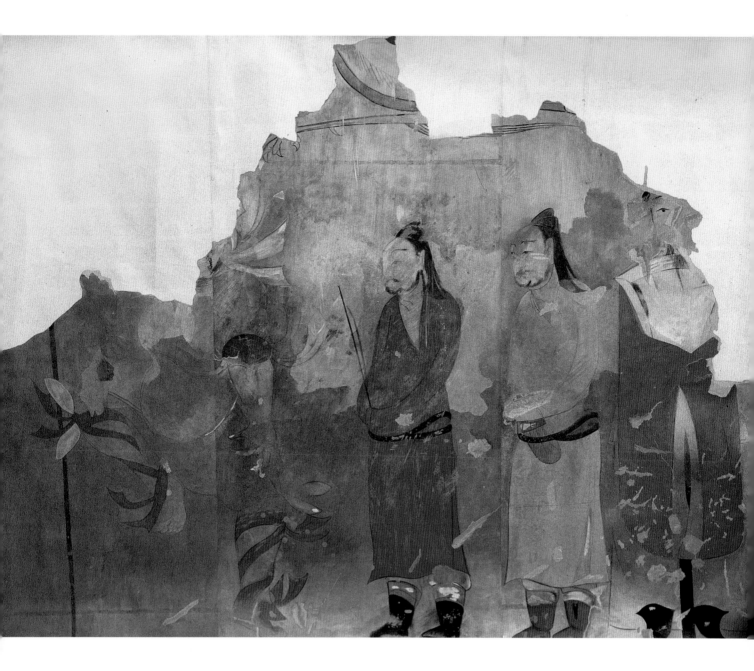

34.侍卫图（二）（摹本）

北齐河清元年（562年）

高约140、宽约205厘米

1973年山西省寿阳县贾家庄北齐库狄迴洛墓出土。已残毁。

墓向197°。位于甬道西壁南侧。存四人，左侧一人坦胸露腹，穿短裤，赤足；右手伸臂，左手按膝，右足上举，左足单立跳舞。第二人双手持鞭于胸前。第三人双手绞袖于腹前。右侧一人双手拱袖按立一剑。

<div align="right">（临摹：龚森浩　撰文：商彤流　摄影：李建生）</div>

Attendants (2) (Replica)

1st Year of Heqing Era, Northern Qi (562 CE)

Height ca. 140 cm; Width ca. 205 cm

Unearthed from Northern Qi Shedi Huiluo's tomb at Jiajiazhuang in Shouyang, Shanxi, in 1973. Not preserved.

35.驼队图（一）

北齐武平元年（570年）

高约150、宽约140厘米

1979年山西省太原市南郊王郭村北齐娄睿墓出土。现存于山西博物院。

墓向203°。位于墓道西壁上栏后段。驼队图的左侧部分，为并辔而行的两名导骑，后有商旅驼队。首领者，头顶光秃，三撮乌发，高鼻、连腮胡。

（撰文：马金花　摄影：高礼双等）

Camel Caravan (1)

1st Year of Wuping Era, Northern Qi (570 CE)

Height ca. 150 cm; Width ca. 140 cm

Unearthed from Northern Qi Lou Rui's tomb at Wangguocun in southern suburbs of Taiyuan, Shanxi, in 1979. Preserved in Shanxi Museum.

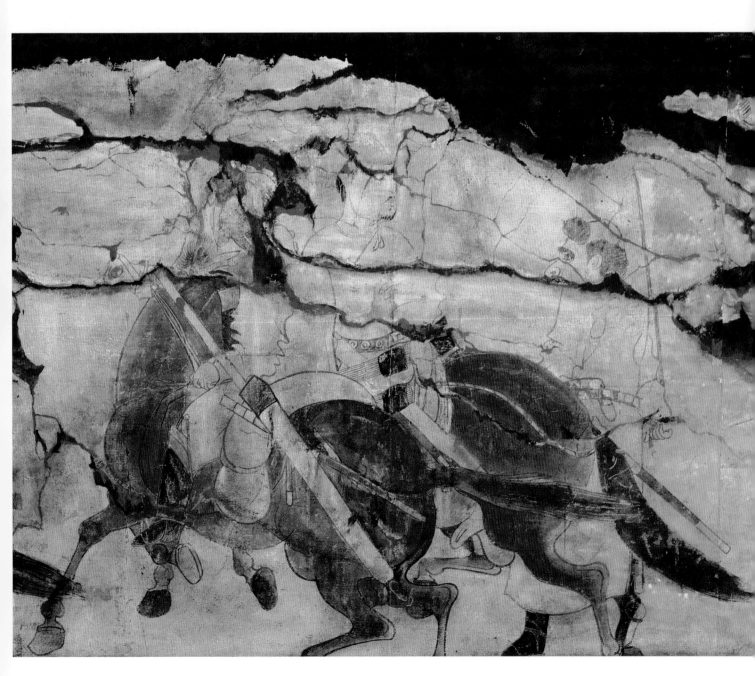

36.导引图

北齐武平元年（570年）

高约140、宽约490厘米

1979年山西省太原市南郊王郭村北齐娄睿墓出土。现存于山西博物院。

墓向203°。位于墓道西壁上栏南端。左侧三只猎犬向前奔突，旁有树丛；其后为策马前行的导骑者二人，皆腰佩剑、挂弓囊，互作询问状。

（撰文：马金花　摄影：高礼双等）

Vanguards

1st Year of Wuping Era, Northern Qi (570 CE)

Height ca. 140 cm; Width ca. 490 cm

Unearthed from Northern Qi Lou Rui's tomb at Wangguocun in southern suburbs of Taiyuan, Shanxi, in 1979. Preserved in Shanxi Museum.

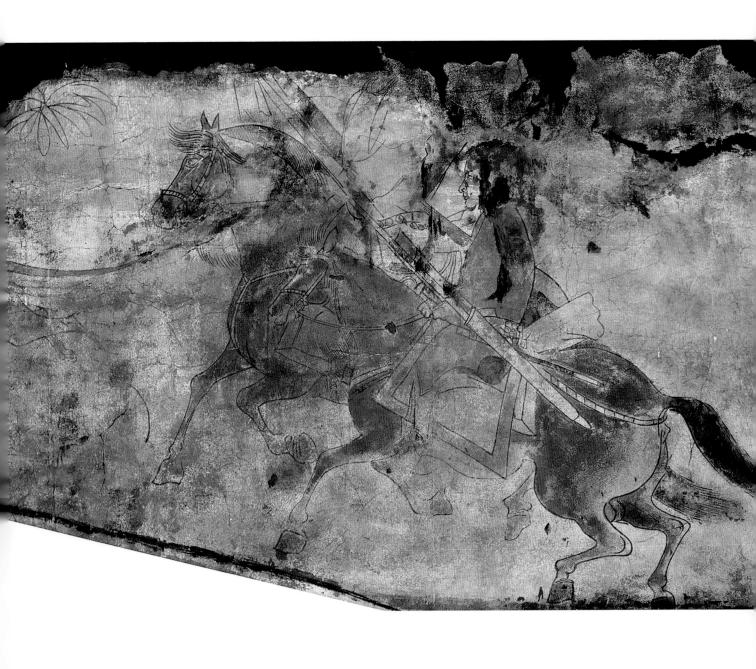

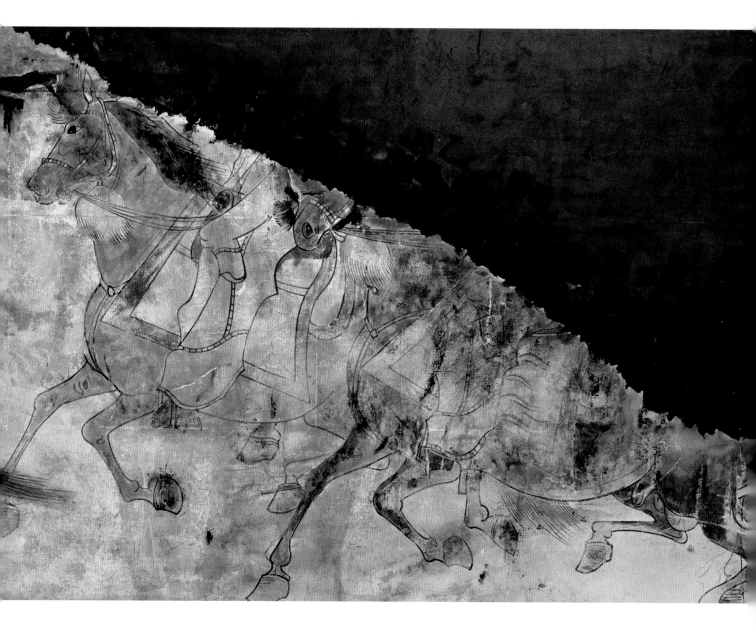

37. 出行图（一）

北齐武平元年（570年）

高约150、宽约420厘米

1979年山西省太原市南郊王郭村北齐娄睿墓出土。现存于山西博物院。

墓向203°。位于墓道西壁上栏前段。画面中部已缺，左行四名骑马的女性，两名徒步随从的侍女。最后一名骑白马的女性，头顶小冠，身穿镶边长袍，腰挂香囊，身份较高。

（撰文：马金花　摄影：高礼双等）

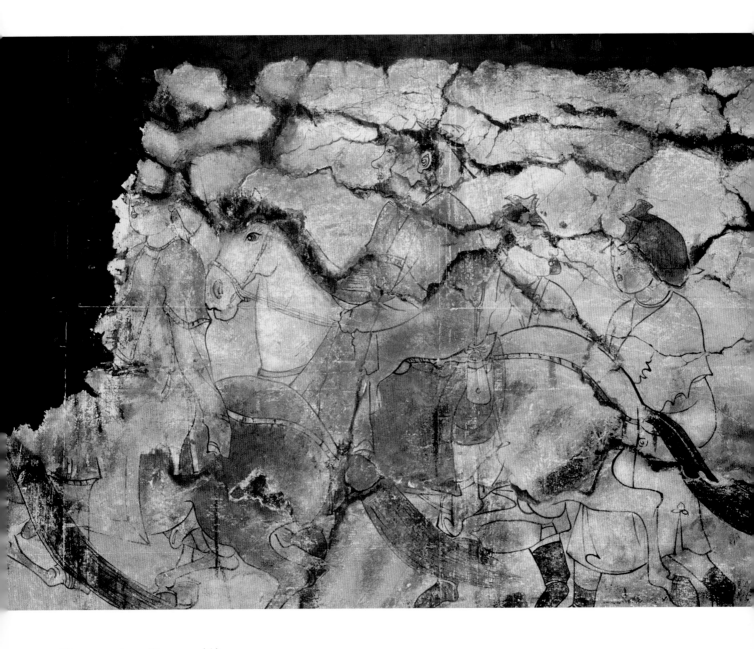

Procession Scene (1)

1st Year of Wuping Era, Northern Qi (570 CE)

Height ca. 150 cm; Width ca. 420 cm

Unearthed from Northern Qi Lou Rui's tomb at Wangguocun in southern suburbs of Taiyuan, Shanxi, in 1979. Preserved in Shanxi Museum.

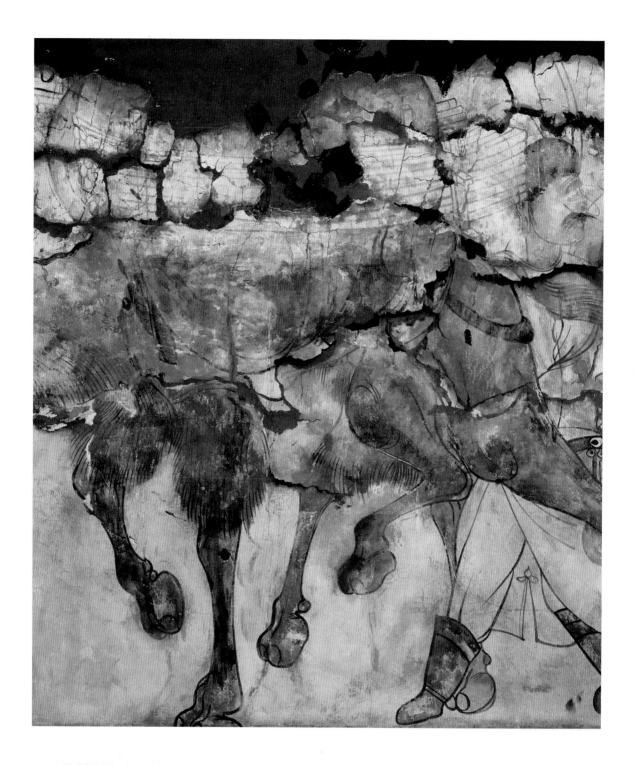

38.驼队图（二）

北齐武平元年（570年）

高约150、宽约140厘米

1979年山西省太原市南郊王郭村北齐娄睿墓出土。现存于山西博物院。

墓向203°。位于墓道西壁上栏后段。驼队图的中间部分，为商旅驼队，均满载货物。御夫，高鼻、短须。

（撰文：马金花　摄影：高礼双等）

Camel Caravan (2)

1st Year of Wuping Era, Northern Qi (570 CE)

Height ca. 150 cm; Width ca. 140 cm

Unearthed from Northern Qi Lou Rui's tomb at Wangguocun in southern suburbs of Taiyuan, Shanxi, in 1979. Preserved in Shanxi Museum.

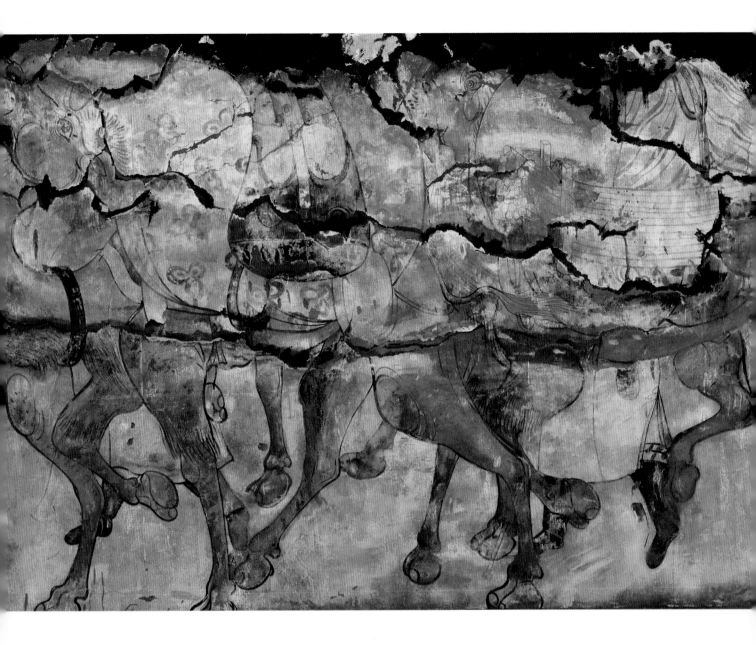

39.驼队图（三）

北齐武平元年（570年）

高约150、宽约120厘米

1979年山西省太原市南郊王郭村北齐娄睿墓出土。现存于山西博物院。

墓向203°。位于墓道西壁上栏后段。商旅驼队的右侧部分。在前行骆驼的蹄足之间，从露出的黑软靴看，有两人置身于驼群的侧后面。

<div style="text-align: right">（撰文：马金花　摄影：高礼双等）</div>

Camel Caravan (3)

1st Year of Wuping Era, Northern Qi (570 CE)

Height ca. 150 cm; Width ca. 120 cm

Unearthed from Northern Qi Lou Rui's tomb at Wangguocun in southern suburbs of Taiyuan, Shanxi, in 1979. Preserved in Shanxi Museum.

40. 出行图（二）

北齐武平元年（570年）

高约140、宽约400厘米

1979年山西省太原市南郊王郭村北齐娄睿墓出土。现存于山西博物院。

墓向203°。位于墓道西壁中栏南端。左侧端为树丛、山石，右段有左行的八名鞍马人物，或后顾、或侧视，随行一空鞍马匹。

（撰文：马金花　摄影：高礼双等）

Procession Scene (2)

1st Year of Wuping Era, Northern Qi (570 CE)

Height ca. 140 cm; Width ca. 400 cm

Unearthed from Northern Qi Lou Rui's tomb at Wangguocun in southern suburbs of Taiyuan, Shanxi, in 1979. Preserved in Shanxi Museum.

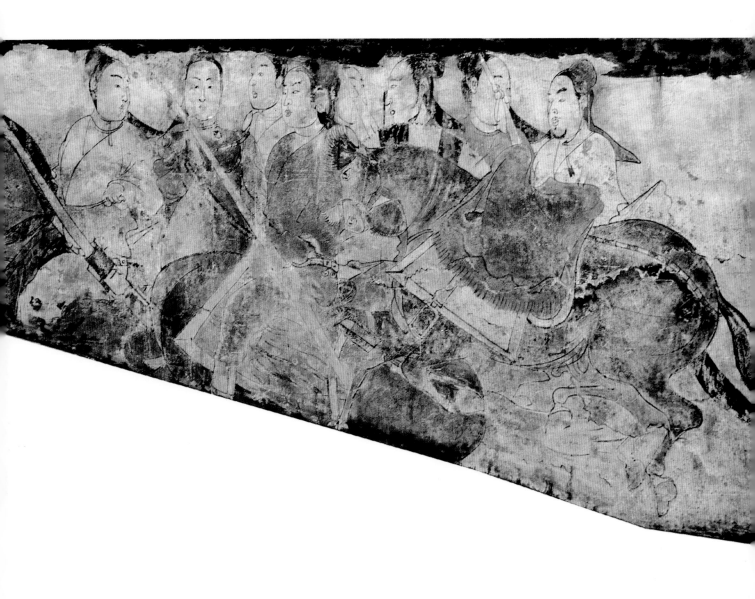

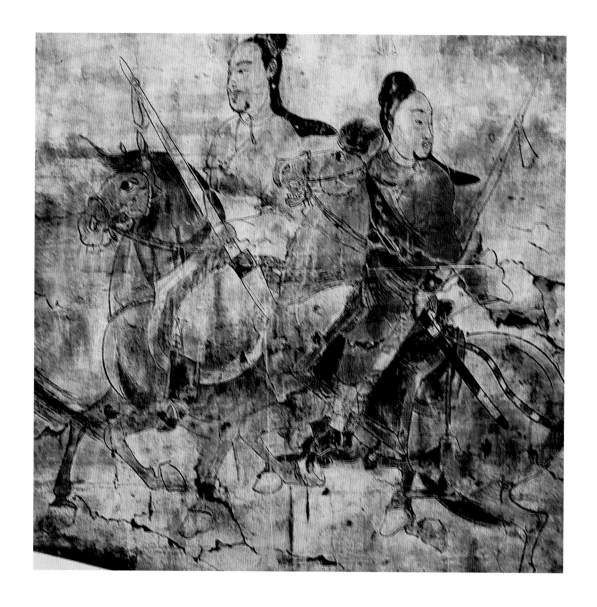

41.出行图（三）

北齐武平元年（570年）

高约150、宽约156厘米

1979年山西省太原市南郊王郭村北齐娄睿墓出土。现存于山西博物院。

墓向203°。位于墓道西壁中栏前段。导骑二人，主者纵辔疾行，从者正在回首，勒马受惊、腾跃。

（撰文：马金花　摄影：高礼双等）

Procession Scene (3)

1st Year of Wuping Era, Northern Qi (570 CE)

Height ca. 150 cm; Width ca. 156 cm

Unearthed from Northern Qi Lou Rui's tomb at Wangguocun in southern suburbs of Taiyuan, Shanxi, in 1979. Preserved in Shanxi Museum.

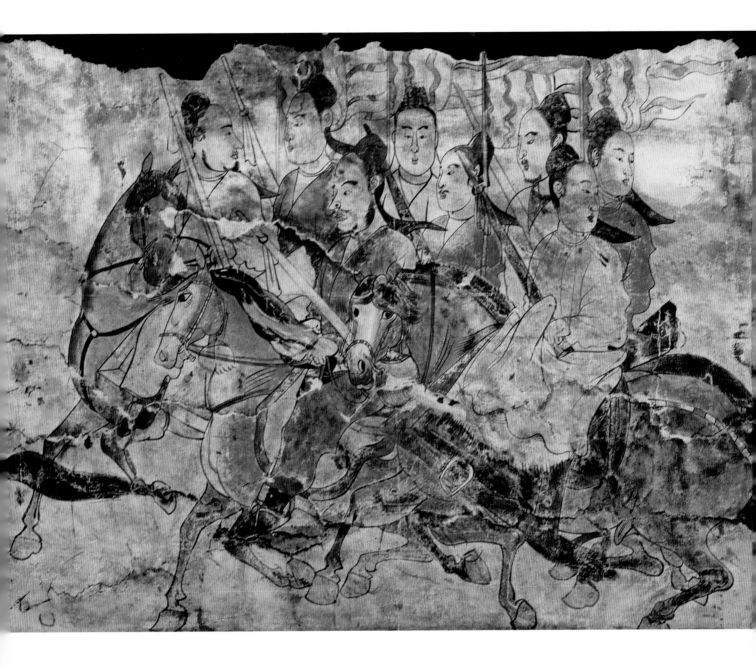

42. 出行图（四）

北齐武平元年（570年）

高约150、宽约215厘米

1979年山西省太原市南郊王郭村北齐娄睿墓出土。现存于山西博物院。

墓向203°。位于墓道西壁中栏偏后部。又是一组八名鞍马人物，首骑者勒缰，从骑者后顾，队伍侧面随行一空鞍的马匹。

<div align="right">（撰文：马金花　摄影：高礼双等）</div>

Procession Scene (4)

1st Year of Wuping Era, Northern Qi (570 CE)

Height ca. 150 cm; Width ca. 215 cm

Unearthed from Northern Qi Lou Rui's tomb at Wangguocun in southern suburbs of Taiyuan, Shanxi, in 1979. Preserved in Shanxi Museum.

43.出行图（五）

北齐武平元年（570年）

高约150、宽约175厘米

1979年山西省太原市南郊王郭村北齐娄睿墓出土。现存于山西博物院。

墓向203°。位于墓道西壁中栏北端。前段有导骑二人，前者策马扬鞭，后者匍伏于坐骑上，马匹前蹄飞跃，后腿下蹲。

<div align="right">（撰文：马金花　摄影：高礼双等）</div>

Procession Scene (5)

1st Year of Wuping Era, Northern Qi (570 CE)

Height ca. 150 cm; Width ca. 175 cm

Unearthed from Northern Qi Lou Rui's tomb at Wangguocun in southern suburbs of Taiyuan, Shanxi, in 1979. Preserved in Shanxi Museum.

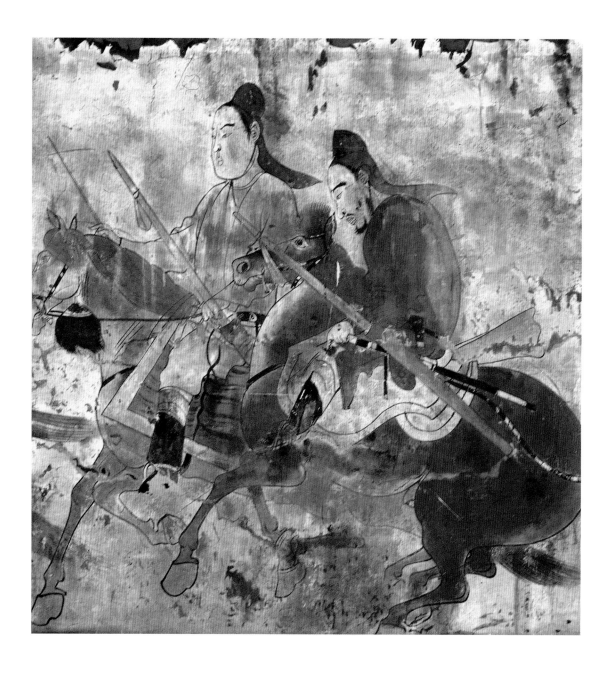

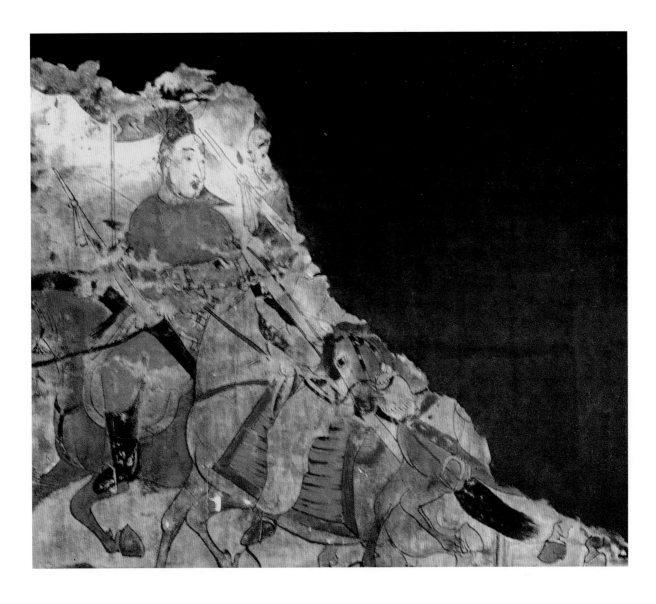

44. 出行图（六）

北齐武平元年（570年）

高约150、宽约150厘米

1979年山西省太原市南郊王郭村北齐娄睿墓出土。现存于山西博物院。

墓向203°。位于墓道西壁中栏北端。后段随行的鞍马人物见有二人三马，画面右侧有残缺。

（撰文：马金花　摄影：高礼双等）

Procession Scene (6)

1st Year of Wuping Era, Northern Qi (570 CE)

Height ca. 150 cm; Width ca. 150 cm

Unearthed from Northern Qi Lou Rui's tomb at Wangguocun in southern suburbs of Taiyuan, Shanxi, in 1979. Preserved in Shanxi Museum.

45. 诞马吹奏图（一）

北齐武平元年（570年）

高约140、宽约260厘米

1979年山西省太原市南郊王郭村北齐娄睿墓出土。现存于山西博物院。

墓向203°。位于墓道西壁下栏南端。左侧有大朵花草，依序闲散着四匹鞍马。

（撰文：马金花　摄影：高礼双等）

Saddled Horses and Playing Buglers (1)

1st Year of Wuping Era, Northern Qi (570 CE)

Height ca. 140 cm; Width ca. 260 cm

Unearthed from Northern Qi Lou Rui's tomb at Wangguocun in southern suburbs of Taiyuan, Shanxi, in 1979. Preserved in Shanxi Museum.

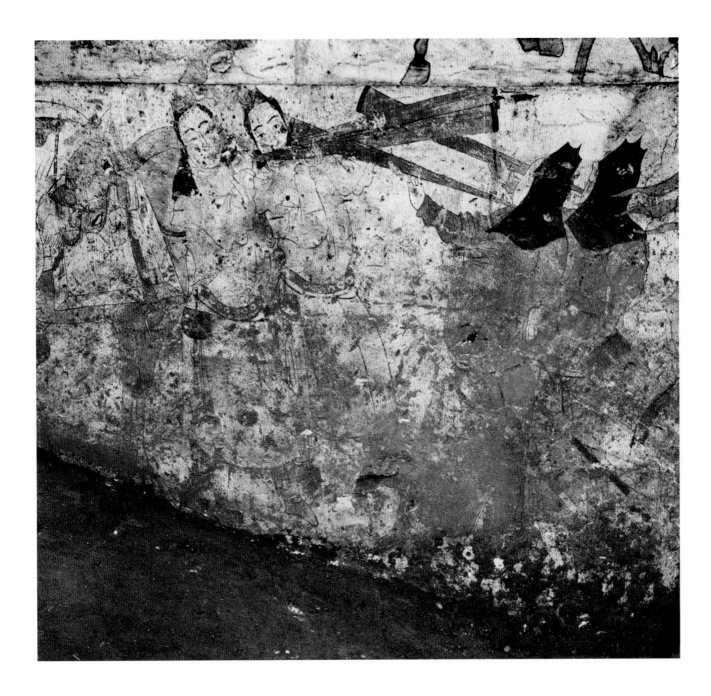

46.诞马吹奏图（二）

北齐武平元年（570年）

高约140、宽约150厘米

1979年山西省太原市南郊王郭村北齐娄睿墓出土。现存于山西博物院。

墓向203°。位于墓道西壁下栏北段。画面上为四名站立的武士，均昂首鼓腹，对吹长角。

<div align="right">

（撰文：马金花　摄影：高礼双等）

</div>

Saddled Horses and Playing Buglers (2)

1st Year of Wuping Era, Northern Qi (570 CE)

Height ca. 140 cm; Width ca. 150 cm

Unearthed from Northern Qi Lou Rui's tomb at Wangguocun in southern suburbs of Taiyuan, Shanxi, in 1979. Preserved in Shanxi Museum.

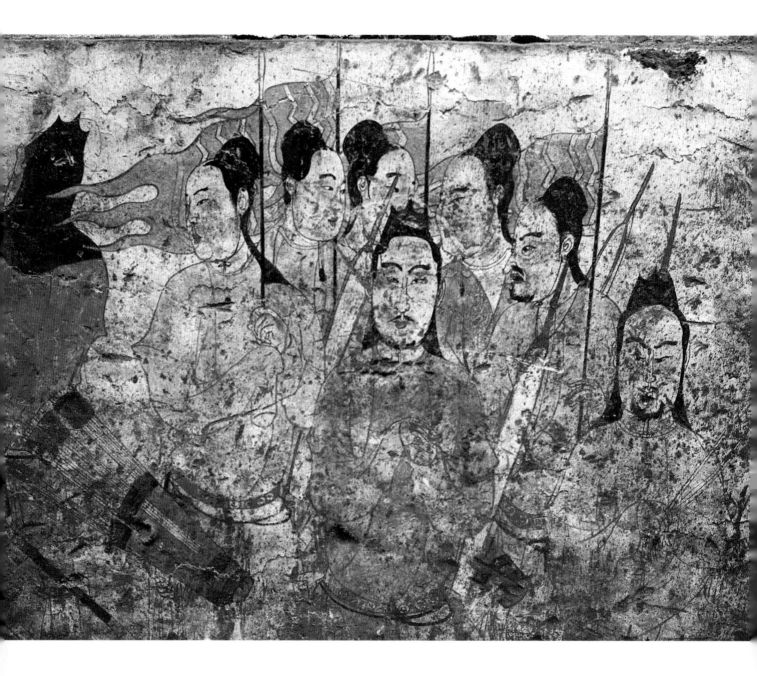

47.武士仪仗图

北齐武平元年（570年）

高约140、宽约210厘米

1979年山西省太原市南郊王郭村北齐娄睿墓出土。现存于山西博物院。

墓向203°。位于墓道西壁下栏北端。此画面为前半部分一组七人排列，或拱手执鞭，或执三旒旗杆；后半部分残缺，仅见有站立的两名武士，均拱手作迎奉状。

<div align="right">（撰文：马金花　摄影：高礼双等）</div>

Guards of Honor

1st Year of Wuping Era, Northern Qi (570 CE)

Height ca. 140 cm; Width ca. 210 cm

Unearthed from Northern Qi Lou Rui's tomb at Wangguocun in southern suburbs of Taiyuan, Shanxi, in 1979. Preserved in Shanxi Museum.

48.回归图

北齐武平元年（570年）

高约156、宽约210厘米

1979年山西省太原市南郊王郭村北齐娄睿墓出土。现存于山西博物院。

墓向203°。位于墓道东壁上栏最北端。画面左部两名武士，或持鞭、或拱手，徒步向前行走，随行着各自的空鞍马匹。画面右部已经残损，鞍马人物不详。

（撰文：马金花　摄影：高礼双等）

Returning Home

1st Year of Wuping Era, Northern Qi (570 CE)

Height ca. 156 cm; Width ca. 210 cm

Unearthed from Northern Qi Lou Rui's tomb at Wangguocun in southern suburbs of Taiyuan, Shanxi, in 1979. Preserved in Shanxi Museum.

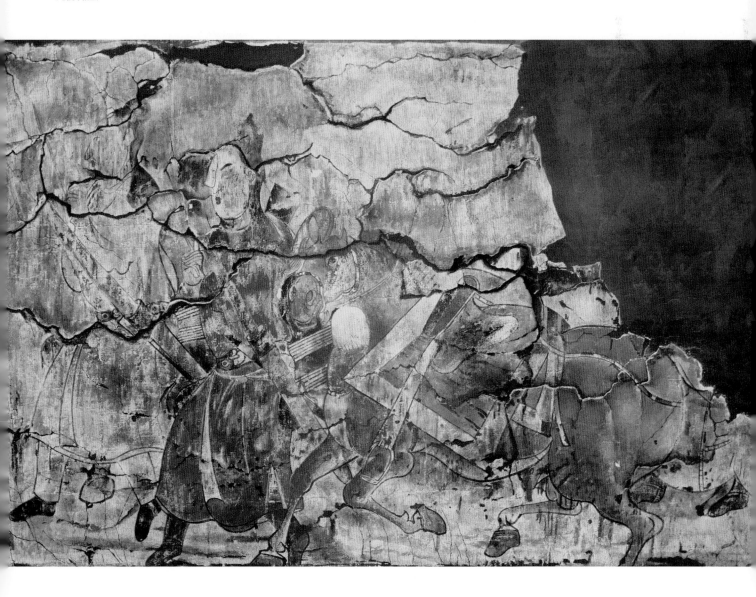

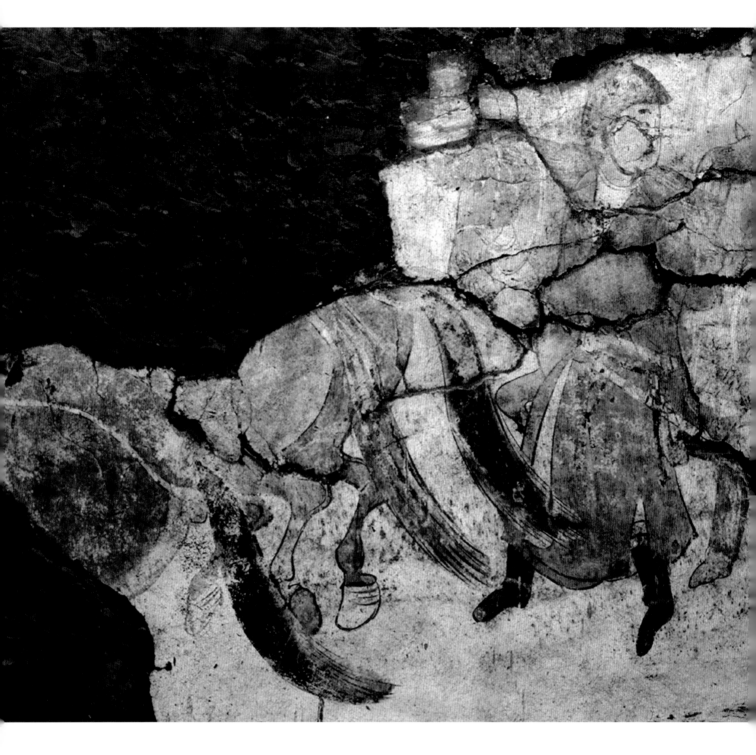

49.驼队图（四）（局部一）

北齐武平元年（570年）

1979年山西省太原市南郊北郭村北齐娄睿墓出土。现存于山西博物院。

墓向203°。位于墓道东壁上栏前段。此为前部二人徒步导引，牵马前行。

（撰文：马金花　摄影：高礼双等）

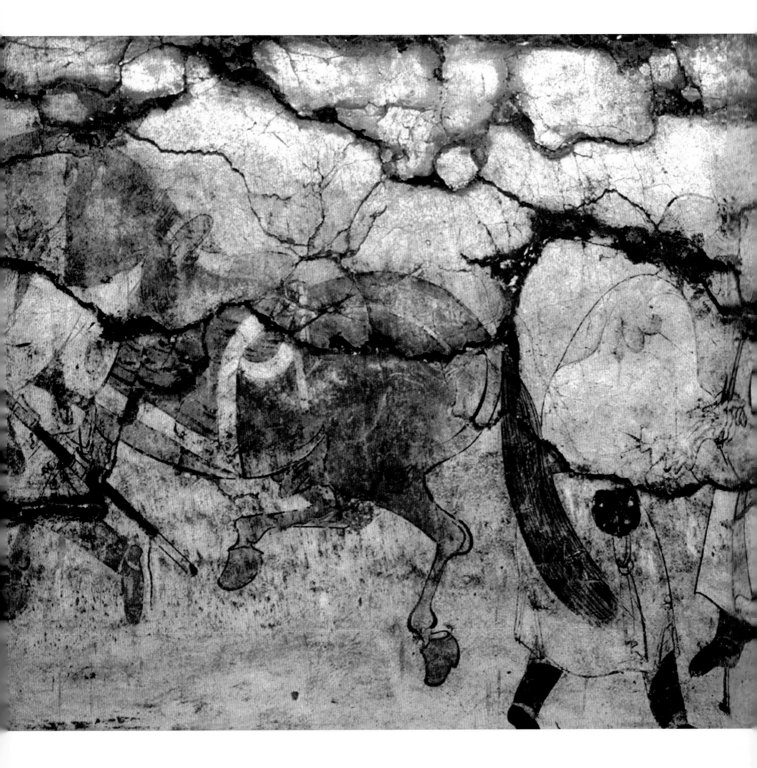

Camel Caravan (4) (Detail 1)

1st Year of Wuping Era.Northern Qi (570 CE)

Unearthed from Northern Qi Lou Rui's tomb at Wangguocun in southern suburbs of Taiyuan, Shanxi, in 1979. Preserved in Shanxi Museum.

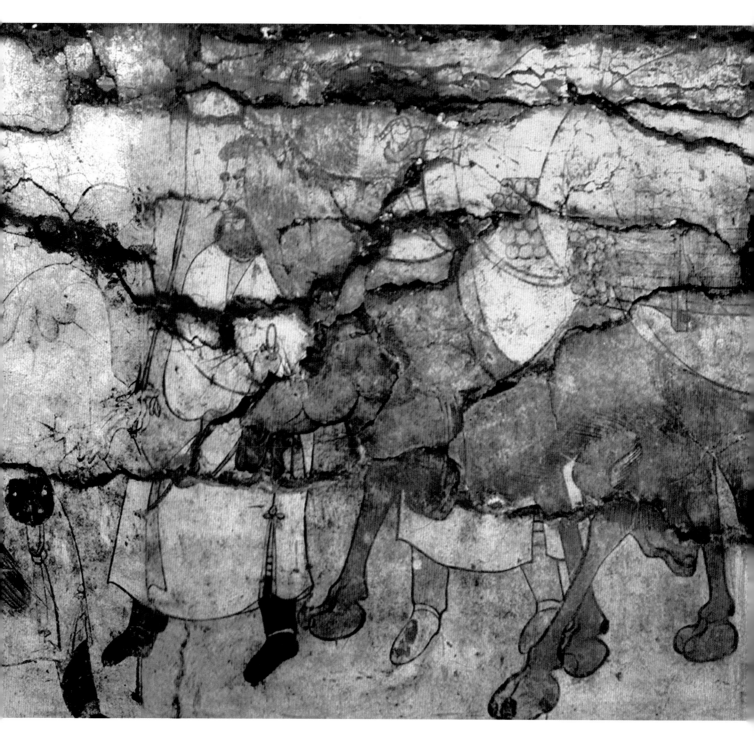

50.驼队图（四）（局部二）

北齐武平元年（570年）

1979年山西省太原市南郊北郭村北齐娄睿墓出土。现存于山西博物院。

墓向203°。位于墓道东壁上栏前段。此为后部骆驼。

<div align="right">（撰文：马金花　摄影：高礼双等）</div>

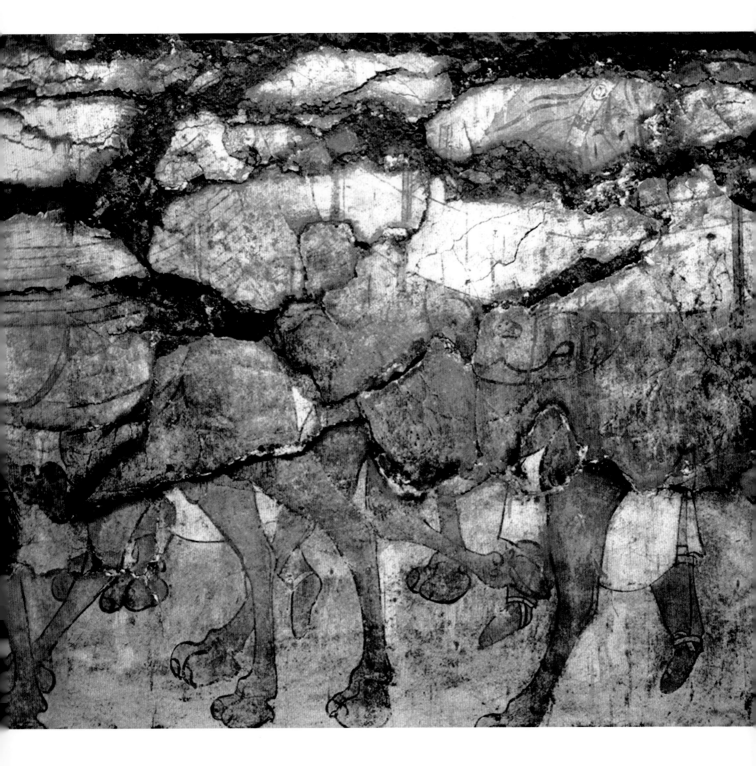

Camel Caravan (4) (Deatil 2)

1st Year of Wuping Era.Northern Qi (570 CE)

Unearthed from Northern Qi Lou Rui's tomb at Wangguocun in southern suburbs of Taiyuan, Shanxi, in 1979. Preserved in Shanxi Museum.

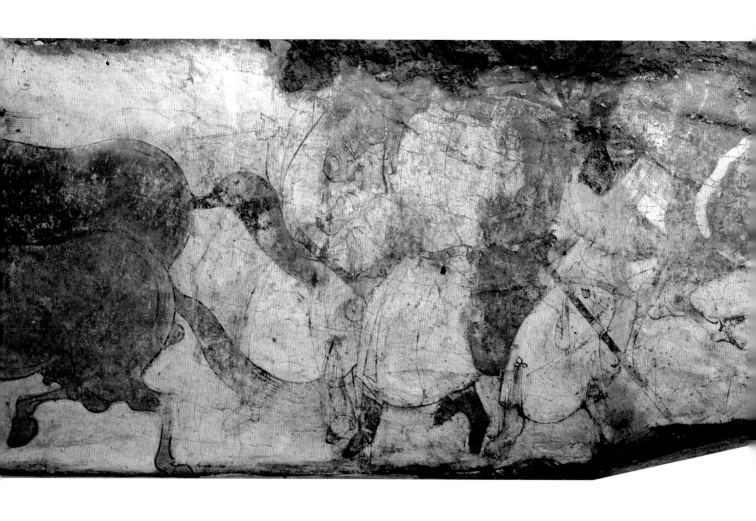

51.随从图

北齐武平元年（570年）

高约140、宽约470厘米

1979年山西省太原市南郊王郭村北齐娄睿墓出土。现存于山西博物院。

墓向203°。位于墓道东壁上栏南端。四人互相交谈状，徒步随行于群马之后，其身后有空鞍的马匹；紧随着两条猎狗。

<div style="text-align: right;">（撰文：马金花　摄影：高礼双等）</div>

Attendants

1st Year of Wuping Era, Northern Qi (570 CE)

Height ca. 140 cm; Width ca. 470 cm

Unearthed from Northern Qi Lou Rui's tomb at Wangguocun in southern suburbs of Taiyuan, Shanxi, in 1979. Preserved in Shanxi Museum.

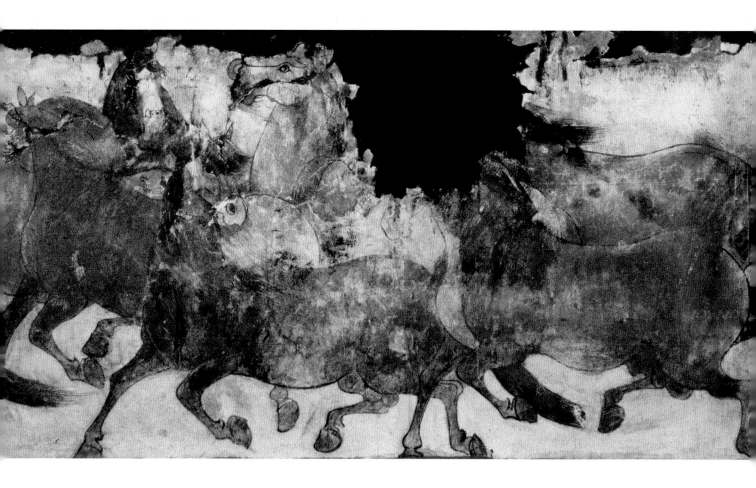

52.群马图

北齐武平元年（570年）

高约140、宽约245厘米

1979年山西省太原市南郊王郭村北齐娄睿墓出土。现存于山西博物院。

墓向203°。位于墓道东壁上栏中部。前部二人徒步导引，牵马前行，回顾马群。此画面为后部随行的七匹犍马，无羁绊，或腾空，或嘶鸣。

（撰文：马金花　摄影：高礼双等）

Horses

1st Year of Wuping Era, Northern Qi (570 CE)

Height ca. 140 cm; Width ca. 245 cm

Unearthed from Northern Qi Lou Rui's tomb at Wangguocun in southern suburbs of Taiyuan, Shanxi, in 1979. Preserved in Shanxi Museum.

53.归来图

北齐武平元年（570年）

高约145、宽约150厘米

1979年山西省太原市南郊王郭村北齐娄睿墓出土。现存于山西博物院。

墓向203°。位于墓道东壁中栏北端。五人五马，徒步牵缰左向前行。随行的马匹络头齐全，鞍鞯俱备，有三旒旗数面。

（撰文：马金花　摄影：高礼双等）

Returning Home

1st Year of Wuping Era, Northern Qi (570 CE)

Height 145 cm; Width 150 cm

Unearthed from Northern Qi Lou Rui's tomb at Wangguocun in southern suburbs of Taiyuan, Shanxi, in 1979. Preserved in Shanxi Museum.

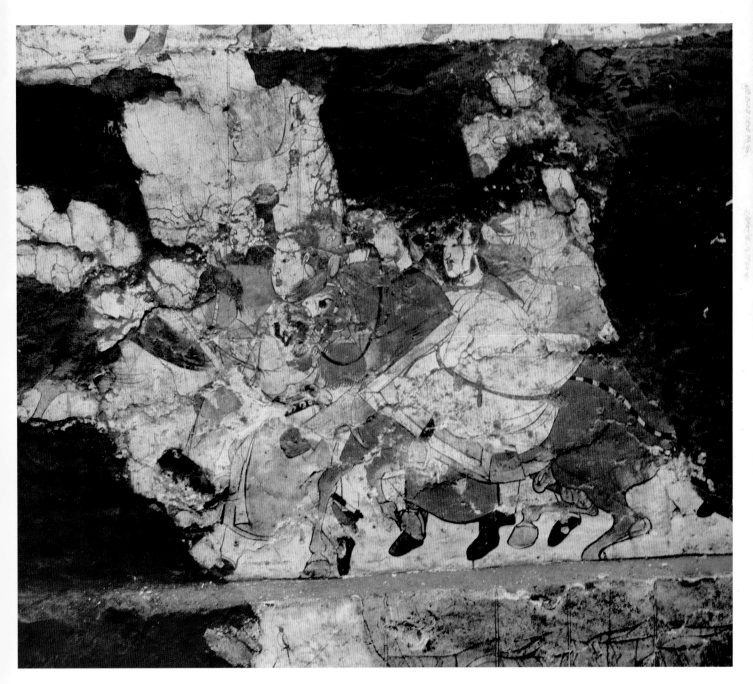

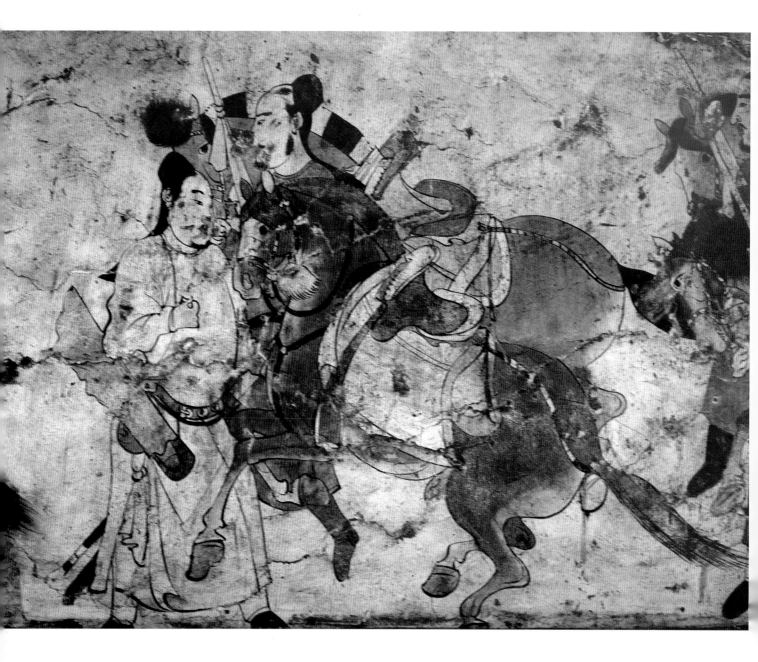

54. 游骑图（一）

北齐武平元年（570年）

高约150、宽约165厘米

1979年山西省太原市南郊王郭村北齐娄睿墓出土。现存于山西博物院。

墓向203°。位于墓道东壁中栏中段。前部为二人徒步，各自牵引着空鞍的马匹。

<div align="right">（撰文：马金花　摄影：高礼双等）</div>

Attending Grooms (1)

1st Year of Wuping Era, Northern Qi (570 CE)

Height ca. 150 cm; Width ca. 165 cm

Unearthed from Northern Qi Lou Rui's tomb at Wangguocun in southern suburbs of Taiyuan, Shanxi, in 1979. Preserved in Shanxi Museum.

55. 游骑图（二）

北齐武平元年（570年）

高约150、宽约175厘米

1979年山西省太原市南郊王郭村北齐娄睿墓出土。现存于山西博物院。

墓向203°。位于墓道东壁中栏中段。后部有随行的五人五马，皆牵缰左向前行。

（撰文：马金花　摄影：高礼双等）

Attending Grooms (2)

1st Year of Wuping Era, Northern Qi (570 CE)

Height ca. 150 cm; Width ca. 175 cm

Unearthed from Northern Qi Lou Rui's tomb at Wangguocun in southern suburbs of Taiyuan, Shanxi, in 1979. Preserved in Shanxi Museum.

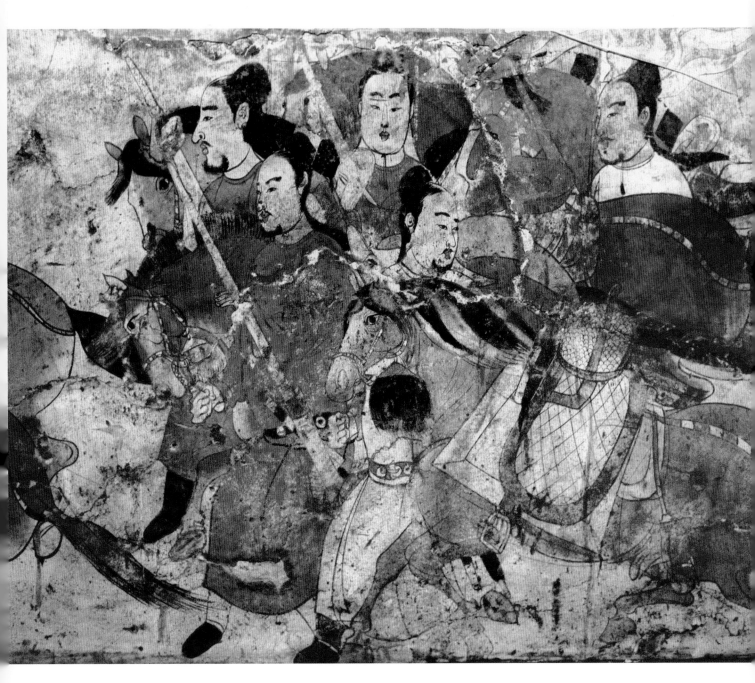

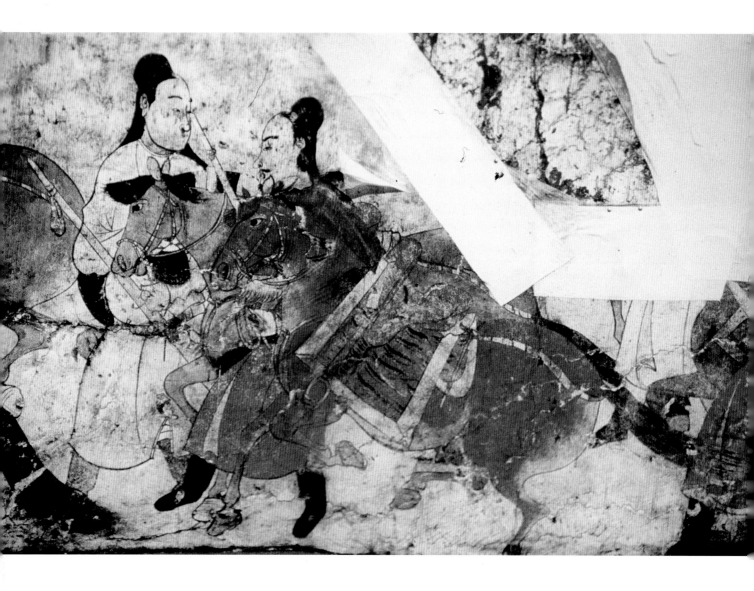

56.随行图（一）

北齐武平元年（570年）

高约150、宽约180厘米

1979年山西省太原市南郊王郭村北齐娄睿墓出土。现存于山西博物院。

墓向203°。位于墓道东壁中栏偏南端。画面右上部残损，为二人手牵马缰，边行边谈，随行两匹鞍马。

（撰文：马金花　摄影：高礼双等）

Attendants (1)

1st Year of Wuping Era, Northern Qi (570 CE)

Height ca. 150 cm; Width ca. 180 cm

Unearthed from Northern Qi Lou Rui's tomb at Wangguocun in southern suburbs of Taiyuan, Shanxi, in 1979. Preserved in Shanxi Museum.

57.随行图（二）

北齐武平元年（570年）

高约150、宽约180厘米

1979年山西省太原市南郊王郭村北齐娄睿墓出土。现存于山西博物院。

墓向203°。位于墓道东壁中栏偏南端。画面右上有残损，为一组五人武士，皆左行，或后顾或侧视，随行各自的空鞍马。

（撰文：马金花　摄影：高礼双等）

Attendants (2)

1st Year of Wuping Era, Northern Qi (570 CE)

Height ca. 150 cm; Width ca. 180 cm

Unearthed from Northern Qi Lou Rui's tomb at Wangguocun in southern suburbs of Taiyuan, Shanxi, in 1979. Preserved in Shanxi Museum.

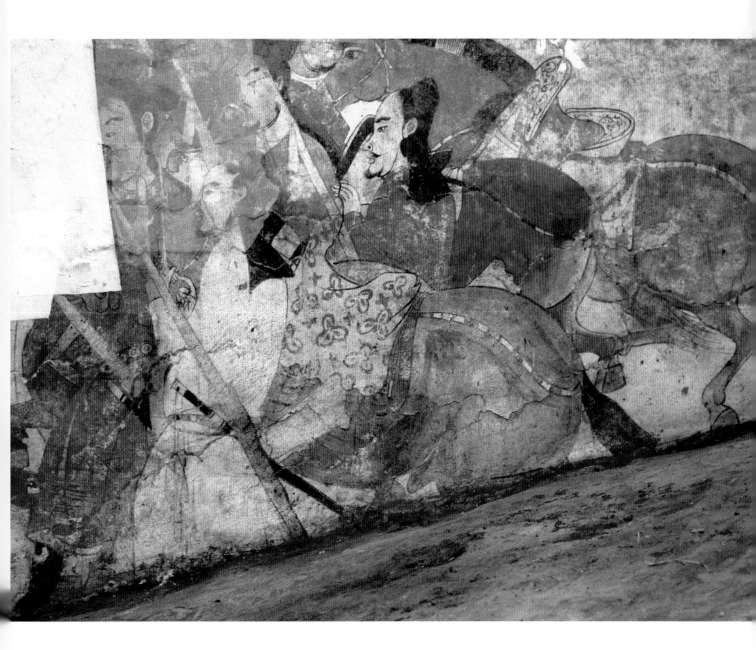

58.山石图

北齐武平元年（570年）

高约70、宽约240厘米

1979年山西省太原市南郊王郭村北齐娄睿墓出土。现存于山西博物院。

墓向203°。位于墓道东壁中栏最南端。山石、枯树及在树枝上戏耍的小猴子。

（撰文：马金花　摄影：高礼双等）

Landscape

1st Year of Wuping Era, Northern Qi (570 CE)

Height ca. 70 cm; Width ca. 240 cm

Unearthed from Northern Qi Lou Rui's tomb at Wangguocun in southern suburbs of Taiyuan, Shanxi, in 1979. Preserved in Shanxi Museum.

59. 仪仗、吹奏图（一）

北齐武平元年（570年）

高约150、宽约210厘米

1979年山西省太原市南郊王郭村北齐娄睿墓出土。现存于山西博物院。

墓向203°。位于墓道东壁下栏最北端。一组13人排列，均拱手作迎奉状，背后有四面三旒旗。

（撰文：马金花　摄影：高礼双等）

Guards of Honor and Music Band (1)

1st Year of Wuping Era, Northern Qi (570 CE)

Height ca. 150 cm; Width ca. 210 cm

Unearthed from Northern Qi Lou Rui's tomb at Wangguocun in southern suburbs of Taiyuan, Shanxi, in 1979. Preserved in Shanxi Museum.

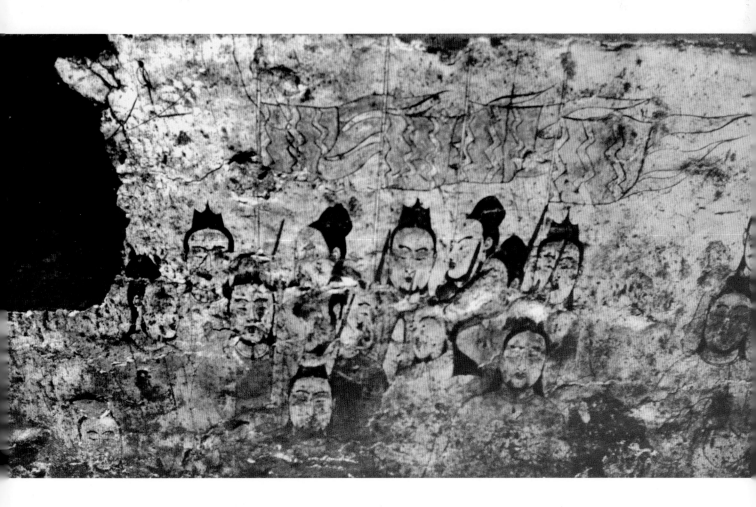

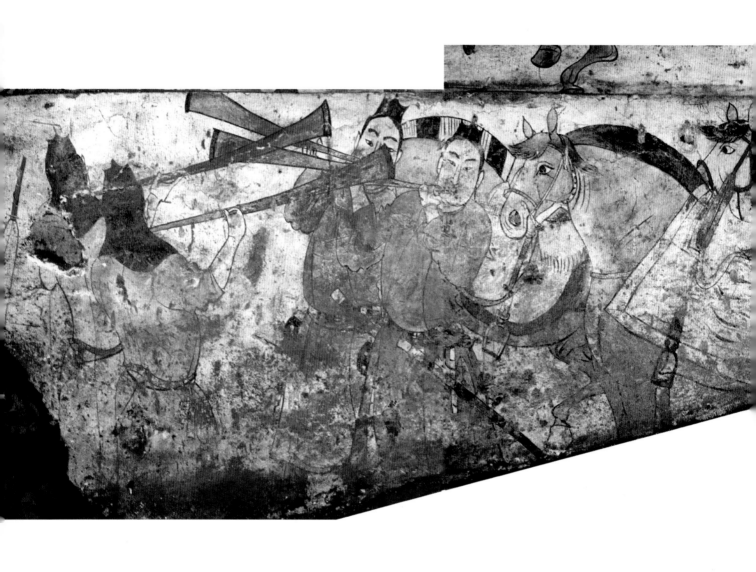

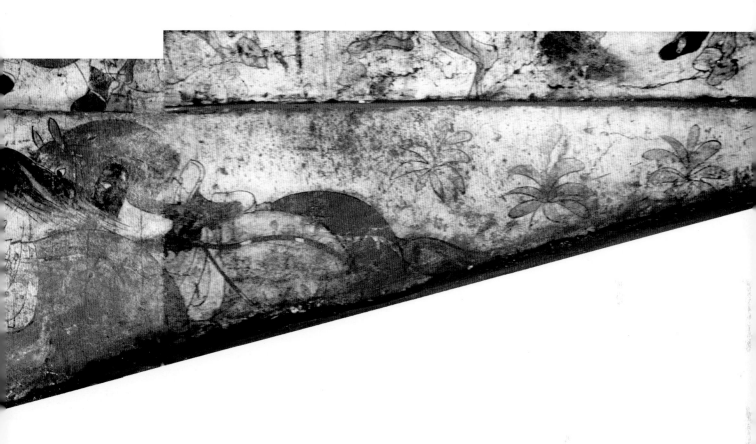

60.仪仗、吹奏图（二）

北齐武平元年（570年）

高约143、宽约500厘米

1979年山西省太原市南郊王郭村北齐娄睿墓出土。现存于山西博物院。

墓向203°。位于墓道东壁下栏最南端。站立四名武士，正在两两相对对吹长角，右侧还有各自的空鞍马匹，以草丛补白。

（撰文：马金花　摄影：高礼双等）

Guards of Honor and Music Band (2)

1st Year of Wuping Era, Northern Qi (570 CE)

Height ca. 143 cm; Width ca. 500 cm

Unearthed from Northern Qi Lou Rui's tomb at Wangguocun in southern suburbs of Taiyuan, Shanxi, in 1979. Preserved in Shanxi Museum.

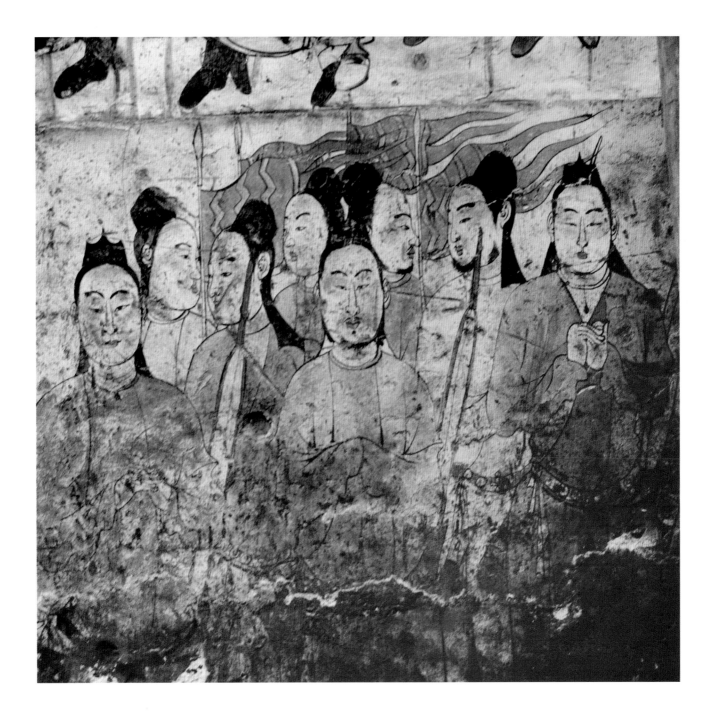

61.仪仗、吹奏图（三）

北齐武平元年（570年）

高约143、宽约200厘米

1979年山西省太原市南郊王郭村北齐娄睿墓出土。现存于山西博物院。

墓向203°。位于墓道东壁下栏北段。站立一组八人武士，皆拱手作迎奉状，背后亦有三旒旗。

（撰文：马金花　摄影：高礼双等）

Guards of Honor and Music Band (3)

1st Year of Wuping Era, Northern Qi (570 CE)

Height ca. 143 cm; Width ca. 200 cm

Unearthed from Northern Qi Lou Rui's tomb at Wangguocun in southern suburbs of Taiyuan, Shanxi, in 1979. Preserved in Shanxi Museum.

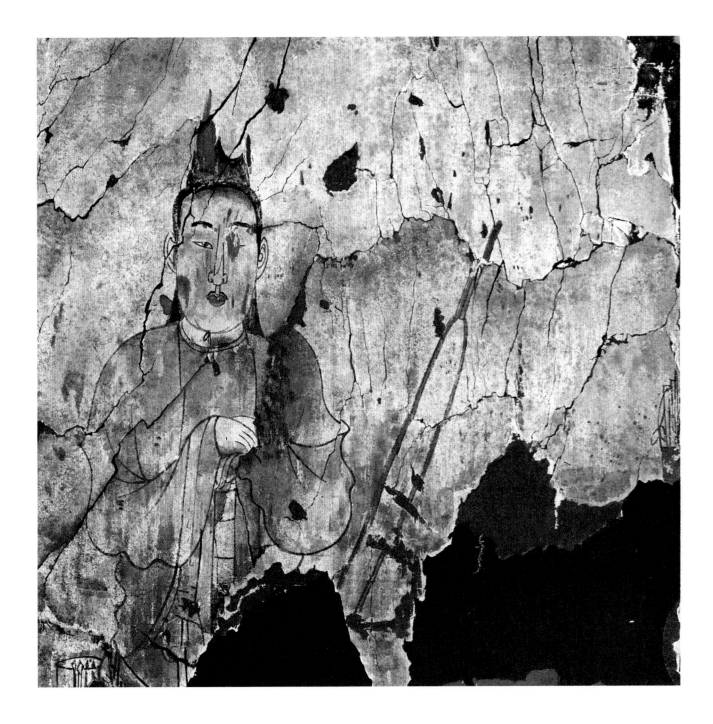

62.仪卫图

北齐武平元年（570年）

高约135、宽约125厘米

1979年山西省太原市南郊王郭村北齐娄睿墓出土。现存于山西博物院。

墓向203°。位于天井、过洞东壁下层。该段画面原有六位戎装的仪卫，此画仅为天井处的一名仪卫，双手拱于胸前，按立斑剑，腰佩矢箙、弓囊。

（撰文：马金花　摄影：高礼双等）

Ceremonial Guard

1st Year of Wuping Era, Northern Qi (570 CE)

Height ca. 135 cm; Width ca. 125 cm

Unearthed from Northern Qi Lou Rui's tomb at Wangguocun in southern suburbs of Taiyuan, Shanxi, in 1979. Preserved in Shanxi Museum.

63.捧物人物图

北齐武平元年（570年）

高约118、宽约85厘米

1979年山西省太原市南郊王郭村北齐娄睿墓出土。现存于山西博物院。

墓向203°。位于天井西壁上栏。画面残损，原为两人一组。左侧一人仅见朱色大袖衫长袍下端，此画面为另一人，头顶扎巾，身穿右衽宽袖长袍，手持一签插物件（似为法器）。

（撰文：马金花　摄影：高礼双等）

Man Holding a Thing

1st Year of Wuping Era, Northern Qi (570 CE)

Height ca. 118 cm; Width ca. 85 cm

Unearthed from Northern Qi Lou Rui's tomb at Wangguocun in southern suburbs of Taiyuan, Shanxi, in 1979. Preserved in Shanxi Museum.

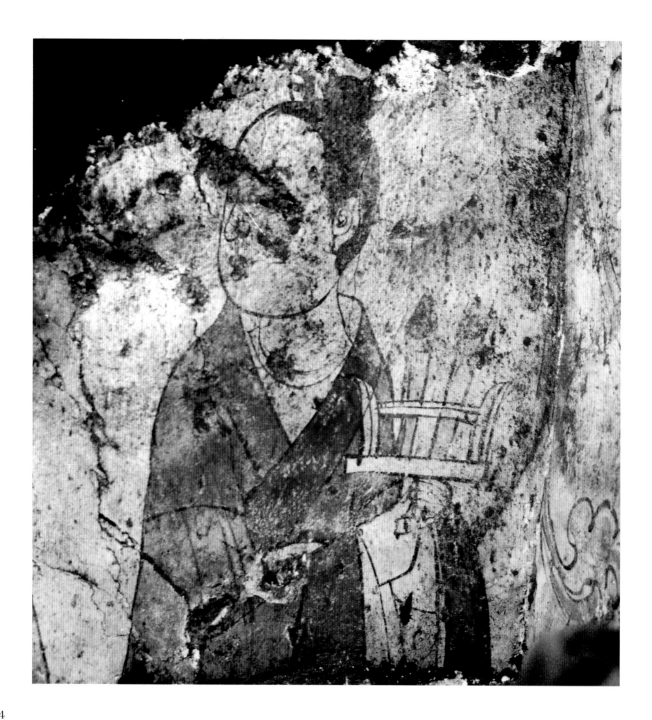

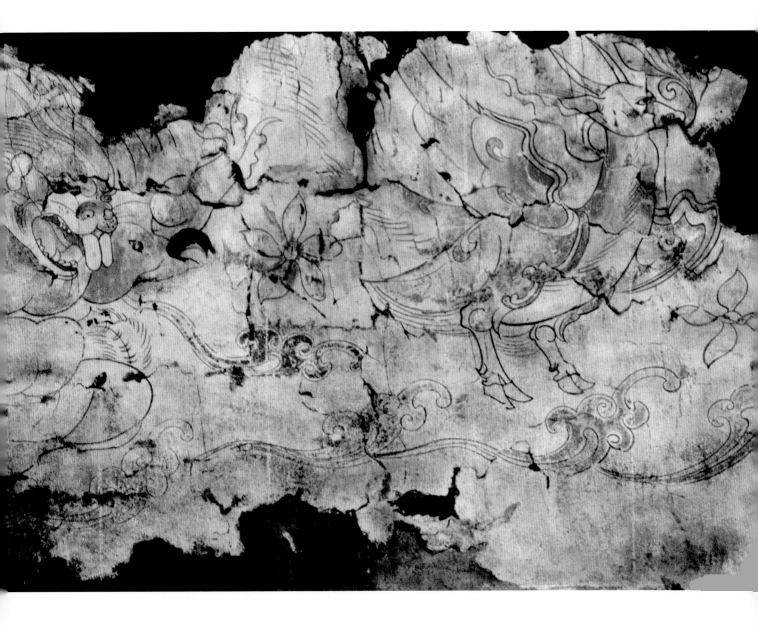

64. 神兽图

北齐武平元年（570年）

高约155、宽约235厘米

1979年山西省太原市南郊王郭村北齐娄睿墓出土。现存于山西博物院。

墓向203°。位于天井南壁上栏。右侧一羊头、鹿颈、鸟身、偶蹄兽，两肋振翅，似为传说中的獬豸。左侧一猪首、熊体、龙爪兽，作驱赶状，似为传说中的方相氏。

（撰文：马金花　摄影：高礼双等）

Mythical Animal

1st Year of Wuping Era, Northern Qi (570 CE)

Height ca. 155 cm; Width ca. 235 cm

Unearthed from Northern Qi Lou Rui's tomb at Wangguocun in southern suburbs of Taiyuan, Shanxi, in 1979. Preserved in Shanxi Museum.

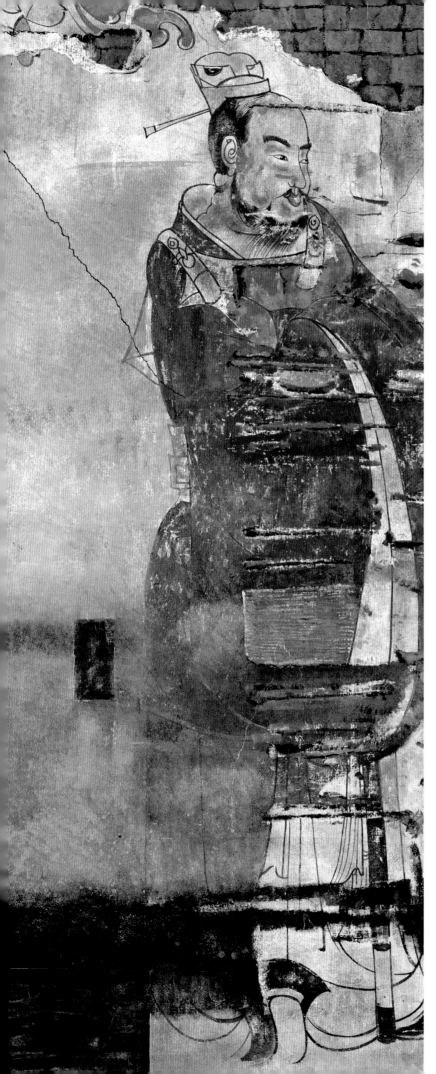

65.门吏图（一）

北齐武平元年（570年）

高约252、宽约117米

1979年山西省太原市南郊王郭村北齐娄睿墓出土。

现存于山西博物院。

墓向203°。位于墓门外甬道东壁南侧（墓门外）。

门吏面向墓外，戴梁冠，穿广袖长袍，外披裲裆；

两袖拱于胸前，拄斑剑。

（撰文：马金花　摄影：高礼双等）

Door Guard (1)

1st Year of Wuping Era, Northern Qi (570 CE)

Height ca. 252 cm; Width ca. 117 cm

Unearthed from Northern Qi Lou Rui's tomb at Wangguocun in southern suburbs of Taiyuan, Shanxi, in 1979. Preserved in Shanxi Museum.

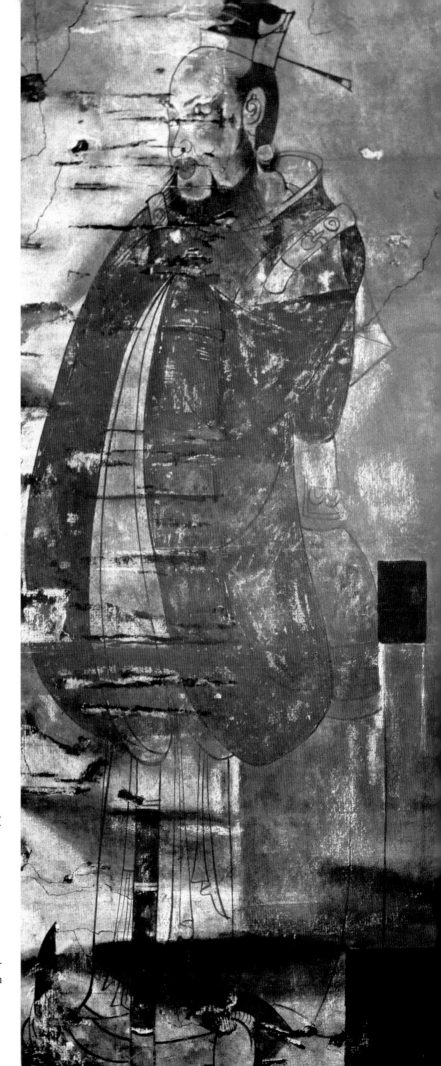

66.门吏图（二）

北齐武平元年（570年）

高约253、宽约125厘米

1979年山西省太原市南郊王郭村北齐娄睿墓出土。
现存于山西博物院。

墓向203°。位于甬道西壁南侧（墓门外）。门吏
面向墓外，头戴梁冠，身穿广袖长袍，肩披裲裆；
两袖拱于胸前，拄斑剑。

（撰文：马金花　摄影：高礼双等）

Door Guard (2)

1st Year of Wuping Era, Northern Qi (570 CE)
Height ca. 253 cm; Width ca. 125 cm
Unearthed from Northern Qi Lou Rui's tomb at Wang-
guocun in southern suburbs of Taiyuan, Shanxi, in
1979. Preserved in Shanxi Museum.

67. 墓门

北齐武平元年（570年）

高约295、宽约172厘米

1979年山西省太原市南郊王郭村北齐娄睿墓出土。现存于山西博物院。墓向203°。墓门由门额石、门楣石和门框石，以及门扇石组成。门额正中刻摩尼宝珠，两侧金翅鸟。门楣刻五朵宝相花。门框刻六组缠枝莲花。右门扇石上绘青龙，左门扇石上绘白虎。

（撰文：马金花　摄影：高礼双等）

Tomb Entrance

1st Year of Wuping Era, Northern Qi (570 CE)

Height ca. 295 cm; Width ca. 172 cm

Unearthed from Northern Qi Lou Rui's tomb at Wangguocun in southern suburbs of Taiyuan, Shanxi, in 1979. Preserved in Shanxi Museum.

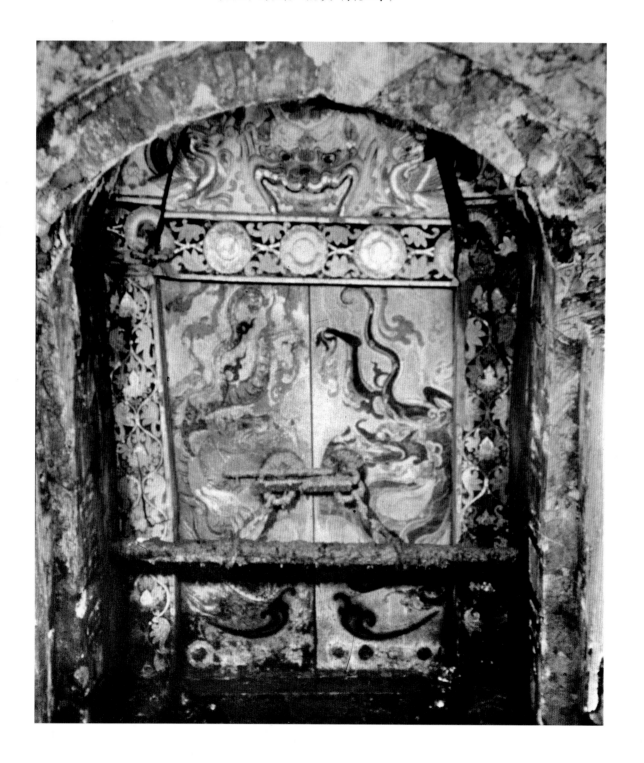

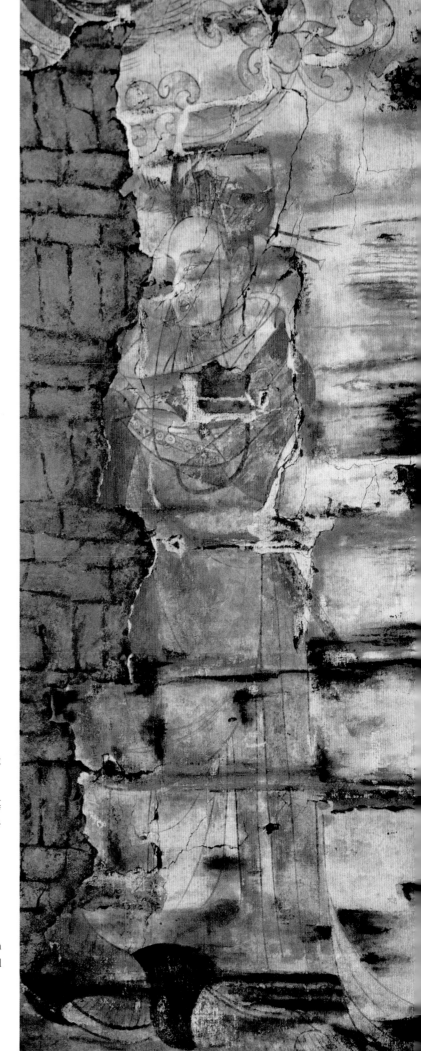

68.门吏图（三）

北齐武平元年（570年）

高约240、宽约100米

1979年山西省太原市南郊王郭村北齐娄睿墓出土。现存于山西博物院。

墓向203°。位于甬道西壁北侧（墓门内）。门吏面向墓外，画面左侧有残。头顶梁冠，外罩纱笼，贯一笄；身穿大袖长袍，外披裲裆，佩剑，双手拱袖于胸前。

（撰文：马金花　摄影：高礼双等）

Door Guard (3)

1st Year of Wuping Era, Northern Qi (570 CE)

Height ca. 240 cm; Width ca. 100 cm

Unearthed from Northern Qi Lou Rui's tomb at Wangguocun in southern suburbs of Taiyuan, Shanxi, in 1979. Preserved in Shanxi Museum.

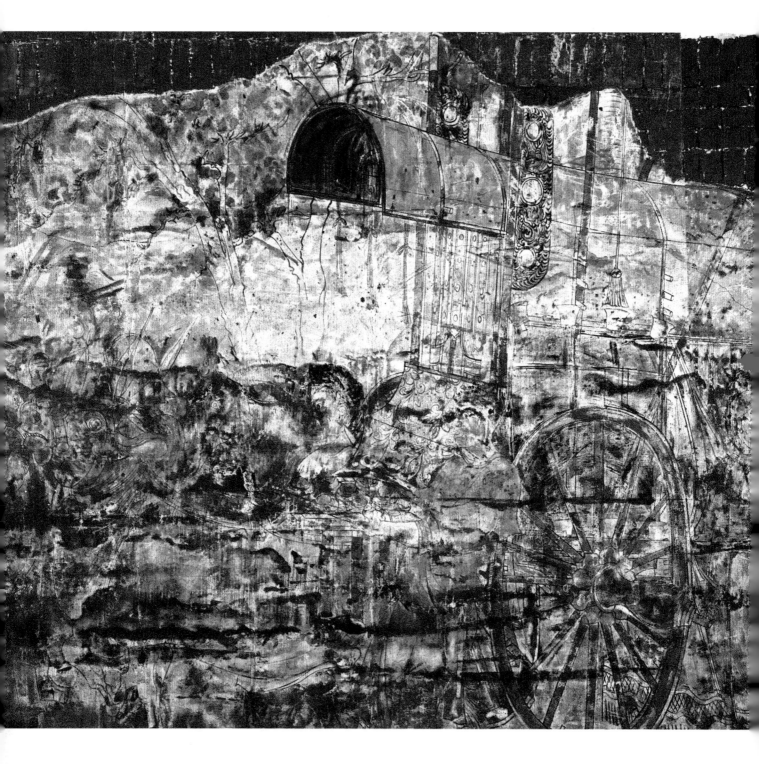

（撰文：马金花　摄影：高礼双等）

69. 牛车备行图（一）

北齐武平元年（570年）

高约150、宽约230厘米

1979年山西省太原市南郊王郭村北齐娄睿墓出土。现存于山西博物院。墓向203°。位于墓室西壁左侧。一胡奴牵犍牛、拉一卷棚顶的安车，车辕前后各有御者；牛车前后垂帘，轼前覆以莲叶图案帷幔，轼幔、锦幡，随风飘展。

Readied Ox Cart (1)

1st Year of Wuping Era, Northern Qi (570 CE)

Height ca. 150 cm; Width ca. 230 cm

Unearthed from Northern Qi Lou Rui's tomb at Wangguocun in southern suburbs of Taiyuan, Shanxi, in 1979. Preserved in Shanxi Museum.

70.牛车备行图（二）

北齐武平元年（570年）

高约150、宽约220厘米

1979年山西省太原市南郊王郭村北齐娄睿墓出土。现存于山西博物院。

墓向203°。位于墓室西壁中段。在安车的后面，一华盖下站立着八名侍女，或捧行装、或持团扇、或端茶、或捧巾；随行的还有两位老者，相互言语状。

（撰文：马金花　摄影：高礼双等）

Readied Ox Cart (2)

1st Year of Wuping Era, Northern Qi (570 CE)

Height ca. 150 cm; Width ca. 220 cm

Unearthed from Northern Qi Lou Rui's tomb at Wangguocun in southern suburbs of Taiyuan, Shanxi, in 1979. Preserved in Shanxi Museum.

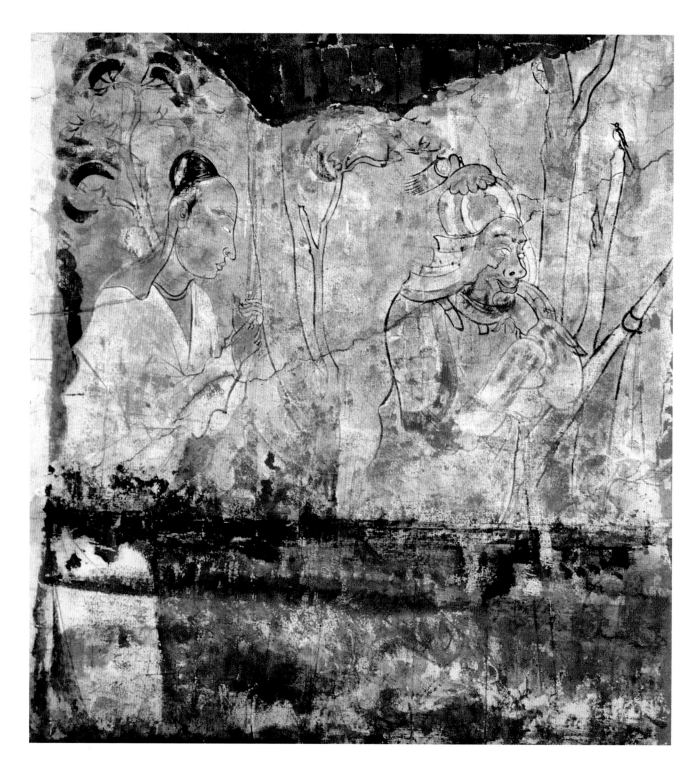

（撰文：马金花　摄影：高礼双等）

71.武士图

北齐武平元年（570年）

高约220、宽约170厘米

1979年山西省太原市南郊王郭村北齐娄睿墓出土。现存于山西博物院。

墓向203°。位于甬道东侧。画面背景有树木、鸟鹊。左侧武士头顶长裙幞头，身穿窄袖长袍，双手持鞭拱于胸前；右侧武士头戴圆盔，身穿铠甲，右手扶杖托左拳顶住下颌。

Warriors

1st Year of Wuping Era, Northern Qi (570 CE)

Height ca. 220 cm; Width ca. 170 cm

Unearthed from Northern Qi Lou Rui's tomb at Wangguocun in southern suburbs of Taiyuan, Shanxi, in 1979. Preserved in Shanxi Museum.

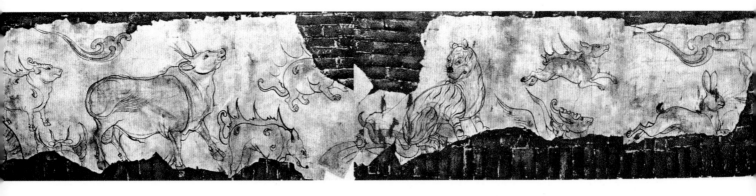

▲ 72. 生肖图（摹本）

北齐武平元年（570年）

高约200、宽约430厘米

1979年山西省太原市南郊王郭村北齐娄睿墓出土。现存于山西博物院。

墓向203°。位于墓顶北壁、东壁相接处的第二层。北壁正中残存一鼠头（残存鼠嘴），北壁东侧有一牛，东壁北端有一虎，东壁正中有一兔。生肖按子午线顺时序排列，其间穿插有神兽。

（临摹：不详　撰文：马金花　摄影：高礼双等）

Zodiac Animals (Replica)

1st Year of Wuping Era, Northern Qi (570 CE)

Height ca. 200 cm; Width ca. 430 cm

Unearthed from Northern Qi Lou Rui's tomb at Wangguocun in southern suburbs of Taiyuan, Shanxi, in 1979. Preserved in Shanxi Museum.

▼ 73. 生肖图（摹本，局部）

北齐武平元年（570年）

1979年山西省太原市南郊王郭村北齐娄睿墓出土。现存于山西博物院。

墓向203°。位于墓顶北壁，东侧有一公牛，昂首右行，健硕；周身遗留有清晰的起稿痕迹。

（临摹：不详　撰文：马金花　摄影：高礼双等）

Zodiac Animals (Detail)

1st Year of Wuping Era, Northern Qi (570 CE)

Height ca. 200 cm; Width ca. 430 cm

Unearthed from Northern Qi Lou Rui's tomb at Wangguocun in southern suburbs of Taiyuan, Shanxi, in 1979. Preserved in Shanxi Museum.

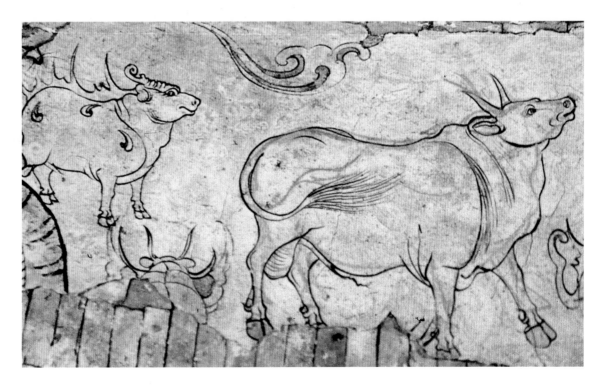

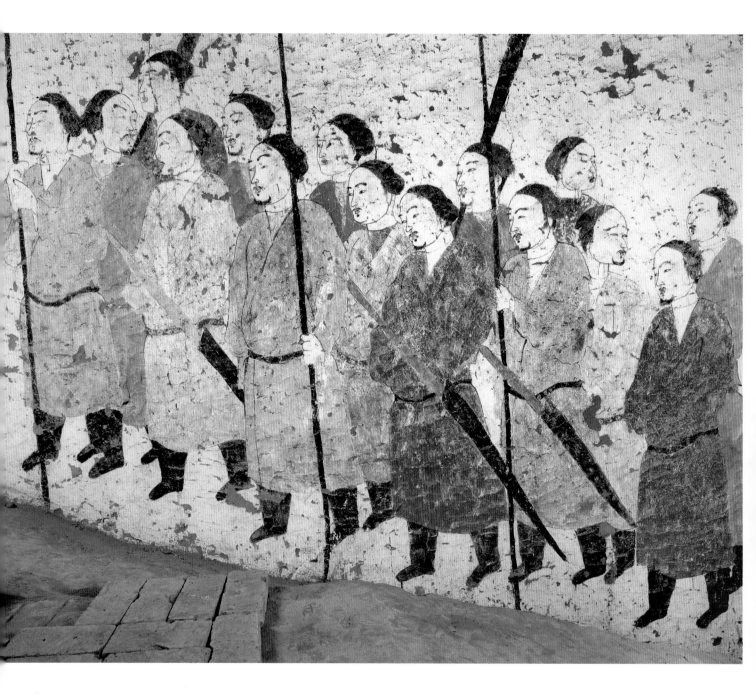

74.仪仗队列（一）

北齐武平二年（571年）

高约175、宽约325厘米

2000年山西省太原市王家峰村北齐徐显秀墓出土。原址保存。

墓向185°。位于墓道西壁中段。为墓道西壁上26人组成的仪仗队列中的第12～26人，其中三人各执一面三旒旗，三人腰际佩长剑，两人肩扛一长角。

<div align="right">（撰文、摄影：陈庆轩）</div>

Guards of Honor (1)

2nd Year of Wuping Era, Northern Qi (571 CE)

Height ca. 175 cm; Width ca. 325 cm

Unearthed from Northern Qi Xu Xianxiu's tomb at Wangjiafengcun in Taiyuan, Shanxi, in 2000. Preserved on the original site.

75. 仪仗队列（二）

北齐武平二年（571年）

高约175、宽约320厘米

2000年山西省太原市王家峰村北齐徐显秀墓出土。原址保存。

墓向185°。位于墓道东壁中段。 为墓道东壁上26人组成的仪仗队伍中的第14～26人，其中三人各执一面三旒旗，两人腰间系弓囊，两人肩扛一长角。

<div align="right">（撰文、摄影：陈庆轩）</div>

Guards of Honor (2)

2nd Year of Wuping Era, Northern Qi (571 CE)

Height ca. 175 cm; Width ca. 320 cm

Unearthed from Northern Qi Xu Xianxiu's tomb at Wangjiafengcun in Taiyuan, Shanxi, in 2000. Preserved on the original site.

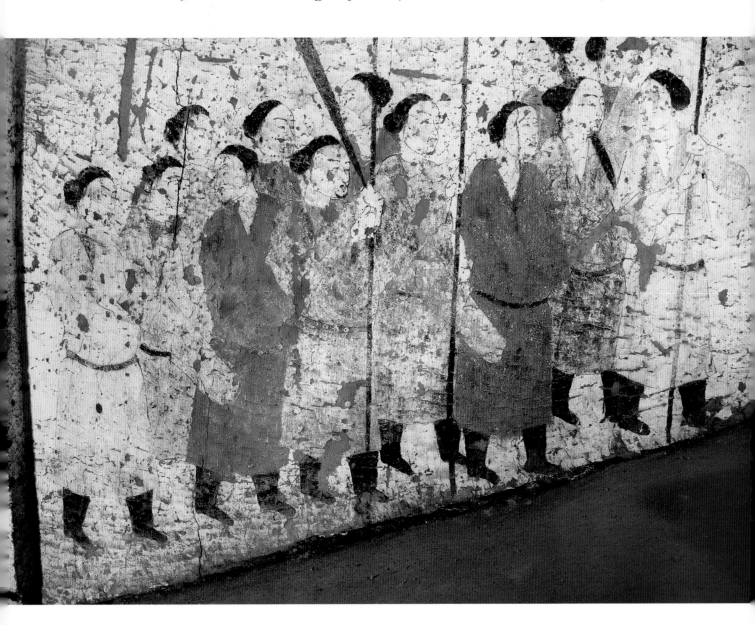

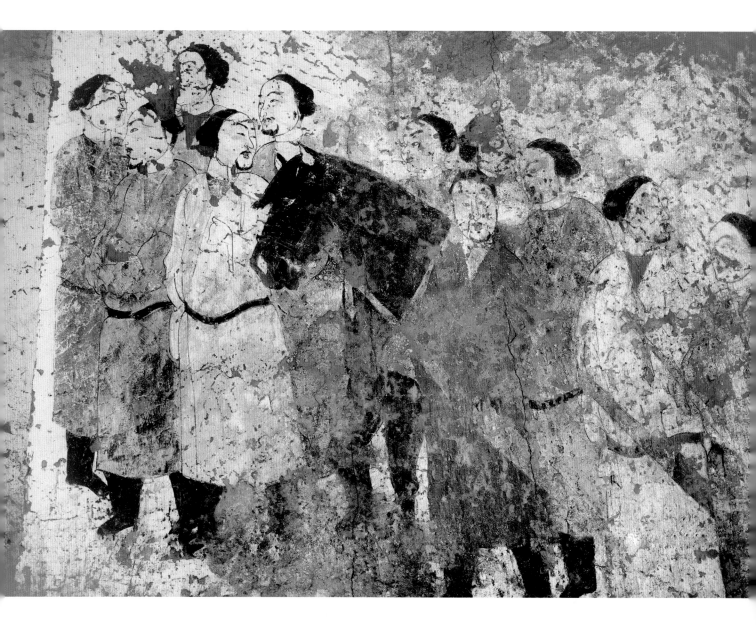

76. 仪仗队列（三）

北齐武平二年（571年）

高约180、宽约280厘米

2000年山西省太原市王家峰村北齐徐显秀墓出土。原址保存。

墓向185°。位于过洞、天井西壁的南端。为过洞、天井西壁19人组成的仪仗队伍中的第1～11人，其中三人佩剑，有一黑色马匹。

（撰文、摄影：陈庆轩）

Guards of Honor (3)

2nd Year of Wuping Era, Northern Qi (571 CE)

Height ca. 180 cm; Width ca. 280 cm

Unearthed from Northern Qi Xu Xianxiu's tomb at Wangjiafengcun in Taiyuan, Shanxi, in 2000. Preserved on the original site.

77.仪仗队列（四）

北齐武平二年（571年）

高约180、宽约205厘米

2000年山西省太原市王家峰村北齐徐显秀墓出土。原址保存。

墓向185°。位于过洞、天井东壁的北端。为过洞、天井东壁上15人组成的仪仗队伍中的第8～14人，其中三人腰间系弓囊，有一黑色马匹。

（撰文、摄影：陈庆轩）

Guards of Honor (4)

2nd Year of Wuping Era, Northern Qi (571 CE)

Height ca. 180 cm; Width ca. 205 cm

Unearthed from Northern Qi Xu Xianxiu's tomb at Wangjiafengcun in Taiyuan, Shanxi, in 2000. Preserved on the original site.

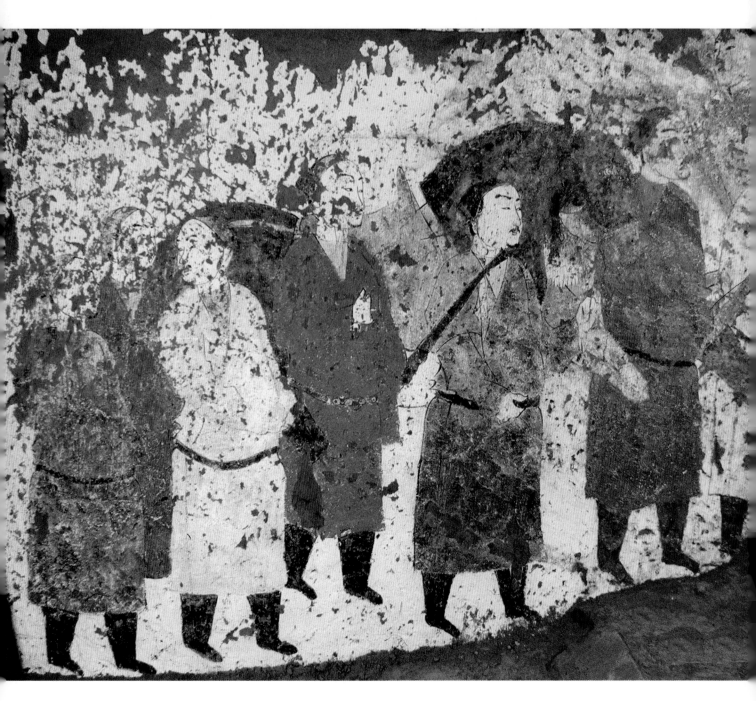

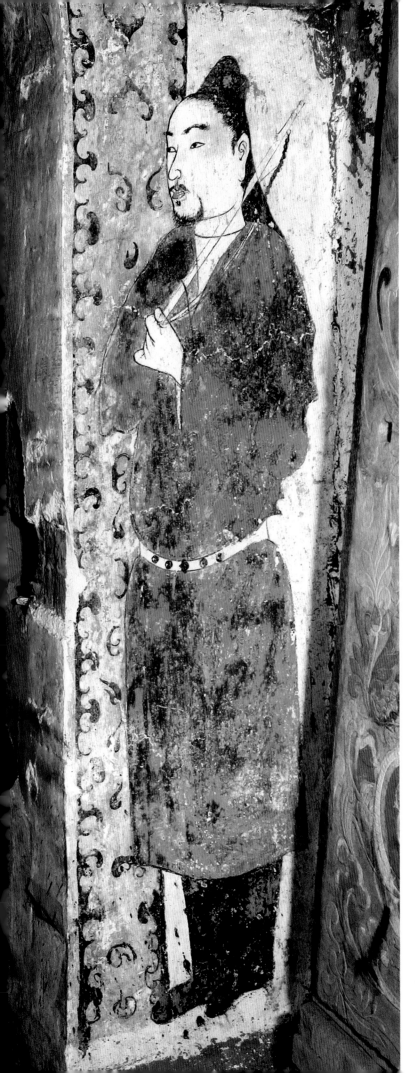

78.执鞭门吏

北齐武平二年（571年）

高约175、宽约35厘米

2000年山西省太原市王家峰村北齐徐显秀墓出土。原址保存。

墓向185°。位于甬道券洞口的东侧。武士，头戴风帽，身穿窄袖右衽长袍，左手执鞭过肩,右手绞袖举于胸前。

（撰文、摄影：陈庆轩）

Door Guard with Whip

2nd Year of Wuping Era, Northern Qi (571 CE)

Height ca. 175 cm; ca. Width 35 cm

Unearthed from Northern Qi Xu Xianxiu's tomb at Wangjiafengcun in Taiyuan, Shanxi, in 2000. Preserved on the original site.

79. 朱雀图

北齐武平二年（571年）

高约160、宽约64厘米

2000年山西省太原市王家峰村北齐徐显秀墓出土。原址保存。

墓向185°。位于两门扇石上。其上部皆刻一兽头鸟身蹄足兽，下部则各刻一青龙、白虎。此为东侧门扇石，其下部原刻一青龙，却用颜料改绘成一振翅的朱雀。

（撰文、摄影：陈庆轩）

Scarlet Bird

2nd Year of Wuping Era, Northern Qi (571 CE)

Height ca. 160 cm; Width ca. 64 cm

Unearthed from Northern Qi Xu Xianxiu's tomb at Wangjiafengcun in Taiyuan, Shanxi, in 2000. Preserved on the original site.

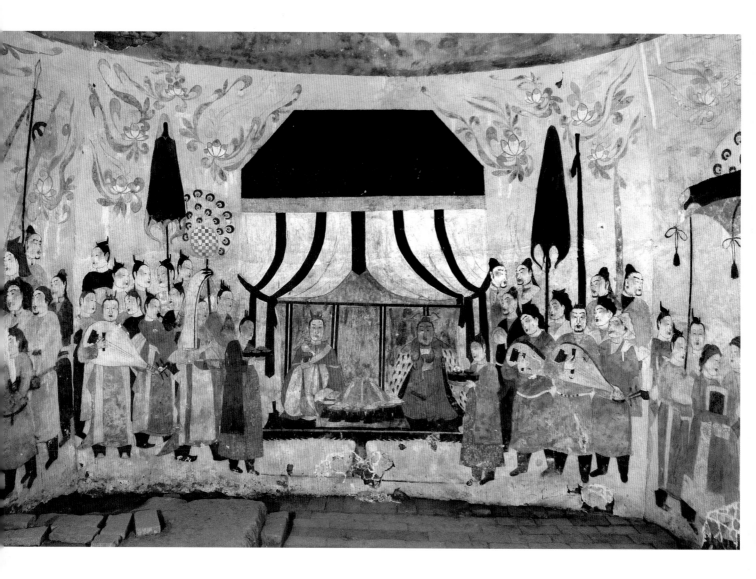

80.夫妇并坐图

北齐武平二年（571年）

高约410、宽约570厘米

2000年山西省太原市王家峰村北齐徐显秀墓出土。原址保存。

墓向185°。位于墓室北壁。天上飘荡莲花，在正中的帷帐内，男、女墓主人右手端漆杯并坐于床榻之上，面前摆放一食案，两侧各有一侍女手捧盘杯。两侧分别有演奏琵琶、五弦、箜篌、芦笙、横笛、拍铍等乐器的男、女乐伎，众侍者中有人手执羽扇、华盖等。

（撰文、摄影：陈庆轩）

Tomb Occupant Couple Seated Abreast

2nd Year of Wuping Era, Northern Qi (571 CE)

Height ca. 410 cm; Width ca. 570 cm

Unearthed from Northern Qi Xu Xianxiu's tomb at Wangjiafengcun in Taiyuan, Shanxi, in 2000. Preserved on the original site.

81.夫妇并坐图（局部一）▶

北齐武平二年（571年）

2000年山西省太原市王家峰村北齐徐显秀墓出土。原址保存。

墓向185°。位于墓室北壁。为"夫妇并坐图"的左侧持有各种乐器的男、女乐伎。

（撰文、摄影：陈庆轩）

Tomb Occupant Couple Seated Abreast (Detail 1)

2nd Year of Wuping Era, Northern Qi (571 CE)

Unearthed from Northern Qi Xu Xianxiu's tomb at Wangjiafengcun in Taiyuan, Shanxi, in 2000. Preserved on the original site.

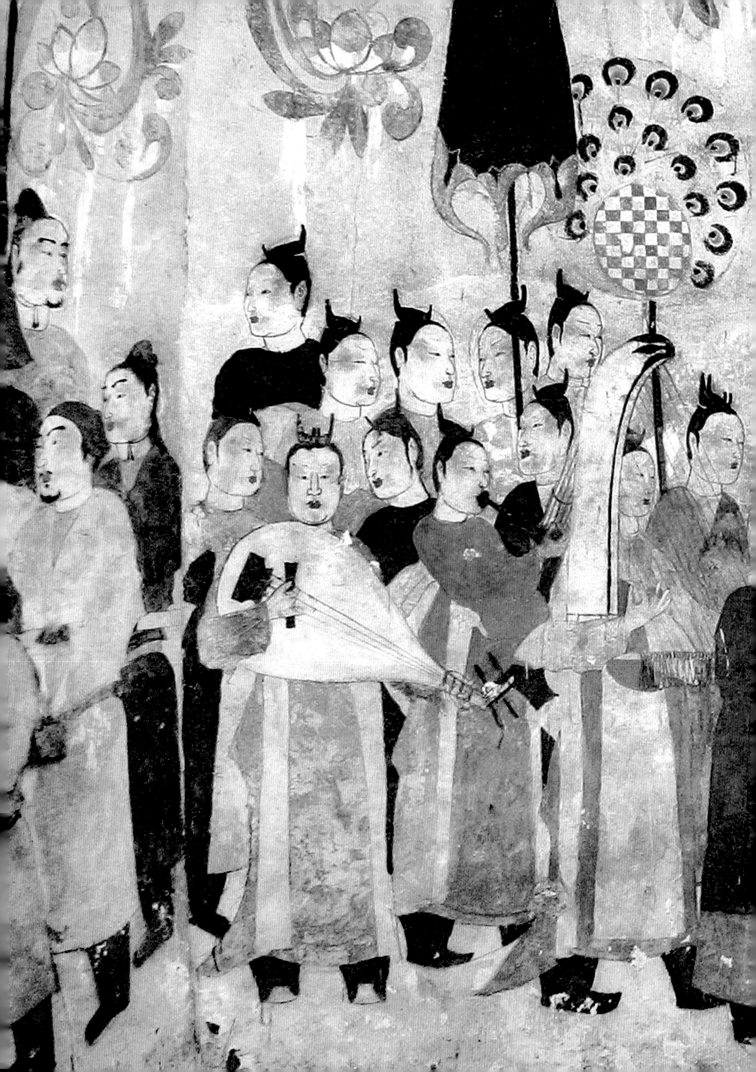

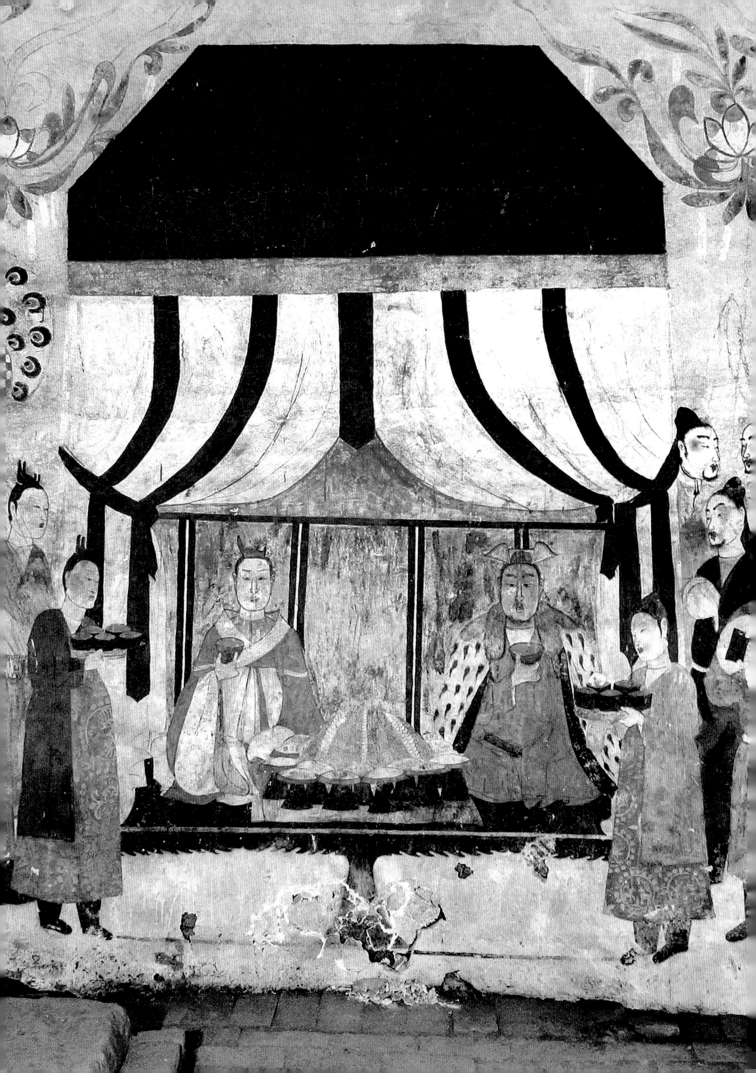

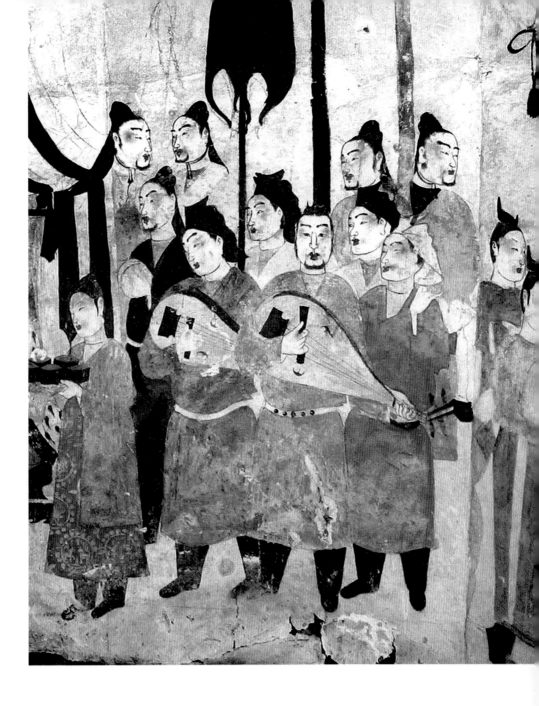

83.夫妇并坐图（局部三）

北齐武平二年（571年）

2000年山西省太原市王家峰村北齐徐显秀墓出土。原址保存。墓向185°。位于墓室北壁。为"夫妇并坐图"的右侧持有各种乐器的男、女乐伎。

（撰文、摄影：陈庆轩）

Tomb Occupant Couple Seated Abreast (Detail 3)

2nd Year of Wuping Era,Northern Qi (571 CE)
Unearthed from Northern Qi Xu Xianxiu's tomb at Wangjiafengcun in Taiyuan, Shanxi, in 2000. Preserved on the original site.

◀ ## 82.夫妇并坐图（局部二）

北齐武平二年（571年）

2000年山西省太原市王家峰村北齐徐显秀墓出土。原址保存。墓向185°。位于墓室北壁。天上飘荡莲花，在正中的帷帐内，男、女墓主人右手端漆杯并坐于床榻之上，面前摆放一食案，两侧各有一侍女手捧盘杯。

（撰文、摄影：陈庆轩）

Tomb Occupant Couple Seated Abreast (Detail 2)

2nd Year of Wuping Era,Northern Qi (571 CE)
Unearthed from Northern Qi Xu Xianxiu's tomb at Wangjiafengcun in Taiyuan, Shanxi, in 2000. Preserved on the original site.

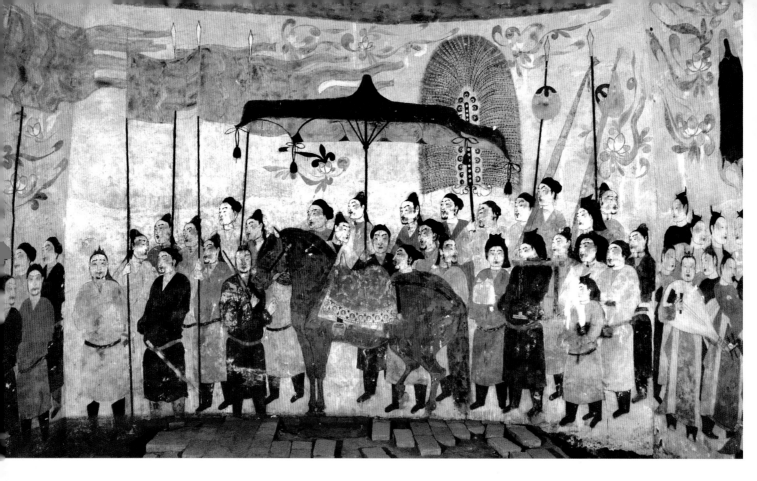

84.鞍马备行图

北齐武平二年（571年）

高约410、宽约575厘米

2000年山西省太原市王家峰村北齐徐显秀墓出土。原址保存。

墓向185°。位于墓室西壁。正中一匹骏马，鞍辔俱全。马前十人中有四人手执三旒旗，马旁九人中有一人手举撑张的伞盖，马后一人手持羽扇，一人抱印，一人左肩扛一胡床，一人双手隐于袖中，其腋下夹一黑色方形物。还有八人中有二人持羽葆，二人持长角。

（撰文、摄影：陈庆轩）

Procession

2nd Year of Wuping Era, Northern Qi (571 CE)

Height ca. 410 cm; Width ca. 575 cm

Unearthed from Northern Qi Xu Xianxiu's tomb at Wangjiafengcun in Taiyuan, Shanxi, in 2000. Preserved on the original site.

85.鞍马备行图（局部）▶

北齐武平二年（571年）

2000年山西省太原市王家峰村北齐徐显秀墓出土。原址保存。

墓向185°。位于墓室西壁。正中一匹骏马，鞍辔俱全；马前十人中有四人手执三旒旗，马旁九人中有一人手举撑张的伞盖，马后一人手持羽扇，一人抱印，一人左肩扛一胡床，一人双手隐于袖中，其腋下夹一黑色方形物。还有八人中有二人持羽葆，二人持长角。

（撰文、摄影：陈庆轩）

Procession (Detail)

2nd Year of Wuping Era, Northern Qi (571 CE)

Unearthed from Northern Qi Xu Xianxiu's tomb at Wangjiafengcun in Taiyuan, Shanxi, in 2000. Preserved on the original site.

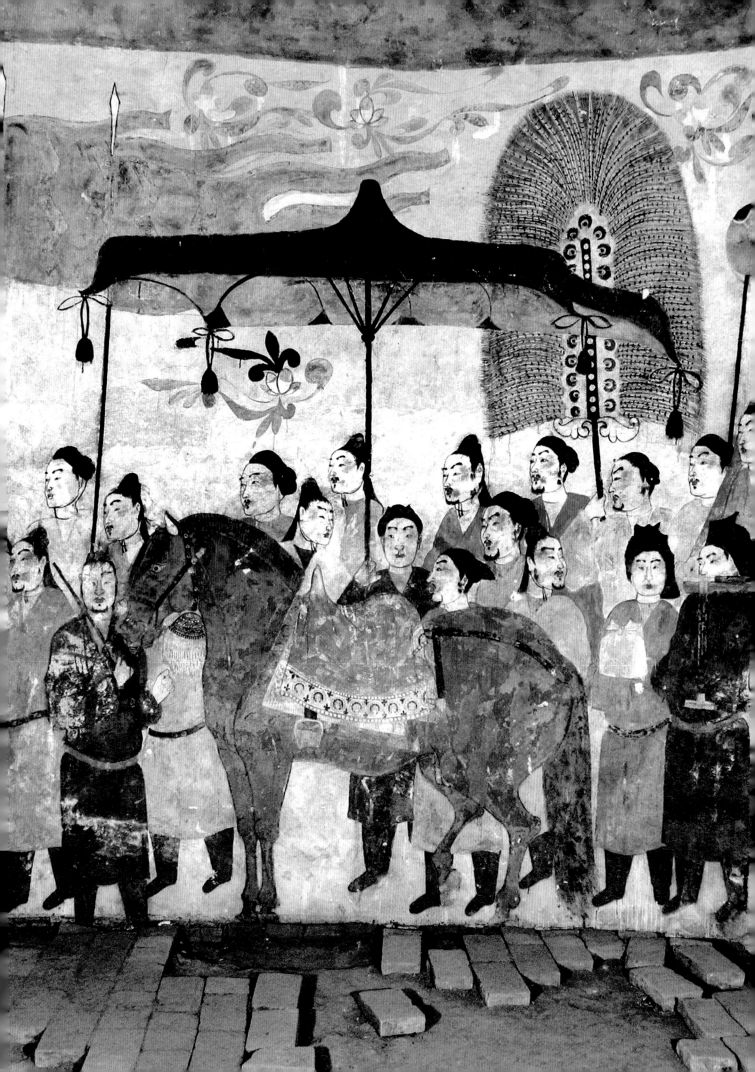

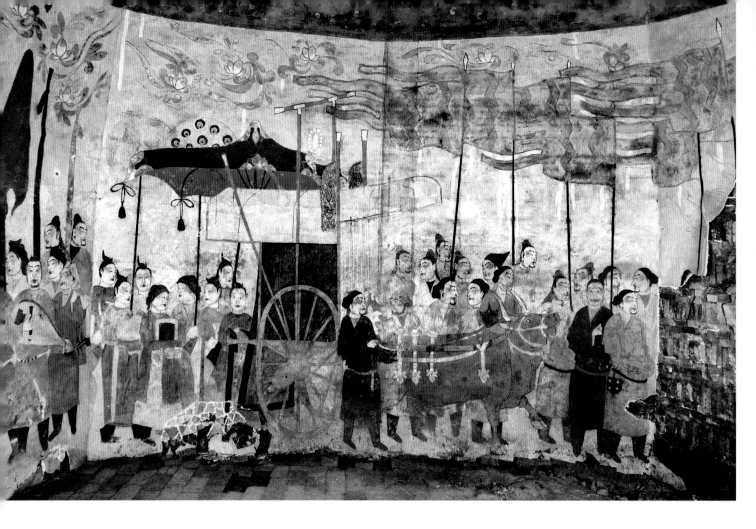

86.牛车备行图

北齐武平二年（571年）

高约410、宽约575厘米

2000年山西省太原市王家峰村北齐徐显秀墓出土。原址保存。

墓向185°。位于墓室东壁。正中一公牛驾车，卷棚顶车辆的两侧高杆上各挑一黼黻；牛后外站立一人，牛后里站立一胡人，牛前有四人执三旒旗，车后众侍女中有三人各执羽扇、华盖等，另有两名侍女，捧黑匣或包袱。

（撰文、摄影：陈庆轩）

Readied Formation and Ox Cart

2nd Year of Wuping Era, Northern Qi (571 CE)
Height ca. 410 cm; Width ca. 575 cm
Unearthed from Northern Qi Xu Xianxiu's tomb at Wangjiafengcun in Taiyuan, Shanxi, in 2000. Preserved on the original site.

87.牛车备行图（局部）▶

北齐武平二年（571年）

2000年山西省太原市王家峰村北齐徐显秀墓出土。原址保存。

墓向185°。位于墓室东壁。正中一公牛驾车，卷棚顶车辆的两侧高杆上各挑一黼黻；牛后外站立一人，牛后里站立一胡人，牛前有四人执三旒旗，车后众侍女中有三人各执羽扇、华盖等，另有两名侍女，捧黑匣或包袱。

（撰文、摄影：陈庆轩）

Readied Formation and Ox Cart (Detail)

2nd Year of Wuping Era, Northern Qi (571 CE)
Unearthed from Northern Qi Xu Xianxiu's tomb at Wangjiafengcun in Taiyuan, Shanxi, in 2000. Preserved on the original site.

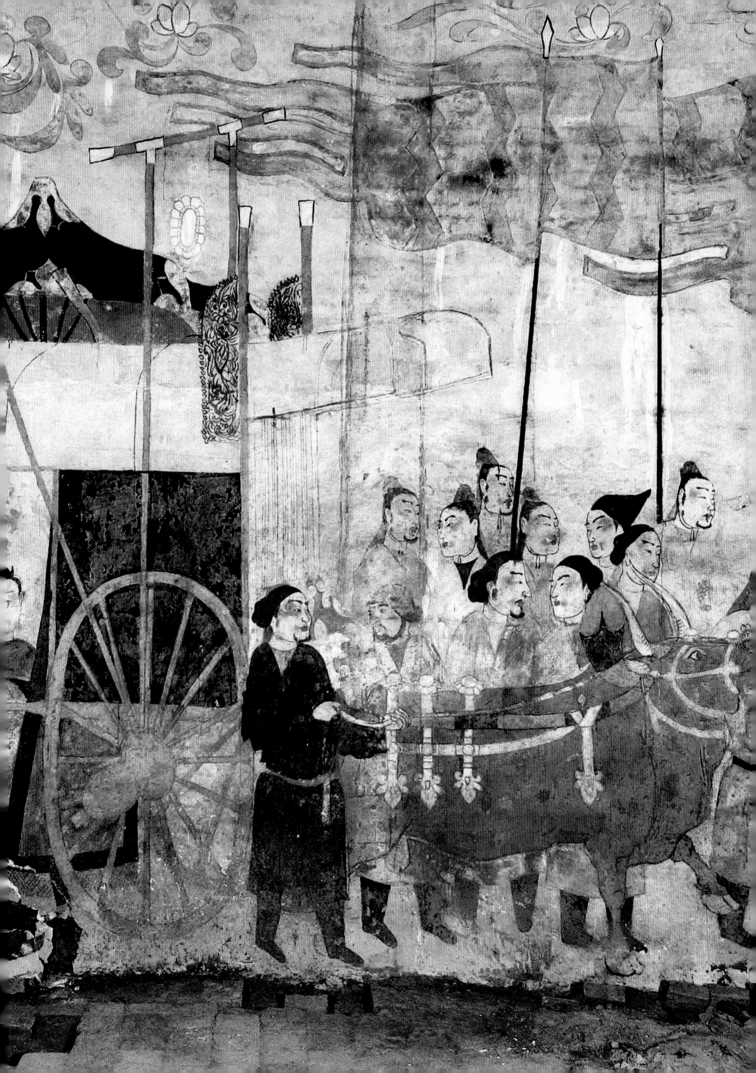

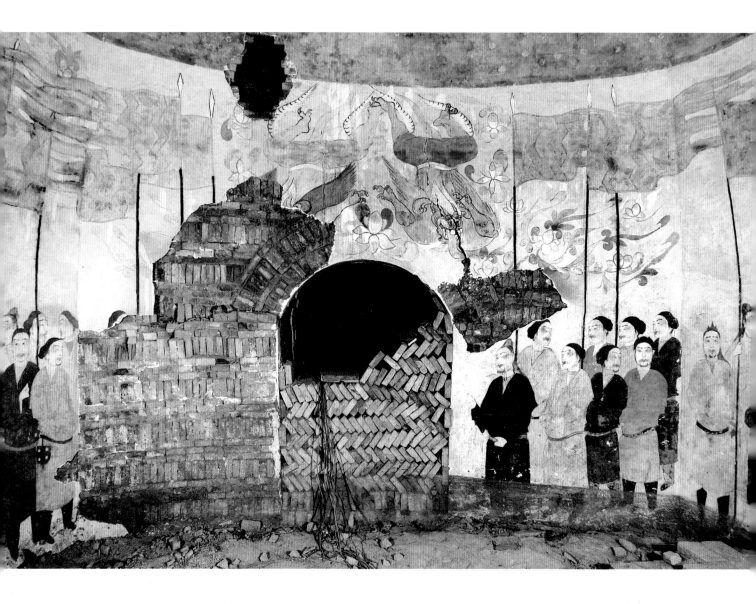

88.仪仗队列（五）

北齐武平二年（571年）

高约410、宽约570厘米

2000年山西省太原市王家峰村北齐徐显秀墓出土。原址保存。

墓向185°。位于墓室南壁。门洞左侧壁画多已脱落，残存三面三旒旗。门洞右侧有八人站立的仪仗队列，其中三人执三旒旗。墓门洞上方有两个神兽向下俯冲。

（撰文、摄影：陈庆轩）

Guards of Honor (5)

2nd Year of Wuping Era, Northern Qi (571 CE)

Height ca. 410 cm; Width ca. 570 cm

Unearthed from Northern Qi Xu Xianxiu's tomb at Wangjiafengcun in Taiyuan, Shanxi, in 2000. Preserved on the original site.

89.仪仗队列（五）
（局部一）

北齐武平二年（571年）

2000年山西省太原市王家峰村北齐徐显秀墓出土。原址保存。

墓向185°。位于墓室南壁门洞上方。

（撰文、摄影：陈庆轩）

Guards of Houor (5) (Detail 1)

2nd Year of Wuping Era, Northern Qi (571 CE)

Unearthed from Northern Qi Xu Xianxiu's tomb at Wangjiafengcun in Taiyuan, Shanxi, in 2000. Preserved on the original site.

90.仪仗队列（五）
（局部二）

北齐武平二年（571年）

2000年山西省太原市王家峰村北齐徐显秀墓出土。原址保存。

墓向185°。位于墓室南壁。门洞右侧有八人站立的仪仗队列，其中三人执三旒旗。

（撰文、摄影：陈庆轩）

Guards of Houor (5) (Detail 2)

2nd Year of Wuping Era, Northern Qi (571 CE)

Unearthed from Northern Qi Xu Xianxiu's tomb at Wangjiafengcun in Taiyuan, Shanxi, in 2000.Preserved on the original site.

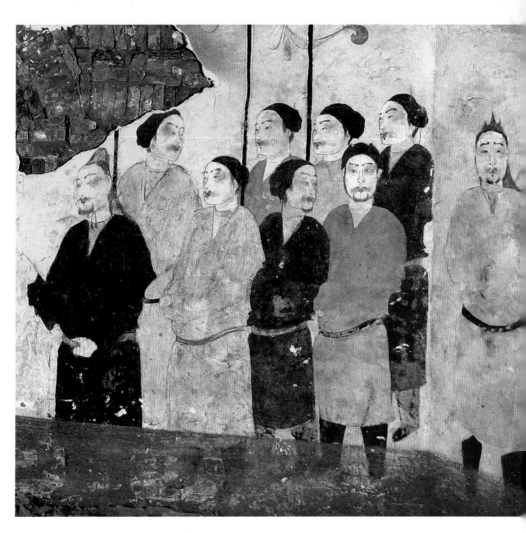

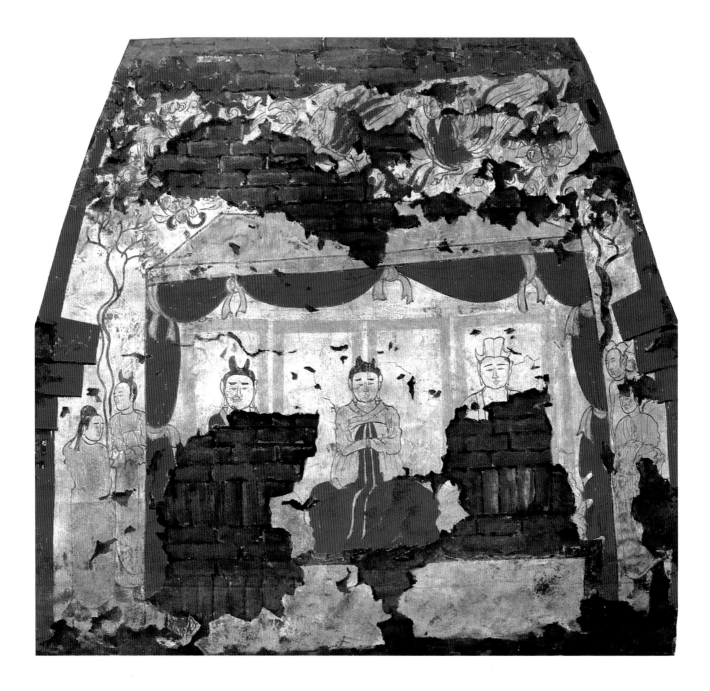

91. 主人并坐图（摹本）

北齐（550～577年）

高约233、宽约250厘米

1987年山西省太原市第一热电厂北齐墓出土。已残毁。

墓向190°。位于墓室北壁。上层中部一金翅鸟，右侧一双翼人首鸟，左侧残缺，以宝相花、流云点缀。下层正中三位女性，端坐于帷幄内，身后排列屏风。两侧各有一株大树，分别站立男、女侍仆，或拱手、或持物。

<div align="right">（临摹、撰文：商彤流　摄影：李建生）</div>

Tomb Occupant Couple Seated Abreast (Replica)

Northern Qi (550-577 CE)

Height ca. 233 cm; Width ca. 250 cm

Unearthed from Northern Qi tomb at No.1 Thermal Power Company in Taiyuan, Shanxi, in 1987. Not preserved.

92. 牛车备行图（摹本）

北齐（550～577年）

高约230、宽约255厘米

1987年山西省太原市第一热电厂北齐墓出土。已残毁。

墓向190°。位于墓室东壁。上层中部一仙人骑龙飞行，右前方一仙人作导引状；凌空几只怪兽，点缀以宝相花、流云。下层左侧站立三名男子，右侧一名御夫、一辆牛车；车后一男持羽葆、伞盖，一女捧衣物。

（撰文、临摹：商彤流　摄影：李建生）

Readied Formation and Ox Cart (Replica)

Northern Qi (550-577 CE)

Height ca. 230 cm; Width ca. 255 cm

Unearthed from Northern Qi tomb at No.1 Thermal Power Company in Taiyuan, Shanxi, in 1987. Not preserved.

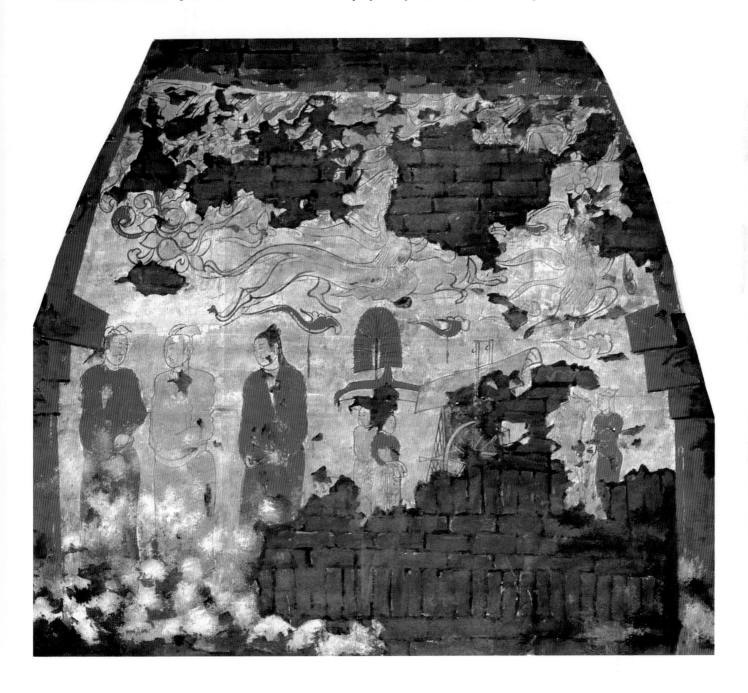

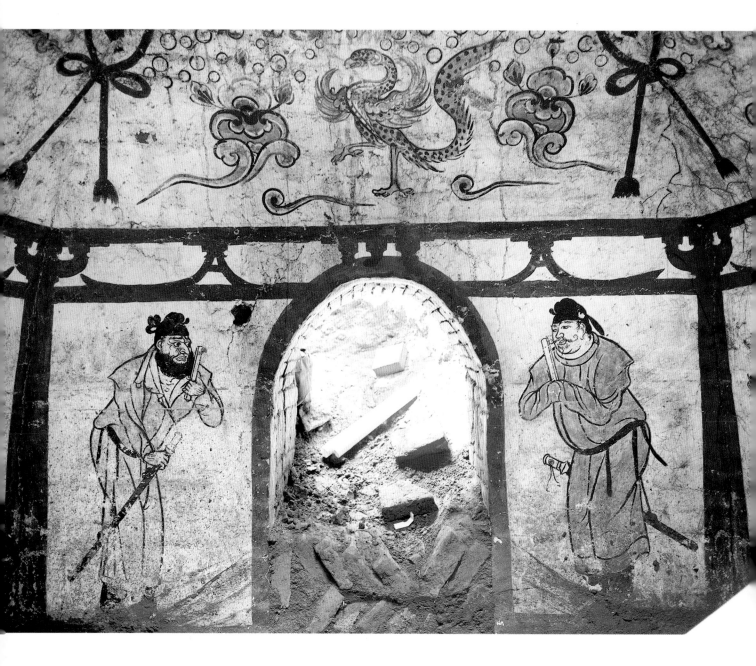

93. 侍奉图

唐武周（690～704年）

高约228、宽约218厘米

1987年山西省太原市焦化厂唐墓出土。已残毁。

墓向180°。位于墓室南壁。墓顶为华盖，两侧有垂幔的挽结，墓壁上层侧立一振翅的朱雀，旁有星象、宝相花、流云。中层涂画出房屋的立柱、额枋、斗拱。门洞两侧壁的下层，各站立一名执笏、躬身的侍吏。

（撰文、摄影：李建生）

Attendants

Empress Wu Zetian's Reign of the Tang (690-704 CE)

Height ca. 228 cm; Width ca. 218 cm

Unearthed from Tang tomb at Jiaohuachang in Taiyuan, Shanxi, in 1987. Not preserved.

94.青龙、人物图

唐武周（690～704年）

高约228、宽约217厘米

1987年山西省太原市焦化厂唐墓出土。已残毁。

墓向180°。位于墓室东壁。墓顶上层一条腾飞的青龙，旁有红日、星象、宝相花、流云。墓壁中层涂画房屋立柱、额枋、斗拱。在紧依棺床的墓壁下层，有"树下老人"的屏风画三框格。在棺床以外的最右侧，站立一名手持拂尘的侍女。

（撰文、摄影：李建生）

Green Dragon and Figures

Empress Wu Zetian's Reign of the Tang (690-704 CE)

Height ca. 228 cm; Width ca. 217 cm

Unearthed from Tang tomb at Jiaohuachang in Taiyuan, Shanxi, in 1987. Not preserved.

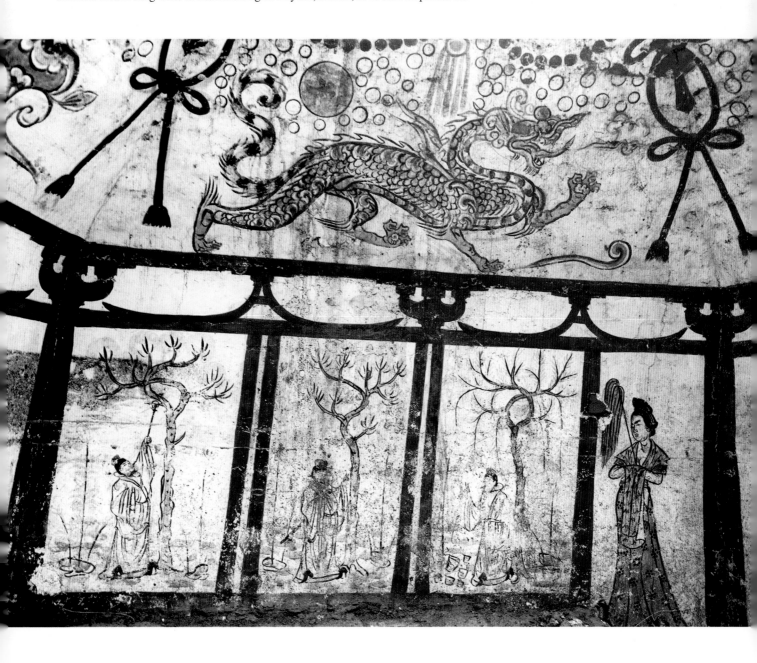

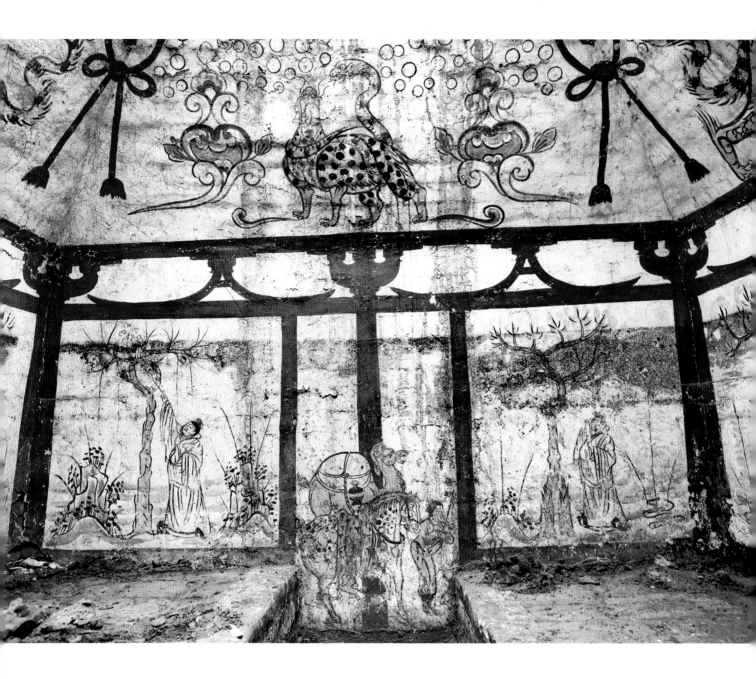

95. 玄武、人物图

唐武周（690～704年）

高约228、宽约218厘米

1987年山西省太原市焦化厂唐墓出土。已残毁。

墓向180°。位于墓室北壁。墓顶上层一蛇缠龟的玄武，旁有星象、宝相花、流云。在房屋额枋、斗拱之下的北壁中部，在立柱前有驼马人物；其左侧屏风画内一老者，伸臂上指一垂柳，祥云飘然逸出；其右侧屏风画中一老翁，应为孝子孟宗。

（撰文、摄影：李建生）

Sombre Warrior and Figures

Empress Wu Zetian's Reign of the Tang (690-704 CE)

Height ca. 228 cm; Width ca. 218 cm

Unearthed from Tang tomb at Jiaohuachang in Taiyuan, Shanxi, in 1987. Not preserved.

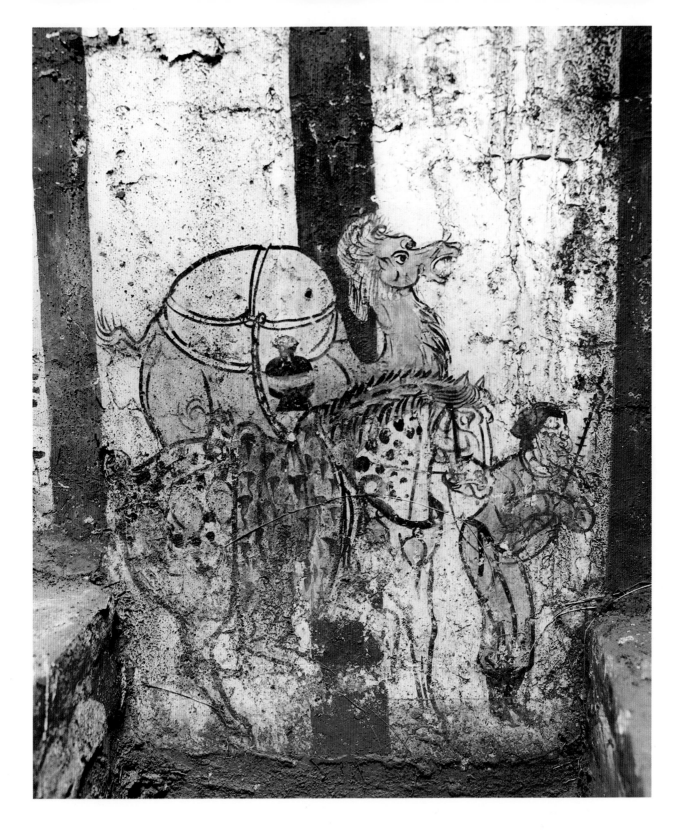

96.驼马人物图

唐武周（690～704年）

高约100、宽约50厘米

1987年山西省太原市焦化厂唐墓出土。已残毁。

墓向180°。位于墓室北壁下层中间。一马、一驼、一胡人，皆站立在立柱前。黑斑红鬃白马，鞍鞯齐备；黄色鬃毛骆驼，背负行囊；右侧一胡人，拱手执鞭。

（撰文、摄影：李建生）

Camel, Horse and Groom

Empress Wu Zetian's Reign of the Tang (690-704 CE)

Height ca. 100 cm; Width ca. 50 cm

Unearthed from Tang tomb at Jiaohuachang in Taiyuan, Shanxi, in 1987. Not preserved.

97. 孝子孟宗

唐武周（690～704年）

高约68、宽约47厘米

1987年山西省太原市焦化厂唐墓出土。已残毁。

墓向180°。位于墓室北壁下层东侧。紧靠棺床的壁面上有屏风画，一老翁，面对大树，以袖拭面，恸哭，因树下有二竹笋，应是孝子人物中"哭竹生笋"的孟宗。

（撰文、摄影：李建生）

Meng Zong, One of the "Twenty-Four Paragons of Filial Piety"

Empress Wu Zetian's Reign of the Tang Dynasty (690-704 CE)

Height ca. 68 cm; Width ca. 47 cm

Unearthed from Tang tomb at Jiaohuachang in Taiyuan, Shanxi, in 1987. Not preserved.

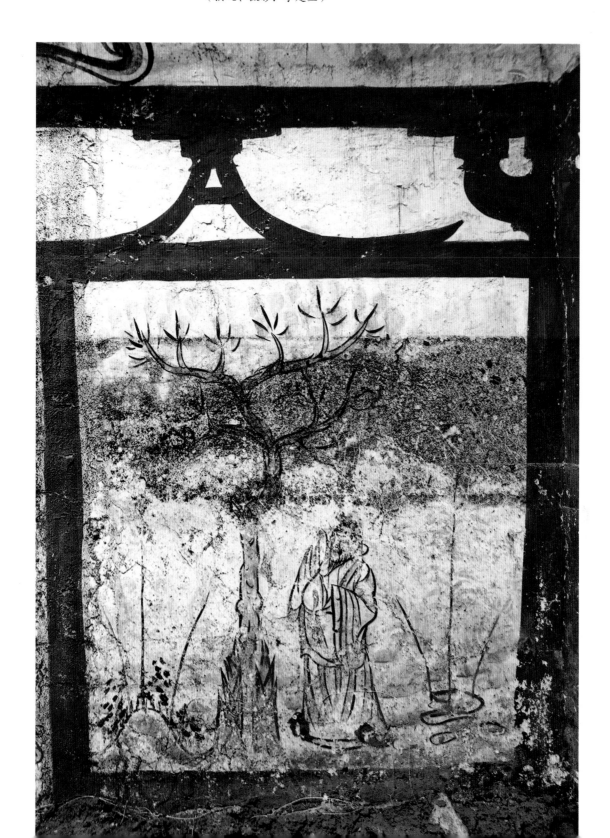

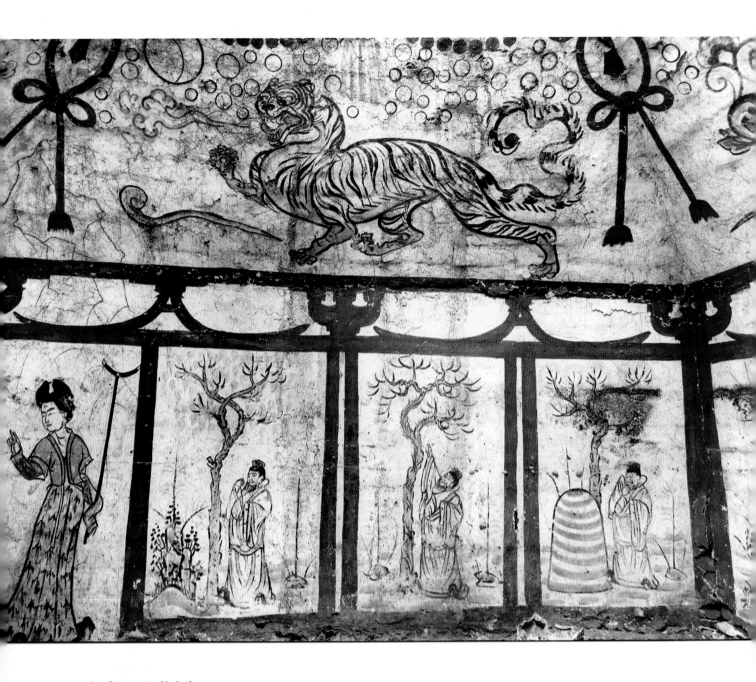

98.白虎、人物图

唐武周（690～704年）

高约228、宽约217米

1987年山西省太原市焦化厂唐墓出土。已残毁。

墓向180°。位于墓室西壁。墓顶上层一奔跑的白虎，旁有弯月、星象、宝相花、流云。墓壁中层画作房屋立柱、额枋、斗拱。墓壁下层有屏风画三框格，分别绘画三幅"树下老人"；左数第一、第二格的人物尚难确定；第三格的老翁，应是孝子王襄。在棺床以外的最左侧，站立一名手持衣叉的侍女。

（撰文、摄影：李建生）

Tiger and Figures

Empress Wu Zetian's Reign of the Tang (690-704 CE)

Height ca. 228 cm; Width ca. 217 cm

Unearthed from Tang tomb at Jiaohuachang in Taiyuan, Shanxi, in 1987. Not preserved.

99.孝子王襄

唐武周（690～704年）

高约68、宽约47厘米

1987年山西省太原市焦化厂唐墓出土。已残毁。

墓向180°。位于墓室西壁下层的北侧。紧靠棺床的壁面上有屏风三框格，此图为最右侧的屏风画，一老翁，面对着树前的坟丘，以袖拭面，恸哭，应是孝子人物中"闻雷泣墓"的王襄。

（撰文、摄影：李建生）

Wang Xiang, One of the "Twenty-Four Paragons of Filial Piety"

Empress Wu Zetian's Reign of the Tang Dynasty (690-704 CE)

Height ca. 68 cm; Width ca. 47 cm

Unearthed from Tang tomb at Jiaohuachang in Taiyuan, Shanxi, in 1987. Not preserved.

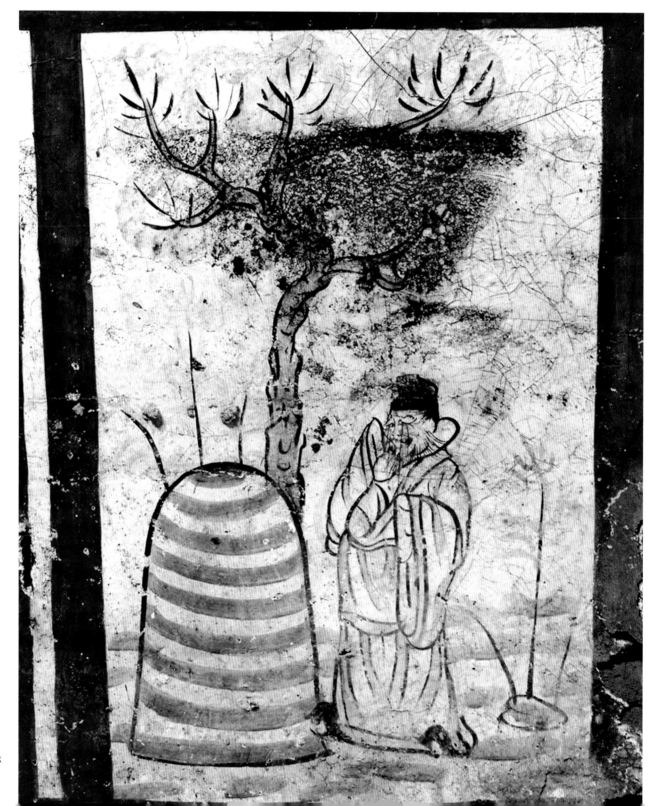

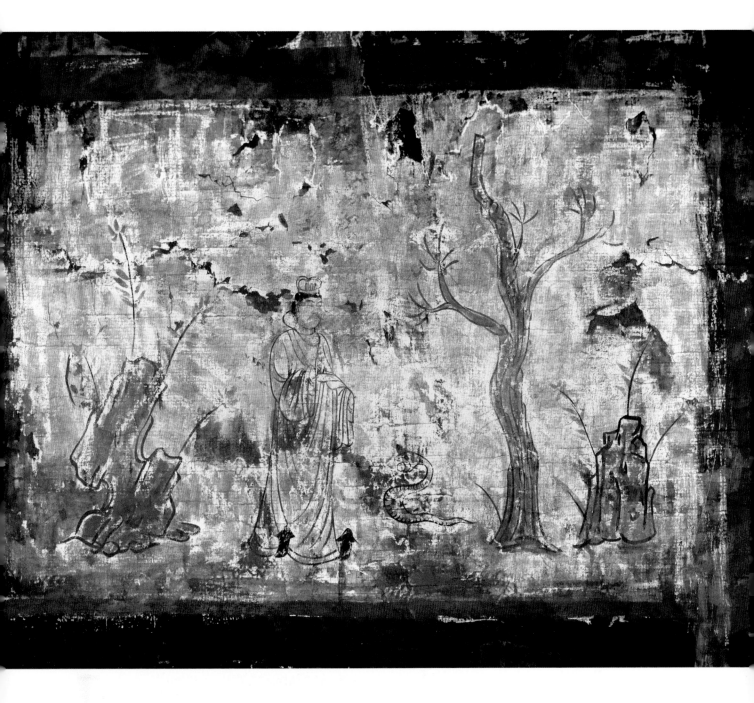

100.随侯受珠图（摹本）

唐武周（690～704年）

高约110、宽约130厘米

1988年山西省太原市金胜村337号唐墓出土。已残毁。

墓向190°。位于墓室东壁北侧。屏风画中，左侧屹立一山石，右侧为一株苍柏、一块怪石。其间站立一老人，俯身下视，双手托巾；面前一蛇，昂首腾起，口中衔珠，献予老者。

（临摹、撰文：商彤流　摄影：李建生）

Marquis Sui Accepting Pearl (Replica)

Empress Wu Zetian's Reign of the Tang (690-704 CE)

Height ca. 110 cm; Width ca. 130 cm

Unearthed from Tang Tomb M337 at Jinshengcun in Taiyuan, Shanxi, in 1988. Not preserved.

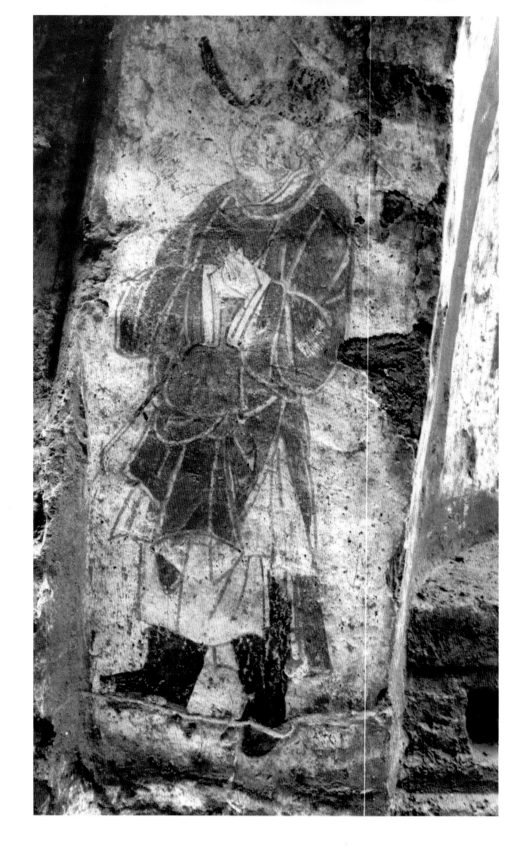

101.门吏图（一）

北汉天会五年（961年）

高约105、宽约45厘米

1994年山西省太原市第一热电厂北汉墓出土。已残毁。

墓向180°。甬道西侧壁绘一守门吏，侧身面向墓外站立，双手拱于胸前，怀抱一条两端露白的黑色杖杆。

（撰文、摄影：商彤流）

Petty Official (1)

5th Year of Tianhui Era, Northern Han Kingdom (961 CE)
Height ca. 105 cm; Width ca. 45 cm
Unearthed from Northern Han tomb at No.1 Thermal Power Company in Taiyuan, Shanxi, in 1994. Not preserved.

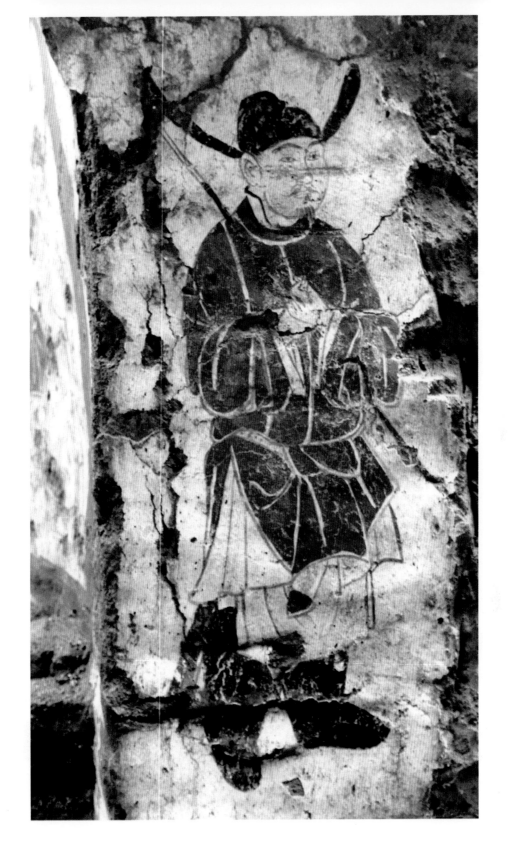

102.门吏图（二）

北汉天会五年（961年）

高约105、宽约45厘米

1994年山西省太原市第一热电厂北汉墓出土。已残毁。墓向180°。甬道东侧壁绘一门吏，其构图、服饰、人物姿态、怀抱器械皆与西壁近似。

（撰文、摄影：商彤流）

Petty Official (2)

5th Year of Tianhui Era, Northern Han Kingdom (961 CE)

Height ca. 105 cm; Width ca. 45 cm

Unearthed from Northern Han tomb at No.1 Thermal Power Company in Taiyuan, Shanxi, in 1994. Not preserved.

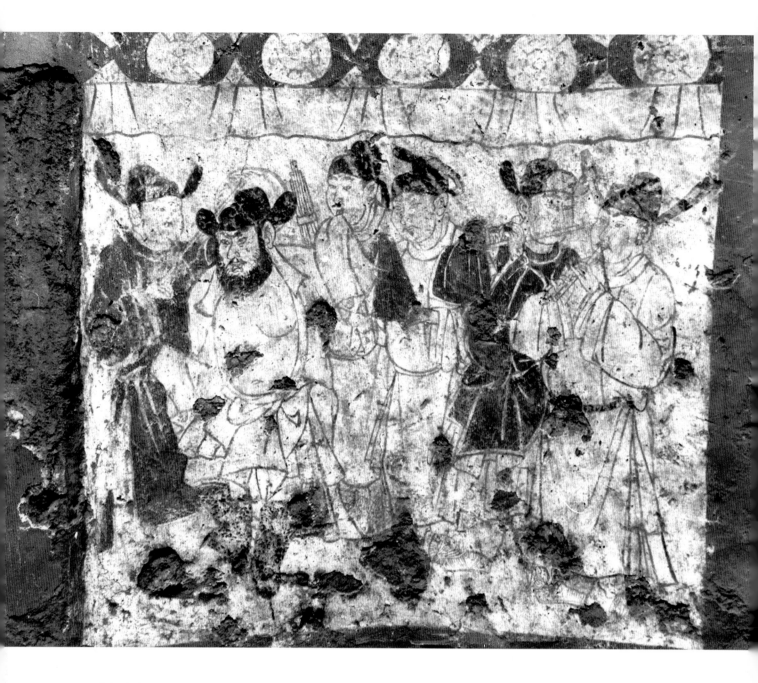

103. 乐舞图

北汉天会五年（961年）

高约121、宽约155厘米

1994年山西省太原市第一热电厂北汉墓出土。已残毁。

墓向180°。位于墓室东南柱间壁。上方一道横楣、一道垂幔，横向排列着五名男性乐人：分别为敲鼓、吹笙、拍板、奏笛、吹笮篥。前场有一名胡人，坦胸露肚，手舞足蹈，正在跳胡腾舞。

（撰文、摄影：商彤流）

Music and Dancing Performance

5th Year of Tianhui Era, Northern Han Kingdom (961 CE)

Height ca. 121 cm; Width ca. 155 cm

Unearthed from Northern Han tomb at No.1 Thermal Power Company in Taiyuan, Shanxi, in 1994. Not preserved.

104.侍仆图

北汉天会五年（961年）

高约105、宽约33厘米

1994年山西省太原市第一热电厂北汉墓出土。已残毁。

墓向180°。位于墓室东北柱间壁。墓壁中间砖砌破子棂窗，其两侧各站立一男侍或女仆。左侧男侍，束髻，长袍，长裤；拱手于胸前，执插手礼。右侧男侍，束髻，长袍，长裤；右手托、左手握一只长颈瓶于胸前。

（撰文、摄影：商彤流）

Attendants

5th Year of Tianhui Era, Northern Han Kingdom (961 CE)

Height ca. 105 cm; Width ca. 33 cm

Unearthed from Northern Han tomb at No.1 Thermal Power Company in Taiyuan, Shanxi, in 1994. Not preserved.

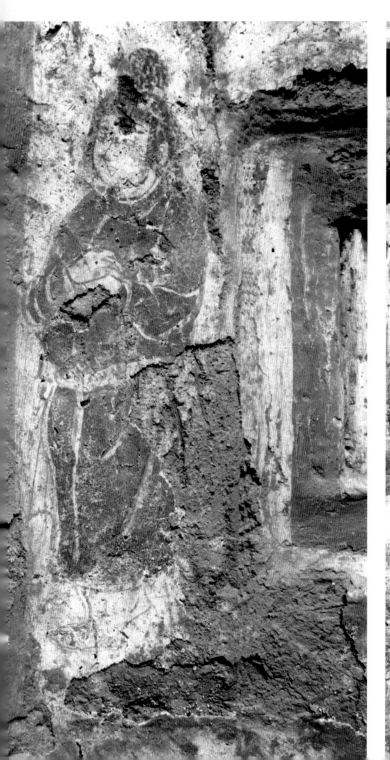
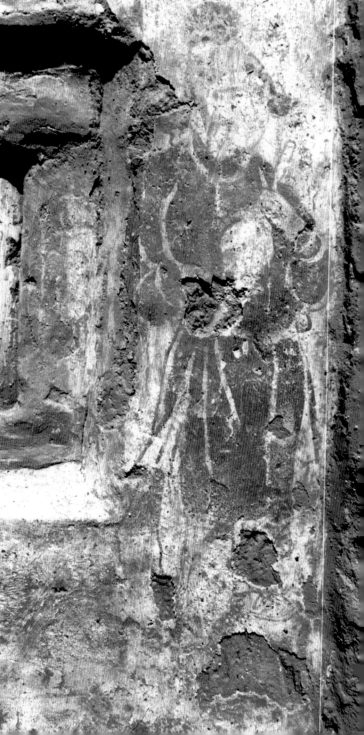

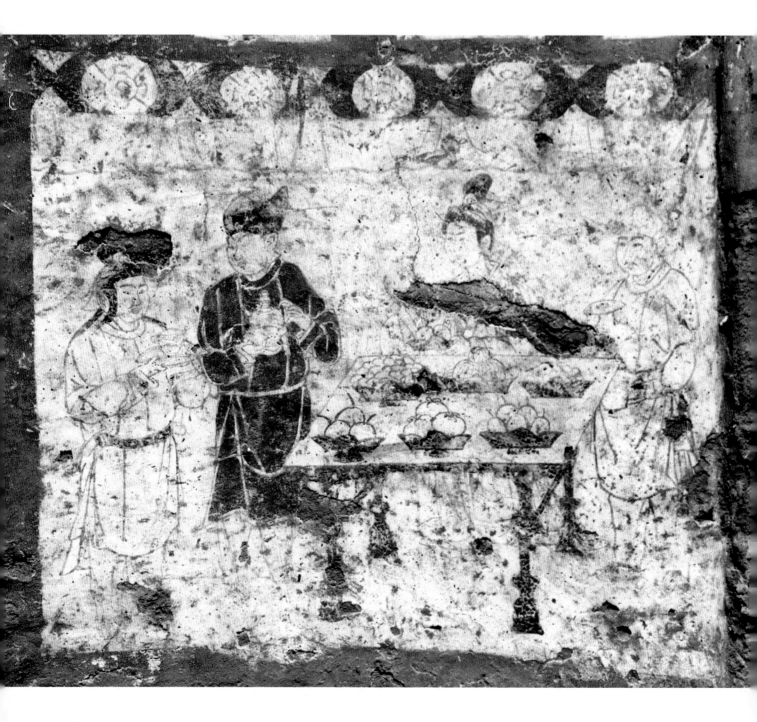

105. 备茶图

北汉天会五年（961年）

高约121、宽约155厘米

1994年山西省太原市第一热电厂北汉墓出土。已残毁。

墓向180°。位于墓室西南柱间壁。上方为阑额、一道垂幔，当间一方桌，摆满果品盘盏；有四名侍者正在劳作。左侧一男侍，平端一托盏；再一男侍，托持一带温碗的注壶；第三人为女仆，平端一果盘；右侧一男侍，怀抱一盘口瓶，表现备茶的场景。

（撰文、摄影：商彤流）

Preparing for Tea Reception

5th Year of Tianhui Era, Northern Han Kingdom (961 CE)

Height ca. 121 cm; Width ca. 155 cm

Unearthed from Northern Han tomb at No.1 Thermal Power Company in Taiyuan, Shanxi, in 1994. Not preserved.

106.罗汉、天王图（局部）

北宋至道元年（995年）

高约45、宽约40厘米

2005年山西省平定县城内宋代天宁寺佛塔地宫出土。已残毁。

墓向173°。位于地宫东壁南侧（近门道处）。左侧残留一罗汉的头部，举哀、悲切；右侧一半身的戎装东方天王，右手握长剑，左手分指以护刃。线描流畅，设色明快。

（撰文、摄影：商彤流）

Arhat and Lokapala (Detail)

1st Year of Zhidao Era, Northern Song (995 CE)

Height ca. 45 cm; Width ca. 40 cm

Unearthed from the underground chamber of the pagoda of Song Tianning Temple at Pingding in Shanxi, in 2005. Not preserved.

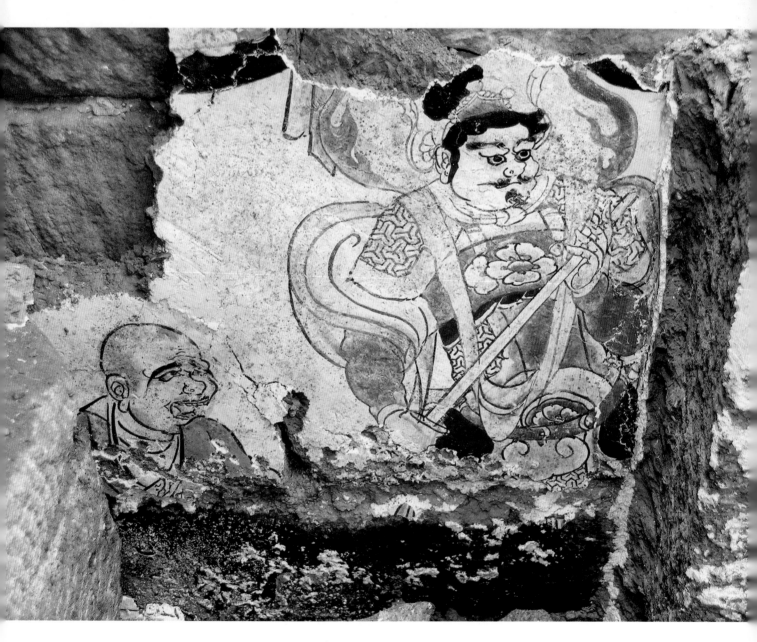

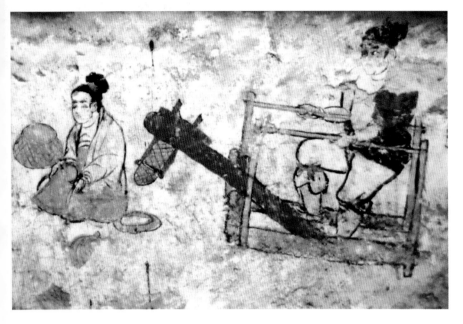

107.舂米图

北宋元丰元年（1078年）

高约45、宽约55厘米

1988年山西省长治市北郊故县村北宋墓出土。已残毁。

墓向180°。位于墓室南壁左侧。一男子双手扶栏，脚踏木、正在舂米；一妇人正在筐米。

（撰文、摄影：王进先）

Husking Rice

1st Year of Yuanfeng Era, Northern Song (1078 CE)

Height ca. 45 cm; Width ca. 55 cm

Unearthed from Northern Song tomb at Guxiancun in northern suburbs of Changzhi, Shanxi, in 1988. Not preserved.

108.推磨图

北宋元丰元年（1078年）

高约45、宽约55厘米

1988年山西省长治市北郊故县村北宋墓出土。已残毁。

墓向180°。位于墓室南壁右侧。画面右侧一男一女扶磨杆正在推磨；画面左侧一妇人正在筛面。

（撰文、摄影：王进先）

Milling Flour

1st Year of Yuanfeng Era, Northern Song (1078 CE)

Height ca. 45 cm; Width ca. 55 cm

Unearthed from Northern Song tomb at Guxiancun in northern suburbs of Changzhi, Shanxi, in 1988. Not preserved.

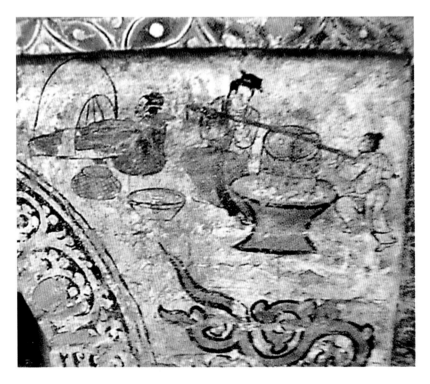

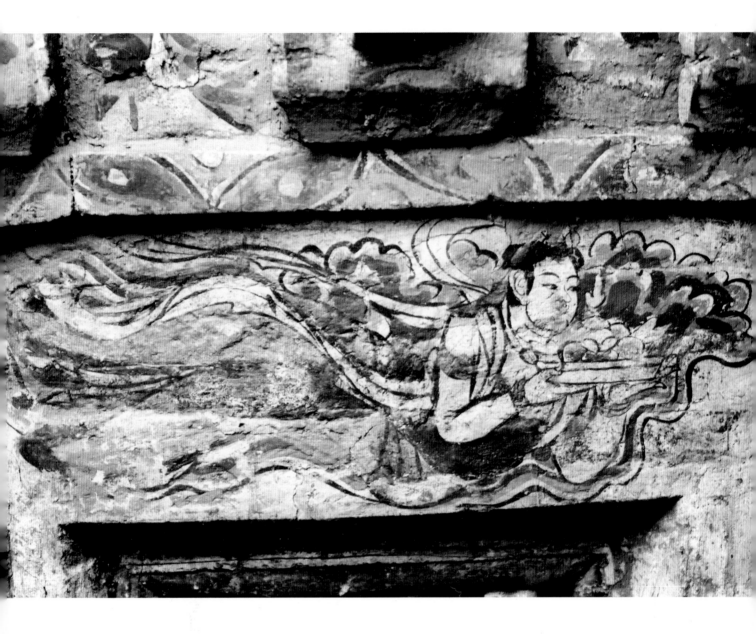

109. 飞天图

北宋元丰元年（1078年）

高约40、宽约72厘米

1988年山西省长治市北郊故县村北宋墓出土。已残毁。

墓向180°。位于墓室东壁上层中部。飞天，女性模样，双手端一盘宝物，俯身飞翔在祥云之间；造型丰满，颇具晚唐五代的画风。

<div align="right">（撰文、摄影：王进先）</div>

Flying Apsaras

1st Year of Yuanfeng Era, Northern Song (1078 CE)

Height ca. 40 cm; Width ca. 72 cm

Unearthed from Northern Song tomb at Guxiancun in northern suburbs of Changzhi, Shanxi, in 1988. Not preserved.

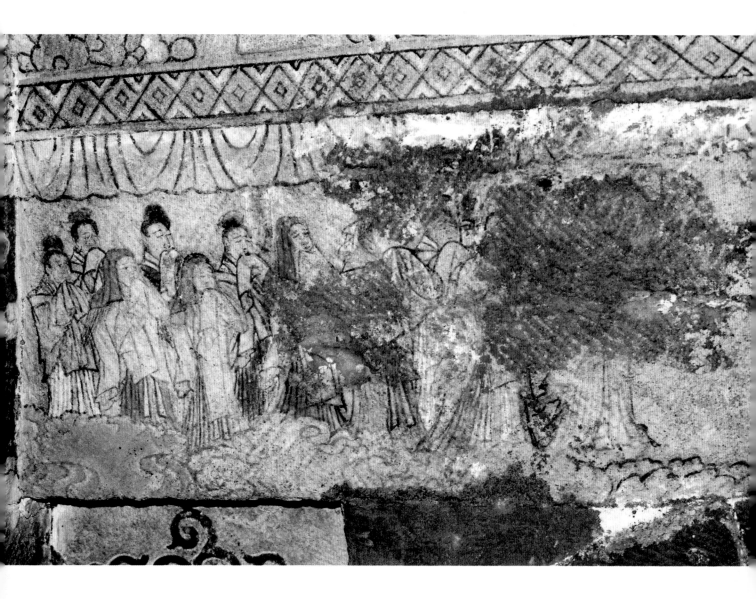

110. 送葬图（一）

北宋元祐三年（1088年）

高约46、宽约74厘米

1999年山西省长治市北郊西白兔村宋墓出土。已残毁。

墓向182°。位于墓室南壁墓门之上。左半段有众孝子披麻戴孝，皆呈掩面哭泣状。

（撰文、摄影：王进先 李永杰）

Funeral Ceremony (1)

3rd Year of Yuanyou Era, Northern Song (1088 CE)

Height ca. 46 cm; Width ca. 74 cm

Unearthed from Northern Song tomb at Xibaitucun in northern suburbs of Changzhi, Shanxi, in 1999. Not preserved.

111.送葬图（二）

北宋元祐三年（1088年）

高约46、宽约80厘米

1999年山西省长治市北郊西白兔村宋墓出土。已残毁。

墓向182°。位于墓室南壁墓门之上。右半段为骑马自远方而来的奔丧人，从骑马人的服饰看，还保留有少数民族的特征。

（撰文、摄影：王进先 李永杰）

Funeral Ceremony (2)

3rd Year of Yuanyou Era, Northern Song (1088 CE)

Height ca. 46 cm; Width ca. 80 cm

Unearthed from Northern Song tomb at Xibaitucun in northern suburbs of Changzhi, Shanxi, in 1999. Not preserved.

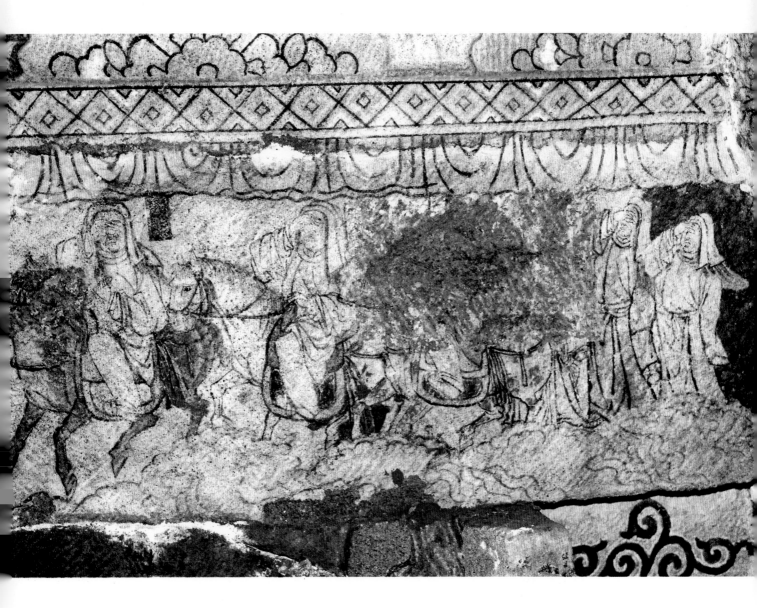

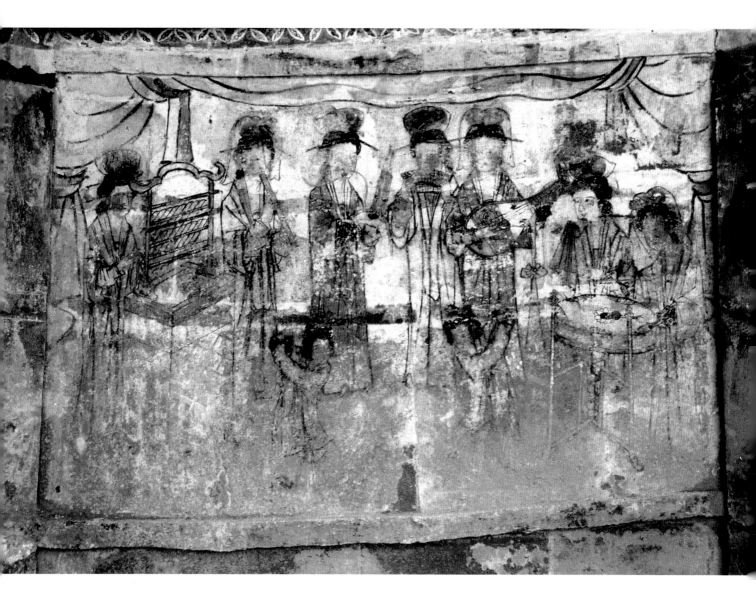

112.伎乐图

北宋（960～1127年）

高约78、宽约121厘米

1991年山西省平定县城关镇姜家沟村北宋墓出土。现存于山西博物院。

墓向172°。位于墓室东南柱间壁。墓壁上方帷帐，正面排列七名奏乐女子，皆梳包髻、罩罗纱，身穿对襟长衫、长裙。自左至右，左起第一人敲击"方响"，以下依次为觱篥、笙、排箫、琵琶、拍板、大鼓。前面有两名女童舞旋，绞袖高举，抬足趋步，相对起舞。

（撰文、摄影：李舍元）

Music and Dancing Performance

Northern Song (960-1127 CE)

Height ca. 78 cm; Width ca. 121 cm

Unearthed from Northern Song tomb at Jiangjiagoucun, Chengguanzhen in Pingding, Shanxi, in 1991. Preserved in Shanxi Museum.

113.北壁图

北宋（960～1127年）

高约286、宽约120厘米

1991年山西省平定县城关镇姜家沟村北宋墓出土。已残毁。

墓向172°。墓室北壁。墓壁正中砖雕一格扇门（假门），其左侧已坍塌，其右侧遗留一侍女，手持鹊尾香炉。

（撰文、摄影：李舍元）

North Wall of Tomb Chamber

Northern Song (960-1127 CE)

Height ca. 286 cm; Width ca. 120 cm

Unearthed from Northern Song tomb at Jiangjiagoucun, Chengguanzhen in Pingding, Shanxi, in 1991. Not preserved.

114.侍女图

北宋（960～1127年）

高约60、宽约24厘米

1991年山西省平定县城关镇姜家沟村北宋墓出土。已残毁。墓向172°。位于墓室北壁东侧。女子向左侧身站立，梳圆髻，身穿交领广袖长袍，双手平端一长柄鹊尾香炉。

（撰文、摄影：李舍元）

Maid

Northern Song (960-1127 CE)

Height ca. 60 cm; Width ca. 24 cm

Unearthed from Northern Song tomb at Jiangjiagoucun, Chengguanzhen in Pingding, Shanxi, in 1991. Not preserved.

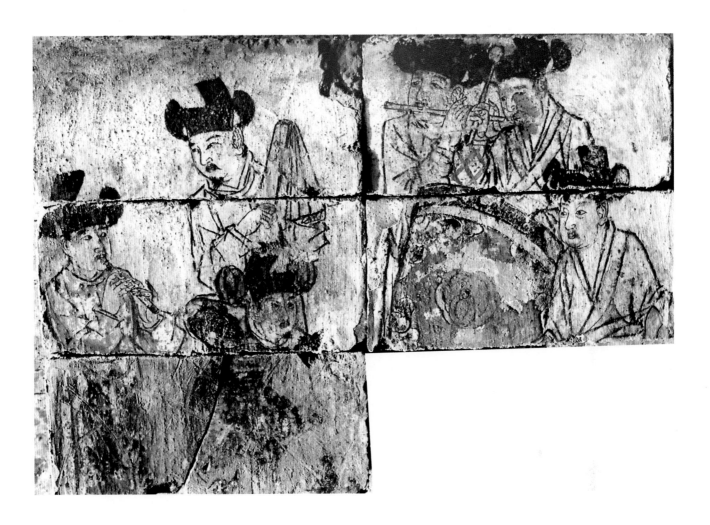

115. 伎乐图（局部）

北宋（960～1127年）

高约37、宽约49厘米

1991年山西省平定县城关镇姜家沟村北宋墓出土。现存于平定县文管所。

墓向172°。位于墓室西南柱间壁。此画面为采集、拼凑而成。错落排列五名奏乐男子及一名舞旋男子；均头戴朝天幞头，圆领或交领窄袖衫。左起第一人吹觱篥，第二人举拍板，第三人吹横笛，第四人握棰击大鼓，第五人拍腰鼓。

（撰文、摄影：商彤流）

Music and Dancing Performance (Detail)

Northern Song (960-1127 CE)

Height ca. 37 cm; Width ca. 49 cm

Unearthed from Northern Song tomb at Jiangjiagoucun,Chengguanzhen in Pingding, Shanxi, in 1991. Preserved in Administration of cultural Relics in Pingding.

116.灯檠侍女图

辽乾亨四年（982年）

高约133、宽约90厘米

1984年山西省大同市南郊新添堡村辽代许从赟墓出土。原址保存。
墓向188°。位于墓室西南壁。左侧一砖雕的灯檠，三叉形灯架顶端上
各置一件灯盏，并画出灯芯燃烧状。右侧站立一侍女，头梳高髻，身穿
交领广袖袄、长裙；左手执一碗，右手持一勺，正在往灯盏里添油。

（撰文：王利民　摄影：张焖）

Maid Adding Oil to Lamp

4th Year of Qianheng Era, Liao (982 CE)
Height ca. 133 cm; Width ca. 90 cm
Unearthed from Liao Xu Congyun's tomb
at Xintianbucun in southern suburbs of
Datong, Shanxi, in 1984, Preserved on
the original site.

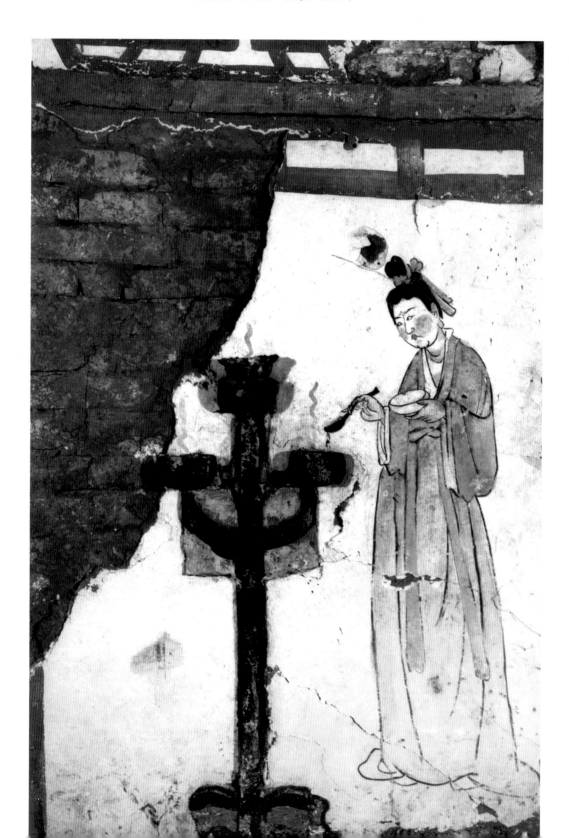

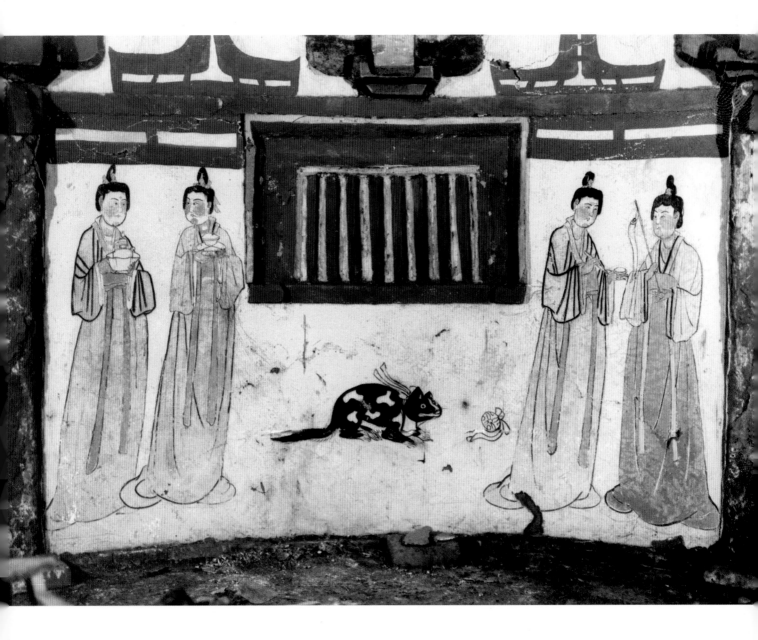

117.侍奉图

辽乾亨四年（982年）

高约133、宽约218厘米

1984年山西省大同市南郊新添堡村辽代许从赟墓出土。原址保存。

墓向188°。位于墓室东北柱间壁。墓壁中央为砖雕破子棂窗，两侧各站立两名侍女；窗下一白黑花猫正欲扑捉绣球。左侧两女子，左起一人捧一带温碗的柱子；第二人捧一托盏，是为奉茶图。右侧两女子，左起一人持一小香匙，托一鹊尾香炉；第二人持拂子，似为奉香图。

（撰文：王利民　摄影：张炤）

Attending Maids

4th Year of Qianheng Era, Liao (982 CE)

Height ca. 133 cm; Width ca. 218 cm

Unearthed from Liao Xu Congyun's tomb at Xintianbucun in southern suburbs of Datong, Shanxi, in 1984, Preserved on the original site.

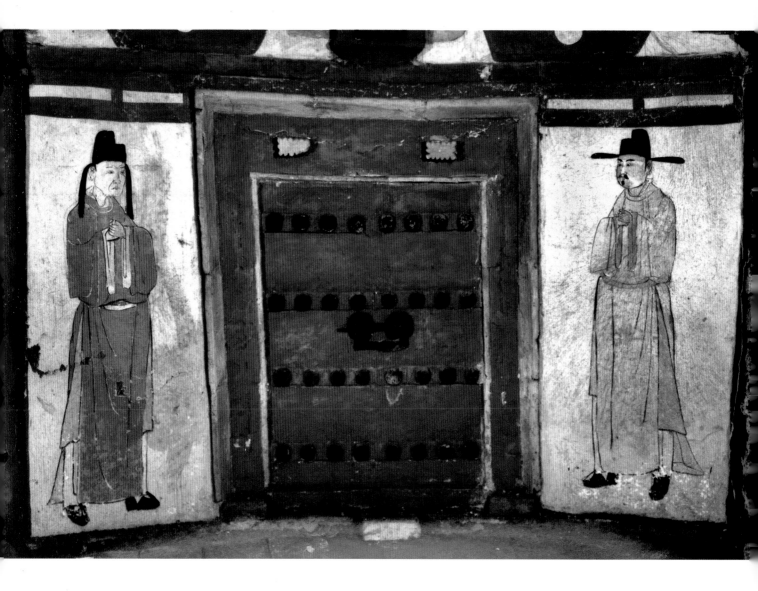

118.门吏图

辽乾亨四年（982年）

高约133、宽约213厘米

1984年山西省大同市南郊新添堡村辽代许从赟墓出土。原址保存。

墓向188°。位于墓室北面柱间壁。墓壁中央为砖雕板门，有门钉、长锁；两侧各站立一名男侍，表情严肃，均身着圆领广袖长袍，行叉手礼。画面右侧男侍头戴展脚幞头，左侧男侍头戴软脚幞头。似为文职幕僚。

（撰文：王利民　摄影：张炤）

Petty Officials

4th Year of Qianheng Era, Liao (982 CE)

Height ca. 133 cm; Width ca. 213 cm

Unearthed from Liao Xu Congyun's tomb at Xintianbucun in southern suburbs of Datong, Shanxi, in 1984, Preserved on the original site.

119. 侍奉图

辽（907～1125年）

高约95、宽约75厘米

2004年山西省大同市机床厂住宅区辽墓出土。现存于大同市考古研究所。

墓向170°。位于墓室西北柱间壁上。两人一组，左侧一男侍，髡发，着圆领窄袖长袍，题记"牛哥"，双手抱一绛红色包袱；右侧一女侍，梳双髻，着圆领窄袖长袍，题记"大喜子"，双手捧一盘口壶。

（撰文：刘俊喜 摄影：高峰）

Attending Servant and Maid

Liao (907-1125 CE)

Height ca. 95 cm; Width ca. 75 cm

Unearthed from Liao tomb at dwelling area of machine Tool Factory in Datong, Shanxi, in 2004. Preserved in the institute of Archeology in Datong.

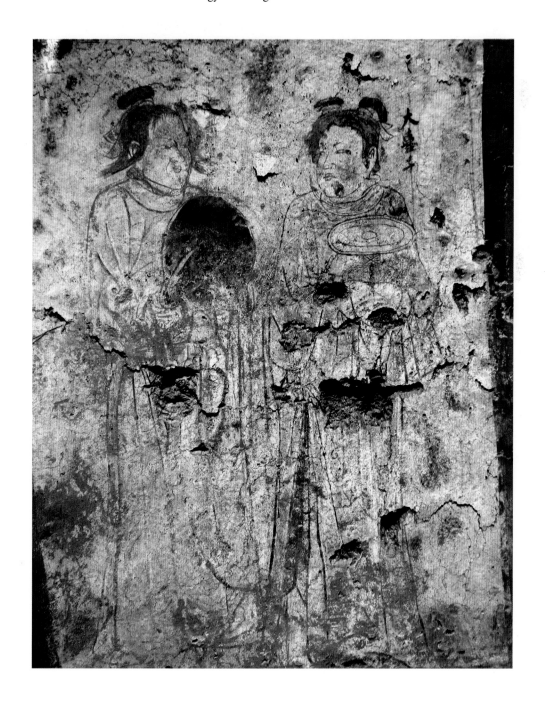

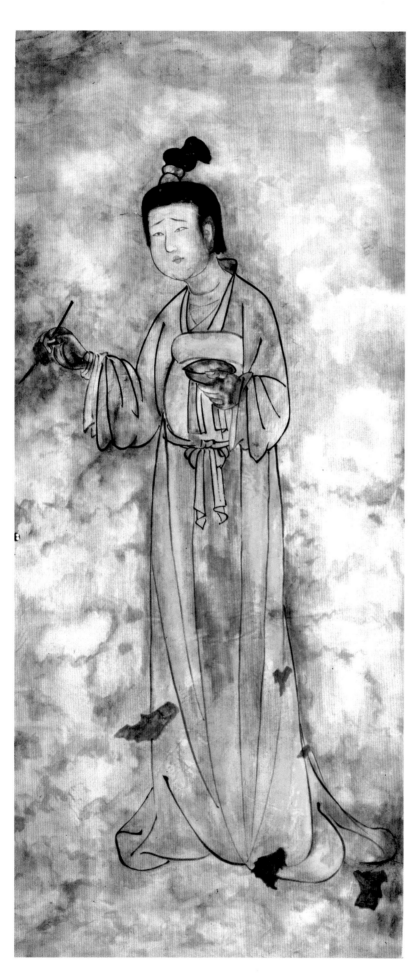

120.灯檠侍女图（摹本）

辽（907～1125年）

高约215、宽约107厘米

1985年山西省大同市纸箱厂辽墓出土。已残
毁。

墓向187°。位于墓室西南壁。一侍女，头顶
挽螺髻，身穿交领广袖上袄、长裙；托一小
碗，持一小匙，正在为身旁一灯檠添油。

（临摹：龚森浩　撰文：王利民　摄影：张焰）

Maid Adding Oil to Lamp (Replica)

Liao (907-1125 CE)

Height ca. 215 cm; Width ca. 107 cm

Unearthed from Liao tomb at Carton Factory in
Datong, Shanxi, in 1985. Not preserved.

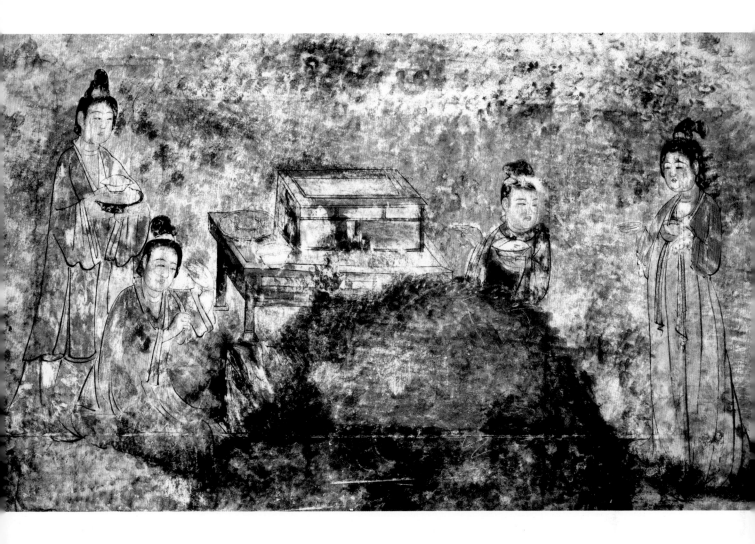

121.备茶图（摹本）

辽（907~1125年）

高约126、宽约246厘米

1985年山西省大同市纸箱厂辽墓出土。已残毁。

墓向187°。位于墓室东南壁。中间一方桌，摆放一箧筍、盏把、盏。左侧一侍女端一托盏，一侍女跪坐，右手持一物，面前似有一火盆，似在备汤。其右侧站立二侍女，一侍女端一大碗，一侍女捧一小盘。

（临摹：龚森浩　撰文：王利民　摄影：张炤）

Preparing for Tea Reception (Replica)

Liao (907-1125 CE)

Height ca. 126 cm; Width ca. 246 cm

Unearthed from Liao tomb at Carton Factory in Datong, Shanxi, in 1985. Not preserved.

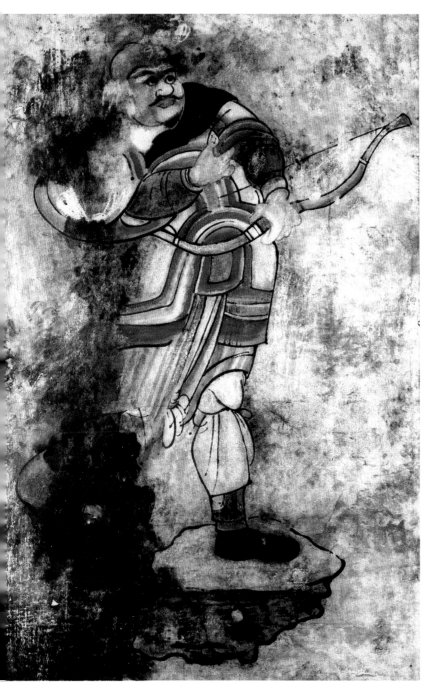

122.镇墓武士图（摹本）

辽（907～1125年）

高约170、宽约90厘米

1985年山西省大同市纸箱厂辽墓出土。已残毁。

墓向187°。位于墓室南壁门洞两侧。左侧一戎装武士，左手持一弓，右手伸指欲拉弦；右侧一甲胄武士，右手握一长剑，左手握拳。人物体态魁伟，皆站立在一块大石之上，面向墓门甬道。

（临摹：龚森浩　撰文：王利民　摄影：张炤）

Tomb Guardians (Replica)

Liao (907-1125 CE)

Height ca. 170 cm; Width ca. 90 cm

Unearthed from Liao tomb at Carton Factory in Datong, Shanxi, in 1985. Not preserved.

123. 驼车图

辽（907～1125年）

高约102、宽约160厘米

2006年山西省大同市铁路生活区辽墓出土。已残毁。

墓向180°。位于墓室东南壁，靠甬道处。一名御者，牵引一匹双峰骆驼拉着的二辕轿车向画面右方行进；车旁有一人跟随。

（撰文：曹臣明　摄影：焦强）

Camel Cart

Liao (907-1125 CE)

Height ca. 102 cm; Width ca. 160 cm

Unearthed from Liao tomb at railway dwelling area in Datong, Shanxi, in 2006. Not preserved.

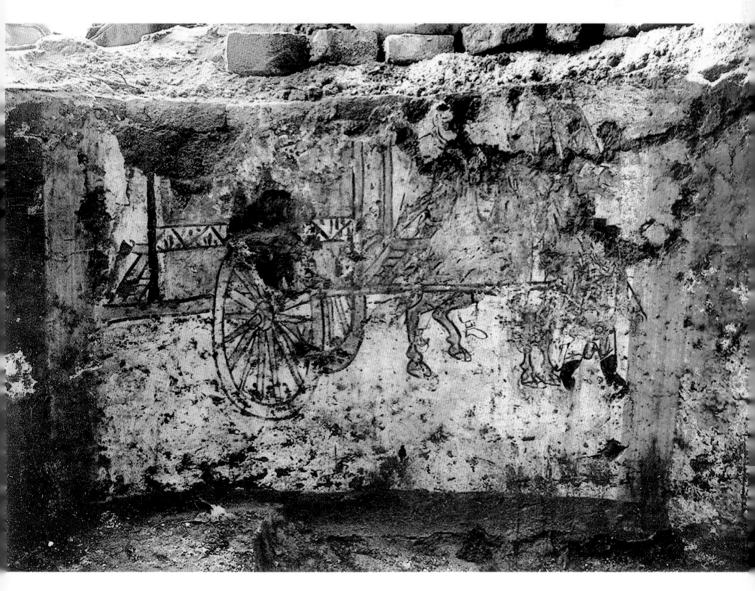

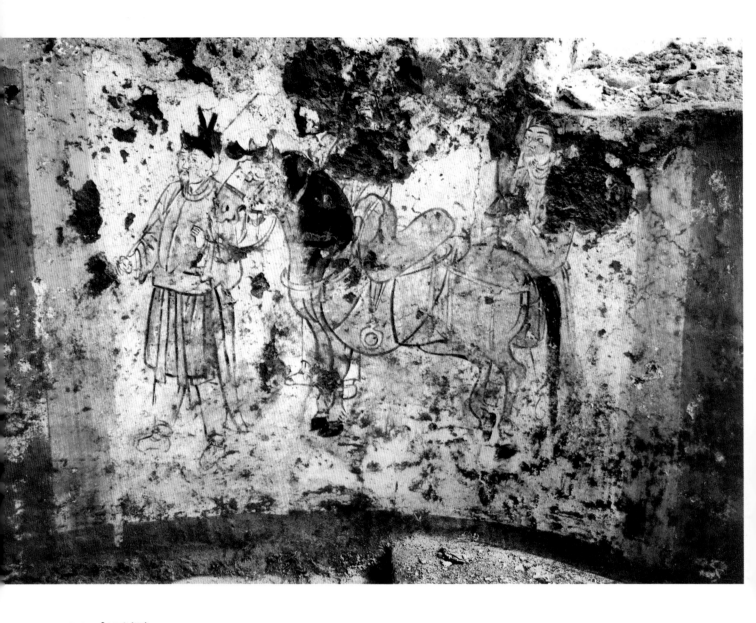

124.牵马图

辽（907~1125年）

高约120、宽约160厘米

2006年山西省大同市铁路生活区辽墓出土。已残毁。

墓向180°。位于墓室西南壁，靠甬道处。一名牵马人，头戴交脚幞头，着圆领窄袖袍，面向墓外，右手执一长鞭，左手牵引一匹鞍马，鞍鞯俱备；鞍马的后面还有两名男侍。

（撰文：曹臣明　摄影：焦强）

Saddled Horse, Groom and Servants

Liao (907-1125 CE)

Height ca. 120 cm; Width ca. 160 cm

Unearthed from Liao tomb at railway dwelling area in Datong, Shanxi, in 2006. Not preserved.

125.鞍马图

辽（907～1125年）

高约72、宽约36厘米

1991年山西省朔州市市政府工地辽墓出土。已残毁。

墓向95°。位于墓室东壁甬道北侧。一男子头戴黑色蹼头，身穿圆领广袖白色长袍，正襟危坐在一匹红色的鞍马上，面向墓外，款款而行。

（撰文、摄影：雷云贵）

Riding Man

Liao (907-1125 CE)

Height ca. 72 cm; Width ca. 36 cm

Unearthed from Liao tomb at building site of Shuozhou municipal government in Shanxi, in 1991. Not preserved.

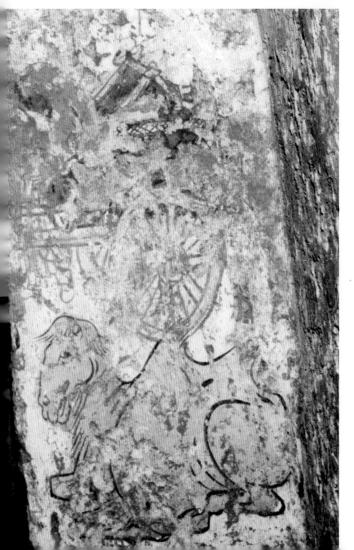

126.驼车图

辽（907～1125年）

高约72、宽约36厘米

1991年山西省朔州市市政府工地辽墓出土。已残毁。

墓向95°。位于墓室东壁甬道南侧。一辆硬山式顶的二辕轿车，其旁站立一名御者；下方蜷卧着一匹黄色的双峰骆驼。表现驼车栖息的场景。

（撰文、摄影：雷云贵）

Resting Camel and Cart

Liao (907-1125 CE)

Height ca. 72 cm; Width ca. 36 cm

Unearthed from Liao tomb at building site of Shuozhou municipal government in Shanxi, in 1991. Not preserved.

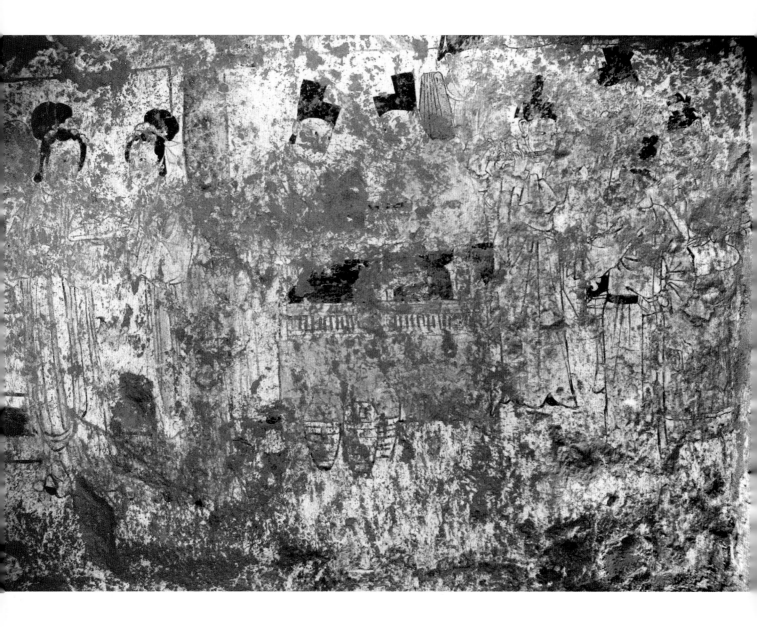

127. 备酒、伎乐图

辽（907～1125年）

高约72、宽约110厘米

1991年山西省朔州市市政府工地辽墓出土。已残毁。

墓向95°。位于墓室北壁。左侧站立两名侍女，一人持纨扇，一人端托盘；右侧一围幔高桌前放置三只酒瓶，桌后站立两名男仆正欲备酒，为备酒场景。画面右侧前方有一人正在舞蹈，后有四名演奏的乐人，分别为拍板、横笛、觱篥和大鼓，表现乐舞场景。

（撰文、摄影：雷云贵）

Banquet Preparation and Music and Dancing Performance

Liao (907-1125 CE)

Height ca. 72 cm; Width ca. 110 cm

Unearthed from Liao tomb at building site of Shuozhou municipal government in Shanxi, in 1991. Not preserved.

128.祭奠图

辽（907～1125年）

高约72、宽约110厘米

1991年山西省朔州市市政府工地辽墓出土。已残毁。

墓向95°。位于墓室西壁（后壁）。上方为黄色阑额、其下为蓝色帷幔；下方一围幔横台上摆放着六个壸门形的围屏，下侧为横贯画面的棺床，棺床两侧各站立两名头戴幞头、持物奉祀的人物。

（撰文、摄影：雷云贵）

Memorial Ceremony

Liao (907-1125 CE)

Height ca. 72 cm; Width ca. 110 cm

Unearthed from Liao tomb at building site of Shuozhou municipal government in Shanxi, in 1991. Not preserved.

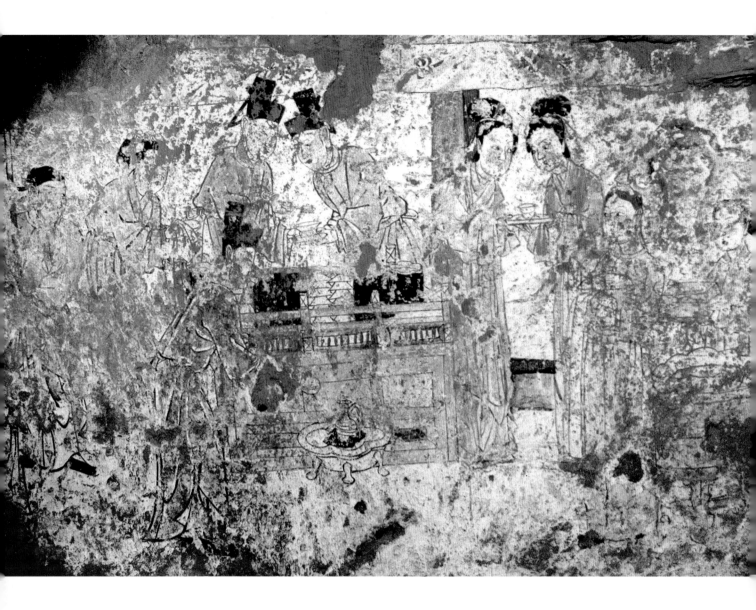

129.备茶图

辽（907～1125年）

高约72、宽约110厘米

1991年山西省朔州市市政府工地辽墓出土。已残毁。

墓向95°。位于墓室南壁。上方为额枋，左侧五名侍仆围绕在桌旁忙碌，桌前一人在风炉旁煎汤，桌后二人分别持渣斗、盏托，桌上置托盏、茶碾，其左侧二人奉递方盒、盏托。右侧两名侍女正在点茶，旁边还站立一名髡发的男童、一名梳髻捧持茶盏的女童。

（撰文、摄影：雷云贵）

Tea Serving Scene

Liao (907-1125 CE)

Height ca. 72 cm; Width ca. 110 cm

Unearthed from Liao tomb at building site of Shuozhou municipal government in Shanxi, in 1991. Not preserved.

130.门神、鞍马图

金天会十三年（1135年）

高约55、宽约70厘米

1999年山西省屯留县李高乡宋村金墓出土。已残毁。

墓向180°。位于墓室南壁墓门右侧。门神有背光，头戴盔、身穿甲，面向墓门为坐像。其右侧还有一人，头戴幞头，身穿袍服，牵马以待侍。其间有犁耧、滚碾等农具。

（撰文、摄影：杨林中）

Door God, Saddled Horse and Groom

13th Year of Tianhui Era, Jin (1135 CE)

Height ca. 55 cm; Width ca. 70 cm

Unearthed from Jin tomb at Songcun, Ligaoxiang in Tunliu, Shanxi, in 1999. Not preserverd.

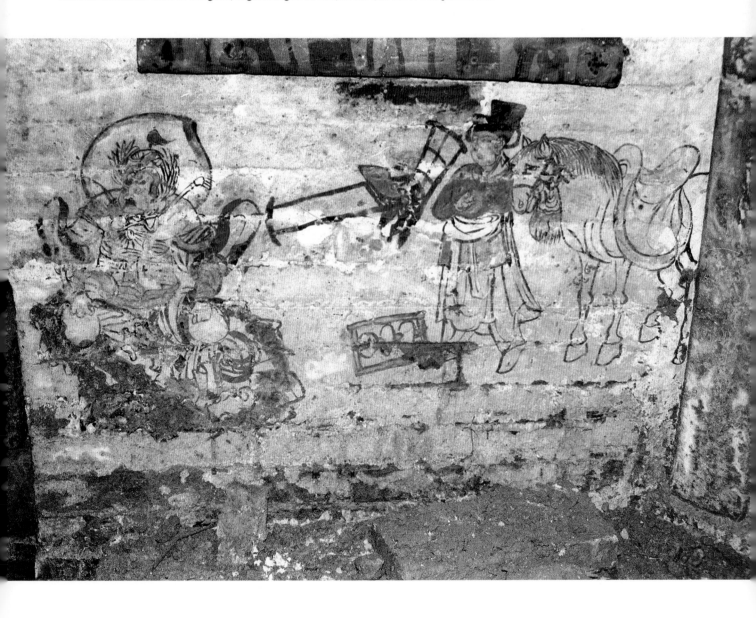

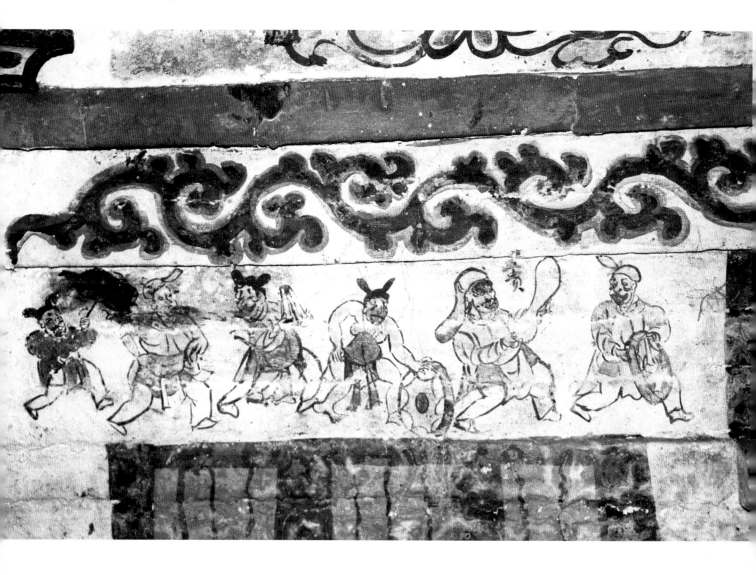

131.杂剧图（一）

金天会十三年（1135年）

高约27、宽约75厘米

1999年山西省屯留县李高乡宋村金墓出土。已残毁。

墓向180°。位于墓室南壁上方左侧。右起第一人，头裹扎巾，持一盘状物；第二人头戴风帽，握皮棒槌，榜题："王贵"；第三人头梳丫髻，涂丑妆，着肚兜，推滚一圆环状物；第四人头扎丫髻，涂丑妆，持拍板；第五人身穿袍服，软巾混裹，舞蹈样；第六人头梳丫髻，涂丑妆，持一伞盖。为杂剧作场场景。

（撰文、摄影：杨林中　王进先）

Drama Performance Scene (1)

13th Year of Tianhui Era, Jin (1135 CE)

Height ca. 27 cm; Width ca. 75 cm

Unearthed from Jin tomb at Songcun, Ligaoxiang in Tunliu, Shanxi, in 1999. Not preserverd.

132.杂剧图（二）

金天会十三年（1135年）

高约27、宽约75厘米

1999年山西省屯留县李高乡宋村金墓出土。已残毁。

墓向180°。位于墓室南壁上方右侧。左起第一人，软巾混裹，持一盘状物；第二人着风帽，握皮棒槌，身后墨书榜题"王贵"；第三人亦软巾混裹，肩扛一方形道具；第四人头戴展脚幞头，身穿袍服，持一团扇；第五人为女子，头顶风帽，身穿褙子，下着裙，持一团扇；第六人头梳丫髻，持一伞盖。正在作场。

（撰文、摄影：杨林中　王进先）

Drama Performance Scene (2)

13th Year of Tianhui Era, Jin (1135 CE)

Height ca. 27 cm; Width ca. 75 cm

Unearthed from Jin tomb at Songcun, Ligaoxiang in Tunliu, Shanxi, in 1999. Not preserverd.

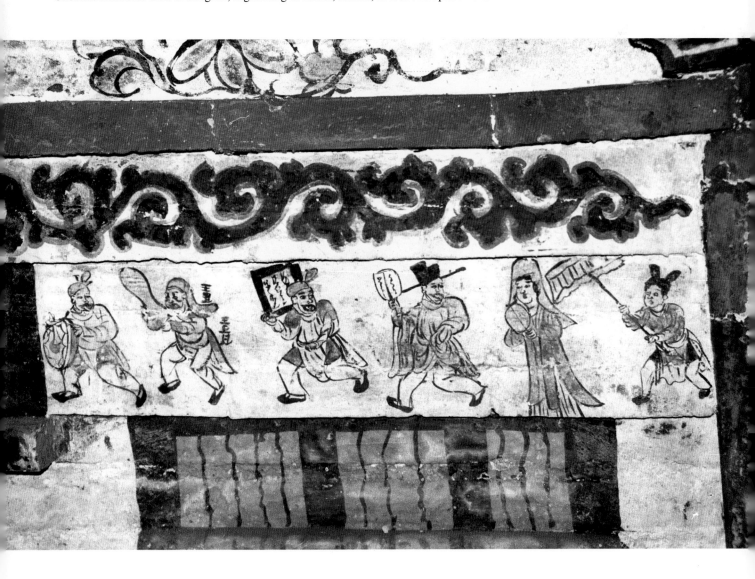

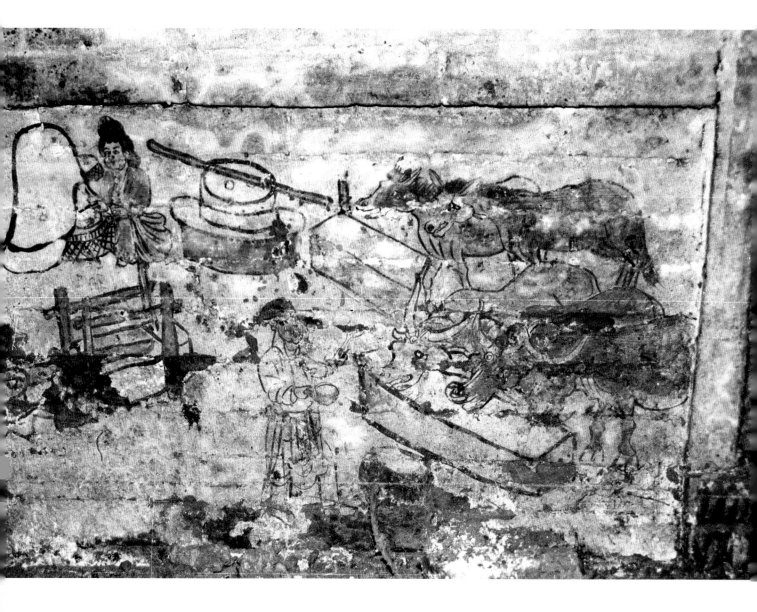

133.劳作图

金天会十三年（1135年）

高约45、宽约57厘米

1999年山西省屯留县李高乡宋村金墓出土。已残毁。

墓向180°。位于墓室西壁左侧。左上方一妇人坐在地上，持箕筐米状，旁有磨盘。右下方为马厩，有二牛二马正在吃料；一男子手持水瓢，站立于料槽前。

<div align="right">（撰文、摄影：杨林中）</div>

Winnowing Grains and Feeding Livestock

13th Year of Tianhui Era, Jin (1135 CE)

Height ca. 45 cm; Width ca. 57 cm

Unearthed from Jin tomb at Songcun, Ligaoxiang in Tunliu, Shanxi, in 1999. Not preserverd.

134.升仙图

金贞元元年（1153年）

高约51、宽约64厘米

1965年山西省长治市东郊南垂村金墓出土。已残毁。

墓向198°。位于墓室南壁墓门上部。梁桥下江水翻腾，有人在水中挣扎。桥左前部有众僧尼，手持钹；桥中部有众仙持幡或捧物；桥右后部有墓主人和捧物侍女。表现通过升仙桥升仙的场景。

<div align="right">（撰文、摄影：王进先）</div>

Ascending Fairyland

1st Year of Zhenyuan Era, Jin (1153 CE)

Height ca. 51 cm; Width ca. 64 cm

Unearthed from Jin tomb at Nanchuicun in eastern suburbs of Changzhi, Shanxi, in 1965. Not preserved.

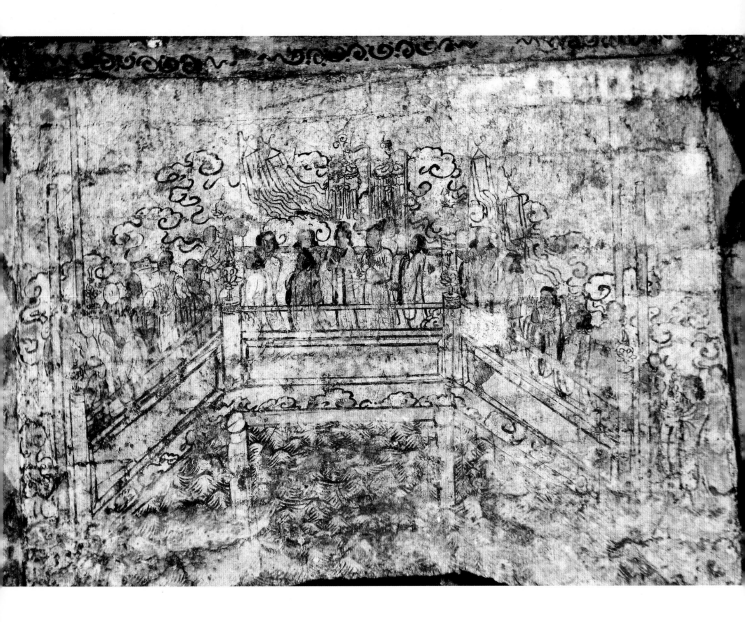

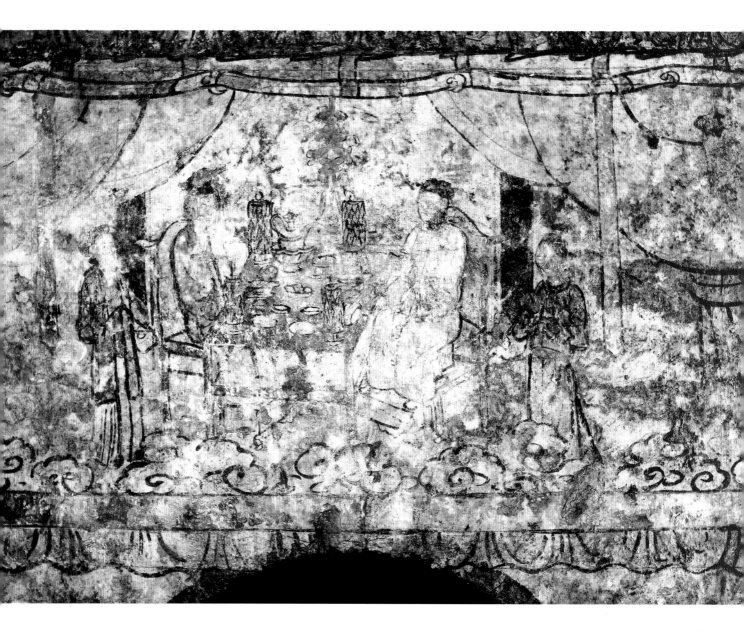

135. 夫妇对坐图

金贞元元年（1153年）

高约51、宽约64厘米

1965年山西省长治市东郊南垂村金墓出土。已残毁。

墓向198°。位于墓室北壁。夫妇二人对坐于高桌的两侧，桌上摆放各式餐具，另有两仆侍分立男女主人两侧，拱手待侍状。

（撰文、摄影：王进先）

Tomb Occupant Couple Seated Beside the Table

1st Year of Zhenyuan Era, Jin (1153 CE)

Height ca. 51 cm; Width ca. 64 cm

Unearthed from Jin tomb at Nanchuicun in eastern suburbs of Changzhi, Shanxi, in 1965. Not preserved.

136.门侍图

金正隆二年（1157年）

高约150、宽约65厘米

1988年山西省大同市南郊（云中大学）2号金墓出土。已残毁。

墓向185°。位于墓室南壁甬道口西侧。一男侍，双手合十，面向墓门站立。头顶髡发，身穿交领广袖长袍，肩披长帛，其内袍下摆曳地。

（撰文：曹臣明　摄影：王银田）

Attendant

2nd Year of Zhenglong Era, Jin (1157 CE)

Height ca. 150 cm; Width ca. 65 cm

Unearthed from Jin Tomb M2 at southern subrubs (Yunzhong University) of Datong in Shanxi, in 1988. Not preserved.

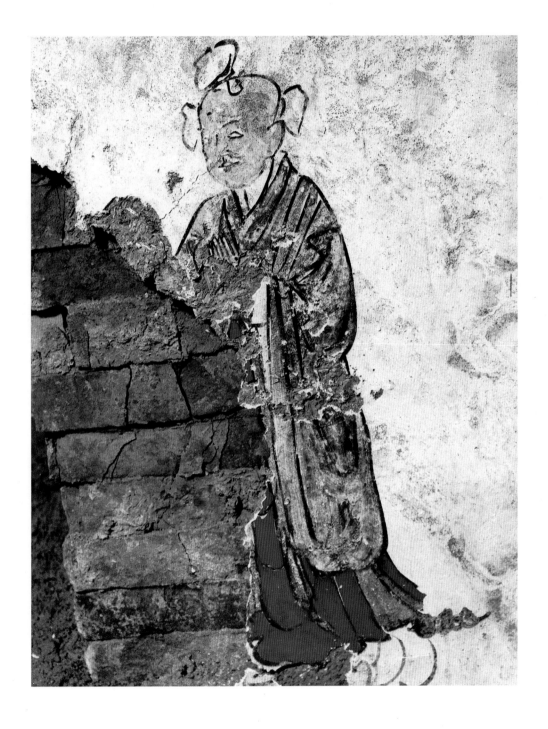

137. 男侍图

金正隆二年（1157年）

高约150、宽约60厘米

1988年山西省大同市南郊（云中大学）2号金墓出土。已残毁。

墓向185°。位于墓室北壁东侧。北壁上有帷幔，下有窗户，坎墙上点缀花卉，两侧分别站立一男侍。此图为右侧男侍，髡发，身穿圆领窄袖长袍，腰系革带，双手拢袖拱于胸前。

（撰文：曹臣明　摄影：王银田）

Servant

2nd Year of Zhenglong Era, Jin (1157 CE)

Height ca. 150 cm; Width ca. 60 cm

Unearthed from Jin Tomb M2 at southern subrubs (Yunzhang University) of Datong in Shanxi, in 1988. Not preserved.

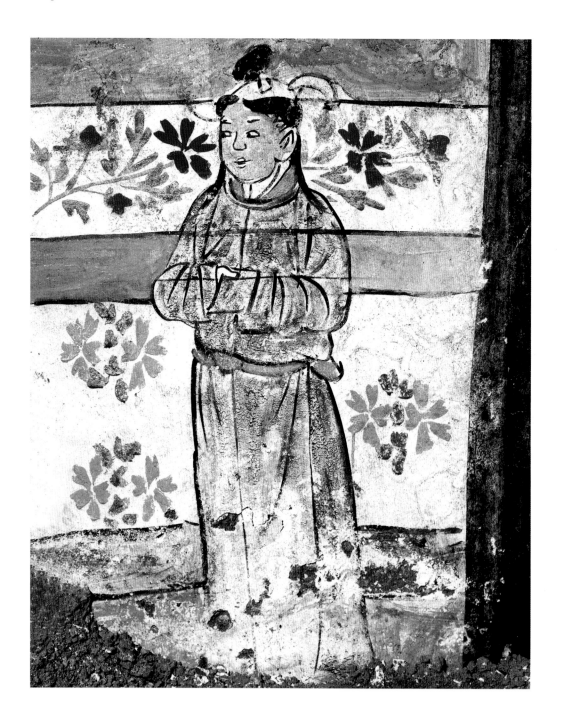

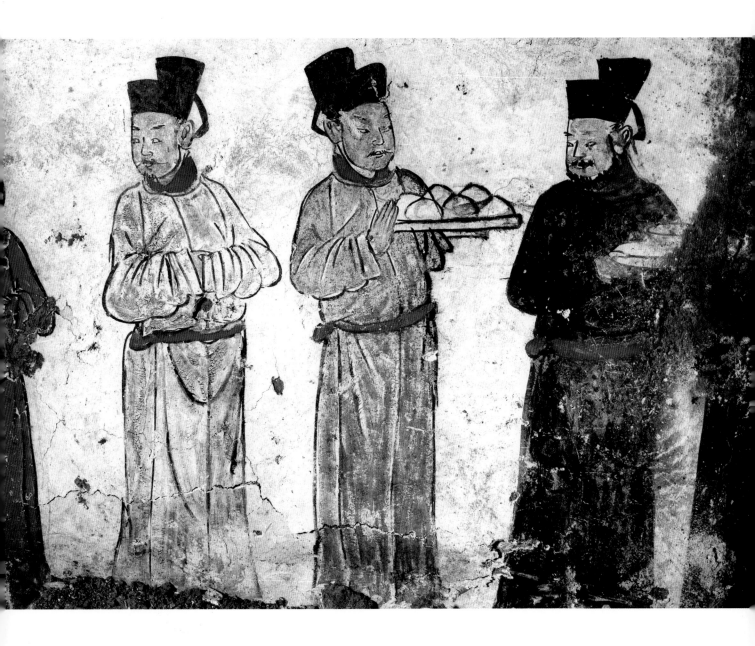

138. 侍宴图

金正隆二年（1157年）

高约150、宽约135厘米

1988年山西省大同市南郊（云中大学）2号金墓出土。已残毁。

墓向185°。位于墓室西壁北侧。西壁为侍宴场面，横向站立八名男侍以及摆放食物的高桌。此图是其右侧的三名侍者，均头戴交脚幞头，圆领窄袖长袍，左侧一人抄手站立；中间一人端一食盘，右侧一人端一劝盏。

（撰文：曹臣明　摄影：王银田）

Feast Waiters

2nd Year of Zhenglong Era, Jin (1157 CE)

Height ca. 150 cm; Width ca. 135 cm

Unearthed from Jin Tomb M2 at southern subrubs (Yunzhang University) of Datong in Shanxi, in 1988. Not preserved.

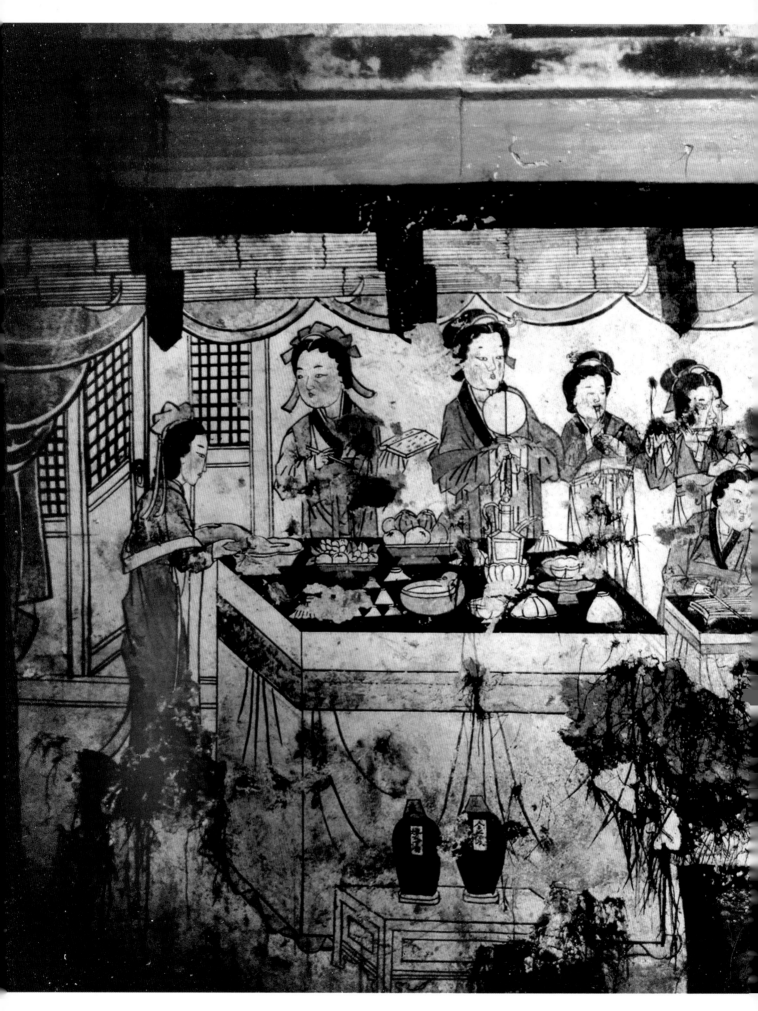

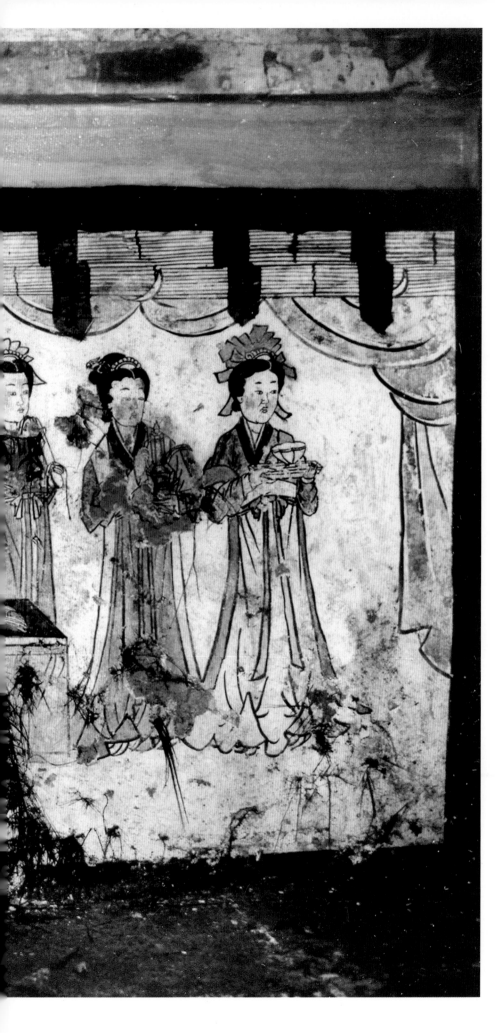

139. 奉酒散乐图

金正隆六年（1161年）

高约105、宽约168厘米

1990年山西省大同市徐龟墓出土。已残毁。

墓向180°。位于墓室西壁。上方一道竹帘、帷幔，左边格窗门扇。当间一高桌，摆放果盘、盆或注碗、台盏等，桌前有二酒瓶；其左侧一侍女，捧一深腹瓶正在注酒；桌后有二侍女，一人执簿册记录，一人拿一团扇。高桌右侧一女子抚筝，还有手持觱篥、横笛、拍板的三名女乐伎。另有二侍女，一人持一注壶、注碗，一人捧劝盏。

（撰文：王利民　摄影：张炤）

Feast Waitresses and Music Band

6th Year of Zhenglong Era, Jin (1161 CE)
Height ca. 105 cm; Width ca. 168 cm
Unearthed from Xu Gui's tomb in Datong, shanxi, in 1990. Not preserved.

140. 奉茶图

金正隆六年（1161年）

高约105、宽约80厘米

1990年山西省大同市徐龟墓出土。已残毁。

墓向180°。位于墓室东壁北侧。画面上方一道竹帘、帷幔，一侍女头梳圆髻，上身穿交领窄袖袄、下着曳地长裙，双手捧一茶盏。其右侧已毁，尚现有一侍女，手执注壶点茶。

（撰文：王利民　摄影：张焔）

Tea Waitress

6th Year of Zhenglong Era, Jin (1161 CE)

Height ca. 105 cm; Width ca. 80 cm

Unearthed from Xu Gui's tomb in Datong, shanxi, in 1990. Not preserved.

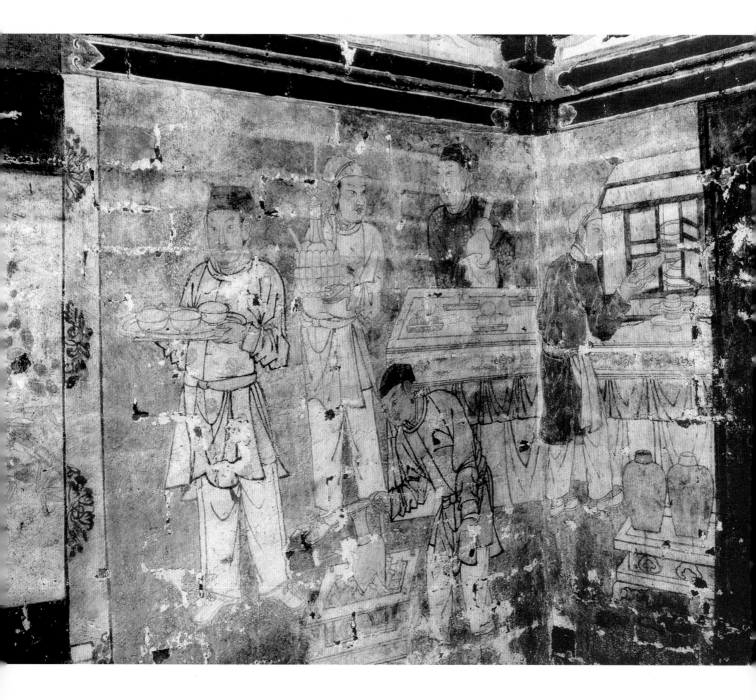

141. 奉茶进酒图

金大定九年（1169年）

高约140厘米

2007年山西省陵川县附城镇玉泉村金墓出土。原址保存。

墓向180°。位于墓室东南角。左起第一人持劝盘，上置酒盏；第二人持带温碗的注壶；下一人在炭炉上煎汤。后面着黑衫者持胆瓶（酒瓶），最后一人正从箱柜中取盏托，下面为两个带座酒瓶。

（撰文：商彤流　摄影：李建生）

Preparing Tea and Wine

9th Year of Dading Era, Jin (1169 CE)

Height ca. 140 cm

Unearthed from Jin tomb at Yuquancun, Fuchengzhen in Lingchuan, Shanxi, in 2007. Preserved on the original site.

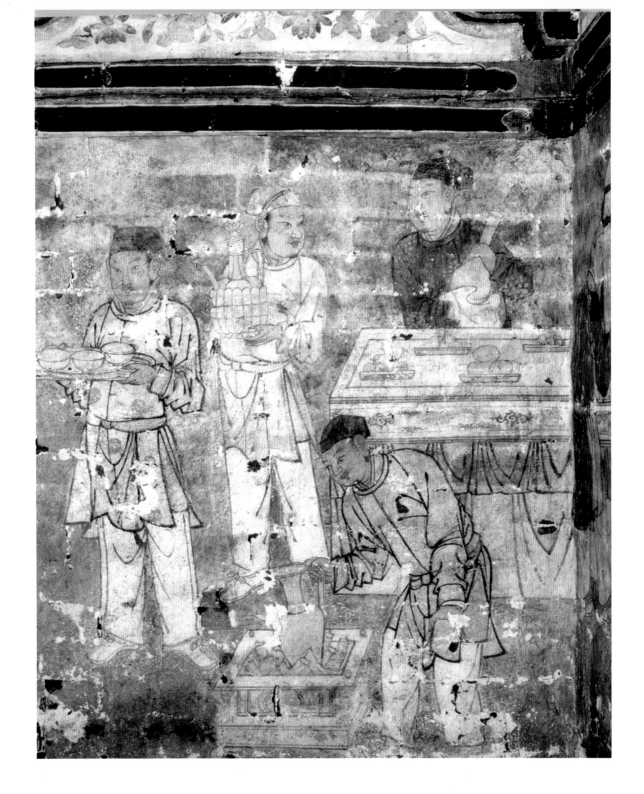

142. 奉茶进酒图（局部一）

金大定九年（1169年）

高约140、宽约103厘米

2007年山西省陵川县附城镇玉泉村金墓出土。原址保存。

墓向180°。位于墓室东壁南侧。左前一男仆，恭敬站立，端
一劝盘三酒盏；右侧下方一男仆，左手撑膝，右手执一壶伸
向塘炉。在一围幔的高桌后面，站立着两男仆，左者捧着带
温碗的注壶，回顾右方；右者左手握着长颈瓶、右手以抹巾
托着瓶底，正在与前者说话。

（撰文：商彤流　摄影：李建生）

Preparing Tea and wine (Detail 1)

9th Year of Dading Era, Jin (1169 CE)
Height ca. 140 cm; Width ca. 103 cm
Unearthed from Jin tomb at Yuquancun,
Fuchengzhen in Lingchuan, Shanxi, in
2007. Preserved on the original site.

143.奉茶进酒图（局部二）

金大定九年（1169年）

高约140、宽约43厘米

2007年山西省陵川县附城镇玉泉村金墓出土。原址保存。墓向180°。位于墓室南甬道口东侧。一男仆，侧背身站立在一摆放着盏托的高桌之前，正将一副盏托从桌案右侧一橱柜里取出；高桌前下方一方形束腰矮桌，放置两个耸肩的圆酒罈。

（撰文：商彤流　摄影：李建生）

Preparing Tea and Wine (Detail 2)

9th Year of Dading Era, Jin (1169 CE)

Height ca. 140 cm; Width ca. 43 cm

Unearthed from Jin tomb at Yuquancun, Fuchengzhen in Lingchuan, Shanxi, in 2007. Preserved on the original site.

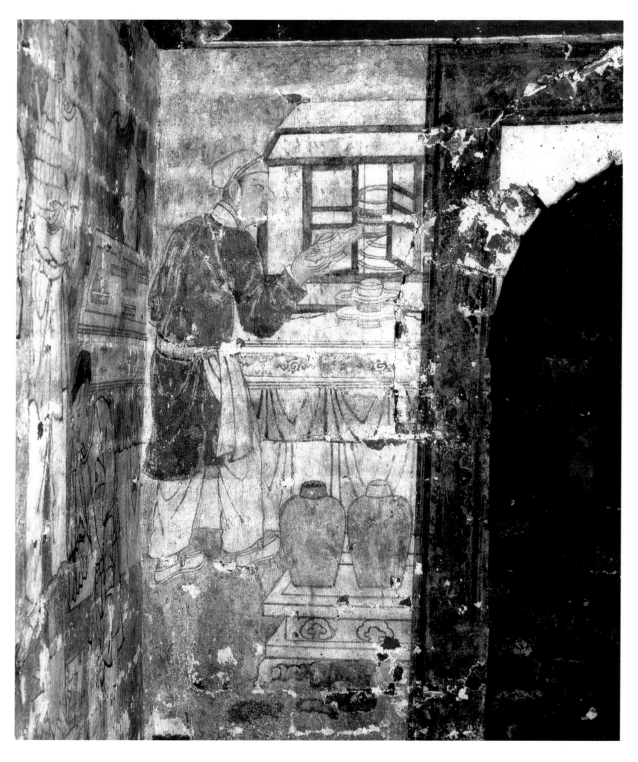

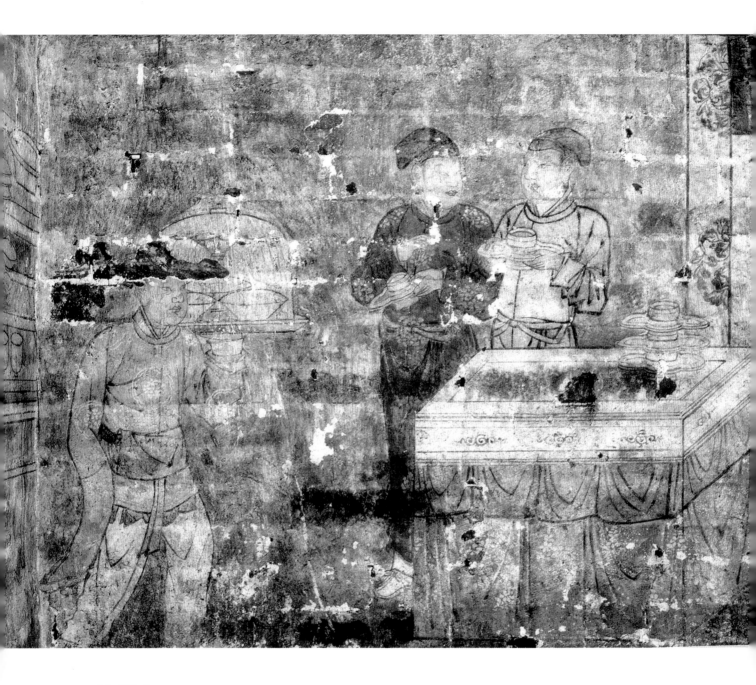

144. 侍茶图

金大定九年（1169年）

高约140、宽约103厘米

2007年山西省陵川县附城镇玉泉村金墓出土。原址保存。

墓向180°。位于墓室西壁南侧。左侧一男仆，举一笼盖茶盏的托盘，向右侧走来。右侧一垂幔高桌，摆有一摞三件的盏托；桌案后面站立二男仆。左者，侧首右顾，其左手斜拿一盏托，右手向右指点；右者，平端一盏托，面向前者，聆听状。

（撰文：商彤流　摄影：李建生）

Serving Tea

9th Year of Dading Era, Jin (1169 CE)

Height ca. 140 cm; Width ca. 103 cm

Unearthed from Jin tomb at Yuquancun, Fuchengzhen in Lingchuan, Shanxi, in 2007. Preserved on the original site.

145.庖厨图

金大定九年（1169年）

高约140、宽约83米

2007年山西省陵川县附城镇玉泉村金墓出土。原址保存。

墓向180°。位于墓室南甬道口西侧。在两张高桌后面，有三名男仆。左侧一仆，俯身面向砧板，持长刀以分切。右侧站立二人，左者端一案三盏，侧身回顾；右者右手拿一长柄圆勺，左手端一盏，面向前者说话。他们的身后还有两张高桌，摆放着食盒及大盆、小碟等。

（撰文：商彤流　摄影：李建生）

Kitchen Scene

9th Year of Dading Era, Jin (1169 CE)

Height ca. 140 cm; Width ca. 83 cm

Unearthed from Jin tomb at Yuquancun, Fuchengzhen in Lingchuan, Shanxi, in 2007. Preserved on the original site.

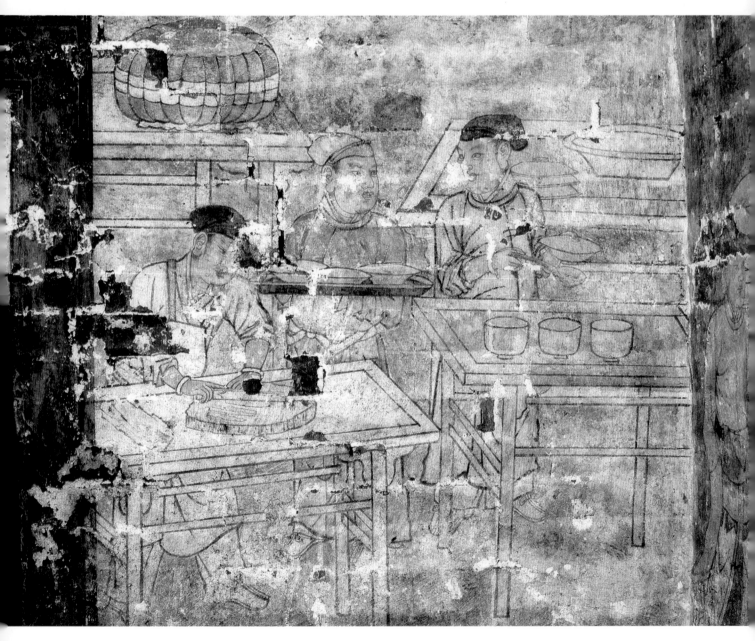

146. 孝子郭巨图

金大定九年（1169年）

高约56、宽约195厘米

2007年山西省陵川县附城镇玉泉村金墓出土。原址保存。

墓向180°。位于墓顶东侧壁。画面右侧一男子持锹掘地，左侧一妇人抱婴，互作呼应状；两人之间有坑凹，内有放射光芒的宝匣；背景绘有树木、流云。是"郭巨埋儿得金"的孝行故事情景。

（撰文：商彤流　摄影：李建生）

Guo Ju, One of the "Twenty-Four Paragons of Filial Piety"

9th Year of Dading Era, Jin (1169 CE)

Height ca. 56 cm; Width ca. 195 cm

Unearthed from Jin tomb at Yuquancun, Fuchengzhen in Lingchuan, Shanxi, in 2007. Preserved on the original site.

147. 孝子董永图

金大定九年（1169年）

高约56、宽约195厘米

2007年山西省陵川县附城镇玉泉村金墓出土。原址保存。

墓向180°。位于墓顶南侧壁。左侧一女子广袖长袍，袖手立于云端，右侧一男子头裹黑巾，身着圆领窄袖长袍，站立在地上，正抬手拭目相送；画面以山坡、灌木为背景。画面体现的是孝子董永与仙女的故事，表现的是"槐荫分别"的场景。

（撰文：商彤流　摄影：李建生）

Dong Yong, One of the "Twenty-Four Paragons of Filial Piety"

9th Year of Dading Era, Jin (1169 CE)

Height ca. 56 cm; Width ca. 195 cm

Unearthed from Jin tomb at Yuquancun, Fuchengzhen in Lingchuan, Shanxi, in 2007. Preserved on the original site.

148. 孝女杨香图

金大定九年（1169年）

高约56、宽约195厘米

2007年山西省陵川县附城镇玉泉村金墓出土。原址保存。

墓向180°。位于墓顶西侧壁。左侧一女子骑于虎身，双手执虎头，似正与老虎搏斗，右侧一老翁惊慌奔逃；背景为山坡、灌木、流云。画面表现的是"杨香打虎救父"的孝行故事场景。

<div align="right">（撰文：商彤流　摄影：李建生）</div>

Yang Xiang, One of the "Twenty-Four Paragons of Filial Piety"

9th Year of Dading Era, Jin (1169 CE)

Height ca. 56 cm; Width ca. 195 cm

Unearthed from Jin tomb at Yuquancun, Fuchengzhen in Lingchuan, Shanxi, in 2007. Preserved on the original site.

149.孝子田真图

金大定九年（1169年）

高约56、宽约195厘米

2007年山西省陵川县附城镇玉泉村金墓出土。原址保存。

墓向180°。位于墓顶北侧壁。中间一棵上有枯枝下有繁叶的大树，三名男子围树站立、皆掩面哭泣，地上散落家什杂物。两侧有土丘，画面上方绘有流云。是"田真三兄弟不再分家"的孝行故事场景。

（撰文：商彤流　摄影：李建生）

Tian Zhen, One of the "Twenty-Four Paragons of Filial Piety"

9th Year of Dading Era, Jin (1169 CE)

Height ca. 56 cm; Width ca. 195 cm

Unearthed from Jin tomb at Yuquancun, Fuchengzhen in Lingchuan, Shanxi, in 2007. Preserved on the original site.

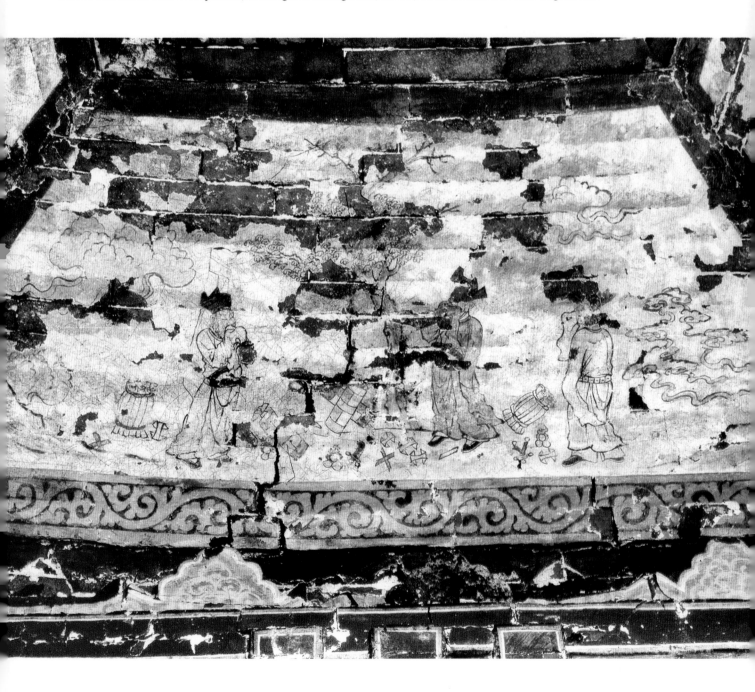

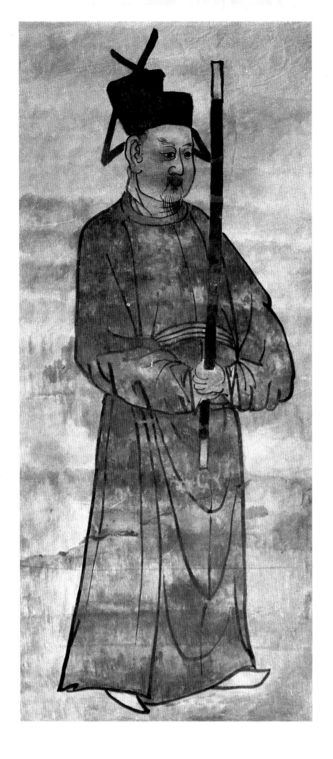

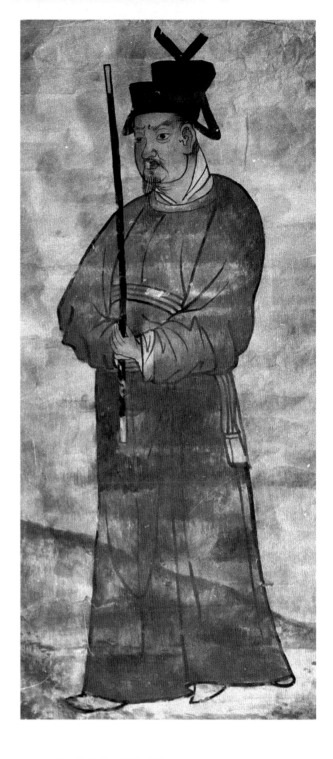

150. 门吏图（摹本）

金大定二十九年（1189年）

高约130、宽约52厘米

1981年山西省长治市故漳村金墓出土。已残毁。

墓向190°。位于墓室南壁墓门左侧。门吏头戴交脚幞头，身着圆领袍服，拱手举杖于胸前，神态威严，作守卫状。

（临摹：不详　撰文、摄影：王进先）

Petty Official (Replica)

29th Year of Dading Era, Jin (1189 CE)

Height ca. 130 cm; Width ca. 52 cm

Unearthed from Jin tomb at Guzhangcun in Changzhi, Shanxi, in 1981. Not preserved.

151. 门吏图（摹本）

金大定二十九年（1189年）

高约130、宽约52厘米

1981年山西省长治市故漳村金墓出土。已残毁。

墓向190°。位于墓室南壁墓门右侧。门吏头戴交脚幞头，身着圆领袍服，拱手举杖于胸前，神态威严，作守卫状。

（临摹：不详　撰文、摄影：王进先）

Petty Official (Replica)

29th Year of Dading Era, Jin (1189 CE)

Height ca. 130 cm; Width ca. 52 cm

Unearthed from Jin tomb at Guzhangcun in Changzhi, Shanxi, in 1981. Not preserved.

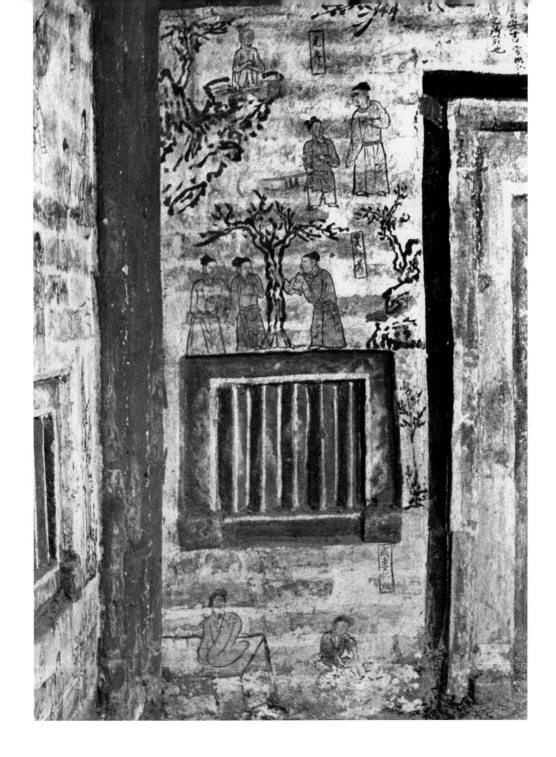

152.孝行图（一）

金大定二十九年（1189年）

高约132、宽约32厘米

1981年山西省长治市故漳村金墓出土。已残毁。

墓向190°。位于墓室东壁耳室南侧。墓壁中间砖雕破子棂窗，其上部绘孝子故事画两幅，两画之间无分隔，人物之间有榜题，上层题字："元觉"，下层题字："田氏□□"；窗下又有一个孝行故事，榜题："武妻□□"。

<div align="right">（撰文、摄影：王进先）</div>

Scenes of Filial Deeds (1)

29th Year of Dading Era, Jin (1189 CE)

Height ca. 132 cm; Width ca. 32 cm

Unearthed from Jin tomb at Guzhangcun in Changzhi, Shanxi, in 1981. Not preserved.

153.孝行图（二）

金大定二十九年（1189年）

高约132、宽约33厘米

1981年山西省长治市故漳村金墓出土。已残毁。

墓向190°。位于墓室东壁耳室北侧。孝子故事画三幅，上下分层无栏隔，人物间字有榜题，上层右侧有一男子执鞭，左侧有象两头，人象之间有题字："舜子"；中层右侧绘一女子携一幼童，左侧绘一男子执一竹竿，男女之间有题字："闵子骞"；壁画以下为砖雕的破子棂窗。窗下的一幅图左侧立有一青年男子，右侧有一男一女端坐，面容苍老。画面左侧有题字："刘明达"。

（撰文、摄影：王进先）

Scenes of Filial Deeds (2)

29th Year of Dading Era, Jin (1189 CE)

Height ca. 132 cm; Width ca. 33 cm

Unearthed from Jin tomb at Guzhangcun in Changzhi, Shanxi, in 1981. Not preserved.

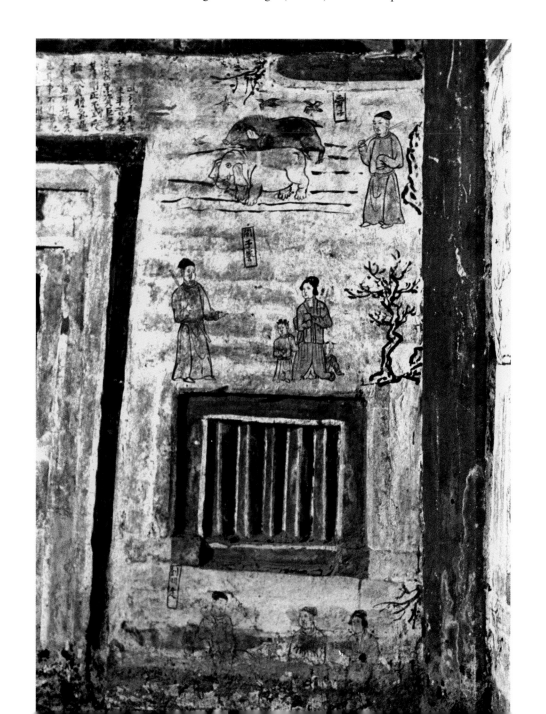

154.门神图

金明昌六年（1195年）

高约90、宽约83厘米

2008年山西省汾阳市东龙观村金代家族墓地5号墓出土。原址保存。

墓向190°。位于墓室甬道两侧。东侧门神手持锏，一脚踏于地上，另一支脚盘曲于矮床之类的家具上；头戴巾子，上身穿袍服，足蹬靴；怒目而视，形象威严。西侧门神与东侧面对，形象基本相同，只是手中所持为宝剑，与东侧略有不同。

（撰文、摄影：王俊）

Door God

6th Year of Mingchang Era, Jin (1195 CE)

Height ca. 90 cm; Width ca. 83 cm

Unearthed from Tomb M5 of Jin family cemetery at Donglongguancun in Fenyang, Shanxi, in 2008. Preserved on the original site.

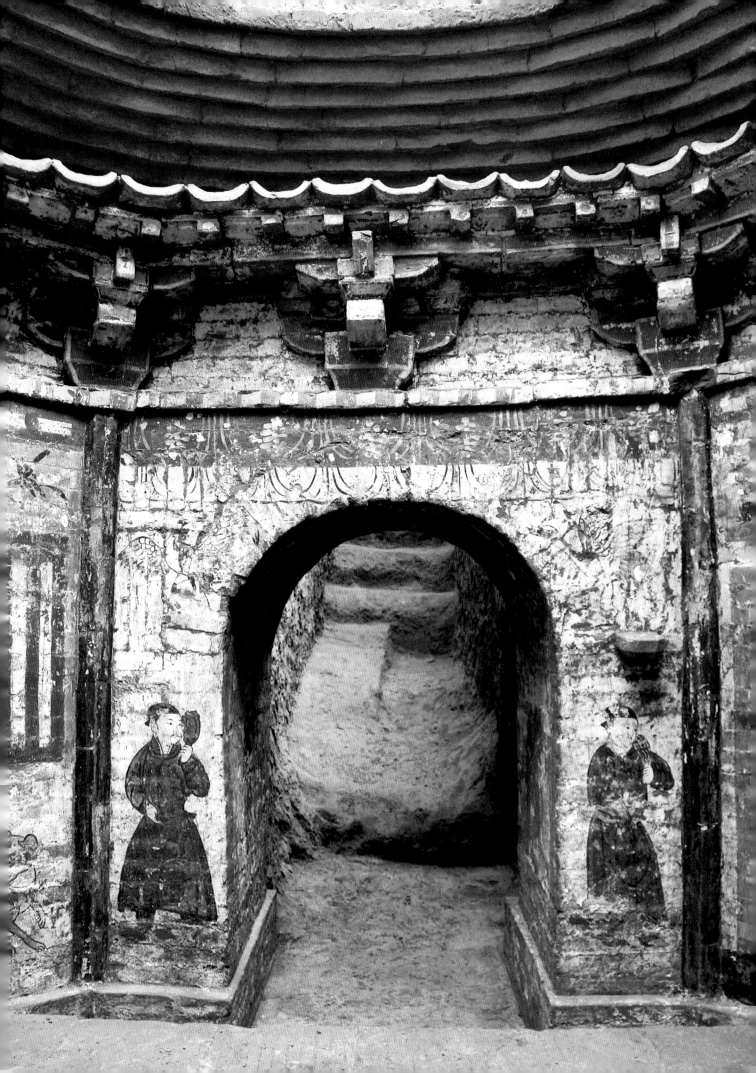

◀ 155. 男侍图

金明昌六年（1195年）

高约86、宽约34厘米

2008年山西省汾阳市东龙观村金代家族墓地5号墓出土。原址保存。

墓向190°。位于墓门内壁的两侧。东侧绘有一个头戴黑巾，上身穿圆领短袍，足着靴的女真男子，左手持扇状物，右手握带；西侧同样绘一男子，衣饰与东侧相同，左肩上扛一个钱袋，右手握带。

（撰文、摄影：王俊）

Servant

6th Year of Mingchang Era, Jin (1195 CE)

Height ca. 86 cm; Width ca. 34 cm

Unearthed from Tomb M5 of Jin family cemetery at Donglongguancun in Fenyang, Shanxi, in 2008. Preserved on the original site.

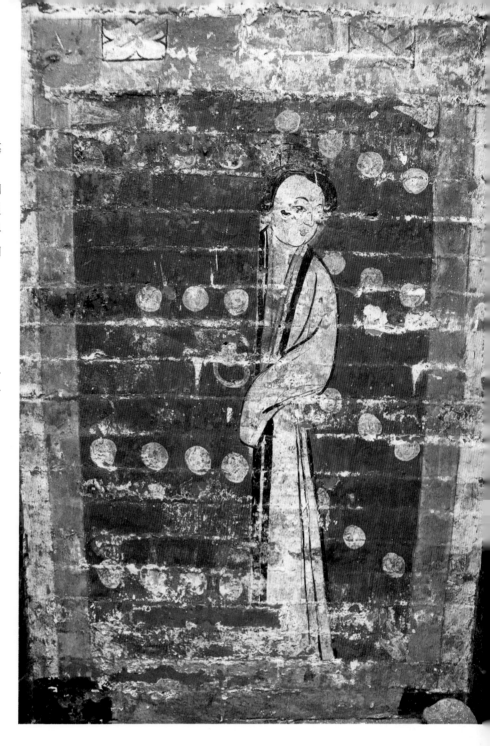

156. 妇人启门图

金明昌六年（1195年）

高约148、宽约94厘米

2008年山西省汾阳市东龙观村金代家族墓地5号墓出土。原址保存。

墓向190°。位于墓室西南壁。板门式假门，上绘黄色门钉，女子高髻、圆脸、细目、小口；着褙子，下着裙；门半开，人半倚。

（撰文、摄影：王俊）

Lady Opening Door Ajar

6th Year of Mingchang Era, Jin (1195 CE)

Height ca. 148 cm; Width ca. 94 cm

Unearthed from Tomb M5 of Jin family cemetery at Donglongguancun in Fenyang, Shanxi, in 2008. Preserved on the original site.

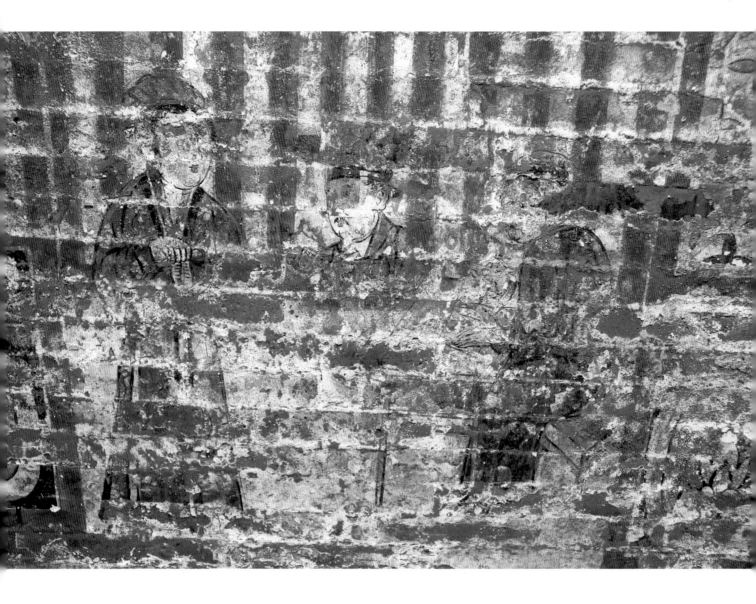

157. "货币汇兑"图

金明昌六年（1195年）

高约148、宽约152厘米

2008年山西省汾阳市东龙观村金代家族墓地5号墓出土。原址保存。

墓向190°。位于墓室西壁，内容分两部分，中间有木栅栏隔开，栅栏上留有方形小口；栅栏内有一账房先生正在挥笔算帐，旁边绘一个妇女手持一贯铜钱；栅栏外绘一个男子手持一个纸条类东西，推测与"货币汇兑"有关。

（撰文、摄影：王俊）

"Currency Exchange"

6th Year of Mingchang, Jin (1195 CE)

Height ca. 148 cm; Width ca. 152 cm

Unearthed from Tomb M5 of Jin family cemetery at Donglongguancun in Fenyang, Shanxi, in 2008. Preserved on the original site.

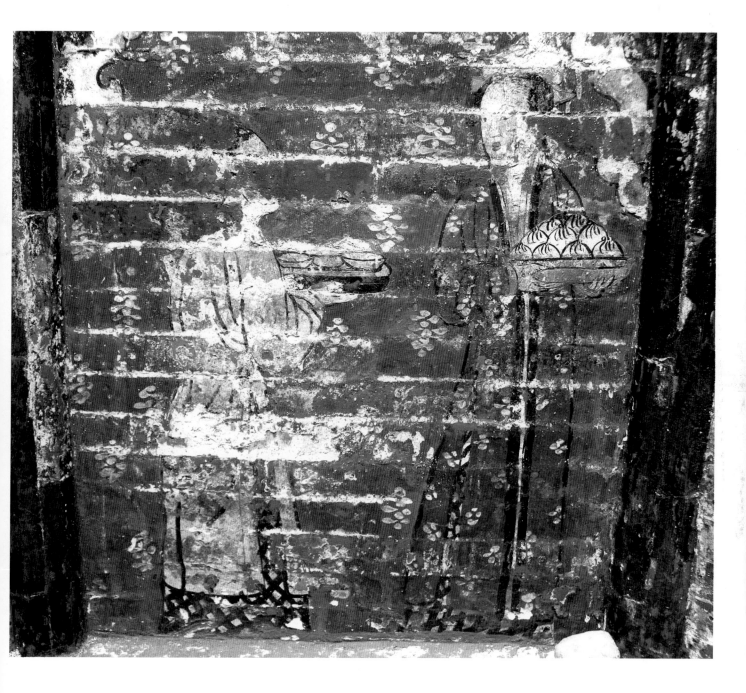

158."香积厨"图

金明昌六年（1195年）

高约148、宽约70厘米

2008年山西省汾阳市东龙观村金代家族墓地5号墓出土。原址保存。

墓向190°。位于墓室西北壁，壁画上部有墨书牌匾"香积厨"三个字，下部绘有两个女侍，一人手中捧着一笼刚出锅的包子，另一个手中持一个托盘，盘中放置三个碗；两位女侍相互顾盼、照应，趋向墓后壁的方向。

（撰文、摄影：王俊）

Kitchen Full of Sweet Smell

6th Year of Mingchang Era, Jin (1195 CE)

Height ca. 148 cm: Width ca. 70 cm

Unearthed from Tomb M5 of Jin family cemetery at Donglongguancun in Fenyang, Shanxi, in 2008. Preserved on the original site.

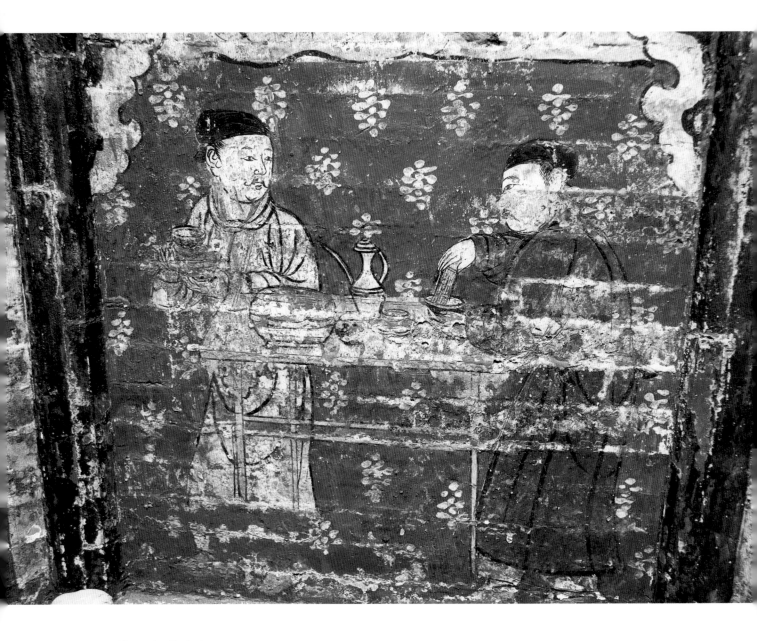

159. "茶酒位"图

金明昌六年（1195年）

高约148、宽约70厘米

2008年山西省汾阳市东龙观村金代家族墓地5号墓出土。原址保存。

墓向190°。位于墓室东北壁，壁画上部有墨书牌匾"茶酒位"三个字，下部绘一张长桌，桌上放置圆盒、注壶、托盏等用具，桌后绘有两个男侍，均戴黑巾，圆领窄袖袍，一个持托盏回头张望，另一位正在桌前持筅击拂。

（撰文、摄影：王俊）

Tea and Wine

6th Year of Mingchang Era, Jin (1195 CE)

Height ca. 148 cm; Width ca. 70 cm

Unearthed from Tomb M5 of Jin family cemetery at Donglongguancun in Fenyang, Shanxi, in 2008. Preserved on the original site.

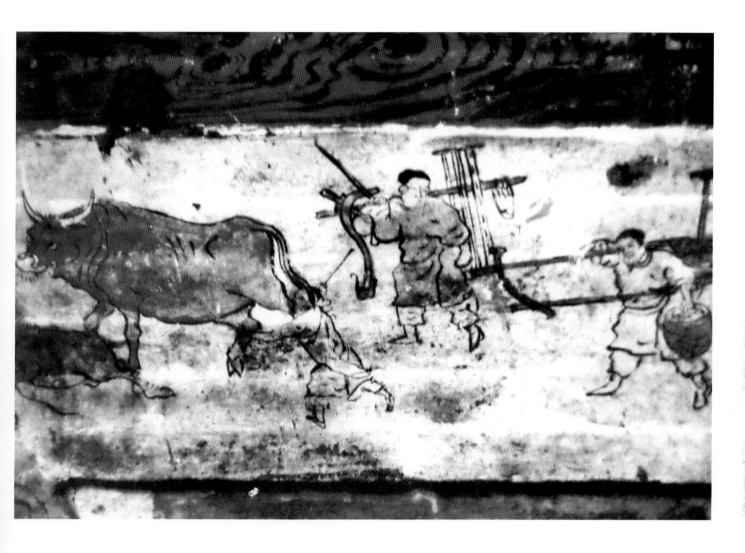

160. 备耕图

金泰和八年（1208年）

高约32、宽约57厘米

1988年山西省屯留县李高村金墓出土。已残毁。

墓向200°。位于墓室北壁中部。左向行走一牛一驴，随后一名男童，作挥鞭驱赶状；随行有两名壮年农夫，或肩扛犁耧，或肩扛犁耙等农具。

（撰文、摄影：王进先）

Preparing for Plowing and Cultivating

8th Year of Taihe Era, Jin (1208 CE)

Height ca. 32 cm; Width ca. 57 cm

Unearthed from Jin tomb at Ligaocun in Tunliu, Shanxi, in 1988. Not preserved

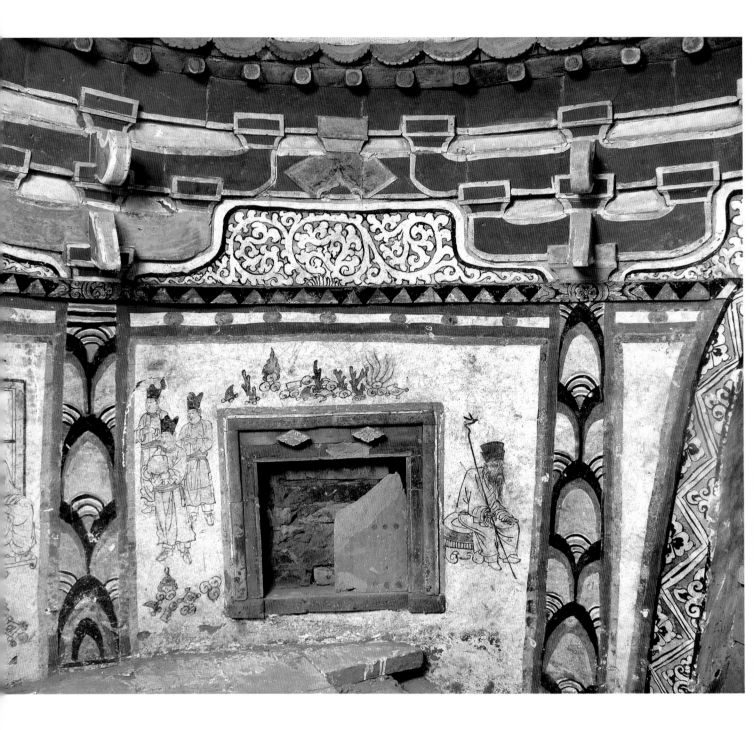

161. 东南柱间壁全景

金（1115~1234年）

高约98、宽约123厘米

2007年山西省繁峙县杏园乡南关村金墓出土。现存于山西博物院。

墓向180°。位于墓室东南柱间壁。中间砌筑一涂朱的板门，门户的上面有各式珍宝奇物。右侧似为蒿里老翁，两手按膝，怀抱一杖，坐在圆凳上；左侧三名男仆前、后站立，均头戴幞头，一人托起包袱，二人抱拳作揖。

（撰文、摄影：商彤流）

Full View of Southeastern Bay

Jin (1115-1234 CE)

Height ca. 98 cm; Width ca. 123 cm

Unearthed from Jin tomb at Nanguancun, Xinyuanxiang in Fanzhi, Shanxi, in 2007. Preserved in Shanxi Museum.

162.东北柱间壁全景

金（1115～1234年）

高约98、宽约124厘米

2007年山西省繁峙县杏园乡南关村金墓出土。现存于山西博物院。

墓向180°。位于墓室东北柱间壁。中间砌筑一涂红框的白色菱花窗，窗户上、下有各式珍宝奇物。其右侧一名文官端坐于高桌之后，头戴展脚幞头，身着圆领窄袖长袍，桌上有帐簿一本。文官身后竖立一面素面屏风、两杆修竹。画面左侧站立五名侍女、一髡发男侍，分别捧持包袱、长盘、渣斗、珊瑚、铜镜等物。

（撰文、摄影：商彤流）

Full View of Northeastern Bay

Jin (1115-1234 CE)

Height ca. 98 cm; Width ca. 124 cm

Unearthed from Jin tomb at Nanguancun, Xinyuanxiang in Fanzhi, Shanxi, in 2007. Preserved in Shanxi Museum.

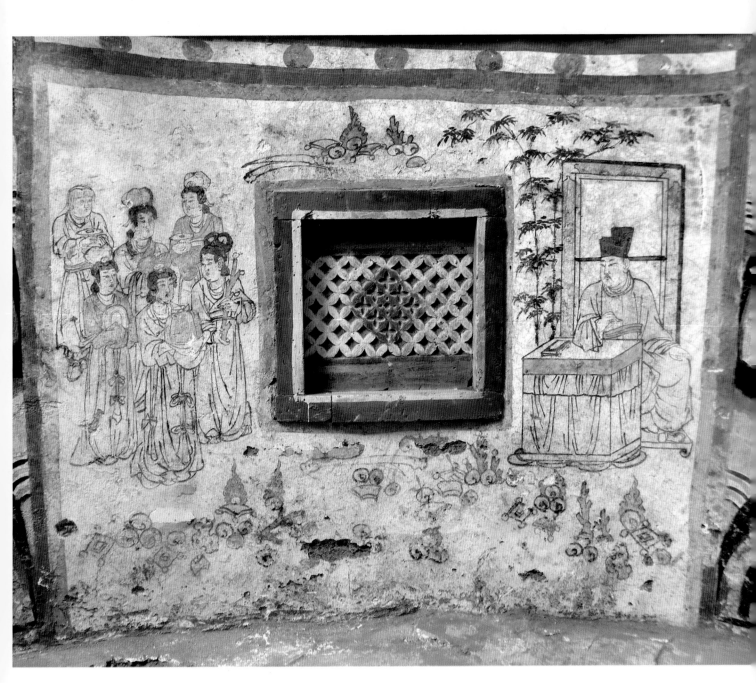

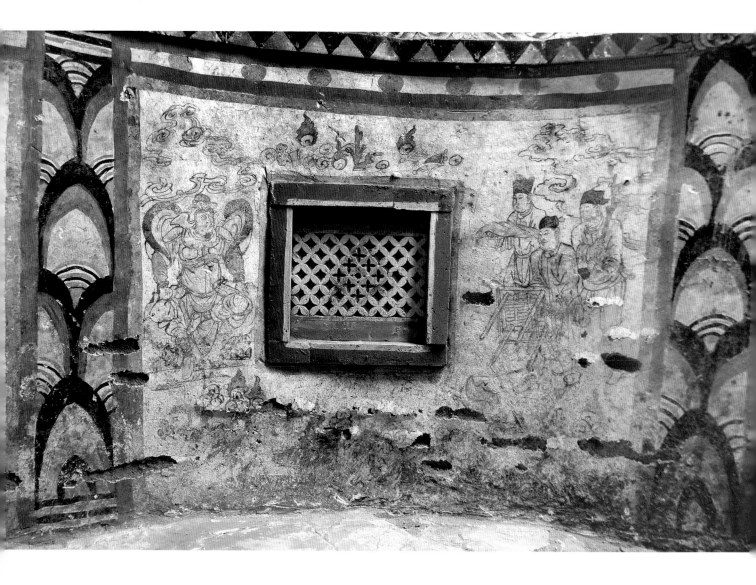

163.西北柱间壁全景

金（1115～1234年）

高约98、宽约124厘米

2007年山西省繁峙县杏园乡南关村金墓出土。现存于山西博物院。

墓向180°。位于墓室西北柱间壁。中间砌筑一涂红框的白色菱花窗，窗户上、下有各式珍宝奇物。其右侧三名男侍，分别捧持矮几、包袱、珊瑚。其左侧一名身披明光铠的武将，正面端坐，双手握拳按于双膝之上。画面人物背后皆彩云缭绕

（撰文、摄影：商彤流）

Full View of Northwestern Bay

Jin (1115-1234 CE)

Height ca. 98 cm; Width ca. 124 cm

Unearthed from Jin tomb at Nanguancun, Xinyuanxiang in Fanzhi, Shanxi, in 2007. Preserved in Shanxi Museum.

164. 西南柱间壁全景

金（1115～1234年）

高约98、宽约123厘米

2007年山西省繁峙县杏园乡南关村金墓出土。现存于山西博物院。

墓向180°。位于墓室西南柱间壁。中间砌筑一涂红的板门，门户的上面绘有各式珍宝奇物。其右侧绘画两杆茂竹与一只锦鸡。其左侧站立男、女侍从，男侍髡发，面向墓门叉手而立；女侍头绾高髻，上襦、长裙，怀抱一件包裹着的器物。

（撰文、摄影：商彤流）

Full View of Southwestern Bay

Jin (1115-1234 CE)

Height ca. 98 cm; Width ca. 123 cm

Unearthed from Jin tomb at Nanguancun, Xinyuanxiang in Fanzhi, Shanxi, in 2007. Preserved in Shanxi Museum.

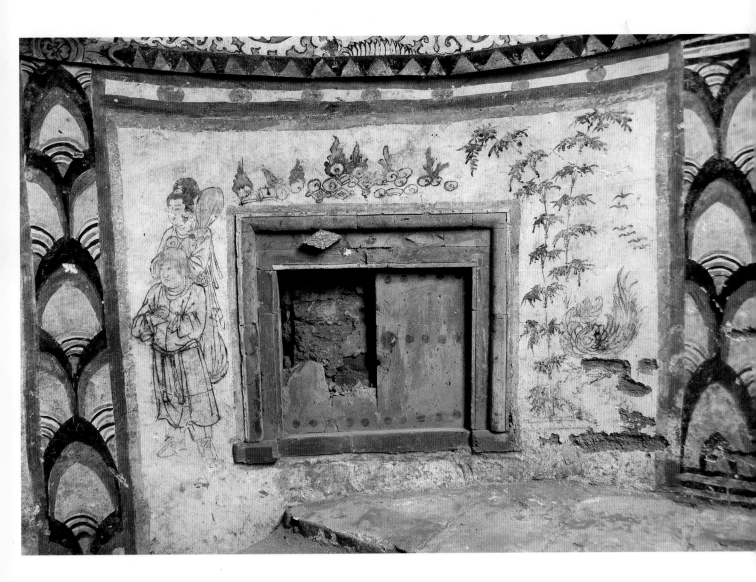

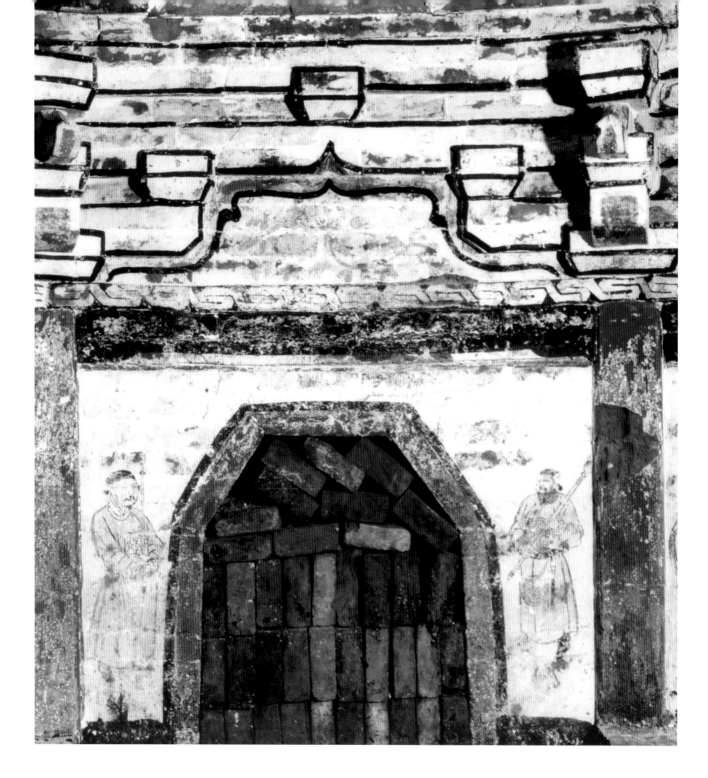

165.门吏图

金（1115～1234年）

约高78、宽112厘米

1994年山西省平定县城关镇西关村1号金墓出土。原址保存。

墓向176°。位于墓室南壁甬道口两侧。左侧一门吏圆脸端庄、短胡须，头戴黑巾，身着圆领窄袖长衫，双手竖握一杆骨朵。右侧一门吏阔面威严、连腮胡，头戴墨巾，身着圆领窄袖长袍，双手斜持一杆骨朵。

<div align="right">（撰文：商彤流　摄影：李舍元）</div>

Petty Officials

Jin (1115-1234 CE)

Height ca. 78 cm; Width ca. 112 cm

Unearthed from Jin Tomb M1 at Xiguancun, Chengguanzhen in Pingding, Shanxi, in 1994. Preserved on the original site.

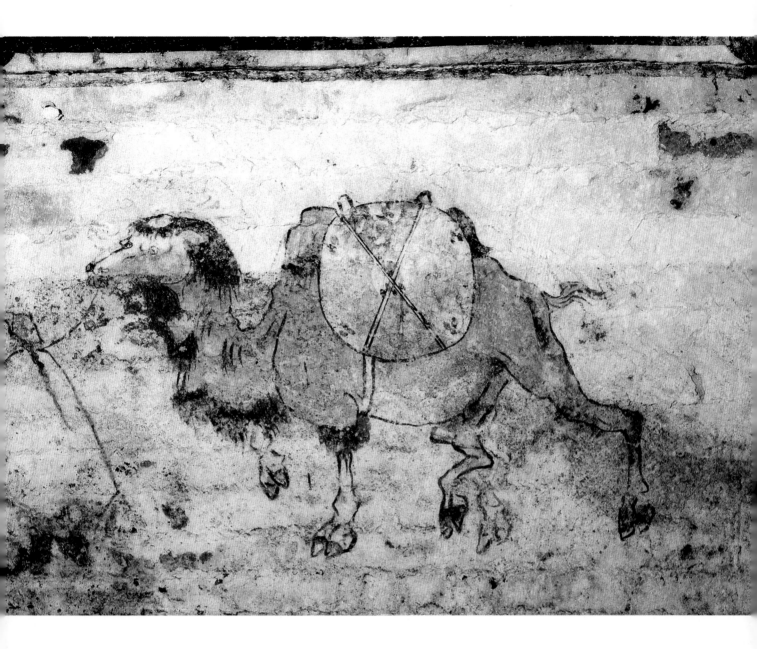

166.驼运图

金（1115～1234年）

高约78、宽约112厘米

1994年山西省平定县城关镇西关村1号金墓出土。原址保存。

墓向176°。位于墓室东南柱间壁。一商旅牵一驼载物左行。商人昂头仰脸、脑后拖一条发辫，头顶毡帽，着大披风、长黑靴。双峰骆驼背负斜十字绑扎的大包袱。

（撰文：商彤流　摄影：李舍元）

Loaded Camel

Jin (1115-1234 CE)

Height ca. 78 cm; Width ca. 112 cm

Unearthed from Jin Tomb M1 at Xiguancun, Chengguanzhen in Pingding, Shanxi, in 1994. Preserved on the original site.

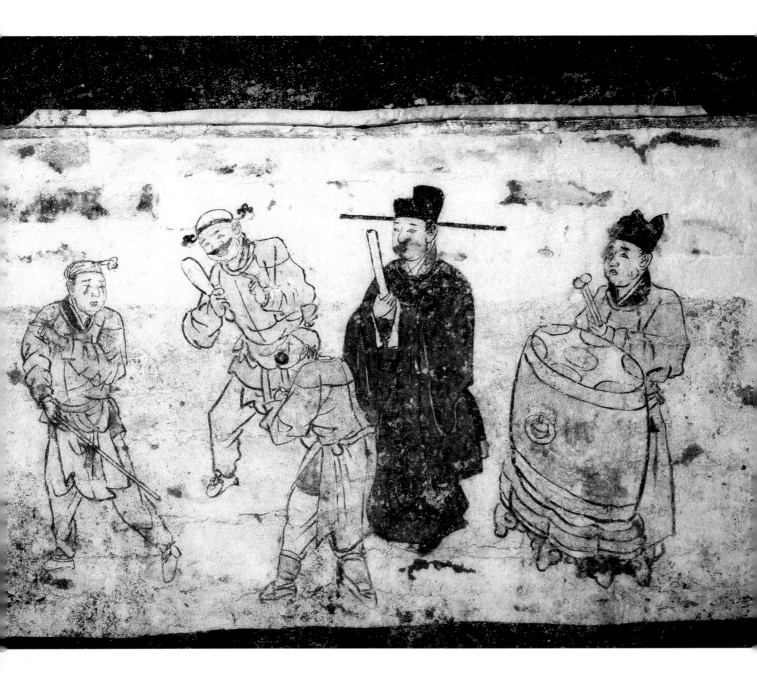

167. 杂剧图

金（1115～1234年）

高约78、宽约112 厘米

1994年山西省平定县城关镇西关村1号金墓出土。原址保存。

墓向176°。位于墓室东面柱间壁。四人正在作场，一人伴奏。左起一人眉眼上竖画墨痕，右手持竿，左手斜指；第二人光头胖脸，两撇黑胡，右手握皮棒槌，左手伸食指；第三人，嘴唇涂黑圈，抱拳作揖样；第四人正面站立，头戴展脚幞头，身着圆领广袖长袍，双手捧笏于胸前；右侧一人站在鼓架后，手握双槌，专注于演出场景。

（撰文：商彤流　摄影：李舍元）

Drama Performance

Jin (1115-1234 CE)

Height ca. 78 cm; Width ca. 112 cm

Unearthed from Jin Tomb M1 at Xiguancun, Chengguanzhen in Pingding, Shanxi, in 1994. Preserved on the original site.

168. 尚宝图

金（1115～1234年）

高约78、宽约112厘米

1994年山西省平定县城关镇西关村1号金墓出土。原址保存。

墓向176°。位于墓室东北柱间壁。左前一女，右手持一葵花镜，反身向后指点状；第二人向左缓行，捧一奁盒；第三人向右顾盼，抱一扎包；第四人趋步左行，右手置于胸前，左手提一包裹；四女皆包髻。其右侧一老翁，随行，抱一包袱。

（撰文：商彤流　摄影：李舍元）

Serving Costumes and Cosmetics

Jin (1115-1234 CE)

Height ca. 78 cm; Width ca. 112 cm

Unearthed from Jin Tomb M1 at Xiguancun, Chengguanzhen in Pingding, Shanxi, in 1994. Preserved on the original site.

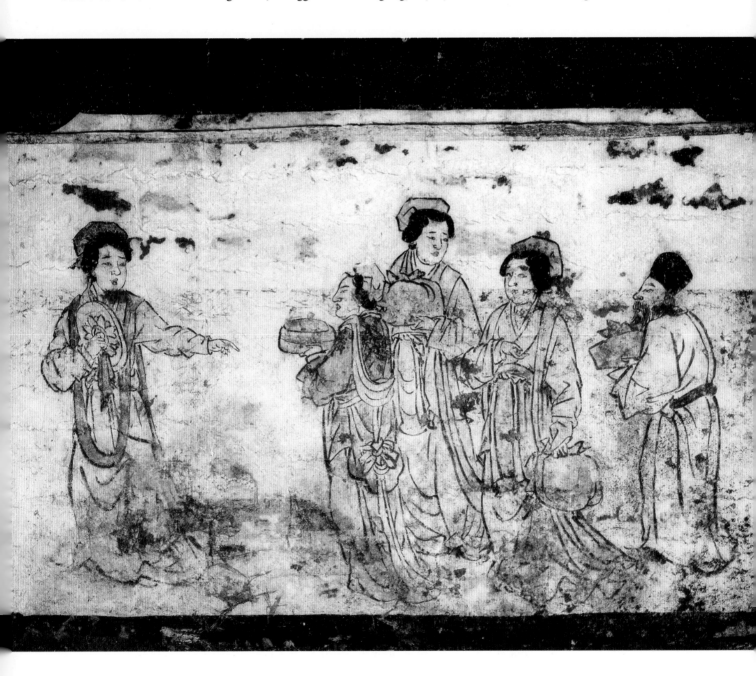

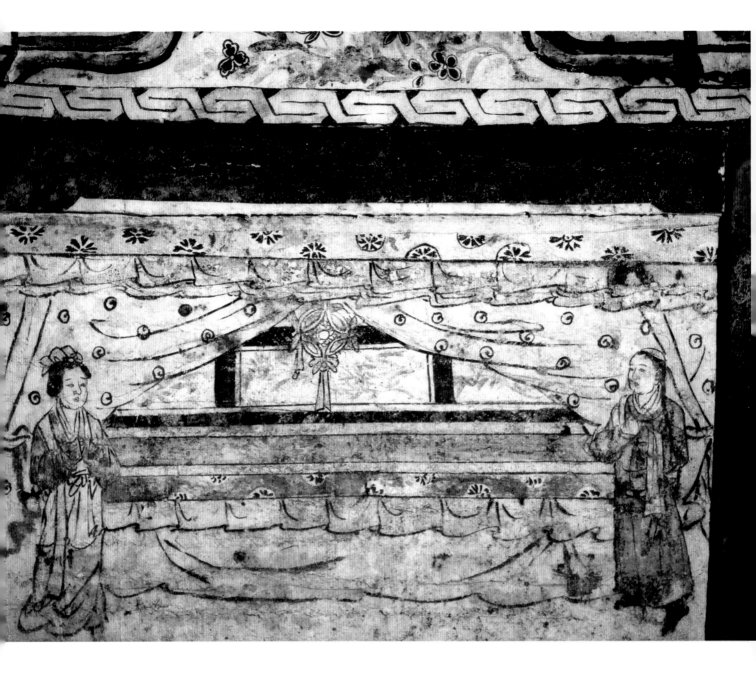

169.内宅图

金（1115～1234年）

高约78、宽约112厘米

1994年山西省平定县城关镇西关村1号金墓出土。原址保存。

墓向176°。位于墓室北面柱间壁。垂帐高悬，笼盖一席床榻，当间挂一绣球。榻前两侧各有一名侍从。左侧一侍女包髻，披帛，身着褙子，拱手站立；右侧一男仆，髡发，身着圆领窄袖长袍，持巾侍立。

<div align="right">（撰文：商彤流　摄影：李舍元）</div>

Bedroom

Jin (1115-1234 CE)

Height ca. 78 cm; Width ca. 112 cm

Unearthed from Jin Tomb M1 at Xiguancun, Chengguanzhen in Pingding, Shanxi, in 1994. Preserved on the original site.

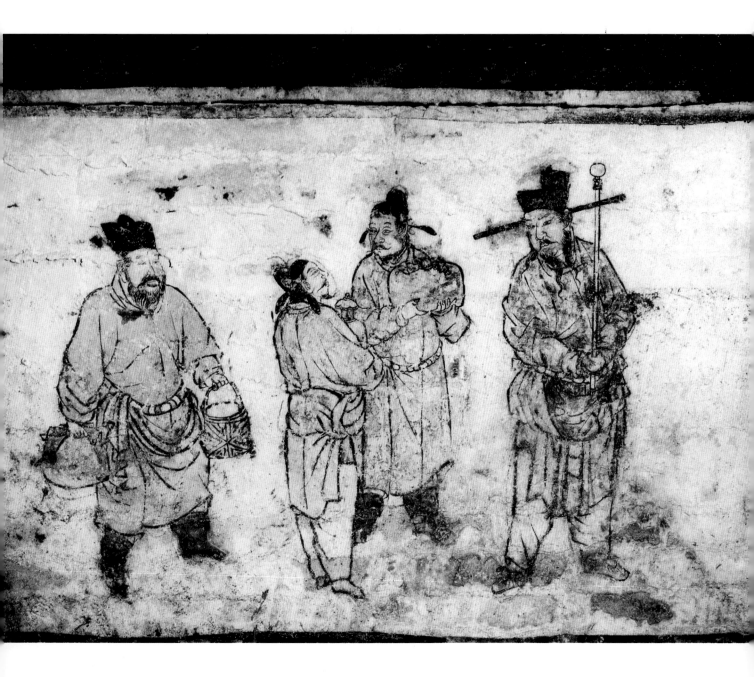

170. 出行图

金（1115～1234年）

高约78、宽约112厘米

1994年山西省平定县城关镇西关村1号金墓出土。原址保存。

墓向176°。位于墓室西北柱间壁。右侧一男侍站立，头戴展脚幞头，身着圆领窄袖长袍，双手持骨朵导引，回首左顾；第二人头戴短脚幞头，身着圆领窄袖长袍，双手托一包袱（食盒）；第三人头戴短脚幞头，身着圆领窄袖长袍，抱一束颈带盖瓶；随后一名老翁，头戴无脚幞头，身着圆领窄袖黄色长袍，左手提一篮，右手拎一包。

（撰文：商彤流　摄影：李舍元）

Preparing for Travel

Jin (1115-1234 CE)

Height ca. 78 cm; Width ca. 112 cm

Unearthed from Jin Tomb M1 at Xiguancun, Chengguanzhen in Pingding, Shanxi, in 1994. Preserved on the original site.

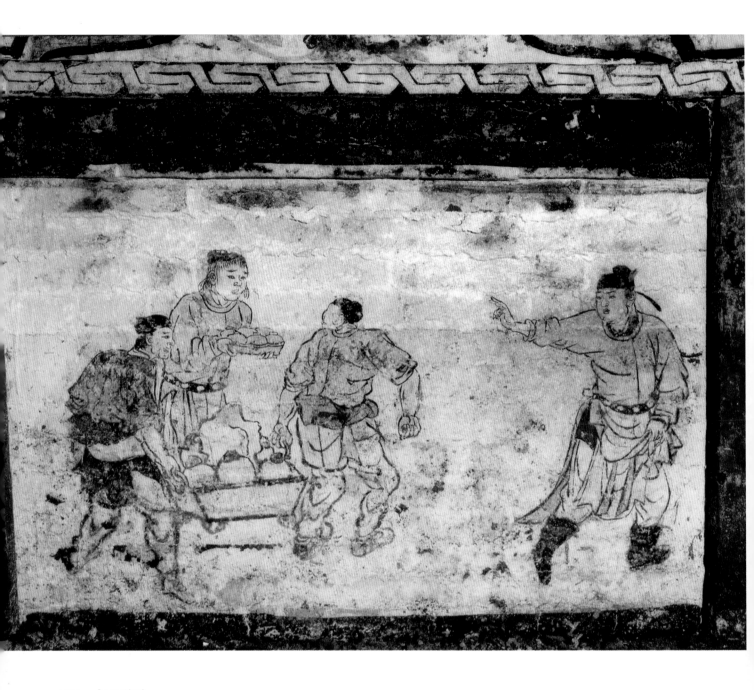

171.奉酒图

金（1115～1234年）

高约78、宽约112厘米

1994年山西省平定县城关镇西关村1号金墓出土。原址保存。

墓向176°。位于墓室西面柱间壁。右侧一人头戴短脚幞头，身着圆领窄袖长袍，回首，招呼另外三人向前行。随行两人提一斗箱，内装满酒坛，旁边站立一童仆，手捧托盘，内似装满小酒瓶。

（撰文：商彤流　摄影：李舍元）

Serving Wine

Jin (1115-1234 CE)

Height ca. 78 cm; Width ca. 112 cm

Unearthed from Jin Tomb M1 at Xiguancun, Chengguanzhen in Pingding, Shanxi, in 1994. Preserved on the original site.

172.马厩图

金（1115～1234年）

高约78、宽约112厘米

1994年山西省平定县城关镇西关村1号金墓出土。原址保存。

墓向176°。位于墓室西南柱间壁。左侧两匹马，正在低头吃草料。其右侧站立一人，持水瓢、提一罐；一人提木桶、拿草叉，立于食槽旁。画面右侧还有一副鞍具。此图与东南壁的驼运图对应。

（撰文：商彤流　摄影：李舍元）

Feeding Horses

Jin (1115-1234 CE)

Height ca. 78 cm; Width ca. 112 cm

Unearthed from Jin Tomb M1 at Xiguancun, Chengguanzhen in Pingding, Shanxi, in 1994. Preserved on the original site.

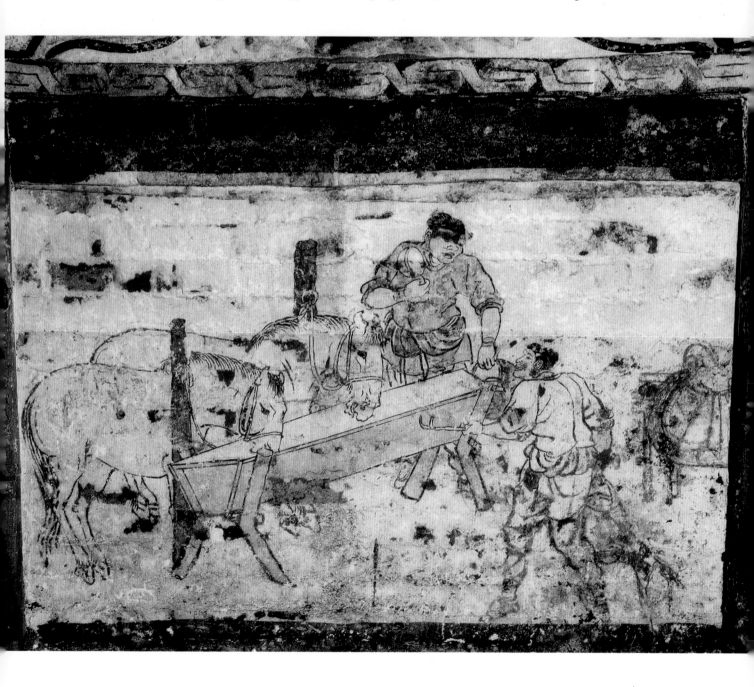

173.奉酒图

金（1115~1234年）

高约110、宽约175厘米

1990年山西省汾阳县北郊（高护校）4号金墓出土。已残毁。
墓向123°。位于墓室南壁。上部一道卷起的竹帘，两侧为格
扇门。当间有一妇人，侧身站立在门幛的前面，双手捧一托
盘，上置酒尊和勺。

（撰文：马昇 摄影：李建生）

Wine Waitress

Jin (1115-1234 CE)

Height ca. 110 cm; Width ca. 175 cm

Unearthed from Jin Tomb M4 in northern suburbs of Fenyang,
Shanxi, in 1990. Not preserved.

174.墓室北壁 ▶

金（1115~1234年）

高约270、宽约144厘米

1990年山西省汾阳县北郊（高护校）5号金墓出土。原址保
存。

墓向126°。位于墓室北壁。墓壁上方砌四铺作斗拱，两侧雕
格扇门；门楣上方三个壶门，内有孝行图或花卉。门楣下有帷
帐，中间摆放一桌案，桌后端坐一人，拢手置于案上，面前和
身侧均放置有账本；身后浮雕一堆成串的钱币。

（撰文：马昇 摄影：李建生）

North Wall of the Tomb Chamber

Jin (1115-1234 CE)

Height ca. 270 cm; Width ca. 144 cm

Unearthed from Jin Tomb M5 in northern suburbs of Fenyang,
Shanxi, in 1990. Preserved on the original site.

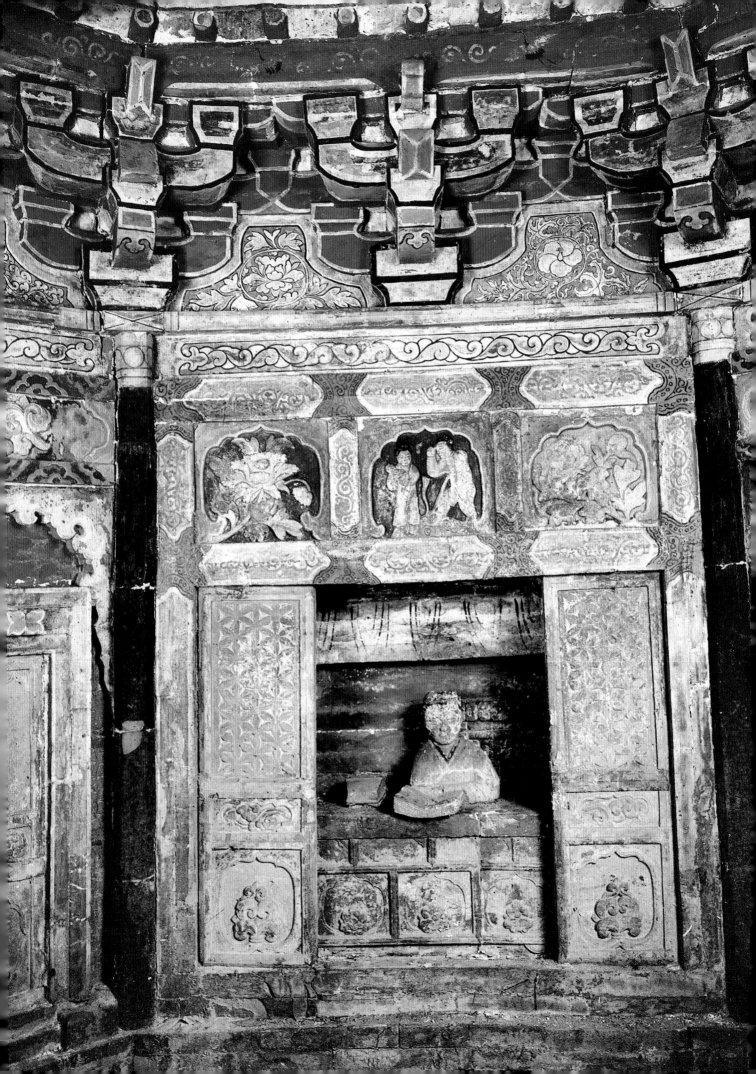

◀ **175. 墓室西壁**

金（1115～1234年）

高约270、宽约144厘米

1990年山西省汾阳县北郊（高护校）5号金墓出土。原址保存。

墓向126°。位于墓室西壁。上方雕单抄单下昂四铺作斗拱，两侧砌倚柱，两边有格扇门；遍施彩绘。门楣下有帷帐，墓主夫妇端坐于高桌之后，桌上有两茶盏并托其身后有屏风。左侧女主人拢袖于桌面上，右侧男主人头戴展脚幞头，手持念珠。

（撰文：马昇　摄影：刘永生）

West Wall of the Tomb Chanber

Jin (1115-1234 CE)

Height ca. 270 cm; Width ca. 144 cm

Unearthed from Jin Tomb M5 in northern suburbs of Fenyang, Shanxi, in 1990. Preserved on the original site.

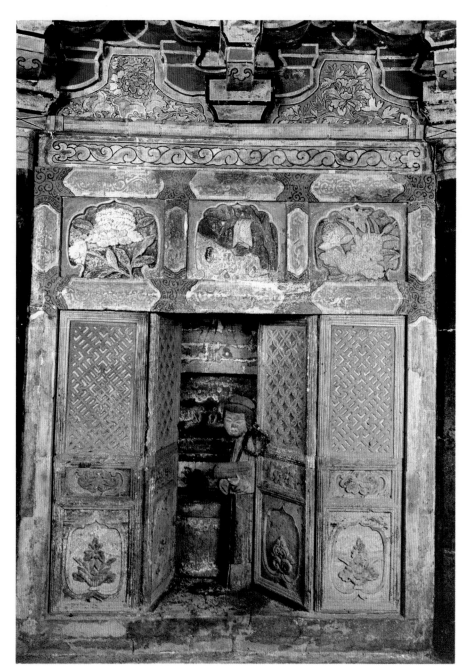

176. 启门图

金（1115～1234年）

高约270、宽约144厘米

1990年山西省汾阳县北郊（高护校）5号金墓出土。原址保存。

墓向126°。位于墓室南壁。墓壁砌筑结构与北壁基本相同，两侧格扇门关闭，中间的两扇开启；门楣下右侧门扇后面，站立着一名妇人，包髻，穿褙子，持盒，意欲出门。

（撰文：马昇　摄影：李建生）

Lady Opening the Door Ajar

Jin (1115-1234 CE)

Height ca. 270 cm; Width ca. 144 cm Unearthed from Jin Tomb M5 in northern suburbs of Fenyang, Shanxi, in 1990. Preserved on the original site.

177.妇人图（局部）

金（1115～1234年）

高约122、宽约66厘米

2001年山西省绛县城内村金墓出土。原址保存。

墓向190°。位于墓室南壁西侧。一老妇，身穿黄地红花褙子，拱手侧立；其身后有一儿童，着圆领长衫，回顾身后。

（撰文、摄影：张惠祥）

Old Woman (Detail)

Jin (1115-1234 CE)

Height ca. 122 cm; Width ca. 66 cm

Unearthed from Jin tomb at Chengneicun in Jiangxian, Shanxi, in 2001. Preserved on the original site.

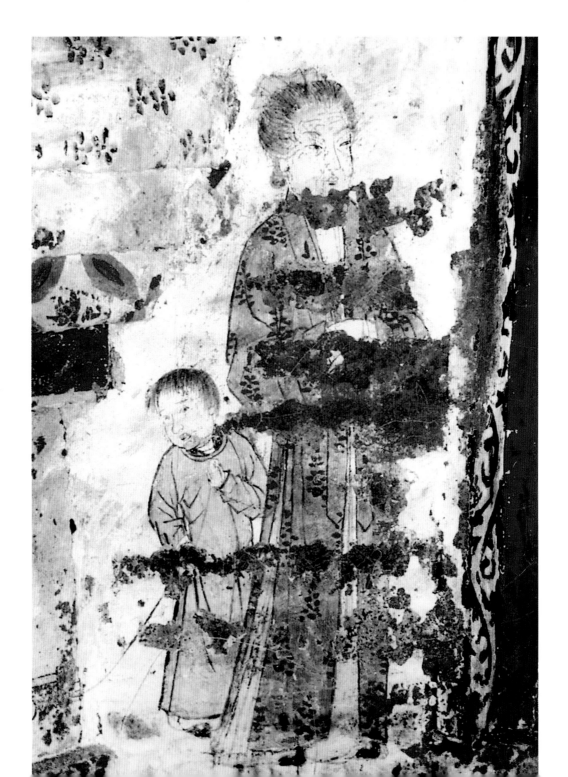

178.侍女图（一）

金（1115～1234年）

高约122、宽约196厘米

2001年山西省绛县城内村金墓出土。已残毁。

墓向190°。位于墓室北壁。柱间壁的中部砖雕砌作格扇门，涂红色；两侧站立持物的侍女。左侧一侍女袖手抱一拍板，另一女侍右手举一柄团扇掩面；右侧一女双手托抱一带盖梅瓶，身后有一梅花鹿，口衔一枝牡丹。

<div align="right">（撰文、摄影：张惠祥）</div>

Maids (1)

Jin (1115-1234 CE)

Height ca. 122 cm; Width ca. 196 cm

Unearthed from Jin tomb at Chengneicun in Jiangxian, Shanxi, in 2001. Not presreved.

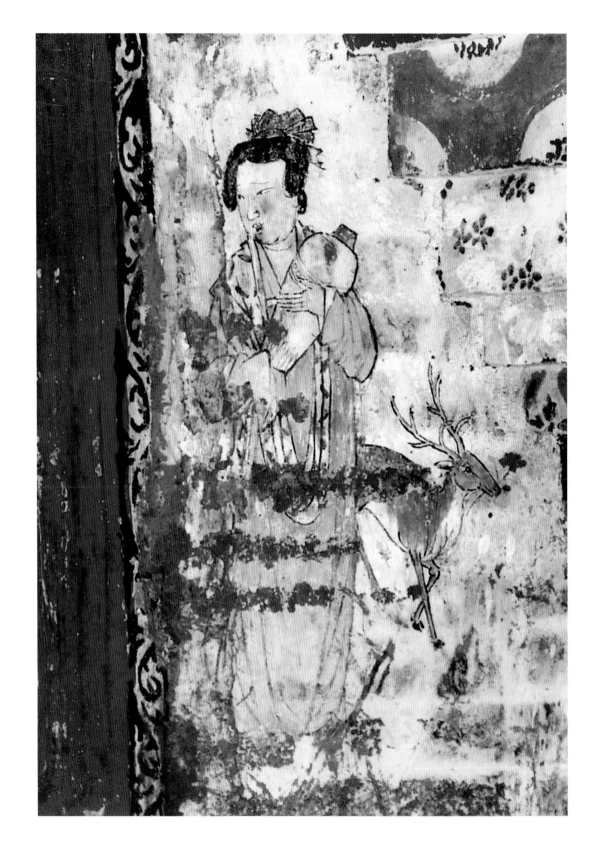

179.侍女图（一）（局部一）

金（1115～1234年）

2001年山西省绛县城内村金墓出土。已残毁。

墓向190°。位于墓室北壁东侧。柱间壁的中部砖雕砌作格扇门，涂红色；门右侧一女头梳包髻，双手托抱一带盖梅瓶，身后有一梅花鹿衔一枝牡丹，寓意富贵长寿。

（撰文、摄影：张惠祥）

Maids (1) (Detail 1)

Jin (1115-1234 CE)

Unearthed from Jin tomb at Chengneicun in Jiangxian, Shanxi, in 2001. Not presreved.

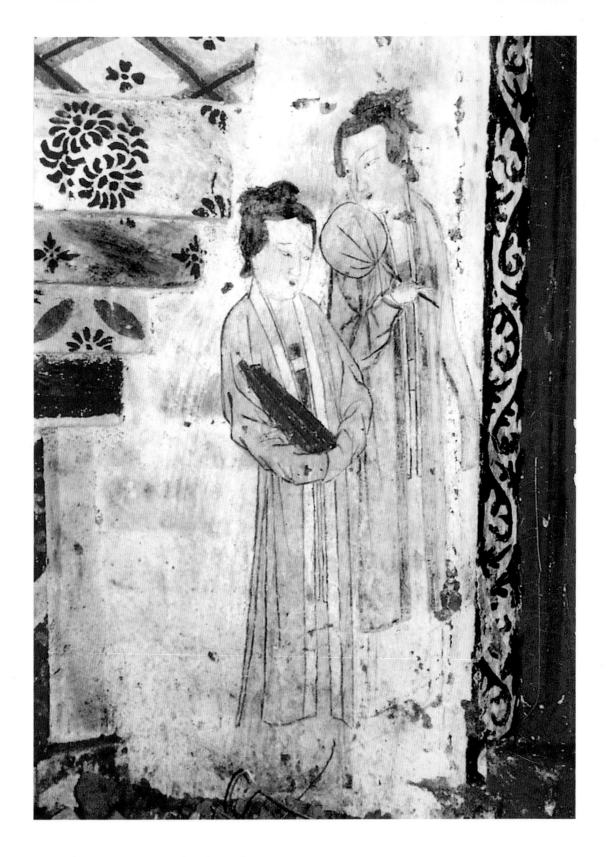

180.侍女图（一）（局部二）

金（1115~1234年）

2001年山西省绛县城内村金墓出土。已残毁。

墓向190°。位于墓室北壁西侧。柱间壁的中部砖雕砌作格扇门，涂红色；门左侧站立持物的侍女两人，均着褙子。左侧女侍袖手抱一拍板，右侧女侍右手举一柄团扇掩面。

（撰文、摄影：张惠祥）

Maids (1) (Detail 2)

Jin (1115-1234 CE)

Unearthed from Jin tomb at Chengneicun in Jiangxian, Shanxi, in 2001. Not presreved.

181.侍女图（二）

金（1115～1234年）

高约122、宽约66厘米

2001年山西省绛县城内村金墓出土。已残毁。

墓向190°。位于墓室北壁西侧。一张红色长桌上，摆放盏托、圆形套盒、盝顶方函等器物，桌下有一盆架上置一盆，另有一罐。两侍女站立在方桌的后面。

（撰文、摄影：张惠祥）

Maids (2)

Jin (1115-1234 CE)

Height ca. 122 cm; Width ca. 66 cm

Unearthed from Jin tomb at Chengneicun in Jiangxian, Shanxi, in 2001. Not presreved.

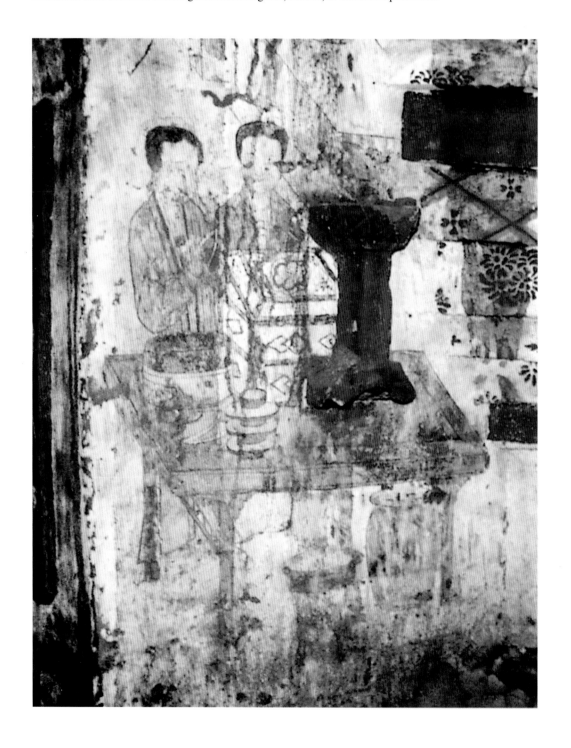

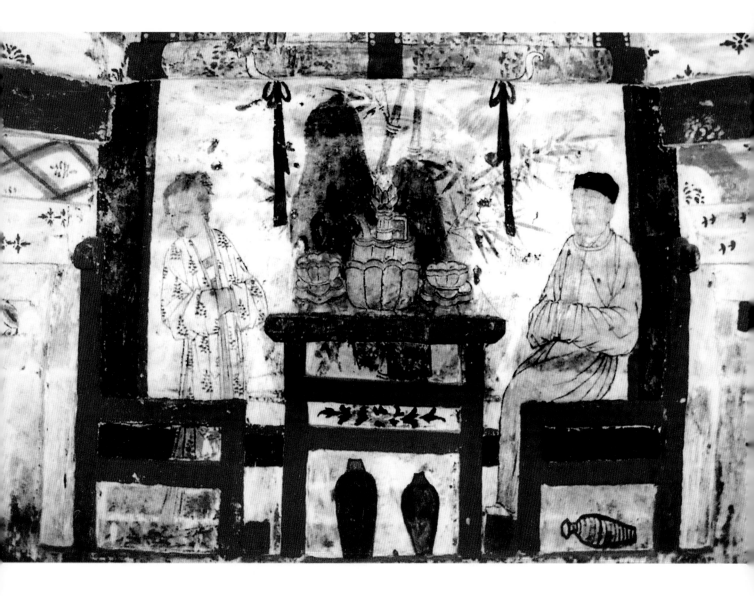

182. 夫妇对坐图

金（1115～1234年）

高约150、宽约196厘米

2001年山西省绛县城内村金墓出土。已残毁。

墓向190°。位于墓室西壁。竹帘悬挂下的当心间壁上为湖石、茂竹，砖砌一桌二椅，桌上摆放温碗注壶一副和托盏一对，桌下有一大一小梅瓶两件。左侧女主人袖手立于椅后；男主人双手拢袖于腹前坐于椅上，椅下一倾倒梅瓶。

（撰文、摄影：张惠祥）

Tomb Occupant Couple Seated Beside the Table

Jin (1115-1234 CE)

Height ca. 150 cm; Width ca. 196 cm

Unearthed from Jin tomb at Chengneicun in Jiangxian, Shanxi, in 2001. Not presreved.

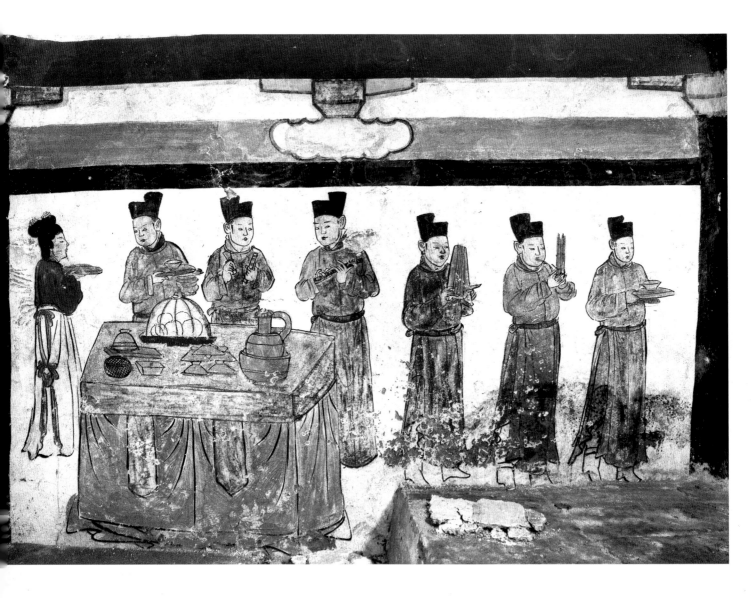

183.侍酒散乐图

金（1115～1234年）

高约150、宽约192厘米

1988年山西省大同市南郊（云中大学）1号金墓出土。现存于大同市博物馆。

墓向180°。位于墓室西壁。左边一高桌，有纱罩的食盘，内放瓜果，以及偏提、盏、钵等器物。其左侧一侍女捧一浅盘，一男侍端一盘盏。右侧四名乐人，左起一人双手持觱篥，第二人握一横笛，第三人拿一拍板，第四人抱一笙。再右边一男侍，端一盘盏。

（撰文：曹臣明　摄影：王银田）

Feast Waiters and Music Band

Jin (1115-1234 CE)

Height ca. 150 cm; Width ca. 192 cm

Unearthed from Jin Tomb M1 in southern suburbs of Datong (Yunzhong University), Shanxi, in 1988. Preserved in Datong Museum.

184. 论道图

金（1115～1234年）

高约121、宽约232厘米

2003年山西省闻喜县上院村金墓出土。现存于运城市博物馆。

墓向180°。位于墓室西壁。上方横楣、卷帘、垂幕，帷帐斜拢。当间一高桌，放置香炉、盏等，以及展开的书册（经卷）。桌后端坐着男主人，面向左侧，右手持一串念珠，两侧站立男、女侍从各一。桌旁侧坐的女主人拢袖于胸前，面向男主人。最右侧一侍女，端一果盘，盘中装瓜桃。此场景所表现的应与墓主人夫妇并坐，男持念珠，女持经卷的含义相同。

（撰文、摄影：张惠祥）

Discussing Scriptures

Jin (1115-1234 CE)

Height ca. 121 cm; Width ca. 232 cm

Unearthed from Jin tomb at Shangyuancun in Wenxi, Shanxi, in 2003. Preserved in Yuncheng Museum.

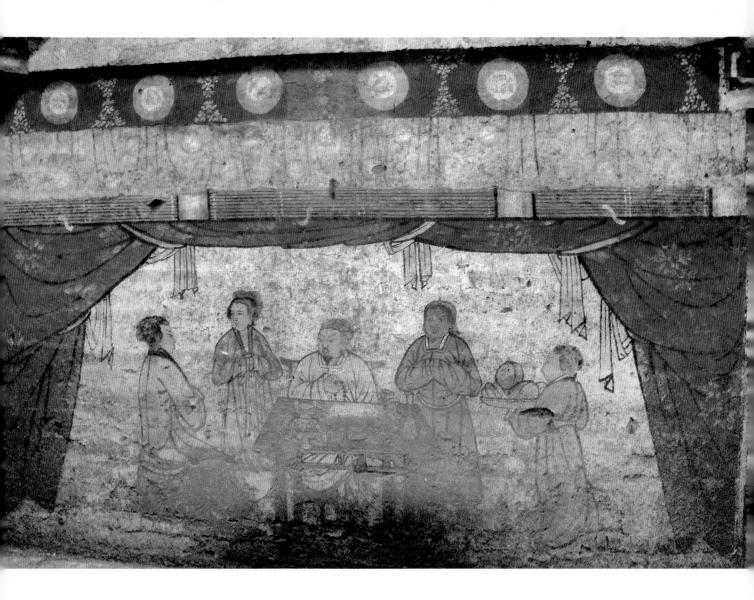

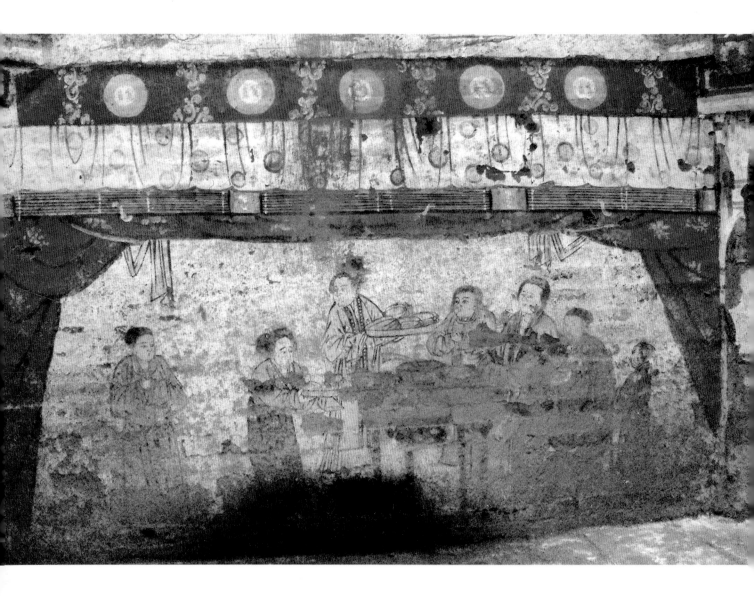

185.侍宴图

金（1115～1234年）

高约121、宽约232厘米

2003年山西省闻喜县上院村金墓出土。现存于运城市博物馆。

墓向180°。位于墓室东壁。上方横楣、卷帘、垂幕，帷帐斜拢。当间一高桌，摆满各种盛食的器皿，可见酒尊和勺。桌后右侧站立女主人，拢袖于胸前，两侧各站立一名侍仆，侍仆后立一侍女；左侧两侍女托装有瓜果的果盘。左侧一名拱手站立的道姑，似人正在与女主人说话。

<div align="right">（撰文、摄影：张惠祥）</div>

Serving Dinner

Jin (1115-1234 CE)

Height ca. 121 cm; Width ca. 232 cm

Unearthed from Jin tomb at Shangyuancun in Wenxi, Shanxi, in 2003. Preserved in Yuncheng Museum.

186.高逸图

金（1115～1234年）

高约52、宽约86厘米

2007年山西省孝义市南郊八家庄58号金墓出土。已残毁。

墓向80°。位于墓室西南壁。四边有黑框，左侧有太湖石、翠竹映衬，右侧为山石、大树。正中一位老者，执杖向左，步行；一仆童，双手抱琴，紧随其后。

<div align="right">（撰文、摄影：畅红霞）</div>

Hermit

Jin (1115-1234 CE)

Height ca. 52 cm; Width ca. 86 cm

Unearthed from Jin Tomb M58 at Bajiazhuang in southern suburbs of Xiaoyi, Shanxi, in 2007. Not presreved.

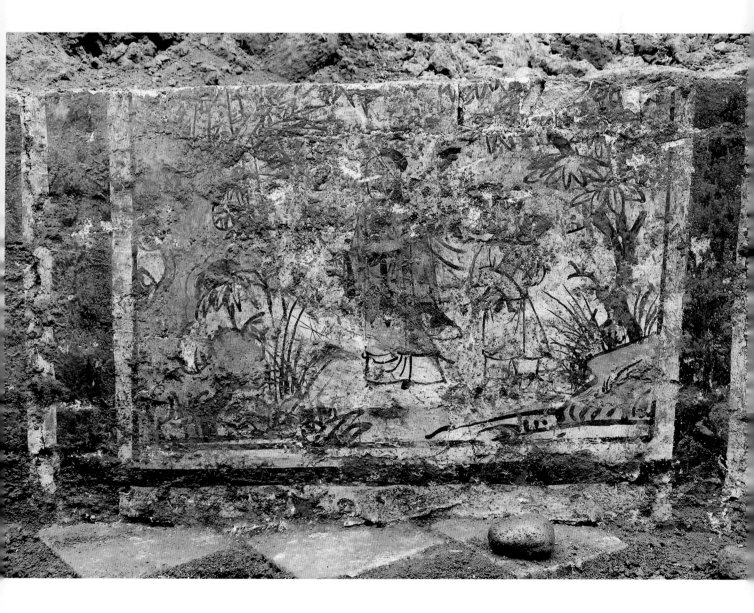

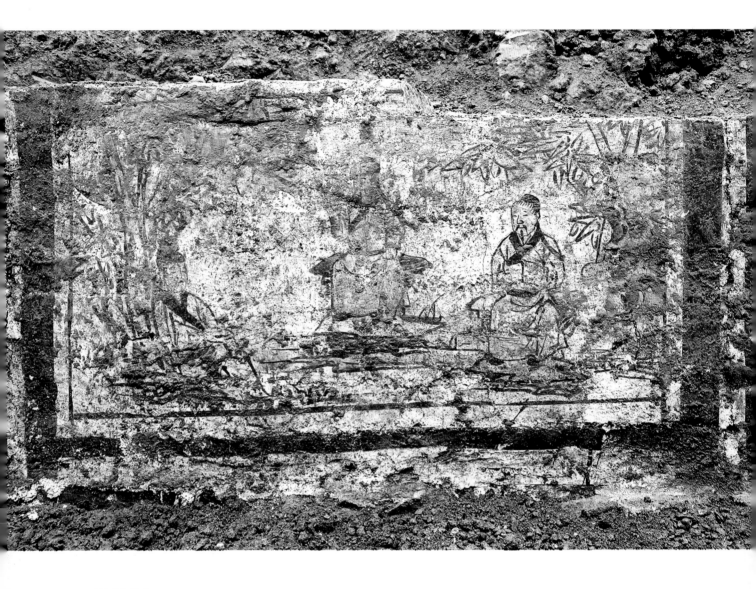

187. 说法图

金（1115～1234年）

高约52、宽约100厘米

2007年山西省孝义市南郊八家庄58号金墓出土。已残毁。

墓向80°。位于墓室南壁。画幅四边有黑框，正中就地端坐一位老者，左臂倚腿，右手比划；左侧一男子背靠大树、盘坐，似有所思；右侧一男子侧坐，袖手于胸前；旁有太湖石、翠竹。

（撰文、摄影：畅红霞）

Preaching

Jin (1115-1234 CE)

Height ca. 52 cm; Width ca. 100 cm

Unearthed from Jin Tomb M58 at Bajiazhuang in southern suburbs of Xiaoyi, Shanxi, in 2007. Not presreved.

188.品果图

金（1115～1234年）

高约52、宽约80厘米

2007年山西省孝义市南郊八家庄58号金墓出土。已残毁。

墓向80°。位于墓室东南壁。四边有10厘米宽的黑框，背景为翠竹，两侧太湖石，画面偏左有一方桌，摆放水果；一名男性正襟端坐于桌后，其右侧一妇人端一果盘，作服侍状。

（撰文、摄影：畅红霞）

Serving Fruits

Jin (1115-1234 CE)

Height ca. 52 cm; Width ca. 80 cm

Unearthed from Jin Tomb M58 at Bajiazhuang in southern suburbs of Xiaoyi, Shanxi, in 2007. Not presreved.

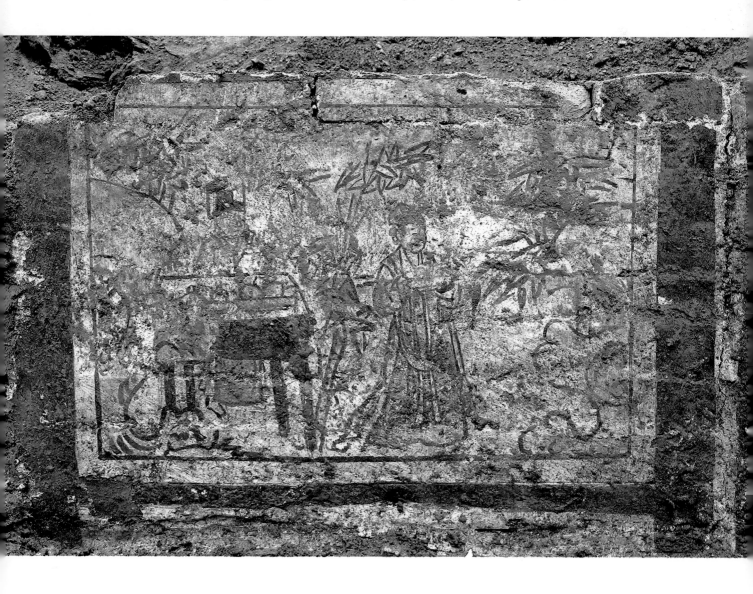

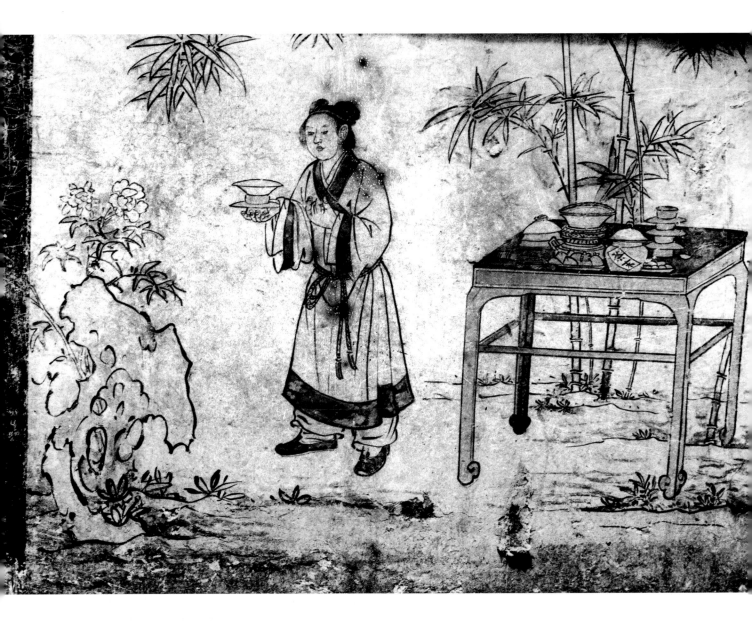

189.奉茶图

元至元二年（1265年）

高约118、宽约152厘米

1958年山西省大同市元代冯道真墓出土。已残毁。

墓向188°。位于墓室东壁南侧。左边一虎眼石及牡丹花，右边几株毛竹，竹前为陈列茶具的方桌，贴有"茶末"标签的盖罐。倒置的茶盏、茶筅、叠摞的盏托、托盘、桃果等。中间站立一道童，左手握物于胸前，右手端一茶盏并托盏向前递出。

<div align="right">（撰文：王利民　摄影：解廷琦）</div>

Serving Tea

2nd Year of Zhiyuan Era, Yuan (1265 CE)

Height ca. 118 cm; Width ca. 152 cm

Unearthed from Feng Daozhen's tomb of Yuan dynasty in Datong, Shanxi, in 1958. Not preserved.

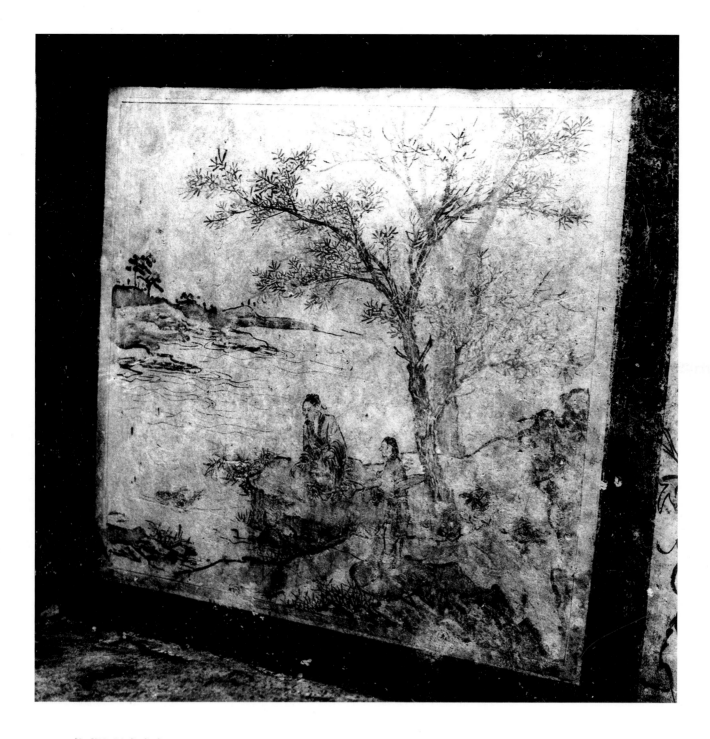

190. 临渊观鱼图

元至元二年（1265年）

高约91、宽约96厘米

1958年山西省大同市元代冯道真墓出土。已残毁。

墓向188°。位于墓室东壁北侧。左侧远山叠嶂、河水涟漪，右侧河岸陡峭、翠柏茂盛。一老者坐于大石之上，俯视河中的游鱼；旁边一侍童，挟带一琴。

（撰文：王利民　摄影：解廷琦）

Watching Fish on the Brook Bank

2nd Year of Zhiyuan Era, Yuan (1265 CE)

Height ca. 91 cm; Width ca. 96 cm

Unearthed from Feng Daozhen's tomb of Yuan dynasty in Datong, Shanxi, in 1958. Not preserved.

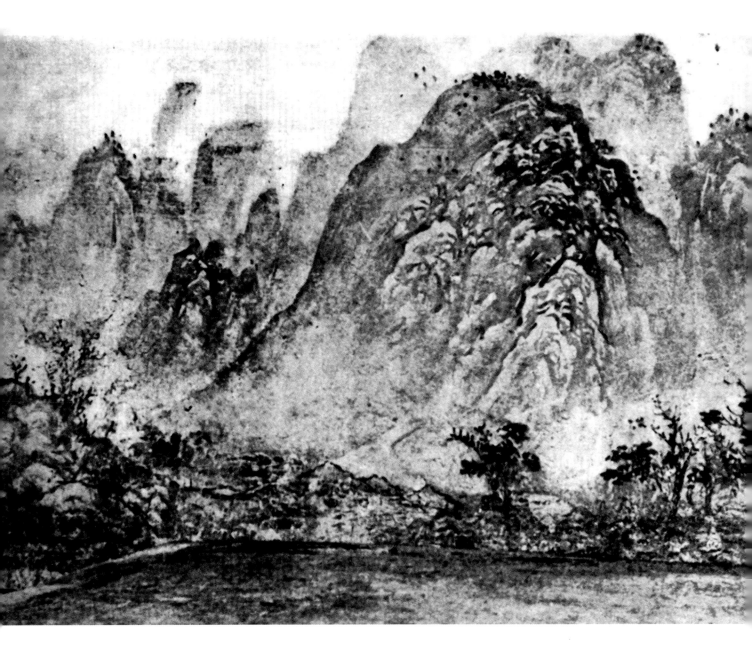

191.疎林晚照图

元至元二年（1265年）

高约91、宽约270厘米

1958年山西省大同市元代冯道真墓出土。已残毁。

墓向188°。位于墓室北壁。群峰叠翠，云雾缭绕；山脚下树木成林，大河浩荡，远有舟，近有屋，还有拉纤的农人。画面右上处有墨题："疎林晚照"。

<div align="right">（撰文：王利民　摄影：解廷琦）</div>

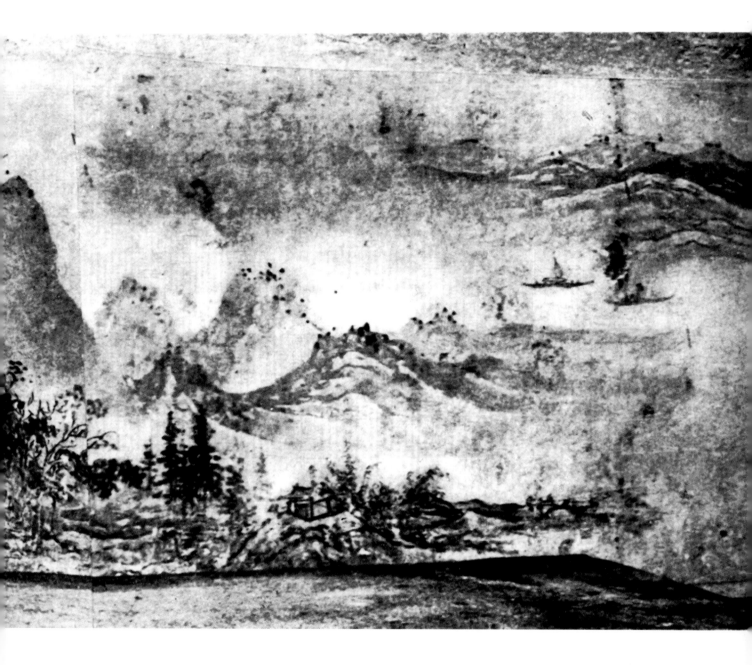

Landscape of "Sparse Forest in the Evening Glow"

2nd Year of Zhiyuan Era, Yuan (1265 CE)

Height ca. 91 cm; Width ca. 270 cm

Unearthed from Feng Daozhen's tomb of Yuan dynasty in Datong, Shanxi, in 1958. Not preserved.

192.侍女备酒图

元至元十三年（1276年）

高约159、宽约176厘米

2004年山西省屯留县康庄村2号元墓出土。现存于长治市博物馆。

墓向180°。位于墓室西壁。壁画有黑色边框，左侧有一高桌，桌上放置盖罐、碗、杯、劝盘、酒尊及酒杓、马盂等。两名侍女站立于桌前，皆头梳红色花髻，身着红、黄色罗裙，一人持壶，另一人手捧劝盘。画面左上部有墨书题记"此位韩汝翼居中"。

（撰文、摄影：杨林中　王进先　李永杰）

Maids Serving Wine

13th Year of Zhiyuan Era, Yuan (1276 CE)

Height ca. 159 cm; Width ca. 176 cm

Unearthed from Yuan Tomb M2 at Kangzhuangcun in Tunliu, Shanxi, in 2004. Preserved in Changzhi Museum.

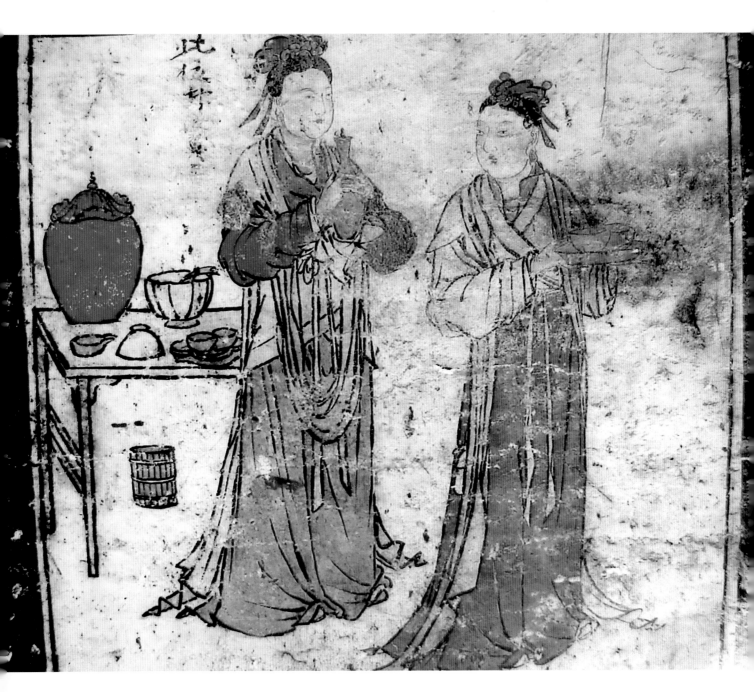

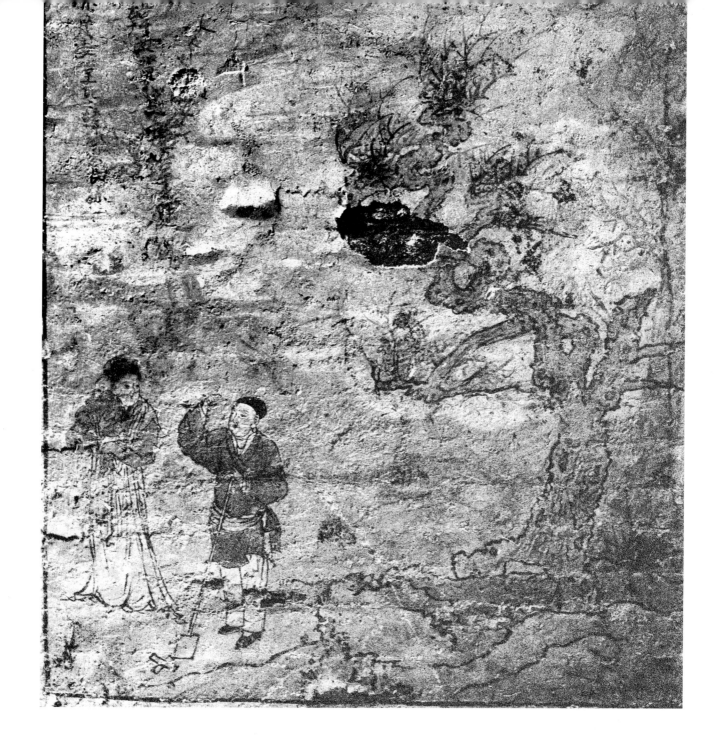

193.郭巨行孝图

元至元十三年（1276年）

高约151、宽约149厘米

2004年山西省屯留县康庄村2号元墓出土。现存于长治市博物馆。

墓向180°。位于墓室西壁北侧。远山、古松；左侧站立一妇女，头梳高髻，怀抱幼子，其旁有一男子，头裹黑巾，左手持铁锹，右手抬起拭汗。画面左上方有墨书题记，字迹漫漶不清，略可分辩为"此位韩□□□□韩庭□□是□堂主韩赟长孙"。

（撰文、摄影：杨林中　王进先　李永杰）

Guo Ju, One of the "Twenty-Four Paragons of Filial Piety"

13th Year of Zhiyuan Era, Yuan (1276 CE)

Height ca. 151 cm; Width ca. 149 cm

Unearthed from Yuan Tomb M2 at Kangzhuangcun in Tunliu, Shanxi, in 2004. Preserved in Changzhi Museum.

194.侍女备茶图

元至元十三年（1276年）

高约159、宽约146厘米

2004年山西省屯留县康庄村2号元墓出土。现存于长治市博物馆。

墓向180°。位于墓室东壁上。壁画有黑色边框，右侧有一高桌，桌上放置酒尊罐、碗、盏托等。两名侍女立于桌后，皆头梳包髻，身着黄、红色罗裙，一持注子，一持茶盏，茶筅击拂，后有一盘石磨。画面右上方有墨书题记，字迹漫漶不清，略可分辨为"此位□堂□□韩赟□五子□至元□"。

<div align="right">（撰文、摄影：杨林中　王进先　李永杰）</div>

Maids Serving Tea

13th Year of Zhiyuan Era, Yuan (1276 CE)

Height ca. 159 cm; Width ca. 146 cm

Unearthed from Yuan Tomb M2 at Kangzhuangcun in Tunliu, Shanxi, in 2004. Preserved in Changzhi Museum.

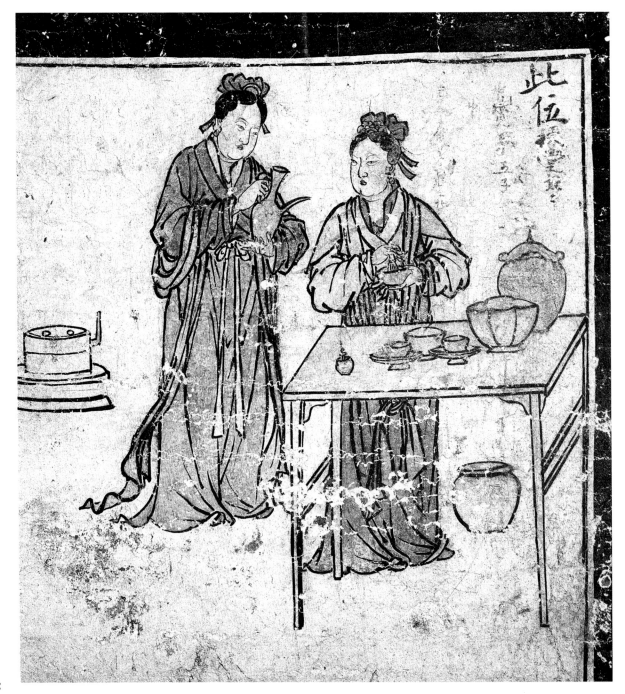

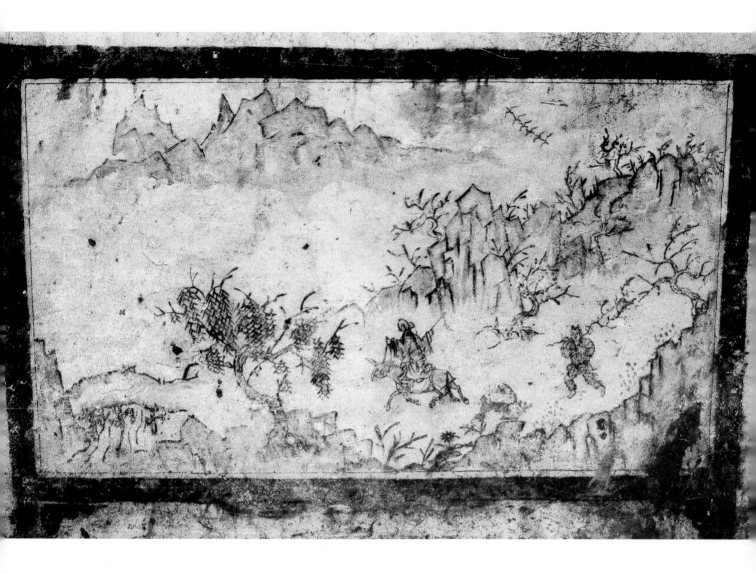

195.隐逸图（一）

元大德二年（1298年）

高约52、宽约98厘米

1986年山西省大同市齿轮厂1号元墓出土。已残毁。

墓向179°。位于墓室东壁北侧（屏风画）。天空中一行飞雁，远山逶迤，山间小路的左侧一小桥，一柳树，主仆二人左行。主人骑驴，返身扬鞭；一仆，荷一梅枝，急急追赶。

（撰文：曹臣明　摄影：周雪松）

Hermit and Attendant (1)

2nd Year of Dade Era, Yuan (1298 CE)

Height ca. 52 cm; Width ca. 98 cm

Unearthed from Yuan Tomb M1 at Gear Factory in Datong, Shanxi,in 1986. Not preserved.

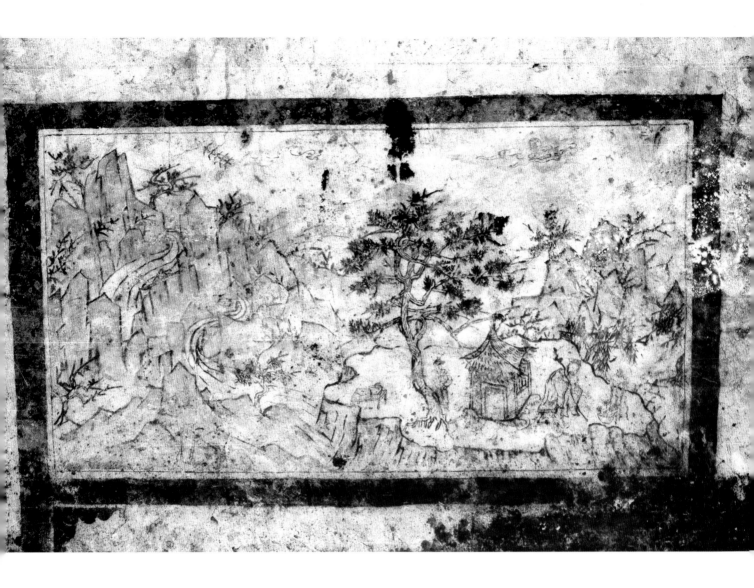

196.隐逸图（二）

元大德二年（1298年）

高约52、宽约98厘米

1986年山西省大同市齿轮厂1号元墓出土。已残毁。

墓向179°。位于墓室北壁西侧。在黑色边框的屏风画内，左侧高山、湍流，右侧一绝壁的平台。平台中间一株松树，左边一方桌，树下一小童；一间茅屋，右侧一持杖的老翁，面前有盆花等物。

<div align="right">（撰文：曹臣明　摄影：周雪松）</div>

Hermit and Attendant (2)

2nd Year of Dade Era, Yuan (1298 CE)

Height ca. 52 cm; Width ca. 98 cm

Unearthed from Yuan Tomb M1 at Gear Factory in Datong, Shanxi,in 1986. Not preserved.

197.隐逸图（三）

元大德二年（1298年）

高约52、宽约78厘米

1986年山西省大同市齿轮厂1号元墓出土。已残毁。

墓向179°。墓室北壁东侧。在黑色边框的屏风画内，右侧一壁高山，一汪池塘，荷花开放，白鹅游荡；左侧池岸上有一茅屋，一老翁执麈尾一柄，其身后有一持杖的小童。

（撰文：曹臣明　摄影：周雪松）

Hermit and Attendant (3)

2nd Year of Dade Era, Yuan (1298 CE)

Height ca. 52 cm; Width ca. 78 cm

Unearthed from Yuan Tomb M1 at Gear Factory in Datong,Shanxi, in 1986. Not preserved.

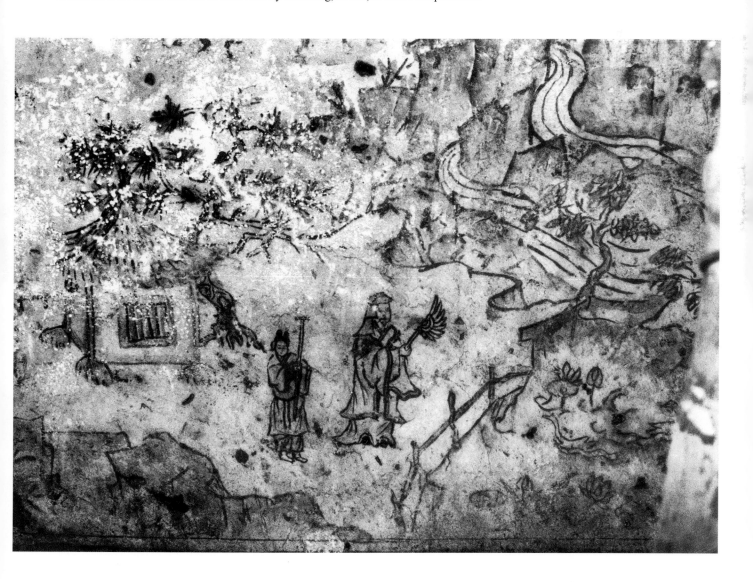

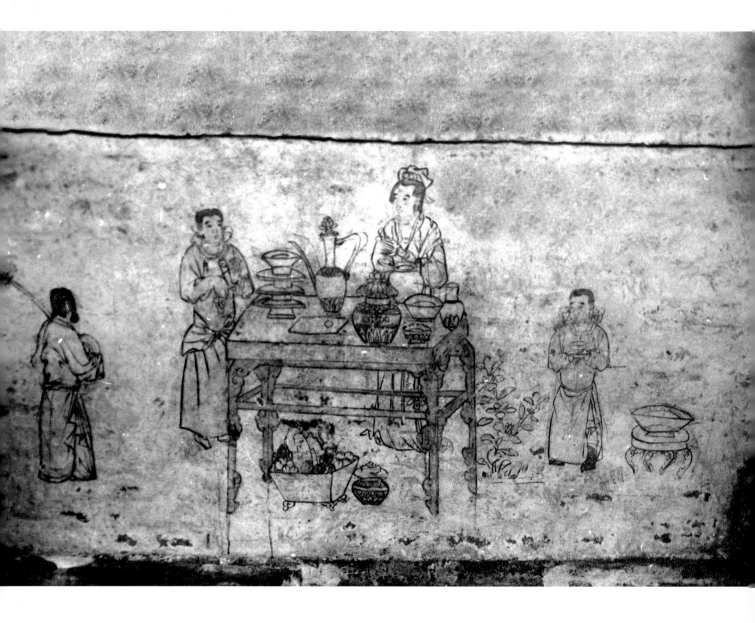

198.备茶图

元大德二年（1298年）

高约104、宽约290厘米

1986年山西省大同市齿轮厂 1 号元墓出土。已残毁。

墓向179°。位于墓室东壁。中部一长桌，摆放盏托、注壶、盖罐等；桌下一斗形盆装满瓜果等、一盖罐，其右侧有一株花草。左侧一女伎背身，抱一二弦琴；桌旁站立两名持物的侍女，右侧一女童端一盏托，旁边置一盆架，上置一盒。

（撰文：曹臣明　摄影：赵岐）

Preparing Tea

2nd Year of Dade Era, Yuan (1298 CE)

Height ca. 104 cm; Width ca. 290 cm

Unearthed from Yuan Tomb M1 at Gear Factory in Datong, Shanxi, in 1986. Not preserved.

199.温酒图

元大德二年（1298年）

高约104、宽约290厘米

1986年山西省大同市齿轮厂 1 号元墓出土。已残毁。

墓向179°。位于墓室西壁。中部一长桌，摆放酒樽及长柄勺、盏托、盖罐等，其左侧一株花草，一盆架上置一盆，还站立一女童，袖手于胸前。桌前两名女婢跽地对坐，其间有一斗形炭火盆，内放一汤瓶，盆后有二酒坛。桌后一侍女端一托盏，桌右侧一女童端一托盏。

<div align="right">（撰文：曹臣明　摄影：赵岐）</div>

Warming up Wine

2nd Year of Dade Era, Yuan (1298 CE)

Height ca. 104 cm; Width ca. 290 cm

Unearthed from Yuan Tomb M1 at Gear Factory in Datong, Shanxi, in 1986. Not preserved.

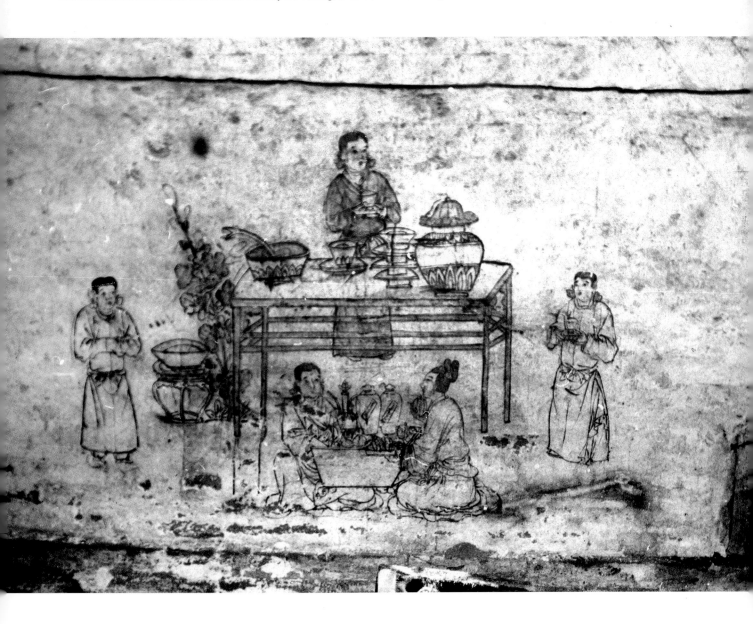

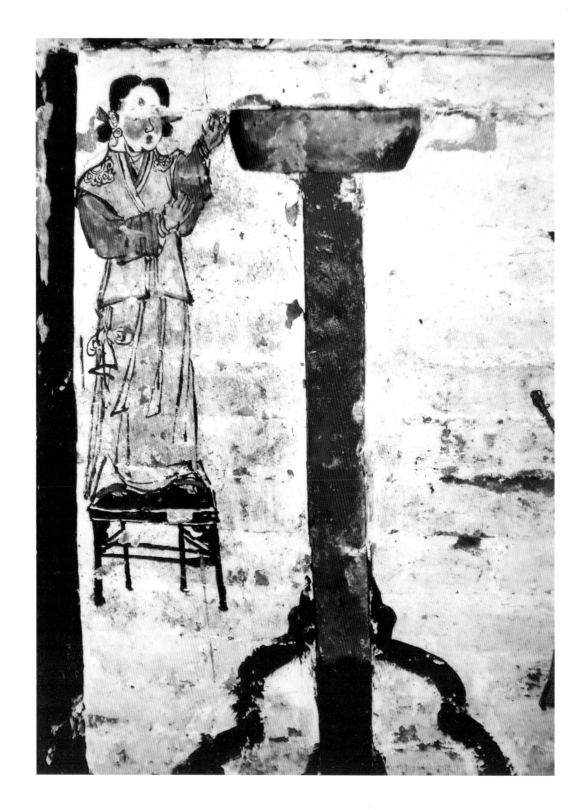

200. 侍女灯檠图

元大德十年（1306年）

高约110、宽约50厘米

2004年山西省屯留县康庄村（工业园区）1号元墓出土。现存于长治市博物馆。

墓向176°。位于墓室南壁东侧。墓壁上砖雕砌作一高大的如意底座灯檠，左侧一名侍女，头梳双髻，身着红衣，外套绿色背衫，下穿灰白色裙，踩踏着一木凳，正在拨灯捻。

（撰文、摄影：杨林中）

Maid Picking the Lamp Wick

10th Year of Dade Era, Yuan (1306 CE)

Height ca. 110 cm; Width ca. 50 cm

Unearthed from Yuan Tomb M1 at Kangzhuangcun (industrial park) in Tunliu, Shanxi, in 2004. Preserved in Changzhi Museum.

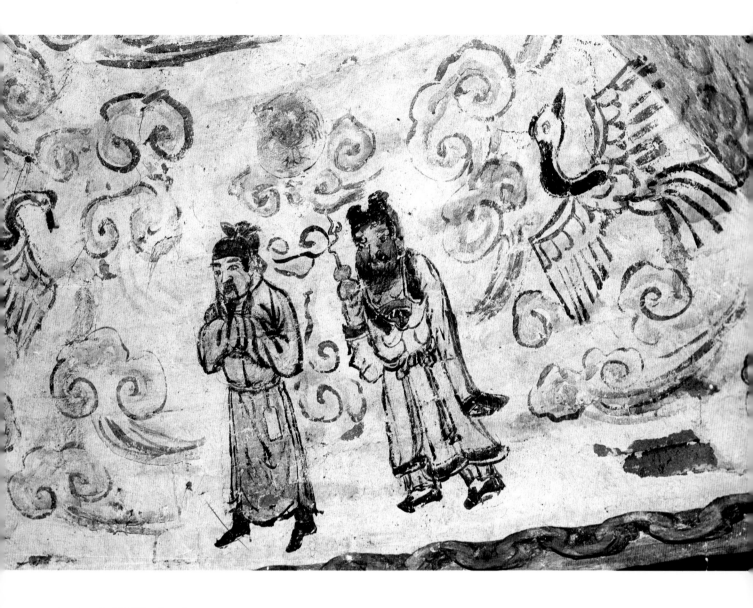

201. 八仙图（一）

元大德十年（1306年）

高约55、宽约80厘米

2004年山西省屯留县康庄村（工业园区）1号元墓出土。现存于长治市博物馆。

墓向176°。位于墓室拱券顶东侧壁的下沿处。为道教传说中的八位神仙，第一段从左到右画面排列为：曹国舅、汉钟离。其四周皆为流云、仙鹤。

（撰文、摄影：杨林中　王进先）

Figures of the "Eight Immortals" (1)

10th Year of Dade Era, Yuan (1306 CE)

Height ca. 55 cm; Width ca. 80 cm

Unearthed from Yuan Tomb M1 at Kangzhuangcun (industrial park)in Tunliu, Shanxi, in 2004. Preserved in Changzhi Museum.

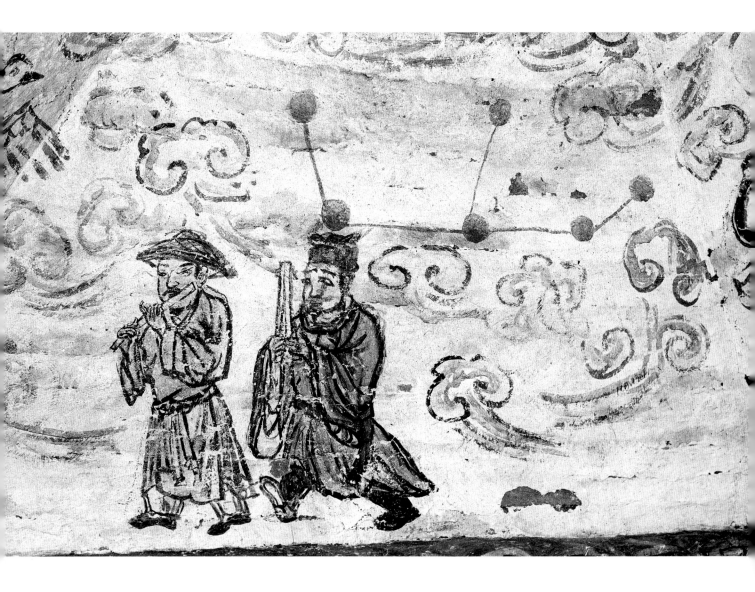

202. 八仙图（二）

元大德十年（1306年）

高约55、宽约88厘米

2004年山西省屯留县康庄村（工业园区）1号元墓出土。现存于长治市博物馆。

墓向176°。位于墓室拱券顶南侧壁的下沿处。为道教传说中的八位神仙，第二段画从左到右面排列为：韩湘子、蓝采和。其四周皆为流云、仙鹤。

<div align="right">（撰文、摄影：杨林中　王进先）</div>

Figures of the "Eight Immortals" (2)

10th Year of Dade Era, Yuan (1306 CE)

Height ca. 55 cm; Width ca. 88 cm

Unearthed from Yuan Tomb M1 at Kangzhuangcun (industrial park)in Tunliu, Shanxi, in 2004. Preserved in Changzhi Museum.

203.八仙图（三）

元大德十年（1306年）

高约55、宽约80厘米

2004年山西省屯留县康庄村（工业园区）1号元墓出土。现存于长治市博物馆。

墓向176°。位于墓室拱券顶北侧壁的下沿处。为道教传说中的八位神仙，第三段画面从左到右排列为：铁拐李、吕洞宾。其四周皆为流云、仙鹤。

<div align="right">（撰文、摄影：杨林中　王进先）</div>

Figures of the "Eight Immortals" (3)

10th Year of Dade Era, Yuan (1306 CE)

Height ca. 55 cm; Width ca. 80 cm

Unearthed from Yuan Tomb M1 at Kangzhuangcun (industrial park)in Tunliu, Shanxi, in 2004. Preserved in Changzhi Museum.

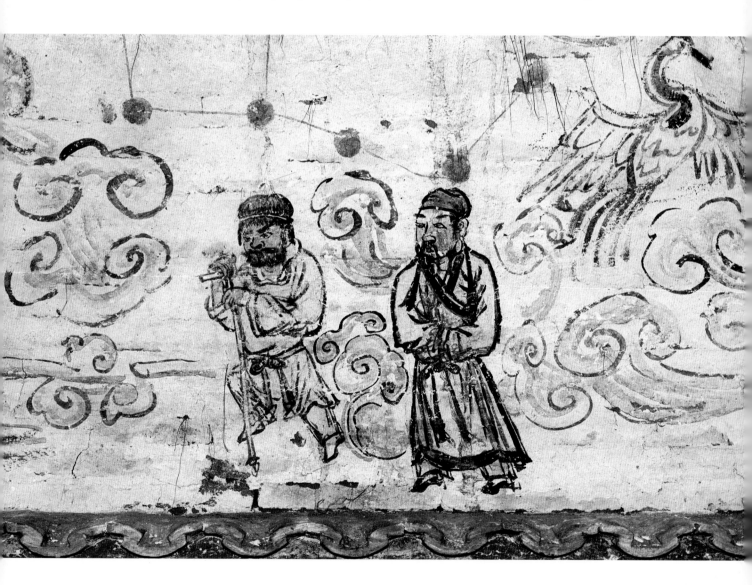

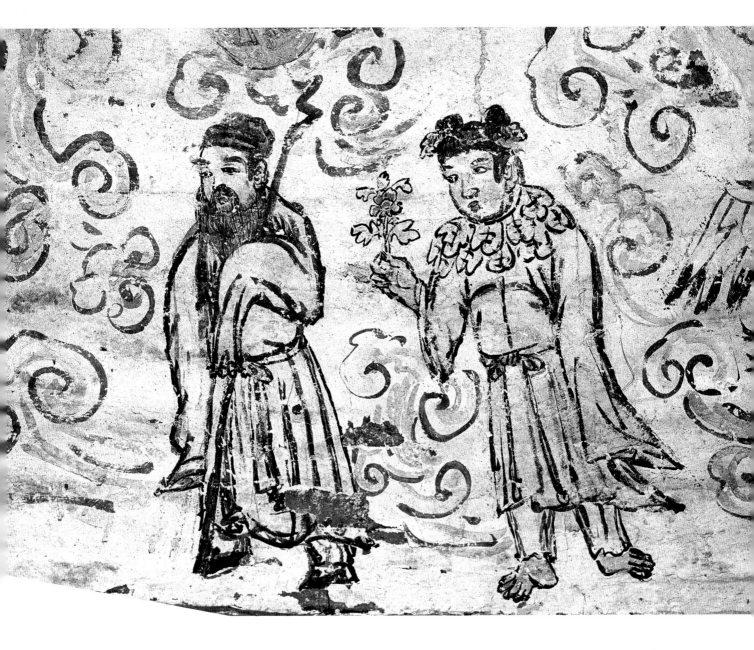

204. 八仙图（四）

元大德十年（1306年）

高约55、宽约88厘米

2004年山西省屯留县康庄村（工业园区）1号元墓出土。现存于长治市博物馆。

墓向176°。位于墓室拱券顶西侧壁的下沿处。为道教传说中的八位神仙，第四段画面从左到右排列为：张果老、何仙姑。其四周皆为流云、仙鹤。

（撰文、摄影：杨林中　王进先）

Figures of the "Eight Immortals" (4)

10th Year of Dade Era, Yuan (1306 CE)

Height ca. 55 cm; Width ca. 88 cm

Unearthed from Yuan Tomb M1 at Kangzhuangcun (industrial park)in Tunliu, Shanxi, in 2004. Preserved in Changzhi Museum.

205. 男侍图

元大德十一年（1307年）

高约71、宽约50厘米

1983年山西省长治市捉马村元墓出土。已残毁。

墓向180°。位于墓室西壁南侧。一男侍，戴笠帽，着长袍，手持茶盏。

（撰文、摄影：王进先）

Servant

11th Year of Dade Era, Yuan (1307 CE)

Height ca. 71 cm; Width ca. 50 cm

Unearthed from Yuan tomb at Zhuomacun in Changzhi, Shanxi, in 1983. Not preserved.

206.侍女图

元大德十一年（1307年）

高约71、宽约50厘米

1983年山西省长治市捉马村元墓出土。已残毁。

墓向180°。位于墓室东壁南侧。一女侍，着交领长袍，双手捧一玉壶春瓶。

（撰文、摄影：王进先）

Maid

11th Year of Dade Era, Yuan (1307 CE)

Height ca. 71 cm; Width ca. 50 cm

Unearthed from Yuan tomb at Zhuomacun in Changzhi, Shanxi, in 1983. Not preserved.

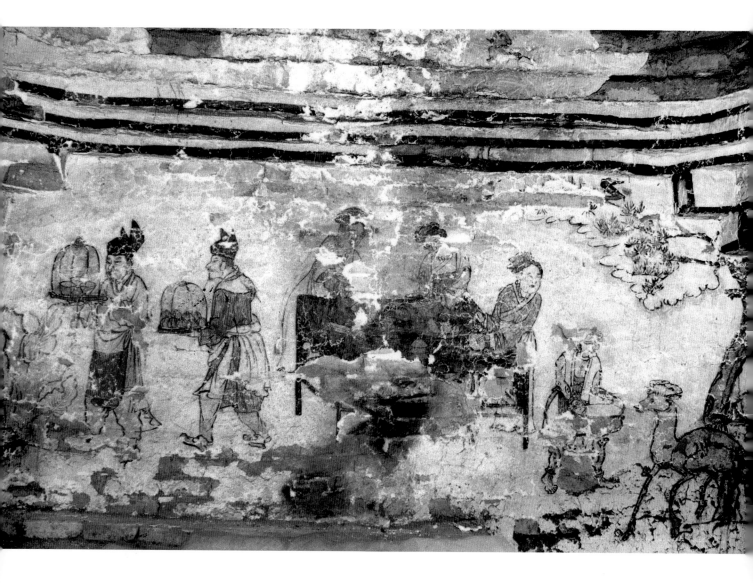

207. 备宴图

元大德年间（1297～1306年）

高约105、宽约210厘米

1995年山西省朔州市西关小康村元墓出土。已残毁。

墓向185°。位于墓室东壁。左边一怪石、右边一柏树，中间摆放一大方桌，有各样食品、食具。左侧二男仆，端着笼盖的食案，左行；在大方桌的后面，三名女仆正在忙碌；右侧，一女童正在给一鹿喂食。

（撰文、摄影：雷云贵）

Preparing for Feast

Dade Era, Yuan (1297-1306 CE)

Height ca. 105 cm; Width ca. 210 cm

Unearthed from Yuan tomb at Xiaokangcun in Shouzhou, Shanxi, in 1995. Not preserved.

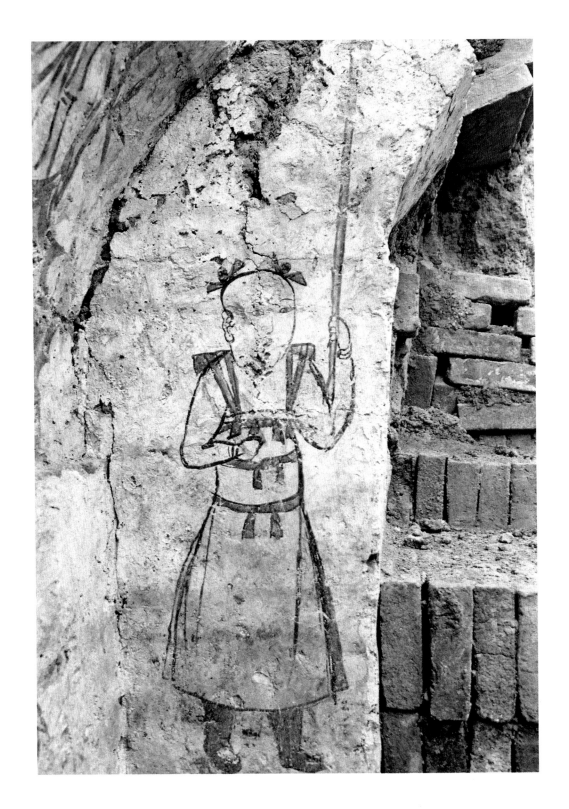

208.门童图

元（1206～1368年）

高约52、宽约26厘米

1986年山西省运城市西里庄元墓出土。现存于山西省考古研究所。墓向180°。位于墓室南壁东侧。男童头顶双髻，赤膊，肩背一卷状物，穿长裙，胸腹上系三条扎带，蹬靴；手腕带镯，右拳置于胸前，左手举起一"T"形长杆。

（撰文：商彤流　摄影：梁子明）

Door Boy

Yuan (1206-1368 CE)

Height ca. 52 cm; Width ca. 26 cm

Unearthed from Yuan tomb at Xilizhuang in Yuncheng, Shanxi, in 1986. Preserved in the Institute of Archeology in Shanxi.

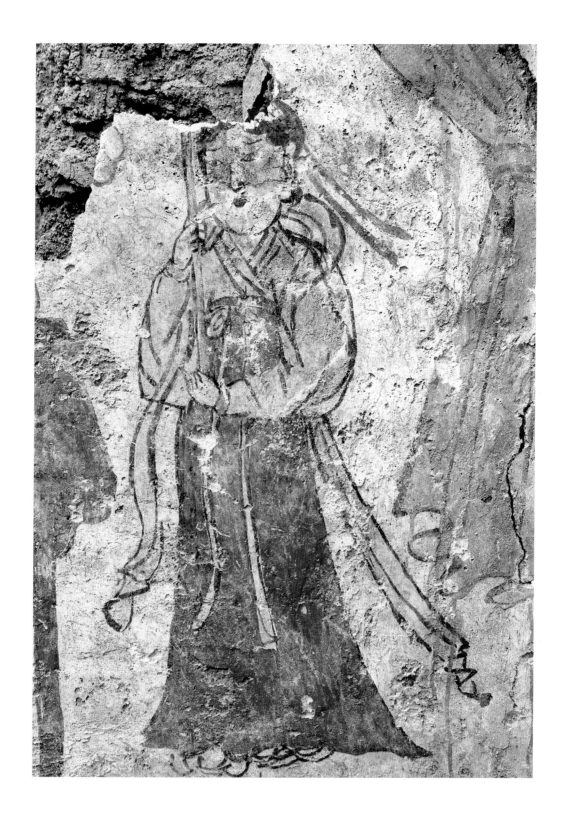

209.侍女图

元（1206～1368年）

高约51、宽约30厘米

1986年山西省运城市西里庄元墓出土。现存于山西省考古研究所。墓向180°。位于墓室北壁东侧。女子头顶双髻，身穿交领短衣，肩披长帛，腰扎长裙，蹬云头履；双手持一长柄物件于胸前。似为墓主夫妇并坐图右边站立的侍女。

（撰文：商彤流　摄影：梁子明）

Maid

Yuan (1206-1368 CE)

Height ca. 51 cm; Width ca. 30 cm
Unearthed from Yuan tomb at Xilizhuang in Yuncheng, Shanxi, in 1986. Preserved in the Institute of Archeology in Shanxi.

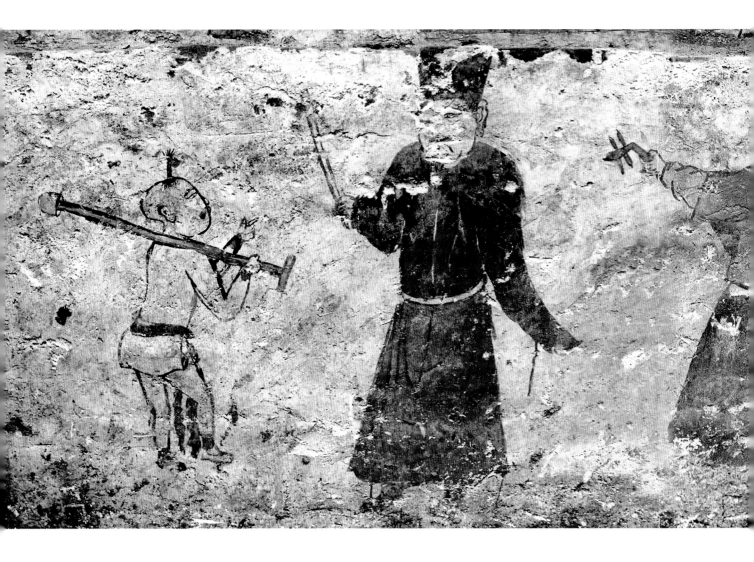

210.伎乐图

元代（1206～1368年）

高约78、宽约230厘米

1986年山西省运城市西里庄元墓出土。现存于山西省考古研究所。

墓向180°。位于墓室东壁。左起一人是男童，左手前指，右手持一长杆槌头扛在右肩上；第二人右手举一短杆，左手向身后甩袖；第三人为女性，背身站立，弹拨琵琶；第四人吹奏横笛；第五人双手持槌击扁鼓；第六人为女子，双手持拍板。

<div style="text-align:right">（撰文：商彤流　摄影：梁子明）</div>

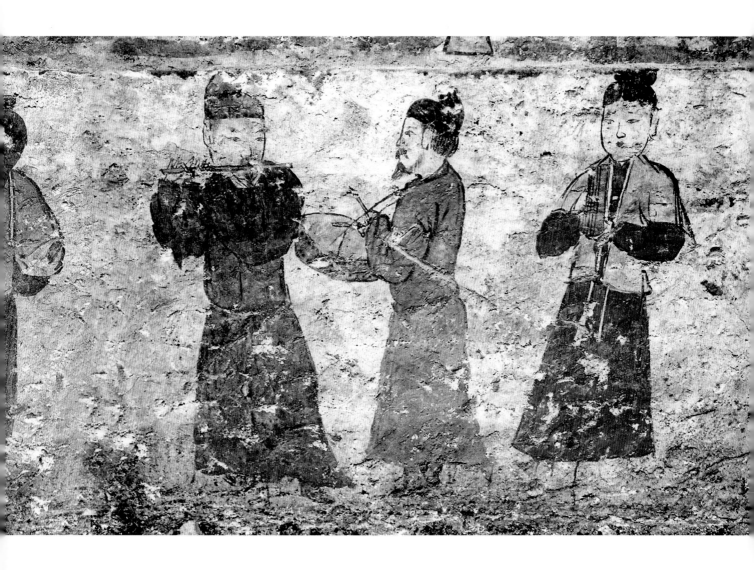

Music Band Playing

Yuan (1206-1368 CE)

Height ca. 78 cm; Width ca. 230 cm

Unearthed from Yuan tomb at Xilizhuang in Yuncheng, Shanxi, in 1986. Preserved in the Institute of Archeology in Shanxi.

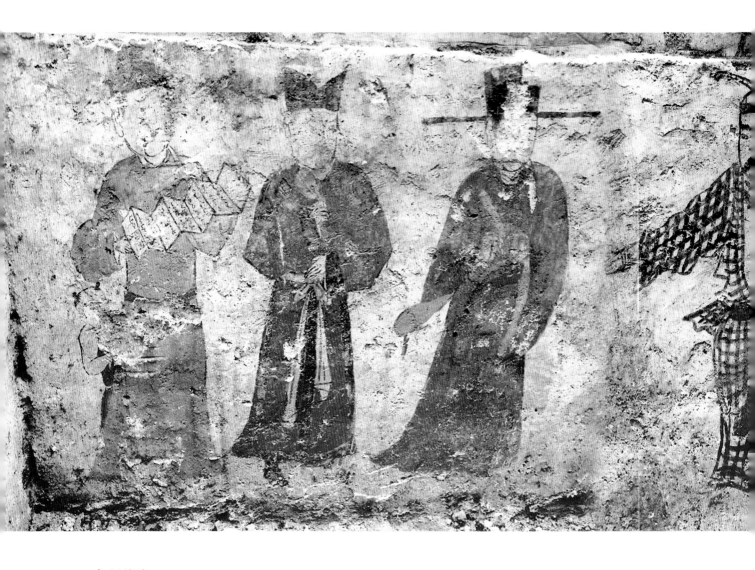

211.杂剧图

元（1206～1368年）

高约78、宽约230厘米

1986年山西省运城市西里庄元墓出土。现存于山西省考古研究所。

墓向180°。位于墓室西壁。左起一人双手持展一戏折，剧目楷书《风雪奇》三字，右腰侧露出一孩童；第二人右手举小扇，左手置于腹部；第三人戴展脚幞头，双手持笏板拱于胸前；第四人头顶竖辫、扎带，面颊一墨线，袒胸，穿方格衫，是演丑角的"副净色"；第五人为女性，两手持拍板。右侧一高桌，摆放水果。

<div align="right">（撰文：商彤流　摄影：梁子明）</div>

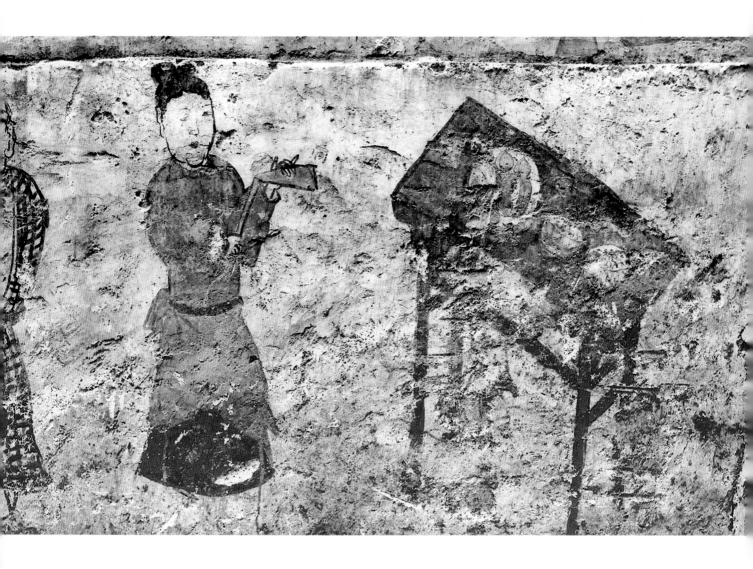

Drama Performance Scene

Yuan (1206-1368 CE)

Height ca. 78 cm; Width ca. 230 cm

Unearthed from Yuan tomb at Xilizhuang in Yuncheng, Shanxi, in 1986. Preserved in the Institute of Archeology in Shanxi.

212. 儿童启门图

元（1206～1368年）

高约120、宽约55厘米

1984年山西省长治市郝家村元墓出土。已残毁。

墓向183°。位于墓室东壁南侧。墓壁上绘画出半开的格扇门，当间站立有一儿童，正在向外探望。

（撰文、摄影：杨林中）

Boy Opening Door Ajar

Yuan (1206-1368 CE)

Height ca. 120 cm; Width ca. 55 cm

Unearthed from Yuan tomb at Hao-jiacun in Changzhi, Shanxi, in 1984. Not preserved.

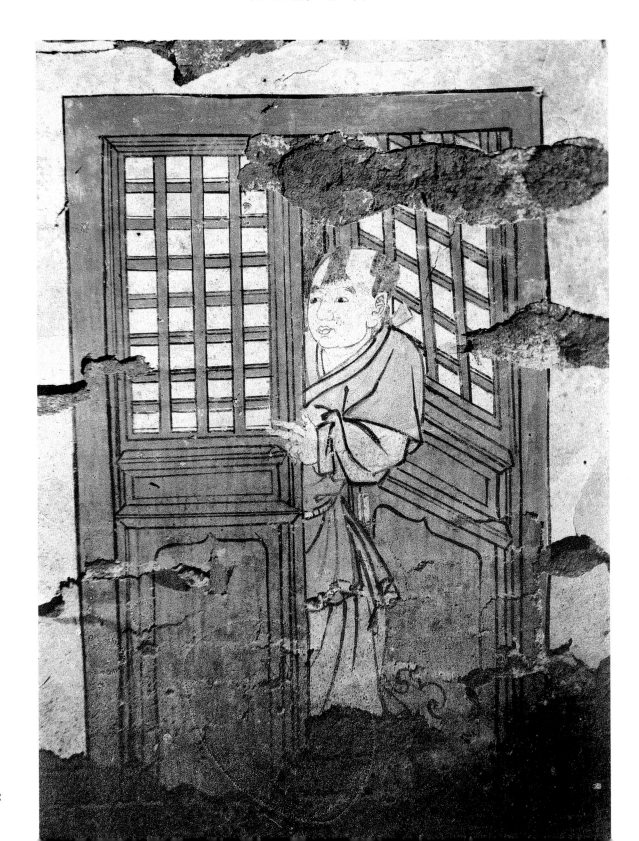

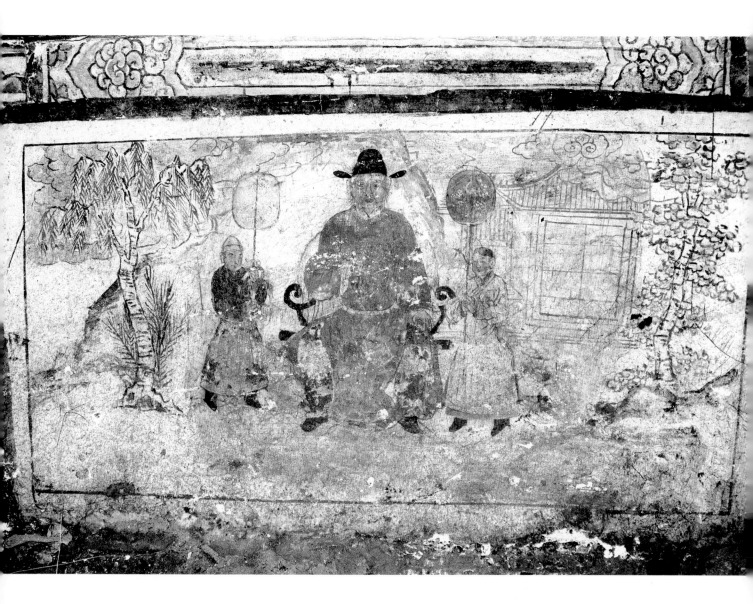

213. 主人神位图

元（1206～1368年）

高约111、宽约144厘米

1999年山西省沁源县东王勇村元墓出土。已残毁。

墓向210°。位于墓室北壁。墓主人头戴黑色幞头，身穿红色圆领窄袖袍服，下着绿色长裤，脚穿黑色靴；正面端坐于交椅上；一男一女手持高柄团扇，分两侧站。左侧分别有山、树，右侧为屋、树。

（撰文、摄影：王进先、王小红）

Portrait of Tomb Occupant

Yuan (1206-1368 CE)

Height ca. 111 cm; Width ca. 144 cm

Unearthed from Yuan tomb at Wangyongcun in Qinyuan, Shanxi, in 1999. Not preserved.

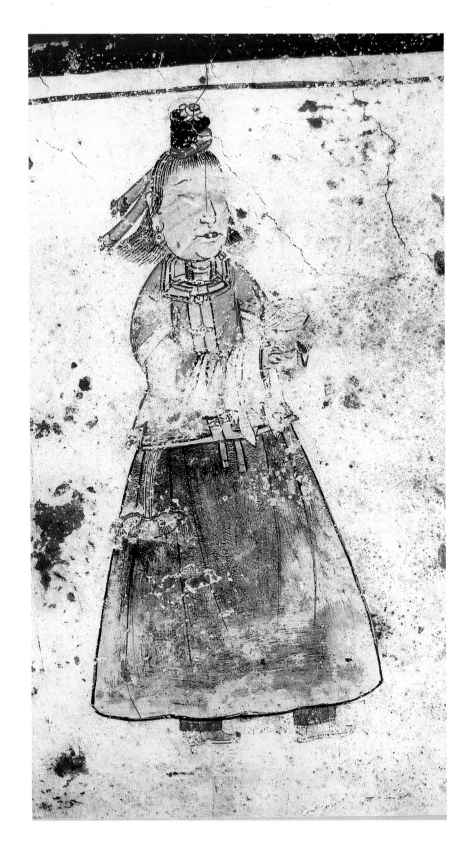

214.侍女图

明嘉靖九年（1530年）

高约114、宽约57厘米

2006年山西省壶关县集店村明墓出土。已残毁。

墓向210°。位于墓室西壁北侧。明代墓室壁画比较少见，从侍女服饰和绘画风格看，还保留有元人的风格与习俗。

（撰文、摄影：王进先、李永杰）

Maid

9th Year of Jiajing Era, Ming (1530 CE)
Height ca. 114 cm; Width ca. 57 cm
Unearthed from Ming tomb at Jidiancun in Huguan, Shanxi, in 2006. Not preserved.

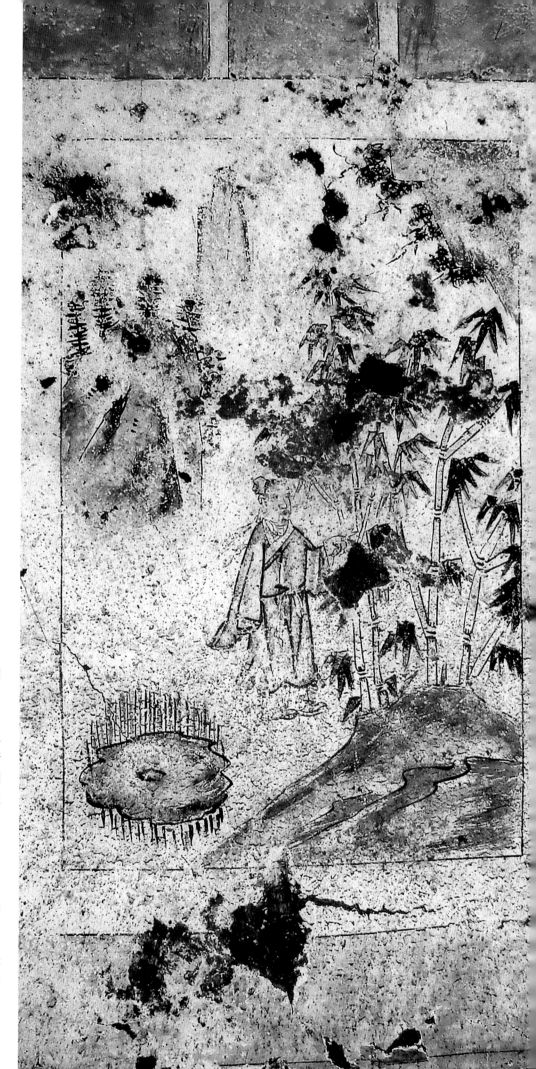

215.挂轴画

明嘉靖九年（1530年）

高约110、宽约54厘米

2006年山西省壶关县集店村明墓出土。已残毁。

墓向210°。位于墓室西壁南侧。这是一幅悬挂在紧靠棺床墓壁上的挂轴画，画面右侧绘有茂竹若干，一男子立于竹旁，画面左侧绘有远山。似为"孟宗哭竹生笋"的孝子故事。

（撰文、摄影：王进先、李永杰）

Hanging Scroll Painting

9th Year of Jiajing Era, Ming (1530 CE)

Height ca. 110 cm; Width ca. 54 cm

Unearthed from Ming tomb at Jidiancun in Huguan, Shanxi, in 2006. Not preserved.

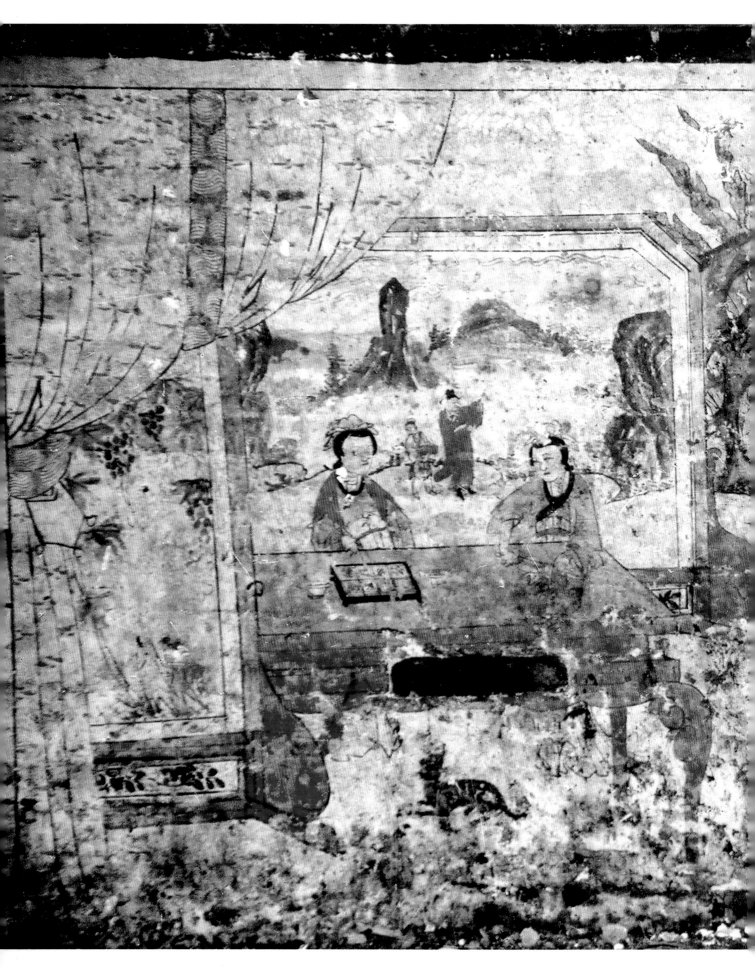

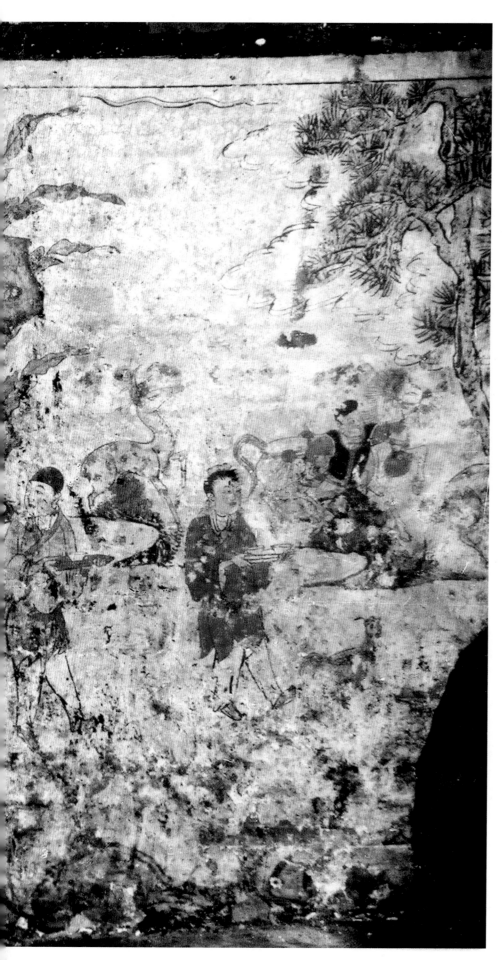

216.富贵家居图

清（1616～1911年）

高约120、宽约144厘米

1988年山西省长治市西郊南寨村清墓出土。已残毁。

墓向198°。位于墓室东壁北侧。壁画场面宏大，左侧为两名贵妇，在两个大屏风间的高桌后饮茶、对话。桌下卧有一黑狗。右侧有两名持托盏的侍仆。

（撰文：朱晓芳 摄影：王进先）

Home Living Scene of Wealthy and Lofty Family

Qing (1616~1911 CE)

Height ca. 120 cm; Width ca. 144 cm

Unearthed from Qing tomb at Nanzhaicun in western subarbs of Changzhi, Shanxi, in 1988. Not preserved.

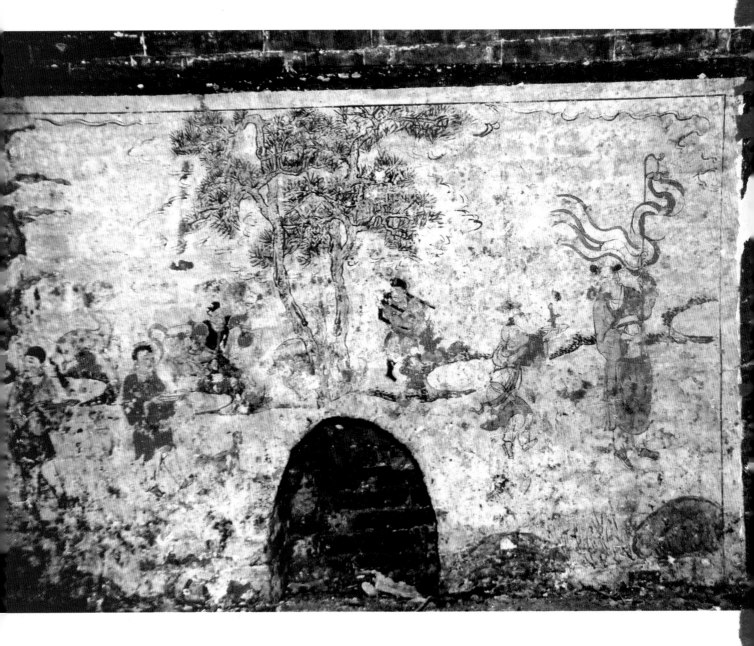

217.富贵图

清（1616～1911年）

高约120、宽约144厘米

1988年山西省长治市西郊南寨村清墓出土。已残毁。

墓向198°。位于墓室东壁南侧。壁画场面宏大，中间有大树，两侧各有一名行者；画面左侧为侍仆托盏，右侧有一名持幡的引路者，随行一名端盘的童子。

<div align="right">（撰文：朱晓芳　摄影：王进先）</div>

Playing Scene of Wealthy and Lofty Family

Qing (1616~1911 CE)

Height ca. 120 cm; Width ca. 144 cm

Unearthed from Qing tomb at Nanzhaicun in western subarbs of Changzhi, Shanxi, in 1988. Not preserved.